Essential CG Lighting Techniques

Dedication

To all the friends and family who have supported me through the
many years of my abnormally circuitous career.

Essential CG Lighting Techniques

Darren Brooker

Focal Press

OXFORD AMSTERDAM BOSTON LONDON NEW YORK PARIS
SAN DIEGO SAN FRANCISCO SINGAPORE SYDNEY TOKYO

Focal Press
An imprint of Elsevier Science
Linacre House, Jordan Hill, Oxford OX2 8DP
200 Wheeler Road, Burlington, MA 01803

First published 2003

British Library Cataloguing in Publication Data
A catalogue record for this book is available from the British Library

Library of Congress Cataloguing in Publication Data
A catalogue record for this book is available from the Library of Congress

ISBN 0 240 51689 3

For information on all Focal Press publications visit our website at:
www.focalpress.com

Printed and bound in Italy

Contents at a glance

Table of contents

Appendices

About the author

Darren Brooker is an award-winning 3D artist, author and illustrator. With over a decade specializing in lighting, rendering and texturing first for architecture and now for animation, he works between the UK and Spain, mainly using 3ds max.

His award-winning short *The Gift* is distributed in Europe by Morphe Art Pictures of Barcelona and is represented at European festivals by the British Council.

His 3D work has involved such companies as Cosgrove Hall Digital and Pepper's Ghost, both leading UK production studios.

His writing credits include *The Guardian*, *CGI*, *3D World*, *Computer Arts*, *Broadcast Engineering News* and *Creation*.

Acknowledgments

First of all comes the team at Focal Press who've made this title possible. From Marie's initial approach at SIGGRAPH 2000 to the final proofreading stage, the professional manner in which the production has been overseen has been much appreciated. This applies equally to the amount of control in terms of layout and design that Focal were willing to give me, which has resulted in a very close match to my initial vision for a definitive lighting text.

Particular thanks goes to the folks at discreet, particularly the staff at the UK and Spanish offices, for their continued help and support over the last decade, as well as for providing the version of 3ds max for the accompanying CD.

The majority of renderings featured in this book were carried out in my home studio on a mixture of Dell and IBM hardware, but a lot of this work involves previous collaboration with London Guildhall University, where the guidance of Mike King and Nigel Maudsley was, as ever, an enormous amount of help. The design and layout of this book also took place in my home in Barcelona, with occasional work at the homes of various friends and family members, who deserve thanks for their patience, not to mention their food and accommodation.

Brant Drewery and his team at *CGI* magazine in London have also been of great assistance over the years, and have provided me with work and pleasure in equal measures, for which I am extremely grateful.

Thanks go to all the individuals that kindly gave me permission to talk to them about their projects and use their images for print, and also the artists who have been very supportive in this project.

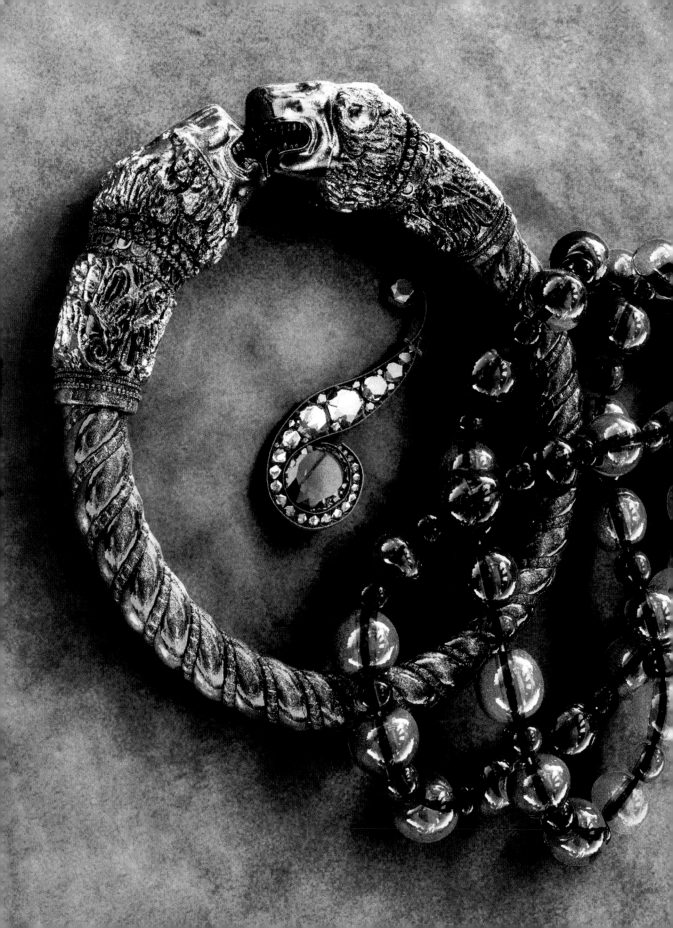

'Light and illumination are inseparable components of form, space and light. These are the things that create ambience and feel of a place, as well as the expression of a structure that houses the functions within it and around it. Light renders texture, illuminates surface, and provides sparkle and life.'

Le Corbusier

The vital role of lighting is understood across a whole range of disciplines, from architecture to animation, film to photography. The modernist architect Le Corbusier, quoted above, perhaps sums up the considerable role it plays most poetically. Though speaking about architecture, his words express succinctly just why lighting is so important in the world of 3D. Equally, he speaks for those working across the full spectrum of visual arts.

Though continually maturing, 3D remains a relatively young industry, and those who work in it can learn a lot from the established lessons of these complementary disciplines. As an industry in its adolescence, it still lacks the knowledge base of tried-and-tested techniques and conventions that have established themselves around these older art forms. Indeed, the conventions that exist in the world of cinema were not established overnight, and those working in the early days of film gradually developed the language of cinema as we understand it

Image courtesy of:
Greg Petchkovsky
www.3dluvr.com/gregpetch/

today. As the world of 3D matures, similar conventions to those that now exist in cinematography will no doubt become established and adhered to. This is indeed happening already. For example, its model of operation is fast becoming stratified by specialism, with many productions divided between modeling, animation, lighting and rendering teams.

This mode of operation demands of 3D artists a skillset that is focused on one specific area, yet an understanding of the full production pipeline is also necessary in order to understand the needs of fellow workers in other teams. In answer to this demand for specialized skills within 3D, this book aims to provide a single volume that looks at both the technical and practical aspects of becoming skilled at using the light tools available within 3D software, whilst placing this in context of the world of lighting in the complementary visual arts and the real world of professional computer graphics production. This book does not only aim to teach the reader the skills demanded of a 3D lighting specialist, it considers the fundamentals, both aesthetic and theoretical, of the real world of lighting, placing this technical knowledge in a wider context.

To become skilled at 3D lighting, one must have a basic understanding of how light works. The emotive power of different hues and color schemes must be comprehended, as must the manner in which the construction of a system of lights unifies a scene, bringing everything together as a cohesive whole that reinforces the atmosphere of the script. Composition and staging need to be appreciated, as well as the psychological effect that these considerations will convey. Only once a thorough understanding of all of these factors has been gained can anyone really call themselves a lighting artist. Fortunately the established rules of cinematography, painting, photography, stage design and architecture can provide many valuable lessons in helping us to understand the wider context in which 3D lighting exists.

With a firm grasp of the principles of lighting, you will understand how to set off the hard work of the other teams in your studio (or hide the bad work), bringing about a cohesive image that reinforces the emotions of the storyline. Until a 3D scene has been lit, it remains a bunch of polygons, and with the lighting carried out professionally, every team involved benefits.

This book aims to use as a cornerstone the lighting conventions that already exist for CG, whilst drawing on the complementary arts to look at the valuable lessons to be learned from these time-honored disciplines. Its four main sections will examine theories, techniques, tips and tricks - from painting, photography, film and television, stage design and architecture - and combine these with practical knowledge and advice from the real world of 3D production to enable you to take this knowledge further.

Whilst all the science will be explained in plain English along the way, this book's main concern is not with the theory of lighting, its aim is to teach the reader how to apply these lessons in CG, with every ounce of theory backed up by tutorials, and every tutorial placed in context of the holistic world of the visual arts.

Who this book is for

Though the level of content of this book is of a high enough level to appeal to existing 3D professionals, the modular nature of the contents makes it perfect for those relatively new to the subject who wish to gain a particular knowledge of the skills and techniques of lighting.

Professional users:
This book is designed to help the experienced 3D user supplement their existing knowledge with new techniques that will provide further creative possibilities and help negotiate the continuing trials and tribulations of the production world.

Intermediate users:
This book is perfect for the user who already has some working knowledge of a 3D application and wants to produce more professional results by learning about the techniques of lighting.

Beginners:
This book aims to cover extensively the skills of 3D lighting in a modular approach that guides the reader step by step using tutorials aimed at teaching the general processes involved rather than the technicalities of dealing with complex 3D scenes.

The tone of the book is intended to be clear and concise without being packed full of jargon. Each industry term is defined in plain English, and backed up with clear and colorful images, diagrams and, of course, renderings. Tutorials are provided in 3ds max format and a demo version of the software is included on the book's CD, but the tutorials are written in such a way that their content is transferable to other 3D solutions.

How to use this book

This book is written in a modular fashion, with the information organized into relevant sections to provide a more effective teaching aid. The first section deals with the important theoretical aspects of lighting in a clear and informative manner. Whilst not going into the theory to an unnecessarily deep level, it does attempt to outline the basic principles of light that will serve as a

guide to the lighting tasks that lie ahead, before moving into the theory of lighting in 3D. The newcomer in particular will find that this section provides an invaluable yet understandable reference to appreciating the physical properties and nature of light and how this relates to computer graphics.

The second section deals with the specific techniques applicable to 3D lighting and forms over half of the book's content. Armed with an understanding from the last section of how lighting operates within the 3D environment the reader will move on to examine different aspects of 3D lighting, where every ounce of theory is backed up by hands-on tutorials. This takes both the aesthetic and theoretical fundamentals of different lighting tasks and breaks each down into a method that fits in with professional 3D pipelines in terms of efficiency and output.

The third section provides guidelines for using the techniques introduced so far in an efficient fashion, as well as tips and tricks for breaking all the rules that have been introduced so far through faking and manipulating, which are all very valuable skills in the world of CG! Knowing which tricks save rendering time and which give the most controllable results allows you, the artist, to work in the most appropriate and flexible way possible.

The fourth section looks at further aesthetic considerations, and how as a lighting artist you have more than just illumination to worry about. An appreciation of composition, drama and the more technical aspects of the job reinforces the concepts introduced thus far and provides several junctions to explore from. From here you should be ready to explore and create all on your own!

Tutorials

Rather than being laid out in a methodical step-by-step fashion, the tutorials are designed to be readable and understandable, with decisions put in context of why they were made. However, an attempt has been made to ensure that each numerical value required has been provided so that the reader is not left guessing. Whilst these numbers will yield results that are faithful to the accompanying illustrations, these should not necessarily be taken as definitive, and experimentation and deviation from these values should be encouraged.

Software requirements

Every effort has been made to ensure that this book does not require any one specific 3D software package. The concepts discussed throughout the book are applicable to all the major commercial 3D applications. Whilst the tutorials are designed to

be used with the demo version of 3ds max that can be found on the accompanying CD, their subject matter can also be easily adapted to any software application. Should you use Maya, Softimage XSI, LightWave or another commercial solution, the techniques and concepts contained in these tutorials will be just as applicable, as lighting skills can be learnt and applied in any of these environments. The more experienced user will be able to transfer the tutorials straight from the page into their particular 3D software, but the less experienced user might first want to run through the tutorials with the demo version of 3ds max. For the newcomer, the tutorials together with the demo version of 3ds max provide the perfect starting point to dive headlong into 3D lighting techniques.

However, it should be stressed that software is not the main focus of this book - terrible results can easily be produced using the best software, and vice versa - its focus is rather an appreciation of the many factors that go together to produce well-lit output.

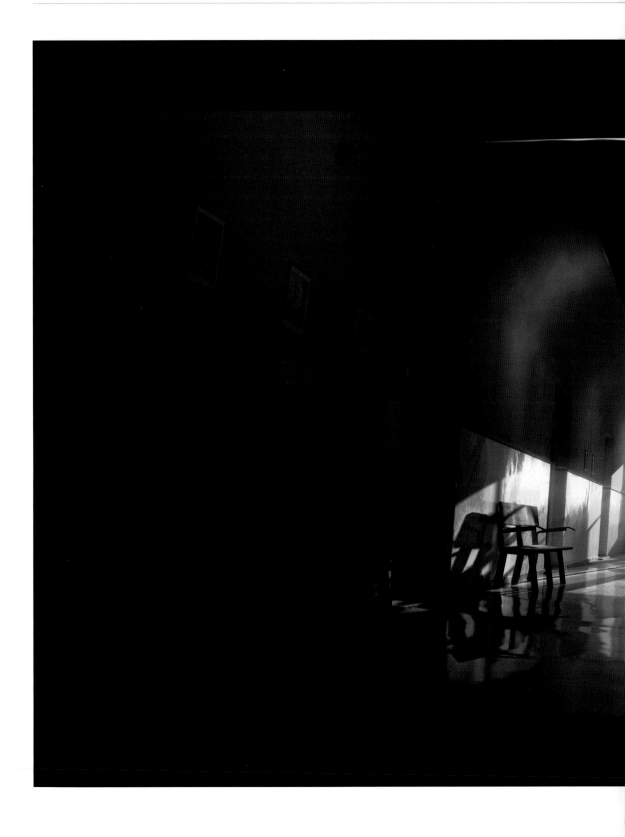

part 1: theory

Image courtesy of:
Johannes Schlörb
www.schloerb.com

2

'And God said, "Let there be light," and there was light.'

Genesis 1:3

Real world lighting explained

Light is incredibly fundamental to human existence, yet we are so accustomed to it that not many of us often really stop to consider it. Light dictates our activities, influences our frame of mind and affects the way we perceive all manner of things. It may be true that the hours a lot of CG lighting artists work mean that they are less accustomed to seeing natural daylight than most people, but an understanding of its nature and behavior is fundamental to being able to work with it effectively.

Whilst this chapter aims to explain the important theoretical aspects of lighting, it will not go into this theory to an unnecessarily deep level. This section is not supposed to be treated as if it were a physics textbook. Instead, the following three short chapters aim to outline the basic principles of light that will serve as a guide to fully understanding the lighting tasks that lie ahead in the following sections. Whilst one must understand light to be able to exploit it fully, this is by no means a chapter that cannot be

Image courtesy of:
Musa Sayyed
www.musa3d.com

skimmed through by the more experienced. Nevertheless, it provides an easily understandable reference to understanding the physical properties and nature of light, which will be particularly useful to those new to 3D and lighting.

The visible spectrum

We are surrounded by a whole different variety of waves in our everyday lives, from x-rays to radio waves. The main difference between these types of waves is their wavelength. They all form part of the electromagnetic spectrum, which goes from the short wavelength of x-rays at one end to radio waves at the other, which have a very long wavelength. Between these two extremes lies a very narrow band that is visible to us, and this is light.

Visible light's wavelength is nearer to the x-ray end, because its wavelength is small - from around 400 nanometers at its smallest value to less than 800 at its largest. (One nanometer is a billionth of a meter.) Taking this subsection, which is called the visible spectrum, we have ultraviolet radiation at the end with the shortest wavelength, known for its harmful effects on skin. Moving up through the visible spectrum, you'd move from violet through blue, green, yellow, orange and finally red before encountering infrared radiation at the opposite end, which we experience as heat.

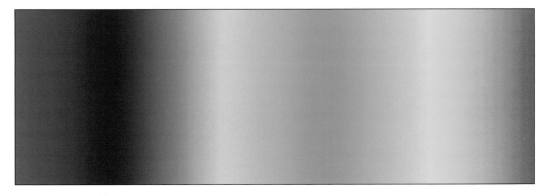

Figure 2.01
The distribution of light within the visible spectrum

Figure 2.02
The pigment- (left) and light- (right) based color wheels

Color mixing

This spectrum of colors is represented on your monitor or TV screen using light of three colors - red, green and blue, known as RGB. These three colors are the primary colors of light, rather than the red, yellow and blue of pigment-based color mixing that you may remember from an early art class.

The reason for this is that paint is mixed using a subtractive approach, whereas light uses an additive. The additive mixing of the three RGB primaries makes white light. This can be demonstrated in 3D by pointing three overlapping lights of red, green and blue at an object and rendering. The result: white light.

In this way, additive mixing takes the black screen of the monitor or TV and adds the three primary colors of light to make white. Subtractive mixing works the opposite way round, starting with a white canvas of paper and mixing the three primary colors to make black. Printers use subtractive color mixing, but rather than use the three primary colors of red, yellow and blue, the complementary colors of cyan, magenta and yellow are used as primaries. Professional machines use a four-color palette with black also thrown in, which is generally referred to as CMYK. The primary reason for the addition of this fourth ink is that for most printed literature a pure black is required for uniform text.

The differences in these color mixing systems mean that it is important to calibrate your monitor to match the printer you are working with if your on-screen rendered image is for print publishing. This process involves altering the monitor display to match the printed version as closely as possible.

Figure 2.03
In the printing process, cyan, magenta, yellow and black plates combine to make a color image

Monitor calibration is important, however, for all 3D users, whatever the delivery medium. As detailed in Appendix A, if you are working with too light a display, your image might look fine on screen, but you'll actually be using less lighting than you should to compensate for your monitor and using only a fraction of the tonal range available. Your output viewed on other monitors will be too dark. This applies in reverse if you are working on too dark a display. If you have not calibrated your monitor recently, make sure you follow the procedure in Appendix A and do so before attempting any of the practical techniques in the next section.

Our perception of light

Our graphics cards may lead us to believe that what we are viewing on the monitor screen is 'True Color'. In reality when sat in front of a PC or a television, what we are in fact seeing is a very restricted interpretation of the whole visible spectrum. The fact that just three colors of light make up a single pixel on-screen means that only red, green and blue colors can actually be displayed and a mixture of these three colors is used to represent colors of other wavelengths.

The reason why we can perceive the full spectrum within such a restricted interpretation of it is due to the way that the human eye operates. Our eyes are only responsive to three parts of the visible spectrum. They sample from these three areas using photosensitive receptor cells called cones, and there are three types of these cones located in our retinas, which each respond to light of different wavelengths. These three values correspond roughly with red, green and blue, but are not limited to these colors, and their sensitivity to areas of the spectrum overlaps.

Figure 2.04
The cones in our eyes detect light in three areas of the spectrum that RGB color roughly corresponds to

The fact the eye works in this manner means that the RGB palette does actually convey a realistic and convincing reproduction of the full visible spectrum to the human eye.

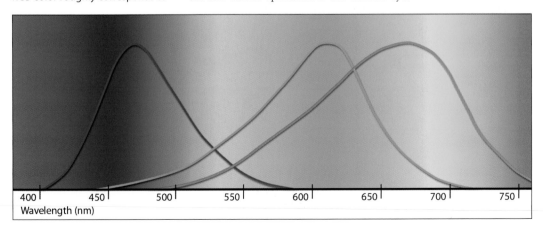

Color temperature

The system of measuring color temperatures works like the Centigrade scale. Subtract 273 from a Centigrade temperature and you get the measurement in Kelvins. The reason for this is that the Kelvin scale begins at absolute zero, rather than at the freezing point of water. As absolute zero is –273 degrees Centigrade, this explains why 273 is the difference between the systems.

This scale was conceived in the late nineteenth century by the physicist Lord William Thompson Kelvin, who discovered that heated carbon would emit different colors depending on its temperature. Increasing the temperature of this substance results in a red light, then as the temperature increases, a yellow light that moves to a light blue and finally violet upon further increase.

Based on this research, the color temperature scale was established, and this is most commonly found in the physical world of lighting design. A 2k tungsten lamp that has a color temperature of 3,275 °K emits light at the yellow end of the spectrum, though this contains enough wavelengths of all the other colors to be considered white light. One thing that must be stressed is that color temperature is based on the visible color and not, as is a common misunderstanding, the physical temperature of the filament. Indeed, the melting point of tungsten is 3,800 °K, so to represent high color temperatures of around 5,600 °K that mimic daylight, special optical coatings must be used that fake a daylight spectrum by reducing the colors complementary to blue.

Table 2.01 provides a list of real-world color temperatures, with the lower temperatures going from red, through white light to blue.

Table 2.01
Common color temperatures

Source	°K
Candle flame	1,900
Sunlight: sunset or sunrise	2,000
100-watt household bulb	2,865
Tungsten lamp (500W - 1k)	3,200
Fluorescent lights	3,200-7,500
Tungsten lamp (2k - 10k)	3,275-3,400
Sunlight: early morning/late afternoon	4,300
Sunlight: noon	5,000
Daylight	5,600
Overcast sky	6,000-7,000
Summer sunlight plus blue sky	6,500
Skylight	12,000-20,000

Color balance

Whilst color temperature might seem a little meaningless in isolation, it is its combination with the concept of color balance that provides a solution to rendering images as if they had actually been filmed. Professional cinematographers use different films that have been color balanced at a specific color temperature. This dictates which color of light will appear white when filmed, and thus how other light sources will be tinted.

There are two types of color-balanced film that are common: tungsten-balanced film for indoor use and daylight-balanced film for outdoor. These two types of stock are balanced at 3,200 °K and 5,500 °K respectively. What this means, if you look at table 2.01, is that for tungsten-balanced film, light of 3,200 °K (i.e. tungsten lamps) would appear white. And yes, you guessed it, for daylight-balanced film, daylight appears white, as the color balance of the film is around the same as for daylight.

The camera in a 3D environment generally does not have these kinds of capabilities, so to produce a rendering that mimics the recognizable colors of film, you need to adjust the colors of your lights using your own judgment. Whilst there's no direct correlation between color temperatures and color values of lights in 3D, using a table of color temperatures will assist you in selecting the tints to give your lights relative to your chosen color balance.

The first decision to make would be your color balance. From here you should look at each individual light source and identify what type of light this actually represents. Then you should tint its RGB value according to its relative position to the chosen color balance, as per the following guidelines.

If the light source is of a lower color temperature than your chosen color balance, then it should be tinted first yellow then red, as the degree of difference between the two temperatures increases. This is shown in the left-hand side of figure 2.05. If the light source is of the same color temperature as the color balance, it would appear white.

If the light source is of a higher color temperature than the color balance, then it should be tinted blue, with the amount of tint again depending on the degree of difference between the two temperatures. This is shown towards the right-hand side of figure 2.05. As you can see from both the left and right hand sides of this diagram, the more the color balance and the color temperature of the light differ, the stronger and more saturated the tint should be. However, you should be careful about not making the colors too bright, as it only takes a small amount of color to begin to tint a surface and too saturated a color will begin to blow out the lighter values of your rendering.

There is no set formula for tinting lights in this way to produce a final look that mimics a recognizable film stock, and your own aesthetic judgment is the best tool. However, one thing that should be understood is that the choice of indoor or outdoor film is not based on the location of a scene, but of its dominant light source, so outdoor daylight-balanced film might be used for an indoor shot if the main light source is a window. This also applies conversely: indoor film is generally used for outdoor night scenes, as the dominant light in this situation would be artificial lights.

For an outdoor rendering, if you wanted to mimic daylight-balanced film, you'd start with a color balance of 5,500 °K. Your light representing the direct sun, depending on the time of day, would, according to table 2.01, have a color temperature of somewhere between 4,300 °K and 5,000 °K. Being slightly less than your chosen 5,500 °K, you'd give this light a yellow tint, with the saturation increasing the lower the value. The light from the sky would be given a saturated blue tint, as its color temperature is much higher than your 5,500 °K color balance. However, the saturation of these tints is something ultimately left to your own assessment. Furthermore, in reality outdoor illumination is made up of many more colors, due to the way in which the sun's light reflects off objects in the environment, bringing into the scene

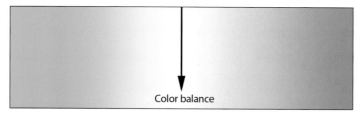

Color balance

Figure 2.05
Once a color balance has been chosen, the RGB values of lights should be adjusted relative to this

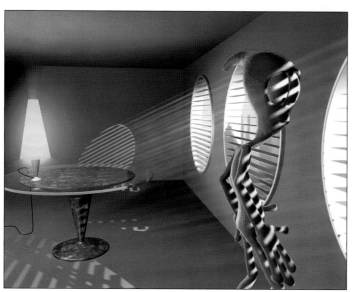

Figure 2.06
With daylight-balanced film, indoor lighting appears yellow

light tinted with the colors of these reflectors. Take a look at your scene and the principal colors of the largest surrounding objects. For example, if your scene were set against a backdrop of a large brick wall, the red color of the light bouncing from the bricks would have to be imparted to your lighting scheme.

For lighting scenarios where the dominant light source was artificial, the same principles would apply, though you'd be looking at a color balance of 3,200 °K to mimic tungsten-balanced film. Now the lights that would have a lower temperature and thus have to be given a yellow tint would be things like domestic lights. Direct sunlight, however, would now be of a higher color temperature and thus would be given a blue tint, unless it was sunrise or sunset. The colors of the light bouncing off the walls, floor and ceiling of the environment would now have to be taken into consideration using extra lighting.

One final thing of note is fluorescent lighting, which has a high color temperature range - from 3,200 °K to 7,500 °K. Whilst this is straightforward with a 3,200 °K color balance representing tungsten-balanced film - all fluorescent sources invariably should be tinted blue - with 5,500 °K as a chosen color balance, should a fluorescent light be tinted blue, yellow or red? The answer depends on what atmosphere you're trying to create. However, for all situations, no matter what the color balance selected, fluorescent light invariably looks more obviously so when it has been given a green tint, as this color makes it look more artificial.

There is certainly no such thing in photography as correct results and the hue, saturation and brightness of any light will appear differently for each individual, producing different colors in the print. This is due to a number of factors: the color balance of the film (which is invariably daylight-balanced), the tint of the flash bulb used and the filters used by the processing laboratory.

Indeed, just as sometimes happens in the world of photography, you might want to throw this whole system out of the window and instead concentrate on a more stylized look. In this case the tinting of lights is still best done by eye, but as with all things, it's ideal to understand how to best use the rules of color balance before you can break them.

The behavior of light

Light obeys a whole heap of rules, some relevant for understanding CG, some not so relevant. One rule that certainly is very pertinent to the world of 3D is the inverse square law. This explains how light fades over distance and this law is applicable to all types of radiation. It is a law that is most easily explained by considering heat. If you walked slowly towards a fire, you

would feel yourself getting gradually hotter. However, the rate at which you would get hotter would not increase uniformly as you approached; you would feel a slow increase early on, but as you got closer and closer to the fire, you'd feel a very rapid increase in heat. This is the inverse square law in action.

The way in which light fades from its source also obeys this law. The light's luminosity (the light's energy emission per second) does not change; what alters is the light's brightness as perceived by the viewer. As light moves away from its source, it covers more area and this is what makes it lose its intensity, fading according to the reciprocal of the square of the distance. For example, at two meters from the distance from the source it has lost a quarter of its intensity compared with one meter from the source. This is simply because the area it has to cover is four times bigger, so the light is spread over four times the area. At three meters, it's lost a ninth of its intensity compared with its intensity at one meter, because it is spread over nine times the area.

This law is important in 3D because this is how real lights behave, and though 3D solutions have an option to turn this behavior on, most in fact have this off as a default, but we'll go into this in more detail when we examine the anatomy of a light later in this section.

Light also obeys the simple law of reflection, which you might remember from physics class. This explains how light is reflected from a surface. The law states that the angle of reflection equals the angle of incidence, which is measured relative to the surface's normal at the point of incidence. The simulation of this law in CG takes place using a rendering process called raytracing, which simulates accurate reflections and refractions.

Figure 2.07
The inverse square law in action

This second term, refraction, describes how light bends and obeys Snell's law, which concerns transparent and semi-transparent objects. Basically this determines the extent of refraction when light passes between different materials. This bending causes the distortion that you can see by looking at a lens. There is no need to explain Snell's law itself, it is simpler to explain what determines how much the light will bend: the index of refraction.

This number is calculated by taking the speed of light (measured in a vacuum) and dividing by the speed of light in a material. Since light never travels faster than in a vacuum, this value never goes below 1.0 for basic applications. At this value there will be no bending of light and as this value increases up to 2.0 and beyond, the amount of distortion will increase. Table 2.02 lists the index of refraction for several materials, with the adjacent figure demonstrating how these values appear once rendered.

Table 2.02
Typical Index of Refraction (IOR) settings

Material	IOR
Air	1.0003
Alcohol	1.329
Water	1.330
Ice	1.333
Glass	1.500
Emerald	1.570
Ruby	1.770
Sapphire	1.770
Crystal	2.000
Diamond	2.419

Figure 2.08
These glasses are rendered with an IOR of 1.330 (left) and 1.500 (right), representing water and glass

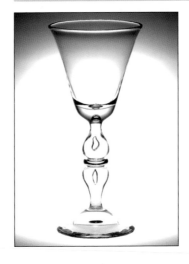
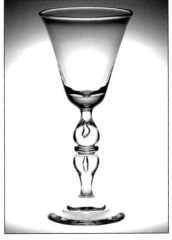

Understanding the qualities of light

The eye is one of the most incredible and intricate organs; yet seeing is so undemanding that we tend never to give this ability a second thought. We are so used to looking in fact, that we can easily spot when something in CG does not look quite right. To ensure that your lighting efforts in 3D appear convincing, there are several characteristics that make a light source look real, and these qualities of light must be thoroughly understood and simulated in 3D.

You'll often come across the term 'quality of light', which invariably means different things to different people. If you gave half a dozen Directors of Photography the task of lighting an identical movie scene, you'd undoubtedly get six very individual and different results, as diverse as the imaginations of these DoPs. First considering the space that the DoP has to light, each would refer to the script and consider the events, emotions and personalities of the story before arriving at a solution, or possibly even several possible approaches.

If you then examined each individual's lighting schemes, you'd no doubt get a wide range of variations that might go from the gritty and realistic to the sumptuous and glamorous. Depending on the nature of the scene, the results might equally be slick and clean or futuristic and stylized. The lighting does not have to follow the script literally: a miserable situation placed within a sunny scene might seem more compelling, particularly if this irony is reflected elsewhere in the script. Matching the lighting to a story can be done in a seemingly infinite number of ways, and each DoP's set-up would be quite individual.

If you then attempted to sit in front of these different versions and categorized the qualities of the lighting in each instance, you'd end up with a long list indeed. If you examined the work of Darius Khondji, for instance, you'd undoubtedly dwell on the way the soft light wraps around its subjects and the way this contrasts with other more hard light sources. Khondji has become renowned for his use of soft lighting techniques in such films as *The Beach*, *City of Lost Children* and *Seven*. This style of using soft lights has become fashionable in cinematography due largely to the advances in lighting equipment.

However, were you to view the lighting efforts of not just Khondji, but the other DoPs you'd given the same task to, you'd find yourself describing not just the soft and hard aspects of lights. Your descriptions would also concern the intensities and colors used, the shapes and patterns that the lights form, the way in which these shadows move. You could go on to describe the motivation behind the light, whether it's natural or artificial and whether it relates to a visible source in the scene.

However, if you attempted to categorize these many different descriptions under as few headings as possible, you'd probably come up with something based around the following: animation, color, intensity, motivation, shadows, softness and throw.

You might come up with more or less categories, depending on how much you think that shadows and throw were part of the same thing, or whether you think animation is a quality of light. Anyway, looking at these rough categories, if you tried to put them into some kind of logical order, you might put intensity first, followed by color, softness, animation, shadows and finally motivation. This would depend on what your role was; if you asked Darius Khondji, he'd probably put softness nearer the top of the list. However, these have been ordered thus from the point of view of a CG professional.

Intensity

The primary reason why intensity is top of our list is because of its role as one of the most obvious and perceptible qualities of light. The light with the strongest intensity in a scene is known as the dominant light and will cast the most noticeable shadows. Indeed, in cinematography's established three-point lighting system, it is this dominant light that is considered the key light. This system of lighting is heavily applied to CG and is described in considerable depth in the following techniques section, so don't worry too much if you don't know about three-point lighting yet.

There is, however, a considerable difference between cinematography and CG where light intensity is concerned. In the world of film, whether you're dealing with a cave scene lit by the

Figure 2.09
Hard light is overused in CG due to it being closer to most 3D applications default settings

light of a single flaming torch, or a beach scene lit by the brightest sunlight, the camera's exposure settings are adjusted to allow it to record properly in these dim or bright conditions. In CG, there are no exposure settings as such, so the intensity of a light source directly affects the final output's brightness and it is this that is altered, rather than the camera's exposure.

The upshot of this is that just as a cameraperson would have to change the exposure settings on the camera depending on the location, a lighting artist has to adjust the intensity of the lights depending on their context within the shot. For example, if the flaming torch were carried out of the cave to the sunlit beach, its intensity would have to be adjusted to a considerably smaller value to make the scene appear realistic and correctly exposed.

The intensity of a light is controlled by its color and its multiplier or brightness value, along with its attenuation. All light in the real world falls off, as previously mentioned in this chapter, at an inverse square rate, that is its intensity diminishes in proportion to the reciprocal of the square of the distance from the light source.

Figure 2.10
Soft light is a little more difficult to achieve, but looks much better

Figure 2.11
Color plays a big part in lighting - red can portray danger or passion

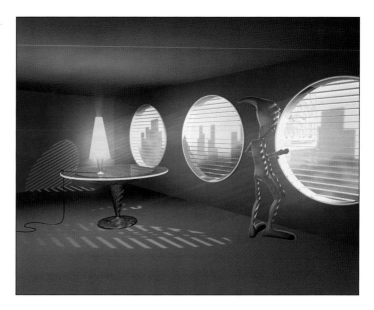

In CG, attenuation can be dealt with in several ways, with inverse square decay one of the options. This is often too restrictive for CG work, so a start value allows you to specify where the decay actually starts, which allows for more realistic results. It's worth noting that light obeying the inverse square rule never actually reaches a zero value, so it's worth setting the far attenuation value to a distance where the illumination appears to have ended to avoid unnecessary calculations. This value along with an accompanying one that dictates the near attenuation point can be used along with linear attenuation to give a very predictable falloff from the near to the far value. Alternatively, attenuation can be turned off entirely, making the distance to the light irrelevant, as the illumination from such a light would be constant.

Color

As a visual clue to the type of light source or the time, season and weather being represented outside of a scene, color is incredibly important. The similarities and differences of lighting colors within a scene will help determine its mood, with more neutral colors giving a more sombre tone, for example. Colors also have emotional properties and different people have different reactions to a color depending on the associations that they make with the color.

Color is extremely useful in reinforcing the type of light source that is being represented, and though this will vary due to the color balance that you may have selected, yellow to orange light is typical of domestic lighting. Place a blue light outside of a window and the viewer will associate the light coming inside the room from this source with the light coming from the sky.

Whilst cameras and film are color balanced for different environments and their light types, the color of light sources in CG needs to be altered depending on not only what type of light you are representing, but also what mood you are attempting to portray. Blue light can help to paint a moody and unhappy scene or a calm serene one, whilst red is often used to signify danger or passion. Consider also the symbolisms that different colors have become associated with - green recalls such things as peace, fertility and environmental awareness on the positive side, but greed and envy on the negative side. Its use in lighting can also reinforce a sense of nausea in a scene, as it imparts a very artificial, almost chemical feel to the light. For all these reasons, color is a sizable consideration in lighting design.

Softness

Though soft light is widespread in the real world, and its use is quite fashionable in the world of cinematography, in CG it appears nowhere near as often as it should. Though it is not that difficult to reproduce the full range of light from hard to soft in all 3D applications, the fact that most default settings produce fairly hard results means that we see more crisp edged shadows than we should in CG productions.

Figure 2.12
Soft shadows appear in CG not nearly as often as they should

We come across hard light in real life comparatively rarely and few of the light sources that we come into contact with exhibit the sharp focus that we so often see in CG. The sun can cast this kind of light, but most of us are used to seeing its light diffused through a layer of clouds or pollution. Bare light bulbs, car headlights and flashlights can also produce the crisp shadows of hard lights, but most lights give the soft edged shadows illustrated in figure 2.10.

Throw

The manner in which a light's illumination is shaped or patterned is described by the term throw. This breaking up of the light can be due to the lampshade of a domestic lamp, blinds or net curtains on windows or clouds in the sky. The approaches to recreating this aspect of light in 3D can vary from modeling the actual object causing the throw effect, which might be likely in the case of a light fitting, to the use of texture maps which cause the light to act like a projector, which would be more applicable for light filtering through leaves or foliage.

These types of texture maps mirror the use of a cookie or gobo (also known as a cucoloris or go-between) in cinematography. These objects are placed in front of studio lights to break the light into interesting patterns of light and shadow. In CG the use of texture maps acting like cookies generally involves a grayscale texture map, where the amount of light allowed through depends on the grayscale value: at one extreme, pure black blocks all light and at the other 100% white lets all light through.

Figure 2.13

Throw patterns break up a light into interesting patterns

Physically placing objects in front of lights works in the same manner as using cookies, and this practice is often used with things like venetian blinds. However, if the window itself were not actually visible in the rendering, it might be more efficient to use a texture map acting as a cookie.

Animation

This might not be a quality that you immediately associate with light, especially if you were thinking about photographs or paintings, but animation is a quality of light that is common to winking car indicators, flickering neon signs and fading sunlight.

Think of several different instances where a light is changing somehow and you can see that when it comes to lights, animation covers color, intensity, shadows and other attributes. Furthermore, the light can actually physically move, in the case of a car indicator, for example, and the objects that a light illuminates can also move, causing moving shadows to appear.

Animating a light's parameters to simulate the flickering of a neon sign, as we'll do in chapter 9, can introduce a gritty sense of location. Merely turning the intensity of a light up and down really quickly and abruptly makes a light appear to flicker, and this is one of the more common ways of animating a light's parameters and one that we'll use when we come to designing the neon lighting later. Animating the color of a light can help to produce a flickering fire effect, especially when coupled with an animated intensity value. This is also true for televisions, which cast a similarly varying light on a scene.

Though animation might not be considered one of the primary qualities of light, what it can bring to a scene in terms of atmosphere cannot be ignored. For instance, a light bulb swinging from the ceiling will create the feeling of movement; from the

Figure 2.14
Animating a light can give a scene a really dynamic feel

gentle swaying of an outdoor light in the wind to the sickness-inducing swaying that might be experienced if this light were in a room on board a ship.

Moving objects in front of a light to produce dynamic shadows can add a great deal to a scene, in the way that a tree swaying in the wind would cast interesting shadows through a window.

Shadows

Shadows play a massive role in describing a light, and this is an area that we will go into in much greater depth in a couple of chapters' time. Shadows add to a scene's realism, consistency, relationships and composition. Rather than thinking of shadows as something that things get lost in (though this can be very useful for hiding imperfections), shadows actually show us things that otherwise would be impossible to see. Arguably, designing shadows is as important a task as designing the illumination in a scene, so important is their role. You will find that when you get down to setting up your lighting schemes in 3D, a huge amount of time will be spent on shadows. You'll face choices as to which algorithms to use to generate both hard and soft shadows, and how to do this in the most efficient manner possible. Such a big subject is this in fact that the whole of chapter 4 is dedicated to the issue.

Motivation

Lights can be categorized by how they operate in the scene in terms of their motivation. Lights will sometimes be referred to as logical, if the light forms part of the logically established sources that are visible or implied within the scene. Logical lights can represent an actual source such as a table lamp, or they can represent the illumination from outside a window.

The placement of lights can also be motivated by purely aesthetic reasons. If a light has been placed simply because the effect it produces is pleasing, then this can be described as a pictorial light. Pictorial lights are often needed, as placing only logical lights can result in a very uninspiring look and it's generally the pictorial lights that introduce the drama and create the emotional link with the audience. Most people looking at a CG production, however, won't even consciously consider your lighting at anything approaching this level, but this is one of the keys to good lighting, if it plays the emotional role that it is designed to without drawing attention to itself, then it has certainly succeeded.

By looking at light in terms of these different qualities, we can begin to learn how to break it down into its component parts and start to be able to record its essence. This is the first step towards seeing light, which is the key to being able to light a scene to underscore and show off the hard work of everyone involved.

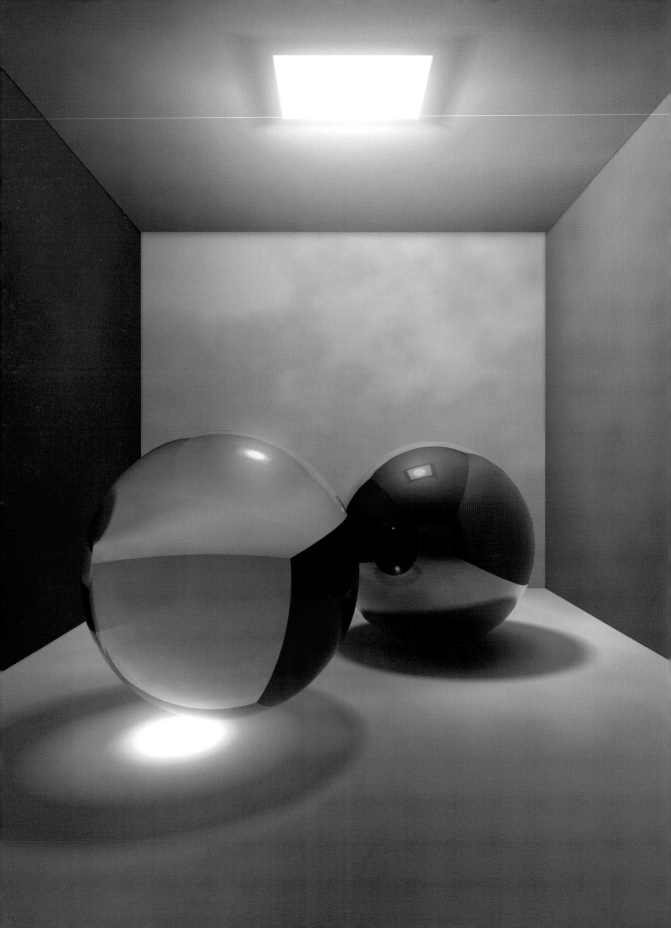

3

'We are storytellers, and we tell our stories with light and sound. Take away the light and all you've got is a radio show. We paint with light. It gives depth and presence to a scene and creates mood. In order to paint with light you first need to see it in all of its nuance and spectrum.'

Scott Billups: *Digital Moviemaking*

Lights in CG

There is a vast difference between lighting a scene and merely illuminating it. All you have to do to illuminate a scene is create a single point light and it's illuminated. Lighting is a different matter entirely, relying on the careful reasoned positioning of the various individual sources that make up a lighting scheme.

Each of your lights should be placed where it is for a specific reason, with the lighting scheme built up steadily and purposefully. As such, you should be able to explain the role of each light in the overall set-up, which should be balanced, with each of these sources playing a harmonious part in the cumulative solution, rather than battling against each other. The lighting scheme should emphasize the 3D nature of the medium of CG, showing off the 3D forms to best effect when rendered. You will never be able to do this by using your software's default light type every time, and as such, a good understanding of the different light types available and their characteristics is very important.

Image courtesy of:
Big Face Productions
www.big-face.com

Point lights

Though referred to as omni lights by 3ds max users and even radial lights by some users, most of us will know this light type as the point light; those using Maya and Softimage XSI certainly will. This is arguably the most apt name because these lights, whatever their name might be, provide a point source of illumination that shoots out in all directions from a single infinitely small point.

The name given to these lights by 3ds max, however, also makes a lot of sense in the way it refers to the omnidirectional manner in which these lights distribute their light through the three dimensions. They are, because of this, the easiest light to set up, but in the real world you'd struggle to find a light that acts in this manner, beyond a star, or possibly a candle flame or firefly. Most lights in reality don't emit light evenly in all directions, especially the electrical lights that they are often used to represent, which you can see by looking at any light bulb around you.

There are of course several options for adapting point lights to work in this manner. You can place the point light within a geometrically modeled light fitting, as in figure 3.01, and turn on the light's shadow-casting function, though as you'll discover in the next chapter, the generation of shadows is the most computationally intensive part of rendering a light, so this might not always be the best option. Alternatively, you could use a bitmap as a projector, which acts as a throw pattern, restricting the emission of light. Point source lights are often used to provide fill lighting, and restricting the objects that are illuminated by these lights to a subset of all of the scene is a common practice to provide controllable levels of local lighting.

Figure 3.01
A point light can use geometry as a way of limiting its illumination

Spotlights

No confusion with names here, a spotlight is a spotlight in any 3D package, and is the basic building block of most lighting situations. This is due to the fact that a spotlight is eminently controllable in terms of its direction. Spotlights cast a focused beam of light like a flashlight beam, and behave as in figure 3.02.

Like point lights, spotlights emit light from a single point, but unlike point lights, a spotlight's illumination is confined to a cone. As such, unlike point lights, spotlights need to be aimed and this can be done in several ways. The most simple method is to position the light freely and rotate it until it's aimed correctly. A method that is often more useful involves giving the light a target object, so it remains facing this no matter how the light is oriented. Alternatively, the light itself can be attached to a 3D object, so that the light moves and radiates from the model, like a car headlight.

As well as being able to manipulate a spotlight's orientation, you can also control its cone, which is defined by two angular values: one defines the hotspot and the other controls the falloff. The

Figure 3.02
Target objects allow spotlights to be aimed most conveniently

Figure 3.03
A spotlight's cone can be adjusted to give soft or hard falloff of light

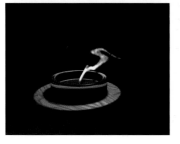
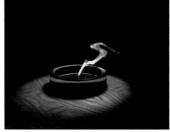

light's intensity falls off gradually from 100% at the innermost hotspot value to 0% at the falloff value that defines the very edge of this cone. Varying the amount between these two values controls the softness of the light at the edge of the cone. With a small difference between these two values, the light will appear in a sharply defined circle, and as these values get further apart, the light's edge will get softer and softer. When given a really soft edge, a spotlight will lose its defined edge and the location of the light itself will become ambiguous, which is a very useful tool, effective for subtly lightening a specific region.

Spotlights will play a major role in the design of any lighting scheme due to their controllable nature. The fact that they can be easily targeted, given a falloff that can range from the crisp and hard to the soft and subtle, makes them an obvious choice for a huge amount of lighting tasks.

Area lights

As we have already discovered, in the real world there is no such thing as a point light, whose illumination comes from an infinitely small light source. Real life light sources invariably have a physical size. Area lights provide a light type with size (or even volume), from across which light is emitted, providing a far more realistic solution for depicting everyday light fittings.

The larger your area light, the softer the shadows will become and the more pervasive the illumination - the light will begin to surround objects that it is bigger than due to the source's size and the way it reaches over them. Conversely, if the same light was

Figure 3.04
Scaling an area light will increase the softness of its shadows

made increasingly smaller, its shadows would become gradually less soft until they eventually become hard edged and crisp. At this point the area light would have been scaled down to a small enough size to start acting as a point light.

Area lights make for very believable lights and as such they are capable of incredibly realistic results, but their downside is that they can be quite computationally intensive and take a lot of time to render. As such, they will often only be used for final quality output, or for producing single still images. In longer productions, their use can be too costly in terms of render times - PDI for instance apparently did not use a single area light in making *Antz* for this very reason - but their look can be achieved using more efficient methods, which we'll get to in a couple of chapters' time when we take a look at arrays. Indeed, in certain solutions, such as 3ds max, area lights simply do not exist, and arrays must be used in their place. Where implemented, however, the area light is the one light type that varies most from solution to solution. Some applications have area lights as a separate entity altogether, some as an extension of standard light types. Existing geometric forms can even be used as area lights in a lot of cases.

Figure 3.05

If your solution does not feature area lights, arrays can be just as good a solution, if not better

All of these different implementations have their advantages and disadvantages. Even having no option for area lights has its advantages, in that when you're designing a lighting scheme to act as an area light, you have control over every light that makes up this scheme and know exactly what each individual light is contributing to the resultant image.

Indeed, algorithms behind area lights vary hugely from solution to solution, with some implementations less perfect than others. For example, if your area light routine simply distributes regular point lights over the area that you've specified, grouping them together as a single entity, then the degree of control that you have over them is less than if you had placed the lights yourself. If you did this, then you would be more able to place and control them individually in as efficient a manner as possible.

Area lights can operate using many different emitters, the first and most common of which is the 2D area light. This generally uses either a circle or a rectangle as its source and is used to mimic lighting panels such as the one in figure 3.04.

Further types include three-dimensional arrangements, such as the spherical area light, which operates like a spherical light fitting and has obvious uses when replicating such fixtures. This can also be used where you need a point light's illumination to be softer, although softening the shadow of the point light might prove less expensive in terms of rendering, though less accurate.

Cylindrical lights have obvious uses too, in the representation of fixtures such as flourescent tubes. Indeed, the linear area light can also be used to represent this kind of fitting and has the benefit of

Figure 3.06

Cylindrical area lights have obvious applications for neon tubes

being one-dimensional, so faster to calculate. This can be quite an effective compromise between speed of rendering and realism. This kind of area light is capable of producing a good degree of realism when it comes to soft shadows, but because it is one-dimensional, its calculation is much faster than the two or three dimensions of the aforementioned area light types. In addition to these standard types, in certain 3D packages, any object can be selected to operate as an area light source. This can appear useful for such unusual shapes as neon signs, but in reality this type of application is best faked.

Directional lights

If you modeled several simple objects and placed a point light up close to them, you'd obviously see that the shadows cast would depend on the relative position of the objects and the source. Move the light steadily further away and you'd see the shadows becoming increasingly parallel. Whilst even the sun is not far away enough to cast totally parallel light, to all intents and purposes it does, as this is how it appears to the naked eye.

Figure 3.07
Directional light hits all objects at the same angle, like the sun's light

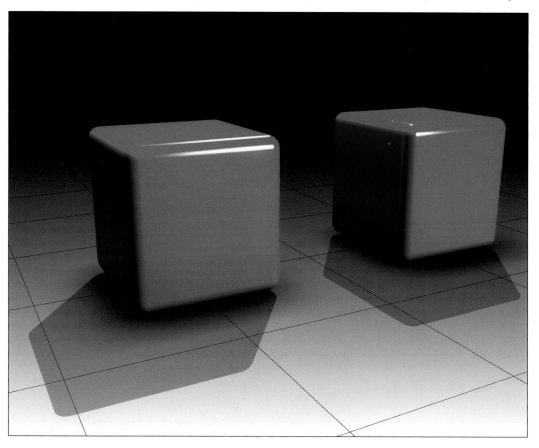

This is the role of a directional light: to cast parallel light rays in a single direction. It is unsurprising then that these lights are used primarily to simulate sunlight, and as such some 3D packages refer to them as sun lights (as well as distant, direct and infinite lights). These types of lights are eminently simple to control: since the parallel light does not vary, its position does not matter, only its rotation does, which is controlled like a spotlight by rotating the light itself or by moving the object to which it is targeted.

However, this type of light should not just be confined to sunlight. Directional lights are also often used for fill lighting, which is a secondary light that complements a scheme's main (or key) light. We'll go into this in more detail in the following techniques section. The general light known as ambient light - which is explained in the following paragraphs - is most noticeable in exterior scenes, when the sky's broad lighting produces an even distribution of reflected light to surfaces not in direct sunlight. Directional lights are a good solution to modeling this kind of light, far better than using your 3D solution's ambient light controls, due to the way that directional light can provide even illumination to large areas.

Ambient light

The final type of light is not a physical light that can be placed in a scene, but the light which we referred to in the last paragraph as ambient light. This general light, or global ambience as it is known in some solutions, is set to illuminate the entire scene. In the real world ambient light is the general illumination we experience from light reflecting off the various elements in our environment.

Figure 3.08
Ambient light provides unrealistic results and should be set to black

Learning to use this lighting type in CG is simple; you learn not to use it! Why? Due to the unrealistic way that 3D packages generally deal with ambient light. In real life, ambient light is light that has bounced off the various objects in our surroundings. It is this type of light that makes it possible for us to see into shadowy corners that aren't directly lit by light sources.

However, in CG this light is applied with uniform intensity and is uniformly diffuse. The upshot of this is that the ambient light is applied using the same value across an entire scene, not taking into account the changes of intensity and color that real world ambient light demonstrates.

CG ambient light is generally controllable only in its amount and color. This is unrealistic because the fact that this light has bounced off the various surfaces of an environment means it has absorbed different tints as it has bounced off different colored objects. Furthermore, real life ambient light varies in intensity around its environment whereas CG ambient light uses a set intensity across the whole scene.

The best practice in lighting is to turn off your ambient lighting by setting its value to black before you even begin adding lights to the scene. Ambient lighting deprives a scene of the depth of shading and color that provide it with valuable variation, especially in the all-important shadow areas, which are important regions, as we'll discover in the next chapter, providing a surprising amount of visual information. Turning on even a small amount of ambient light robs you of the full range of tones available, as pure black will now appear slightly grayed.

Indeed, whatever you set as the value of your ambient light effectively becomes the darkest value allowed in your scene. Keeping the full range of tones enables better contrast. If you really have to add a little ambient light to a scene using these controls, then do it after you've added all your lights, and use it sparingly.

Figure 3.09
With ambient light, the image is robbed of contrast (left)

Adding fill lights is the best way to provide a subtle level of secondary lighting that works like real life ambient light. This is more controllable and produces far richer and more realistic results. We'll learn all about using secondary fill lighting to give your scene this kind of general lighting in the next section.

The anatomy of a CG light

All of the aforementioned light types have some common parameters, as well as some that are specific to their individual type. For example, spotlights have a specific group of parameters that control the hotspot and falloff (which defines the cone of illumination), as well as the target distance, if this is being used. Of the common parameters, the simplest of these is the on/off toggle, which is invaluable in isolating individual light sources to test their effect. Indeed, lighting a scene is all about testing and revising the lighting set-up, and the initial placement of lights takes a fraction of the overall time.

Color is also common to all light types, and is an important consideration as we have discovered. Color is most commonly specified using RGB values, though the HSV model (Hue, Saturation, Value) is also used. Many people use the RGB model exclusively, as they find it preferable for color selection, but the HSV model is very useful in terms of increasing the brightness of a color. With the HSV model, the Hue field chooses the color from the color model, the Saturation field the purity of the color (the higher the saturation, the less gray the color). The Value field sets the brightness of a color, and it is this that can be used to control the intensity of a light, in combination with its Multiplier value. This value amplifies the power of the light (by a positive or negative amount), so setting the multiplier value to 2.0 would double the intensity of the light. Many people use this value to increase the intensity of a light, which can cause colors to appear burned out, as well as generating colors not usable for video. For example, if you set a spotlight to be red but then increase its Multiplier to 10, the light is white in the hotspot and red only in the falloff area, where the Multiplier isn't applied. For this reason, Multiplier settings should generally be kept between 0 and 1.0, but no higher, unless the work involves a special effect that requires this. Rather than use a light with a Multiplier value of 2.0, it's a better idea to use two lights with Multipliers of 1.0.

Negative settings can also be used for the Multiplier and values less than zero can be very useful indeed, though likewise they should not really go beneath –1.0. Negative settings result in light that darkens objects instead of illuminating them. Most commonly, negative lights are used to subtly darken areas like the corners of rooms, though they can be used to fake shadows themselves with the benefit of less computation time.

Also useful in gaining close control over a scene's lighting is the ability to exclude or include objects from a light's influence. This feature, which obviously does not occur in nature, allows you to add a light that specifically illuminates a single object but not its surroundings, or a light that casts shadows from one object but not from another.

Attenuation settings allow you to control how light diminishes over distance. In real life, as we've already touched on, light decays in proportion to the square of the distance from the light source. Using this type of decay provides a subtle realism to the

Figure 3.10
Fill lights are the best way to provide subtle secondary lighting that works like real ambient light

Images courtesy of:
Jason Kane
www.KaneCG.com

light, but can prove too restrictive and can produce dim results in areas distant from the light whilst at the same time applying an overly bright area around the source. The use of inverse square attenuation also does not reduce the light calculation time as one might first think, as the light actually never fades to zero. To this end, most solutions actually provide the ability to input two values - near attenuation and far attenuation - that control where the attenuation begins and where it ends. With the far value used to specify an end to the light's illumination, render times are actually improved by a decent margin, as light only travels within this attenuation range, so the renderer is saved the calculation of anything that lies outside this area.

These two values can also be used to control exactly how a light attenuates, for precisely controllable results, and the option to still use inverse square falloff is often provided, as is the option for linear falloff. This algorithm calculates a light's decay in a very straightforward manner, falling off in a straight line from full intensity to zero intensity between the near and far values. Linear decay produces results that are not quite as realistic as inverse square, but the upside is that the falloff is much more predictable.

Whilst lights with no attenuation can demand unnecessary calculations, it can often produce the most realistic results, especially in terms of bright light entering a relatively small space. The few meters that sunlight, for instance, travels within a CG scene is proportionally nothing compared with the gargantuan distance that the light has traveled from the sun, so any attenuation that might occur in this small space would be too minute to be spotted by the naked eye.

Shadows are also managed from within a light's controls, and the reason that this has been left until the end of this chapter is because they merit a whole chapter to themselves...

Figure 3.11
A light's controls as seen in 3ds max

4

'Envy will merit as its shade pursue,
But like a shadow proves the substance true.'

Alexander Pope

The importance of shadows

Though you might consider shadows something that things get lost or hidden in, this element of lighting is actually so vital in terms of composition, spatial relationships and contrast, that its importance in a lighting scheme simply cannot be overstated. Shadows vary enormously in shape, form and quality with the environment's illumination. It is the ability to reproduce these characteristics that lies at the heart of obtaining realistic renderings.

The human eye takes a cue from shadows not only in judging where a light source is located, but also what an object is made of, how far away it is and how it relates spatially to its surroundings.

As well as being one of the most important aesthetic considerations for a lighting artist, in the world of CG shadow rendering is also one of the most important technical aspects to get to grips with. From the initial choice of algorithm, shadow casting can be an extremely computationally intensive business, so

Image courtesy of:
Massimo Barberis
web.tiscali.it/pureart

knowing the rules of how to best represent your lighting scheme's shadows is vital, as is then learning how to break these rules and trick your way to convincing shadows in a fraction of the time.

Though the ability to hide things in shadows can prove very useful, the visual role of shadows is more considerable than you might first guess. They serve many purposes visually in terms of composition, detail and tonal range.

Perhaps the most obvious function that a shadow serves is to serve as a visual clue to depth and position. Without shadows, as you can see in figure 4.01, it's difficult to judge where the different elements are located relative to their surrounding environment. The relative size of the various cubes gives you a clue about their depth in the image, but without knowing that the cubes are all of the same size, this cannot be taken as given.

With the shadows present, however, it's easier to judge the positions of the cubes. The size of the different objects becomes apparent and we can see which are actually suspended in space and which are resting on the ground plane.

You can also see from this same image that the shadows help impart a better tonal range to the rendering. This is of particular importance when you are dealing with environments consisting largely of similar colors. Without the shadows, the elements that make up such a scene would be more difficult to tell apart. The contrast that the shadows bring gives important visual clues that help to shape the space and define the elements within it.

Figure 4.01
Without shadows it's difficult to judge relative positions of objects

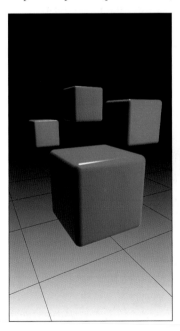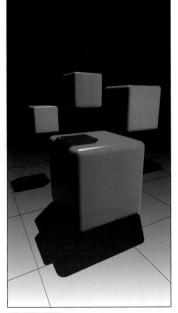

The way in which lighting can help show off the modeling work in a scene is of paramount importance. CG productions deal in a three-dimensional form, and though this is invariably presented as a series of flat rendered images, lighting has a pivotal role to play in reinforcing a production's 3D nature. For instance, lighting can be purposefully placed to produce a shadow that reveals the outline lying perpendicular to the camera, which as such would not normally be apparent. Likewise, using a throw pattern such as one that would be produced by a horizontal or vertical blind can be an unusual way of emphasizing a subject's three-dimensional form, which might otherwise have been less apparent.

Furthermore, it's not just what's framed in the image that shadows tell us about, they also give us clues as to what lies outside of a rendering. The sense of what's going on outside the frame is important in cinematography, and a long creeping shadow can tell of us a mysterious approaching figure that tells us a little of the story without revealing the identity of the character. Shadows inform us as to what lies in the space around the viewer, and what is out of shot can go a long way in terms of atmosphere and mood.

As you'll examine in futher detail in chapter 15, it's important to consider the overall composition and balance of your output and shadows can be very useful as a compositional device. They can be used to give detail to large areas that might be otherwise too bland, to frame key elements and to draw your audience into a certain area of the image. Shadows can be an incredibly useful tool in terms of quickly establishing the all-important focal points of a rendering, by obscuring the areas surrounding the focal point, you are effectively framing part of the image.

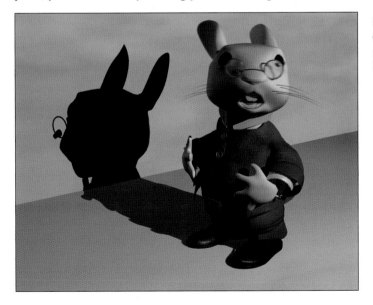

Figure 4.02
Carefully considered lighting can reveal details that could otherwise be hidden to the viewer

Additionally, shadows reassure us that objects are sharing the same space. This might not seem like a big consideration, but in the world of CG you'll often have scenes that don't relate to normality: a talking rabbit dressed up in a suit and sporting a monocle is not something that you see every day.

Shadows help to bring such disparate elements together into a visually cohesive whole. If you want an audience to accept a scene which is somewhat implausible, the shadow can be a great tool in creating convincing interaction that assures the viewer that yes, what they are seeing is actually happening. Without the subtle interplay of shadows, even the most photorealistic of scenes becomes less credible, and the human eye is so used to seeing shadows that it does not take much to stretch the illusion too far.

The technical side of shadows

Though on the whole there are only two algorithms that are generally used for shadow generation, the amount of variation that can be produced between these two methods is wide, in terms of softness, form, quality, color, and most importantly, render times. The difference between one set-up and another might not be vast in terms of the visual results, but the all-important factor of rendering speed might be hugely different.

Shadow-mapped shadows use a bitmap that the renderer generates during a pre-rendering pass of the scene. This bitmap, called a shadow map (or depth map in some applications) is then projected from the direction of the light. Depth mapping is perhaps the more accurate term, as the calculation involves

Figure 4.03
Rendering with shadow maps can produce undesirable results

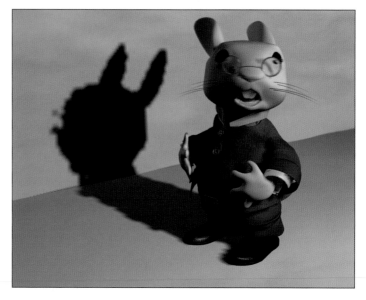

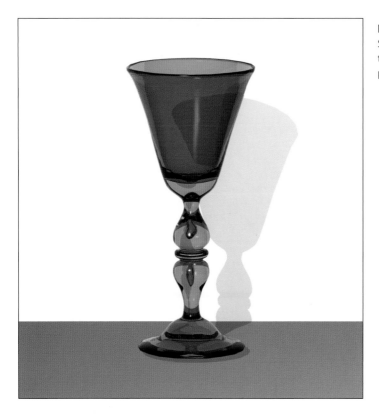

Figure 4.04
Showing the color cast by transparent objects is often only possible using raytraced shadows

numbers that represent the distances from the light to the scene's shadow casting objects. With this information pre-calculated, the rendering process does not cast light beyond distances specified in this map, making it appear that shadows have been cast.

Raytraced shadows are generated by tracing the path of rays sampled from a light source. This process is called raytracing, and by following the rays in this manner the software is able to calculate very accurately which objects are within the light's zone of illumination and casting shadows.

The differences between these two processes are considerable, and the choice of shadow type can have a great effect on both rendering speed and output quality. Shadow maps can provide a soft edge in all 3D solutions, whilst raytracing produces hard-edged shadows in all applications, but can only be made soft in some. Shadow mapping is less accurate, but as a result generally requires less calculation time than raytraced shadows. Finally, showing the color cast by transparent or translucent objects is generally only possible using raytracing to generate the shadows.

Generally, raytraced shadows require little by way of adjustment and they are not bogged down with swathes of controls, so in terms of fine-tuning, they require less effort. Shadow maps, on

Figure 4.05
Shadow maps are more
controllable in terms of their
softness

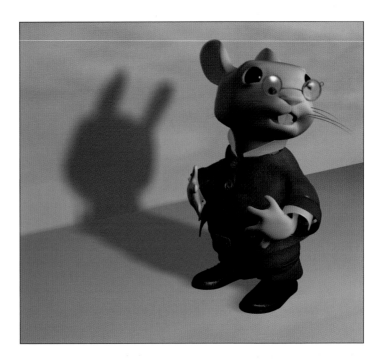

the other hand, have far more features and functions, so generally
take a fair amount of tweaking from their default settings. The
reason that this adjustment is necessary is because shadow-map
shadows are only bitmaps, and you need to keep in mind their
resolution in relation to your distance from the shadow, and the
detail required by the shadow.

If their resolution is too low (especially if the camera is very
close) the shadow can end up looking blocky and crude. If
shadows appear too coarse and jagged when rendered, the map
size needs increasing or blurring. However, the greater their
size, the more memory required and the longer the shadow takes
to generate. If hard edges are required, there can come a point
where using raytracing is a better option, depending on the
complexity of the scene. The more complex the shadow casting
objects, the longer the render time for raytraced shadows.

If you have enough RAM to hold the entire scene including the
shadow maps, then shadows don't affect performance, but if the
renderer has to use a virtual memory swap file, rendering time
can slow considerably.

The upside of shadow-mapped shadows is that they are much
more controllable in terms of their softness, and thus it's easier to
control the tradeoff between quality of output and render time.
Not all 3D packages give you the two shadow generation
algorithms for all lights, however. One further point of note is that
as an omni is the equivalent of six shadow-casting spotlights in

certain applications, the memory requirements of shadow-mapped omni lights jump up as a result, as obviously do the render times if you begin to work outside the amount of RAM on your machine. Sometimes, only raytraced shadows will do. If you were attempting to render a scene with transparent objects, this method's ability to handle transparency and tinting of light due to these objects being colored can make it the simplest choice, if not the method with the shortest render time. In attempting to produce convincing results with this kind of scene using shadow mapping, you'd have to place additional lights that did not include the transparent surfaces in their shadow casting in an attempt to cheat the correct look. Nevertheless, a convincing cheat that works in half the time of the raytraced solution might be exactly what is needed in a realistic production environment.

The key to controlling render times with shadow mapping depends on several things, the first of which is the shadow's resolution, which dictates the level of detail within the shadow cast. Raising this value makes for increased accuracy, but with the usual penalty on memory requirements. Too low a resolution can result in blocky aliasing around the shadow's edges and the larger the light's coverage, the greater the distance this map has to be spread over, so again, the resolution might need to be increased.

By keeping any shadow-mapped lights restricted to as tight an area as possible you are making certain that these shadow maps are used efficiently. After tightening the light's hotspot and falloff values, reduce the shadow map size as much as is possible. When shadows are required across a siginficant space, it can be much more economical to use an array of lights with smaller shadow maps rather than just one light with a huge shadow map.

Figure 4.06
Using shadow mapped lights side by side can be more efficient

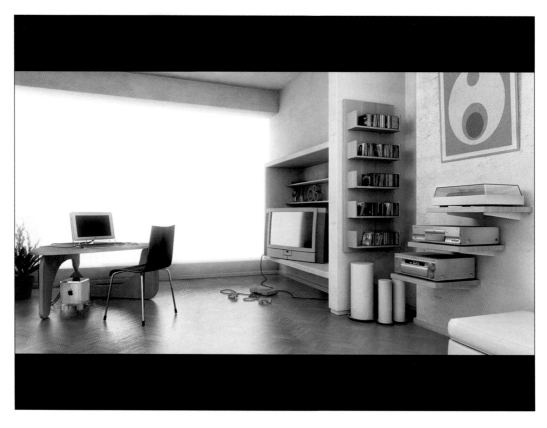

Figure 4.07
Soft raytraced shadows fall off more realistically than shadow maps

Image courtesty of:
© Tobias Dahlén
www.rithuset.se

Illustration for an intranet-solution for Thalamus.
Agency: Mogul Sweden

As you can see from table 4.01, eight lights with a shadow map resolution of 512 side by side would demand 8Mb of memory to render. This compares favorably with a single light of resolution 4,096 (the same as eight lots of 512), which would demand 64Mb, eight times the amount. Alternatively, one light with its shadows turned off could be used to illuminate the entire area, and then shadow casting spotlights could be placed selectively in the various locations where they were needed, thus keeping things as tight and efficient as possible. Furthermore, some 3D solutions allow lights to overshoot, which limits shadow casting to within the cone, but allows the illumination to overshoot this area, which can be useful for large-scale illumination when coupled with efficient shadows. Finally, shadow casting omni lights should be avoided if possible, as the memory requirements can be up to six times that of a spotlight.

To avoid the crisp shadows that are seen too often in CG, you'll need to acquaint yourself with the shadow's controls. Physically small lights do cast hard-edged shadows, as do distant light sources, but in real life most lights cast shadows with some degree of softness. The larger the light fitting, the softer the shadows cast, and whilst shadow mapping can certainly produce soft edges, not all 3D applications support this when using raytraced shadows.

A shadow-mapped shadow is made soft by applying a blur to the shadow map itself. Increasing the amount of blurring increases the render time, but it is worth bearing in mind that smaller resolutions of shadow maps can be used when blurred in this way, thus extra time spent computing the blur is often saved from the shadow map calculation. Blurring raytraced shadows is often as simple as clicking in a checkbox that specifies the use of soft shadows, but the algorithm behind this method might involve creating many instances of this light that can increase render times unrealistically. As you can see in figure 4.07, the two approaches produce differing results, with the more accurate raytraced method producing the most realistic results, with shadows growing softer as the distance from the shadow casting object increases.

This type of shadow is about as good as it gets in terms of quality, but as you might expect this comes at the expense of render time. Calculating soft raytraced shadows can be akin to using raytraced shadows with area lights. This can take a prohibitively long time, and their use might be best limited to one-off still renderings, as an array of shadow mapped lights would take comparatively a fraction of the time, and that's why learning how to cheat shadows is what everyday production techniques often come down to.

Table 4.01
Shadow map memory requirements

Shadow map resolution2 x 4 = memory requirement

512	1Mb
1,024	4Mb
2,048	16Mb
4,096	64Mb

Faking it

Whilst using the accurate raytraced soft shadow methods will generally give you the best results in the most straightforward manner, the fact that shadow calculation is the most time consuming part of a light's rendering means that we often need to fake our way to a quicker solution. There are several tricks and techniques employed in CG to save on render times.

Lights with negative brightness are sometimes used to add fake shadows into a scene. By adding such a light with its multiplier or intensity given a negative value, you can selectively darken a region. As we've touched on before, this technique is most commonly employed to selectively and subtly darken a scene in areas like the corners of rooms, but it can also be a useful way of cheating quick rendering soft shadows.

With a scene illuminated only by lights that cast no shadows, target a spotlight at the base of the object, where the fake shadow is to appear. This light should also not be set to cast shadows, but the object that is to cast the shadow should be excluded from the light's illumination. Finally, adjust the brightness or multiplier to a negative number, which will darken the area at the object's base rather than lighten it. Adjusting the hotspot and falloff will control how soft edged this shadow appears.

By constantly evaluating different methods of lighting your scenes and minimizing the need for shadows you will certainly keep render times down. Simply not lighting the areas where you want the shadows to fall might sound strange, but can be effective and saves your software a whole lot of bother.

This practice is commonplace when it comes to designing simple light fittings. Rather than simply use an omni light to represent the bulb and use the lightshade to cast shadows on the ceiling and floor, two spotlights can instead be used inside the shade - one oriented upwards and one downwards - whose cones fit the circular holes in the shade making it appear that the lightshade is actually casting shadows. A third light should also be introduced in the form of an omni which will illuminate the semitransparent shade and mimic the light passing through it. By using three lights, none of which are set to cast shadows, in place of a single source that uses shadows, you not only speed up the render, but allow the lamp's illumination to be more closely manipulated.

Shadows-only lights can be used to create shadows without adding any light to a scene, something that obviously is not possible in real life. However, if shadows are the most costly part of rendering light, why would you want to introduce shadows-only lights? The value of these lights is found in terms of cheating lighting angles to hide a modeling imperfection perhaps, or reveal something that would otherwise fall in shadow, or even as a stylistic or compositional device. The use of shadows-only lights also gives you more individual control over the shadow's color, saturation and so on, without having to alter the scene's lighting. Furthermore, as touched on previously, these lights, when used selectively to cast shadows in restricted areas, can provide a very controllable and efficient solution in large illuminated areas of a scene that can first be lit with a light set not to cast shadows.

Not all 3D applications have the ability to cast shadows-only lights, but this needn't be a problem. To get round this, you merely need to create the light that casts the shadows that you desire, and then clone this first light. Turn shadow casting off the new clone and set the brightness or multiplier to the same amount as the first, but give it a negative value. The result of these two lights is a shadows-only light, with the illumination of the first light counteracted by the negative brightness of the second.

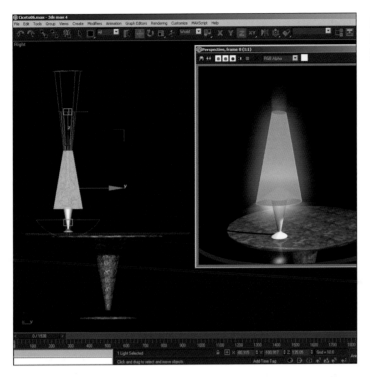

Figure 4.08
By reducing the need for shadows, you can keep render times down

When to fake

Though there are only two widely used algorithms for shadow generation, as this chapter should have demonstrated, there are a huge amount of ways of manipulating your lights to produce results that don't take an age to render. Knowing when to fake and when not to fake is something that comes with experience, and your own reasoning will become your best tool. Yes, computer processors are getting faster all the time so you might be able to get away with using increasingly intensive algorithms, but a lot of the decisions will be based on a studio's production schedules, and whether they allow for the extra time it takes to set up a convincing lighting design using the methods outlined here. Indeed, more often than not you'll be asked to produce results that render as efficiently as possible in little time due to other production demands. In this situation, it is not viable to set up a quick, accurate solution that is slow to render, nor is it ideal to spend a long time experimenting on a faked solution that renders quickly.

In these situations, the only way to make a quick compromise is to know as many ways of completing a lighting task as possible, whether faked or not. Knowing all the options will enable you to best find a happy medium between quality of output, speed of render, set-up time and the degree of control that each method furnishes the user with.

To use shadows or not?

The fact that casting a shadow is the most computationally expensive part of rendering a light is not the only reason you should consider restricting shadows within your lighting scheme to select sources. Visual considerations can sometimes also dictate that only one or two of your lights need to cast shadows. In considering this, you should ask yourself several questions, some of which might only become apparent as you begin to render and refine your output.

The first and most important consideration concerns the light sources in your scene and what they represent. Does the scene require shadows to fall from any particular source in terms of the necessary realism? With a single shadow casting light in place, the next question you should ask is of this source: is it enough on its own? Single shadow scenes can work well, and a common set-up is to have the key light casting a shadow and any fill light set not to. For scenes requiring no great complexity of lighting, this is generally a good method if what you desire is a clean, straightforward solution.

However, if you decide that there are other places within the scene that shadows should be being cast from, you should turn these on and work with these shadows in place. Now you are in a good position to judge whether extra shadows are needed. Even with several light sources casting shadows as you might expect them too, things might not look visually cohesive, and you might want to consider adding shadows from your fill lights to tie things together. This is especially likely if you just have one shadow-casting source, as the ambient light that bounces around the

Figure 4.09
No shadows at all can often look quite realistic enough

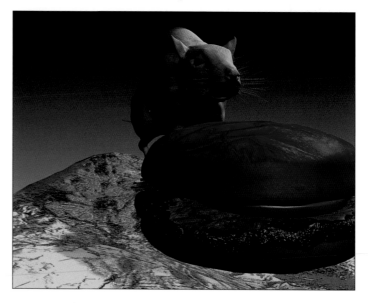

surfaces of a scene would generally cast additional subtle shadows. Turning on shadow casting for your lights representing this bounced light can help to build up a subtle level of secondary shadowing that really adds to the realism.

Having fill lights that cast shadows is particularly necessary if your key light becomes obstructed at any point within an animation, as it will cast large shadows as a result, and these can look somewhat flat and uniform. Secondary shadowing adds a depth and variation to the image that can impart a sense of life.

However, too many shadows can begin to compete, especially when the surrounding environment is very simple, and a subtle approach is more often than not necessary to avoid disorderly results. Too many light sources casting shadows, especially if these shadows are all coming from different directions, can produce results that are visually distracting. Indeed, look at the world around you, and you can see that most shadows are soft edged and subtle, so a couple of underplayed shadows can often look more convincing.

Furthermore, you should not rule out using no shadows whatsoever, depending on the visual style you are aiming for. A great deal of 2D productions manage quite happily without shadows, and especially if it's a slightly more abstract look that you are going for, then the lack of shadows will improve your render times no end and can impart a stylized edge that when done right can be extremely appealing. With the lighting set up to match the environment, the variations in unlit dark areas that appear on the subject can appear convincing enough, and the need for actual shadows is not always necessary.

Figure 4.10
Many overlapping shadows can prove visually distracting

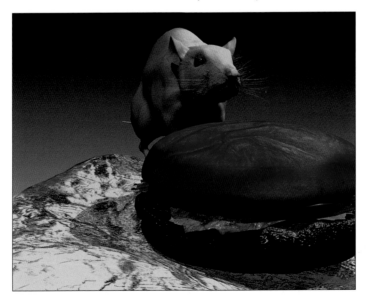

Shadow saturation

The saturation of shadows is a major factor in achieving realistic and believable results, and whilst shadows that are too light can look just as unrealistic, it's generally darkness that causes the problems. Even when a lone bright light source is illuminating a scene, the light bouncing off the surfaces of the environment lightens the shadow it casts. Adjusting the saturation of your shadows is possible in several ways.

The first and most obvious method is by using the shadow color control, which imitates light penetrating the shadow area. Unfortunately, this light penetrates only the cast shadow, and not the unlit portion of the object casting the shadow, which can result in an unrealistic amount of contrast between these two adjacent areas, as shown in figure 4.11.

This is not the only problem either; the strange phenomenon of shadows leaking through objects can occur when the shadow color has been altered. This rather freaky occurrence makes using shadow color a somewhat flawed solution.

The equally unappealing second option is to use global ambience to brighten the whole scene slightly, but as discussed in the previous chapter, this control should not be used if it can at all be avoided. Allowing even a small amount of ambient light into your scene deprives you of the full range of tones available, as pure black will now appear slightly grayed. Furthermore, the ambient light that is added will not bring out any details on the object's unlit side, as ambient light simply adds an unvarying amount of illumination across the scene.

Figure 4.11
Too much contrast can result by lightening shadow colors

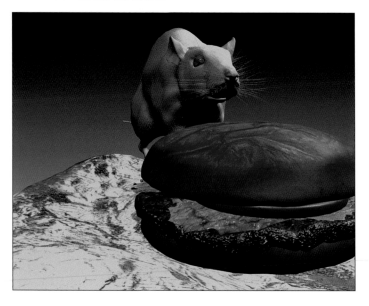

The only real way to lighten your shadows is to add fill lights to recreate the light bouncing off the surfaces surrounding your object. This lightens (or darkens) the cast shadow and the unlit portion of the object consistently and the unlit portion is illuminated in a way that brings out any detail across this area. Fill lights representing the light bouncing off the surrounding surfaces that are colored to match their material imparts not only a sense of realism, but adds to the all-important visual richness and depth of a rendering.

part 2: techniques

Image courtesy of:
Jason Kane
www.KaneCG.com

5

'Remember the phrase "Lights, camera, action"? Lights come first for good reason. Without them the camera and action are useless.'

Chuck B. Gloman & Tom LeTourneau: *Placing Shadows*

Learning to light

Lighting in CG, as in the world of cinematography and photography, is all about producing a final look that reinforces the mood of a scene and creating the all-important emotional connection with your audience. As long as your lighting successfully achieves this, the way in which the set-up was constructed is largely unimportant. However, in CG the fact that there are so many different methods of arriving at a solution makes the whole process much more flexible. Though scenes might look similar, the different approaches to their lighting set-ups can vary by a surprising amount.

In attempting to learn lighting in the following chapters, it is important that rather than focus on how you are lighting a scene you should concentrate on the reasons why you are lighting it, not just the buttons you are pressing. This will help you to appreciate the various different principles and when to apply them, rather than approaching lighting as a step-by-step task.

Image courtesy of:
Frank Lenhard
www.ixdream.com

Basic three-point lighting

The convention of three-point lighting is one that is firmly established in cinematography, and has become the main foundation for lighting in CG too. One of the principal reasons for this is that the technique helps to emphasize the 3D nature of your production by using light to reinforce the three-dimensional forms within a scene. Experimentation with this simple method can bring all kinds of variations to almost any CG lighting scheme, and learning how to get the most out of the basic three-point set-up will equip you for many situations.

It might sound like common sense to state that making sure everything is illuminated and visible to the camera does not constitute good lighting. Ensuring that the three-dimensional form of your subject is fully appreciated takes considered lighting from various angles, and this is where three-point lighting comes in.

The last thing you want is for your animation to look as flat as the screen that it will be viewed on, and three-point lighting's approach is based on treating light almost as a modeling tool. Learn it well and your 3D productions will look just so and your modeling team will thank you for showing off its work to full effect.

Flat looking output most commonly occurs when a single light source is pointed flat on at an object from behind the camera, which would be like a professional photographer using nothing but a camera mounted flash. The three light sources that you might have guessed make up three-point lighting serve different purposes, yet work together to emphasize shape and form in the final output, which is invariably two-dimensional.

Figure 5.01
Three-point lighting can really help to emphasize 3D forms

The difference that this approach makes can be seen in figure
5.01, where the leftmost statue has been lit with one light near
the camera, whilst the one on the right benefits from a basic
three-point set-up. The difference is quite startling, with the form
of the statue far more apparent with three-point lighting.

The three lights

There are unsurprisingly three lights involved in three-point
lighting, and each has a specific function.

Key light

Providing the main illumination in a scene, the key light is the
dominant light, or the one that casts the most obvious shadows.
This defines a scene's dominant lighting, giving the biggest clue
to the location of the presumed light source.

Fill light

The job of the fill light is to control the density of the shadows
created by the key, softening its effect. The primary fill is usually
placed on the opposite side of the subject from the key, where it
makes the side of the subject in shadow more visible.

Backlight

Helping to separate the subject from the background, the
backlight gives the scene depth. It does this by illuminating the
back of a subject, and in doing so it creates a subtle glowing edge
to the subject, which helps to create definition.

When placing these lights, the overall effect desired is one of
variation, with no large areas of shading. Studying your
renderings closely is the only way to do this, though there is a
useful method for gauging just how much variation you're
getting with your lighting. This involves turning off any sub-
division surfaces or similar smoothing algorithms or producing a
low-res proxy version of your subject so you can more easily
judge the lighting in individual areas. Viewing your subject
defined by bigger polygons rather than smooth surfaces allows
you to quickly determine how the light varies across your
subject's surface. Regions of the model where the shading does
not alter from plane to adjacent plane will appear flatter and less
three-dimensional than those areas with greater variation.

With your model displayed in this manner, it is a lot easier to
quickly gauge how the lighting varies across your subject, and
your aim should be to use the aforementioned three lights to
make the gradients as varied as possible.

Key light

Figure 5.02 shows just the key light added to our statue, and with just this light our subject is illuminated from one side, with the other side falling off into an unrealistic level of darkness. The key light is the most influential of the three lights involved, as its intensity is greater than any other light. This means that it will create the most defined and noticeable shadows, whose angle, density, softness and so on will provide clues to the type and location of this source, as well as serving as pointers to the time of day, if this light is representing the sun.

For this reason, choosing the angle of your key light relative to your camera is of paramount importance. Cameras should always be placed first when working with three-point lighting, with the key light following closely behind. Changes of camera angle from shot to shot within a scene can require subtle changes of lighting set-up. The key is usually placed above the subject to some degree, so that the shadows point downwards, as this is how we're used to seeing things illuminated. However, placing the light too high up can result in shadows that obscure and this can be less than flattering.

How far you move the light to one side of the subject depends on the light source you are trying to mimic, though to move the light too far to one side can again result in distracting shadows. If you were working on an exterior scene, then the time of day and season would dictate the position of the key light. With a warm light placed to form soft shadows that fall at an oblique angle, the result would be a scene that looked as if it were set during the early morning or late afternoon.

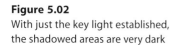

Figure 5.02
With just the key light established, the shadowed areas are very dark

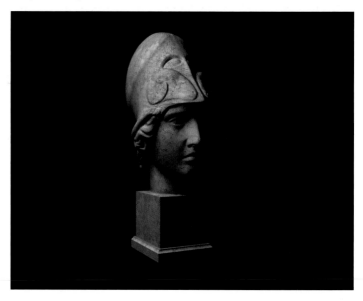

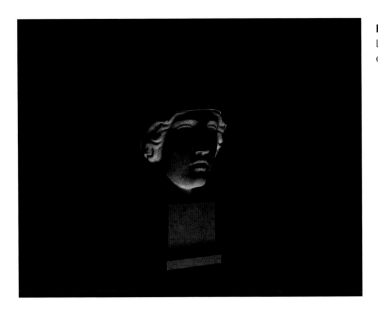

Figure 5.03
Low level key lighting can produce extremely eerie results

The key light, however, is not always located in front of the subject, because as its role is to represent the dominant light source in the scene, it can be to the rear of the subject if the scene was, for example, lit primarily from a window to its rear. This scenario places the key light where it could present a silhouette of the subject to the camera, which can be quite dramatic, and is known as an upstage key light in stage lighting. In this case your key light remains a key light, despite its position at the back of the subject, as what defines the key light is the fact that it is the brightest light, which therefore casts the most distinct shadow.

The prominence of these shadows will be reduced as the amount of fill light used increases. The ratio of the intensities of the key light to fill light goes a long way to establishing the atmosphere of a scene, with low key-to-fill ratios invoking a lighter, happier mood than high ratios, which produce a darker atmosphere. The importance of this light in terms of mood is perhaps demonstrated most clearly by the low level positioning of the key light, which produces a very unnatural lighting, which can make a regular character look menacing and invoke a very spooky atmosphere. Whether the key light in this situation comes from a campfire or a light held under the chin by the character itself, the result is noticeably eerie, which can be a good device.

The best guide when placing a key light is the shadow it casts. For regular lighting set-ups, the angle formed by the light, subject and camera should be roughly between 10 and 50 degrees to the left or right of the camera, as well as above the camera. Finally, when you're working on test renderings from a sequence bear in mind that a single rendered image is just a snapshot representing just one fraction of a second. Your lighting set-up

will need to work with your character's movement, so always bear this in mind. Rendering your scene at all your character's key poses is important, especially if the subject turns from the camera and appears in profile, when the turn of around 90 degrees can really test your lighting set-up.

The most flattering set-up is the portraiture set-up, which is commonly used by portrait photographers. Here the key light is placed so as to cast a small shadow of the nose below or below and to one side toward the corner of the mouth. Photography of a subject in profile, however, requires that the key light be moved between 10 and 50 degrees of being perpendicular from the camera, from the left or right.

These angles should certainly be kept in mind when placing your key light, but only as rough guides. What is far more important is the angle at which your shadows will fall and what this suggests about the presumed light source.

Fill light

Generally placed on the opposite side of the subject from the key, the primary fill light should generally not be strong enough to create shadows that compete with those of the key. In cinematography, the fill light is generally placed around eye level, so as not to cast its own shadows onto the subject's face. However, because in CG we can turn a light's shadows off so easily, vertical position is not as important. Nevertheless, the fill should not really be placed any lower than the eye level, as then you have upward illumination of the face, which can be unsettling.

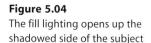
Figure 5.04
The fill lighting opens up the shadowed side of the subject

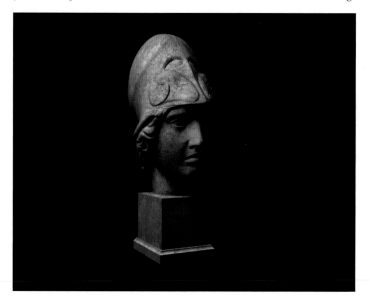

In both cinematography and CG the primary fill light's role involves several things. The first is to open up the shadows of the key light. The second is to provide subtle illumination of the subject where it lies in the shadow of the key light. However, in CG the fill light also has to act as the indirect illumination that occurs naturally in real life, which is something that film makers don't need to worry about. Here, the key light provides its own fill either through the natural reflections off surrounding surfaces, or through manipulation using boards to bounce the light back at the subject. The fill light in CG has to represent this bounced light (unless radiosity rendering is being used), otherwise you end up with surfaces that unrealistically do not bounce any light back at the subject, as in figure 5.02.

The fill light in CG then also has to simulate this reflected light, and as such should take on the color of the reflecting surface. However, the position of the fill light does not have to be so precise as to represent this perfectly, and its position can vary quite a lot. Roughly opposite is about as precise as it needs to get, though don't position things too symmetrically, as this can soon begin to look too staged. If rough positioning guidelines were to be suggested, like the ones for the key, between 10 and 60 degrees to the left or right of the camera, and up to 15 degrees above the camera would be about right. It is worth attempting to ensure that the fill and key lights actually overlap in terms of their illumination, as this ensures that you have no patches where there will be minimal variation in shading.

Obviously, if your fill light is representing light that has bounced off the larger elements of a scene's environment, as well as secondary illumination sources, then one fill light might not be

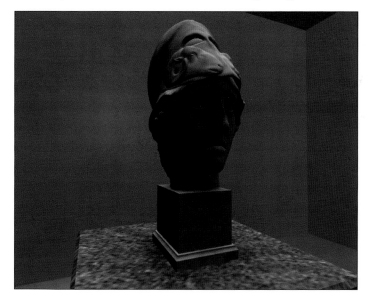

Figure 5.05
Many fill lights can be used to represent indirect illumination

enough. It's not unusual to have a dozen or more fills in a scene, with some representing bounced light and others secondary light sources. You might still want more to help soften the key light's shadows further. There's no real problem with using as many fill lights as you need.

Backlight

The ability of the backlight to separate the subject from the foreground makes it more important in 3D than it does in today's cinematography, where it is used much less than it used to be, in the days of black-and-white film. Working without color increases the need to separate elements from the background when similar tones are involved, as invariably occurs. There is occasionally a need for this technique in CG, when the sense of depth is an important consideration, or when working in black-and-white, though it is not always actually needed, as color can provide sufficient visual separation.

Figure 5.06
Working in black-and-white
increases the need for backlighting

Image courtesy of:
Plaksin Valery
plaksin@ktk.ru

In photography and cinematography, a backlight is generally placed directly behind and above a subject, striking an angle of around 45 degrees. At a higher angle, it might begin to toplight the subject, causing distracting highlights on a character's forehead and nose, whilst at a lower angle, there's a danger of lens flare. However, in the world of CG, backlighting tends to be fixed somewhere between 50 and 10 degrees above or below the camera, as there's no problem with lens flares.

The main problem that occurs with backlighting in CG is that it is actually quite difficult to simulate properly. This is because no matter how organic a subject might look, the model's cleanly defined surfaces don't have the layers of hair, dust and fibers that we have all around us in real life. This is what backlighting catches and illuminates, causing this layer to subtly glow, due to the light being diffused slightly. Because this layer does not exist in CG, putting a backlight directly behind the subject is often relatively ineffective, as the subject will not appear to receive any illumination due to the lack of this diffuse layer.

If your subject is a character with hair, then backlighting can be very effective, as this will begin to act more like backlighting in real life, catching this light in the same manner. However, adding fur or hair is a very render intensive process, so to add fur simply for better backlighting is ludicrous, but if hair already exists on a subject, then backlighting can provide great results, providing this effect looks credible in your scene.

Backlighting without hair, as is generally the case, requires that the backlight be moved up over the subject so that it just catches the edges of its surface. Different shading models also work better

Figure 5.07
Backlighting can be difficult in CG and is often best built into materials

than others at catching backlighting, so experiment with these settings. Quite often you'll find that one backlight won't be enough, and an array of these lights might well be needed to get the backlighting that you desire.

One final thing that can help is to use a slight falloff map in the self-illumination channel of your subject, which can create a slight glow on the faces whose normals point outwards from the camera view, the outer edge of a surface.

Key-to-fill ratios

The relationship between key light and fill light is important in terms of your lighting scheme's contrast, which has a significant effect on the mood of the rendering. Basically, this is determined by the ratio of the intensity of your key to your fill light. A high key-to-fill ratio has comparatively little fill light, so it is darker and more moody, with lots of contrast. A low key-to-fill ratio has a lot of fill light, which results in lighter results, with less contrast and a lighter and happier mood.

Figure 5.08
Low key-to-fill ratios can impart a light and cheerful mood

© 2002 Sesame Workshop/Pepper's Ghost Productions

The intensities are measured at the subject, not from within the light itself, which is easier with real lights and a light meter, but not all that difficult in CG. Taking the intensity of the lights and working out the loss of intensity due to falloff you will arrive at figures for the key and fill intensities. If there is more than one fill light, you simply need to total each one's intensity.

The falloff will follow the inverse square rule if you are using this form of attenuation, which is the most tricky part to calculate, and if you are using linear attenuation this will be easier to work out. One further noteworthy point is that any fill light that overlaps the key should be added to both the key and fill lights.

Too high a ratio can result in the rendering being too dark in the shadowed areas, due to the relative lack of fill, and likewise too low a ratio can produce uniformly flat results, which is due to the fill light being bright enough to counteract the key.

Finally, it is worth pointing out that the terms low-key and high-key, which are used in the physical world of lighting, confusingly enough mean the opposite of what you might expect. So, low-key is a high key-to-fill ratio, and high-key is a low key-to-fill ratio.

Low key-to-fill

Ratios of around between 2:1 and 4:1 are classified as having a low key-to-fill ratio, which produces brightly lit renderings with little contrast in the scene's lighting. The brightness of the resultant output and the way that any shadows are opened up by the pervasive light invokes a happy, positive mood. Figure 5.08 uses a low ratio, with the key light bouncing off the light and highly reflective snowy landscape and opening up the shadows.

Exterior scenes are on the whole much more likely to feature a low ratio if it's an overcast day. Direct sunlight does not generally produce low ratios, unless there's snow to reflect the sunlight and give the high level of fill required or the walls of the scene are of a light nature. Cloudy conditions scatter the sunlight and this reduces the key light of the sun whilst brightening the sky. Stylistically the happy, bright look that can be achieved with low ratios is frequently used in CG productions targeted at a younger audience.

Generally speaking, interior scenes are more likely to produce low ratios than scenes set outdoors. Here, the potential for light, reflective surfaces and walls is higher. This type of interior, with its light colored surfaces, would bounce sufficient light back into the scene to produce a low key-to-fill ratio. At the low end, you should avoid going below around 2:1, as it is at approximately this level that a key light will start to become overwhelmed by the competing fill, and your results will be in danger of becoming unappealingly flat and uniform.

High key-to-fill

When your ratio approaches 10:1 and beyond, your output can be said to have a high key-to-fill ratio, which will result in dark shadows that contrast strongly with the brightly lit areas. Due to the lack of reflected light, this type of lighting would most likely occur at night in the real world, where there would be no fill light coming from the sky, which explains the dramatic, mysterious atmosphere this type of ratio can create. Figure 5.09 uses a high ratio of 10:1, with the key light coming from the adjacent room. Due to the single light source, there's relatively little bounced light represented using fill lights.

The key to using this kind of ratio successfully lies in carefully regulating your light to illuminate the important visual details well, therefore using the full range of tones available to you by having well lit sections alongside the dark portions of your render. Just because a scene is set in dark conditions, this does not mean it should be underlit, and your subject should remain well lit, if only partially, so that there is no fear of the audience not being able to make out the important details and action.

High key-to-fill ratios are only generally used for night scenes, where the key light represents the moon or artificial light. Stylistically, this kind of look was established by the film noir directors of the 1940s and is still used frequently in horror movies to build suspense.

Figure 5.09
High key-to-fill ratios can impart a very dramatic atmosphere

Contrast

The difference in the tonal range of television and video means that if your final output method is going to be film, the ratios suggested here may need to be adjusted. Film can support a 1,000:1 contrast ratio, whilst television can only sustain around 150:1, a fraction of this. For television work, you should work with much more fill light than when working towards film (or even print), and for television the key-to-fill ratio should never exceed around 9:1. In film, however, you would only achieve the same effect with a ratio of around 18:1.

Tutorial - three-point lighting

In this tutorial you will learn the basics of three-point lighting by examining a simple interior scene and setting up the lighting to produce a flattering set-up. You will set up the key light to represent the dominant light source, the fill light to mimic bounced light from the right-hand wall and the backlight to emphasize depth. You will set the attenuation of each light so it behaves as a real-world light would, before calculating the key-to-fill ratio and experimenting with these settings to produce different lighting contrasts and moods.

Open the C5-01.max file from the tutorials folder of the CD. You will see two busts mounted on marble display stands. The room, which as you can see from the Top viewport is square, currently has no lights set up, and your first task will be to place the key light. This is going to represent several spotlights targeted from the opposite corner of the room.

For this you need to create a spotlight, which we'll clone several times to create the lights. First create a spotlight, anywhere in the scene, targeted on the bust in the corner of the room. Click the Move button, then right-click it to bring up the type-in dialog. This light should be located at X:0, Y:-1,500, Z:5,000. (The units are set up to represent millimeters, so 5,000 units is 5 meters). Now in the Front and Top viewports, move the spotlight's target up to the level of the middle of the busts. Rename this light *SpotKey01* and give it a Multiplier value of 1.0. Turn on shadow casting by checking the Cast Shadows checkbox and clicking the color swatch, give the light a slight green tint to represent fluorescent lighting.

If you render now, you should notice several things. The shading across the busts falls off into black, which is unrealistic, as there would be light bouncing off the walls and floor that would illuminate this area. We'll correct this in a moment with our fill lights. The shadows are pure black, which will also be addressed by the fill lighting. The edges of the shadows look jagged and too well defined, which we'll correct using the shadow map settings.

Figure 5.10
Shading across the busts falls off unrealistically into black with only the key light present

First though, we'll put the other spotlights into place. With the Shift key held down, drag the spotlight in the Top viewport slightly upwards and release. Now in the resultant dialog, select Instance and specify 3 copies. Your scene will now suddenly look washed out with light. To rectify this, change the Multiplier value of your light to 0.25, a quarter of the original value, which between the four lights will have the same effect as the original light (as you specified Instance, all the lights will change to reflect this).

Rendering now, the level of illumination should be fine, but there's four distinct shadows that look a little too well defined and realistic. In the Shadow Map Parameters rollout, change the Sample Range to 20, which will blur the shadows together producing softer, more realistic results.

To turn attenuation on for these lights, in the Attenuation Parameters rollout, change the Decay Type to Inverse Square. Rendering now will give you a solid black image, so first of all increase the Multiplier value up to 1.0 and now change the Decay Start value until you get more realistic looking falloff (around 2,500 should do it).

The fill lights next, which we'll use to represent the bounced light coming off the two walls, starting with the concrete one. Place an omni light at the same height as the busts, along the right-hand wall, just in front of the busts towards the camera, so the line from the camera to the busts via the light is around 90 degrees. Set this to 0.3 Multiplier, with shadows turned off, and sample a color from the GreyConcrete.jpg file, something around R:143, G:138, B:145. Now use the Exclude button to exclude the *WallRight* object. A render will reveal that this does not really illuminate the

area between the two display stands, so clone an instance of this light that is located to shine directly down the gap between the two. Now turn off the Specular component of this light by clearing the Specular checkbox, and halve the Multiplier value to 0.15, so the total illumination from the two lights is the same as before. Rename these two lights *OmniRightWall01* and *02*.

Do the same thing from the back wall, with a light that will operate as fill and backlight too. This light should be another omni, identical to the last apart from the Multiplier, which should be 0.1, and the color, which should be the same as the rear wall's

Figure 5.11
Your fill lights should be placed to represent the bounced lighting

Figure 5.12
Fill lighting will open up the dark shadows realistically

color within the Diffuse slot of the blue wall material, found inside the *MuseumInterior* material (R:0, G:145, B:213). This should be named *OmniRearWall01*.

Position this light behind the right-hand bust from the point of view of the camera and move it above the bust, level with the camera. Now exclude the *WallRear* object from the light. Again, clone an instance of this light so that it is positioned behind the leftmost bust, relative to the camera.

Now, to check your shading on the bust, hide the *BustRight* object and unhide the *BustRightLowres* object. If you change the camera viewport to a perspective view by clicking in it and pressing P, you should be able to use the Arc Rotate and Zoom controls to look straight at this low-res bust. The shading should be varied across the facial features, if it is not then you should experiment with moving your fill lights around until you get a good variation. Now hide or delete the low-res bust and unhide the original.

To calculate the key-to-fill ratio, you need to work out how the attenuation of the key affects the intensity at the subject. So, as we've used Inverse Square:

$$
\begin{aligned}
\text{Intensity at the subject} &= \text{intensity at light} / \text{distance}^2 \\
&= 1 && / 2.8^2 \\
&= 1 \times (255/255) && / 7.84 \\
&= 0.13
\end{aligned}
$$

NB (2,800 units is 2.8 meters)

As there are four key lights, the key's intensity is four times this value: 0.52. Now the two fill lights have no attenuation, but their HSV values affect their intensity, as the Value field is not 255. So, for the *OmniRightWall* lights, their intensity is:

$$
\begin{aligned}
\text{Intensity at the subject} &= \text{Multiplier value} \times (\text{Value}/255) \\
&= 0.1 && \times (145/255) \\
&= 0.057
\end{aligned}
$$

The *OmniRearWall* lights are not calculated as they do not illuminate the front of the subject. There are two of these lights, so the total fill intensity is 0.11. This needs adding to the key total too because these fills overlap the key light. So, the key-to-fill ratio is 0.63/0.11, which is approaching 6:1, pretty representative of the environment we're trying to recreate. Try experimenting with the various settings to achieve different key-to-fill ratios, looking at their effect on the lighting, contrast and mood of the resultant image.

6

'When asked to explain how lighting contributes to film making, I often show a completely black slide to emphasize that without light, it doesn't matter how great the composition and acting are - nothing can be seen.'

Sharon Calahan, Director of Photography, Pixar: Advanced RenderMan

Making light work

It does not matter how firm your grasp of the variety that can be achieved with simple three-point lighting if you as a lighting artist do not stop to consider the emotional aspects of the story at hand. Knowing all the lighting tricks in the book is all well and good, but without proper considered application, all your technical wizardry will be for nothing. Your lighting needs to operate on an emotional level to do several things: it should illicit a reaction from your viewer that is coherent with the storyline, it should guide the viewer visually to the focal points of a scene, whilst reinforcing the desired atmosphere and providing your audience with clues as to locations and characters. It should do all this whilst emphasizing the three-dimensional nature of your production and helping with the framing and composition of every scene.

Every lighting scenario needs careful consideration, and the following chapters break down the lighting tasks that you might face into logical sections: indoor lighting, outdoor lighting and

Image courtesy of:
© Brian Taylor 2001, 2002
www.rustboy.com

special lighting techniques, where unique challenges like underwater lighting are covered. Before we take this step, however, there are several more concepts that need to be introduced.

Other light types

There are several other light types that you may encounter, which are found more in the world of theater and film than in CG. It is useful to know what purpose these lights serve to be able to communicate with those from a traditional lighting background.

Hair lights

This kind of light does exactly what you might expect from its name, illuminating the subject's hair, providing a nice highlight that also helps to separate the subject from the background. This light is used mostly in photography, as it is only effective if a subject is not moving around a great deal. In CG its use is limited, unless you are using a fur shader, in which case it could be considered, especially as its position can easily be constrained to follow the hair around. However, usually any backlighting that would be set up to work with fur shading would probably serve the purpose of a hair light.

Kicker lights

The kicker is a type of light that is located behind a subject, but unlike a backlight is offset to one side or the other. In film this is used generally for dramatic effect, or can be used to represent a motivational source. The effect of using kickers can be heightened if two are used on either side of the subject, with the sides illuminated, and the front shadow lessened by using fill.

Rim lights

Also referred to as sidelights, these lights have the same purpose as backlights, providing a separation from the background, from one or both sides of the subject, though slightly behind the subject. This results in a similar light rim around the subject that provides the separation; though this has a more delicate feel to it. Consequently rim lights are a popular form of lighting in dance-led theater productions, as it emphasizes the dancers in a lighter more graceful way.

Background lights

Background lights are widely used on film locations to light the set's walls or the studio cyclorama, which has a great effect on the mood of a shot. These lights in particular have to be placed carefully, as they have a habit of giving away the illusion that a scene is lit by a primary source like the sun or a window's light.

Figure 6.01
The effect of using rim lights gives
a very delicate and graceful feel

In CG there is little need for these kinds of lights, as a light with
no attenuation will spread illumination evenly across any size of
backdrop. There is often a need to focus the viewer on a
particular area of the background or set in a 3D scene, and in this
case a spot can be pointed at the object to produce enough
supplementary illumination. If shadows are set to be cast, you
should be careful that the location of these types of lights casts
shadows that are consistent with the key light.

Area lights

As we've already discovered, area lights are extremely useful in
that their physical size is representative of real-life light fixtures,
and it is this factor that makes for the soft lighting that is so
desirable. The rule of thumb for area lights is that the bigger they
are the softer the shadows they cast will be, but also the longer the
render time. For this reason using area lights is not always possible.
Additionally, not all 3D applications support them. Users of those
packages that do have area lights will, however, testify that they
are not always practical to use because of their render times.

The solution, for those that don't have them and those that can't
afford their rendering time, is to use a simple array of lights spread
over the surface of the object representing the light fitting, which
would be given full self-illumination and possibly even glow. It
must be stressed though, that far from being a workaround, the
techniques of using a basic grid of lights to represent an area light
is an everyday production practice: the spotlight with shadow map
is still the mainstay of any production's soft lighting, not the more
expensive area lighting techniques you might think are used.

Tutorial - area lights

In this tutorial you will learn how to set up a simple area light, making the physical fixture look realistic and creating an easily controllable array of lights that make for convincing soft shadows. Having set up your dominant light source you will then set up fill and backlighting to complement the subject.

Open the C6-01.max file from the tutorials folder of the CD. You will see a creature in the center of a room underneath a central light fixture. The room, which as you can see from the Top viewport is square, currently has no lights set up, though the first one you'll set up will be based on the box in the center of the ceiling. The room resembles what's known as a Cornell box, which is used to demonstrate bounced lighting.

Select the *LightBox* object and add an Edit Mesh modifier. In Face Sub-Object mode, drag over the whole box to select all 12 faces, and down in the Surface Properties rollout, change their Material ID to 1. Now repeat this, selecting only the two faces that make up the large bottom side and change their ID to 2. In a new slot in the Material Editor, specify a Multi/Sub-Object material with 2 Sub-Materials. Rename this material *LightBox* and apply it to your *LightBox* object. Now, in the first material slot, specify a dark gray material based on the Metal shader, and in the second slot, make the diffuse color pure white and turn the Self Illumination up to 100%.

Now for the first of our spots that will make up the area light: choose the Free Spot light type and click in the Top viewport to create this light pointing directly downwards. Now move this to

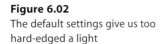

Figure 6.02
The default settings give us too hard-edged a light

X:0, Y:0, Z:8,000, central to the fitting and change the cone's hotspot and falloff values to 30 and 60 respectively. After ensuring that the Cast Shadows checkbox is on, tint the light slightly green to represent fluorescent lighting. Make sure that your shadows are Shadow Mapped and render with the default settings, you should get something like figure 6.02. From this, we can see that despite the falloff being satisfactory, the shadow from this light is way too hard-edged for a light of this size and this proximity. In the Shadow Map Parameters rollout, changing the shadow map Size to 256 and the Sample Range to 15 should result in suitably soft shadows.

Rename this light *KeyAreaSpot01* and move it to the far left corner of the light fitting - X:–2,000, Y:–2,000, Z:8,000 - if you want to position it precisely. Next invoke the Array tool and in the dialog specify an instanced 4 by 4 array spaced 1,250 units along both X and Y. For those who don't understand the dark arts of the Array tool, you should first type 1,250 in the top left Incremental X box to set the spacing in the first dimension. Then you should enter 4 in the 1D Count box to specify how many lights are placed along this axis. Finally check the 2D radio button and enter 4 in its Count field, along with 1,250 in the adjacent Incremental Y box. Don't forget to specify Instance!

Rendering now will produce an image with almost completely burned-out whites, so reduce the Multiplier value to 0.1 and render once more. Finally, the attenuation should be set to Inverse Square to give the light real world decay, and the start value should be set to 5,000 or else the effect will be too dim. With this light representing the key light, a fill should be introduced to give the scene some general illumination. For this, we'll place a non-shadow casting omni directly underneath the light fitting,

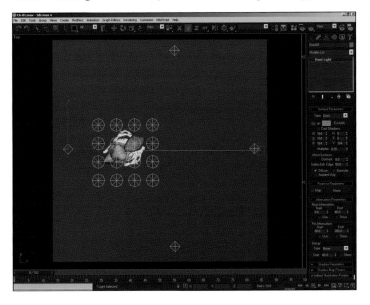

Figure 6.03
Placing the fills colored according to the walls they are representing

renaming it *FillAreaOmni*. This should be set to pure white, with a Multiplier value of 0.25 and placed centrally to the fitting.

Our second fill should be placed level with the camera in front of the near wall. It should be given a 30% gray to represent the color of the concrete wall. It should again be non-shadow casting, have its Specular component turned off and its Multiplier should be set to 0.25. Rename this *FillNearWall01* and create an instance of it placed in the center of the far wall, relatively close to it, as in figure 6.03. We need two more lights, both placed centrally on the blue and yellow walls, both exactly the same as the two we've just created, apart from their colors, which should be pure blue and pure yellow; their Multiplier values should be 0.15 and 0.25 respectively. The blue light should have the *BlueWall* object excluded from its illumination, and the yellow light should have the *YellowWall* excluded. All your fills should have their Specular component turned off.

By tinting these last two omnis in this way, what you have done is placed two lights that represent the light from the central fitting that would bounce off these walls, picking up their color on the way. This is how light acts in real life, reflecting off the various surfaces of its environment. This process is called indirect or global illumination. This will be explained in depth in the following chapter, where you'll also learn how to fake this effect properly.

Figure 6.04
Our end result looks like the light has bounced around the scene

Arrays

You might be forgiven for not knowing anything of lighting arrays, no matter which 3D solution you use. Look through the help files and manuals of most packages and you'll find no mention of them. This is also true of the vast majority of books aimed at teaching specific 3D software solutions. This lack of documentation is remarkable, as they can be extremely useful lighting tools.

It wasn't long ago that it seemed we were all struggling along using single instances of lights, but now arrays are used more widely to light whole scenes or objects properly, which you just can't do with single lights. A single light is not representative of a real lighting fixture because the light is coming from an infinitely small point, so the light will not wrap around the object in the same way.

Arrays can be thought of as area lights, because that's basically what they are: an array of lights spread over an area. However, just because you have area lights in your 3D package don't jump ahead to the next section. The problem with area lights is that they are usually difficult to control. Generally you don't know how many individual lights are making up the area light, and also the area light color is not generally controllable to the level of the individual light. This is why arrays of lights give you much more control - some can be set up as shadow casting, some not, they can be given different intensities, and of course colors.

At the simplest level, if you spread lights out over a rectangle, as in the previous exercise, you have an array that acts like a simple rectangular light fitting. However, this is only the start of what is

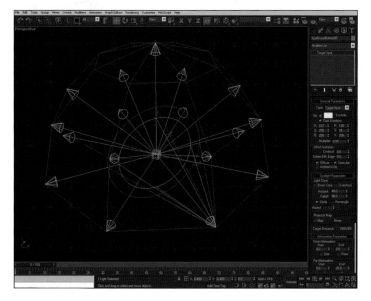

Figure 6.05
A dome array can be used to easily represent an outdoor environment

Figure 6.06
Arrays can be used to give nice soft
shadows to a subject

possible, and by using them with three-dimensional forms such as domes, you can build up some interesting lighting effects that can create a realistic environment. This is largely because by creating a large array in this fashion gives you the opportunity to alter the light's intensities from different areas of the environment, and more importantly, the light's color. The fact that lights can be given different hues more accurately represents the real world environment surrounding a scene or an object, with the colors from each light representing the light that would be bouncing off the objects in the environment.

Lighting arrays are best assembled in a similar manner to lighting rigs, with lights attached to the vertices of primitive objects using the snap tools. Setting up a plane with the relevant number of length and width segments is the best way to arrange a rectangular set-up. Likewise, if you're constructing a dome array, the best way to go about this is to use half of one of the spherical primitive objects. Rather than using a geodesic type of primitive, it's usually best to use a regular spherical object divided like a globe using lines like longitude and latitude. You can then organize your lights more easily in horizontal rows, which makes the identification of each individual light a much simpler task.

There are many effects that can be achieved with arrays organized in tubular form, or as a ring, box, or any other way that you might find useful. Depending on the colors given to the individual lights the illumination will vary and by specifying some lights as shadow casting and some not, vast variations in the shadows cast by the array are possible. Obviously, the more

lights that are set to cast shadows, the longer the render time will be, but the softer the shadows will become. Once set up, lighting arrays can be used over and again to represent skies, light fittings and so on. They work fantastically well as fill lights, providing subtle alterations in color and intensity around an object, whose dominant light source is generally a separate entity from the array. This does not mean that extra fill lights are not necessary for the scene though, they might not be, but you should always question whether additional fills would further emphasize the 3D nature of an object or enhance your overall lighting scheme.

Tutorial - light arrays

In this tutorial you will learn how to set up an array of lights around a dome, which will act like the illumination from an open sky. You'll construct the dome as a kind of rig, positioning lights at individual vertices and linking them to the dome. You'll then set up the colors and intensities of the lights to represent the illumination coming from an early morning sky.

Open the C6-02.max file from the tutorials folder of the CD. You will see a few rocks just beyond the foreground, but apart from that, the scene is empty. In the Create panel, press the Sphere button and using the keyboard entry create a sphere of radius 1,000, with eight segments. Now go into the Modify panel, rename this *ArrayDome*, and enter 0.5 into the hemisphere setting, which gives you exactly half a sphere, making sure that the Squash radio button below is selected. In the Display panel, use the Hide Unselected button to make things a little simpler.

Figure 6.07
Using snaps makes placing the lights much more straightforward

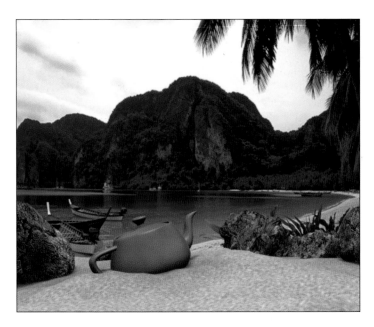

Right-clicking the 3D Snap Toggle button right at the bottom of
the screen gives you the different snap options; turn just the
Vertex option on before clicking the button again to actually turn
the snaps on. You can close the floating dialog to see better, and
maximize the Top viewport. If you now choose Target Spot in
Create > Lights, you should see a blue marker when you move
the cursor over any of the hemisphere's joints.

You should go around the dome and place lights at as many of the
vertices as you want to, not worrying too much about where the
targets for these lights are placed. For this exercise you should
place one right in the middle, plus a ring of lights along the
bottom two rows. Now in the Select Objects dialog, select all of
these spotlights (you should have 17) and using the Select and
Link tool, use the Select Objects dialog again to link these to the
hemisphere object.

Now you should select all of the spotlight target objects and in the
XYZ coordinate type-ins at the bottom of the screen, move all of
them to X:0, Y:0, Z:0. Create a dummy object at the same point
and select all of the target objects, and link these to the dummy,
which you should rename *DummyDome*. Link this dummy object
to the *ArrayDome* object and you're done.

Selecting the *ArrayDome* object now (check that you're not still in
Select and Link mode), you should be able to move the dome
around, scale it, squash it, whatever, with the omnis remaining
firmly in place at the vertices. To make the sphere invisible, you
should right-click it and choose Properties and uncheck the
Renderable check box.

You should now rename your 17 omnis so that they can be identified more easily - something like *SpotDomeBottom01-08*, *SpotDomeMid01-08* and *SpotDomeTop* - ensuring that your numbers correspond on the eight radial branches. The bottom row of lights should all be set to the same Multiplier value, say 0.1, and be given color tints to match the immediate environment of the area, which if you can see from rendering is sand and foliage. Set the color of *SpotDomeBottom01-04* to a light green - R:85, G:55, B:255 - and 05-08 to a sandy yellow - R:35, G:75, B:255. This represents the light bouncing from the immediate environment, which should be set to match the surroundings whenever you use the dome array. Make this row of lights non-shadow casting.

We're using 5,600 °K film and partly overcast sky has a color temperature of around 8,000-10,000 °K, which is higher than our chosen color balance, so would appear to have a blue tint. So, color the next row's lights accordingly to represent this illumination - R:135, G:35, B:255 - with shadow casting turned on and the Multiplier value set to 0.2. Finally, the center light should be set to a pure white and given a Multiplier of 0.75, again with shadows turned off. You might want to Group this whole construction together under a single name, as it does appear rather large in the Select Objects dialog, then you can just open and close the group as you want to change colors and intensities.

Now if you unhide our teapot object and render the scene, you should see that the shadows are nice and soft, the lighting appears natural and sits comfortably with the background. Most importantly, the main lighting is coming from directly overhead, but the array's peripheral lights provide some wraparound and direct illumination given their subtle coloration.

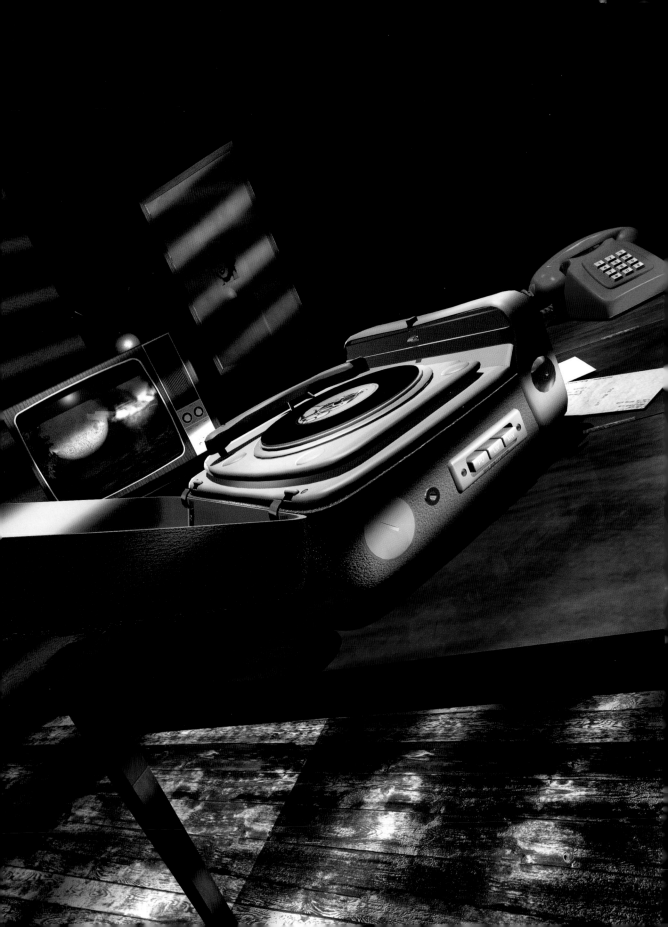

'Architecture is the masterly, correct and magnificent play of masses brought together in light.'

Le Corbusier

Indirect illumination

The role of light has long fascinated many architects, arguably none more than Le Corbusier, who was a master at using natural light to help define spaces and routes within his buildings. Doubtlessly he would be fascinated by today's computer-based visualization techniques, and the way in which light's role in a building can be accurately portrayed at any time of any day. Not only can the design be evaluated in terms of how the lighting interacts with its forms and spaces, but also analysis of different scenarios can present the architect with extremely accurate lighting data.

The techniques introduced in the last couple of chapters of using colored fill lights to represent the light bouncing off the predominant surfaces of a scene mimics the way in which light reflects around an environment in real life. This process is called indirect or global illumination, where light reflected from surrounding objects illuminates the subject. We've already begun to

Image courtesy of:
Big Face Productions
www.big-face.com

explore the process of faking this lighting component, but for architects and designers wanting more precise results, global illumination calculation generally involves radiosity rendering.

Radiosity

Radiosity is just one method of rendering indirect light, which can also be calculated using hybrid global illumination and photon mapping algorithms. These methods of rendering can produce startlingly realistic results, which can easily be confused with photographs. Radiosity uses at its core an algorithm that calculates diffuse reflection. The scene's surfaces transmit back the light they receive into the scene, with subtle color bleeding occurring between surfaces, as in real life.

Radiosity works progressively, meaning that it continues to bounce light around a scene and continually refines the resultant rendering, so the longer it is left to render, the more accurate the results will be. There is a point where the calculations will make no visible difference to the rendering, but to get a reasonable level of quality generally requires a fair amount of processing time, depending on the level of detail in the scene.

Figure 7.01
In the real world, light bounces around coloring its surroundings

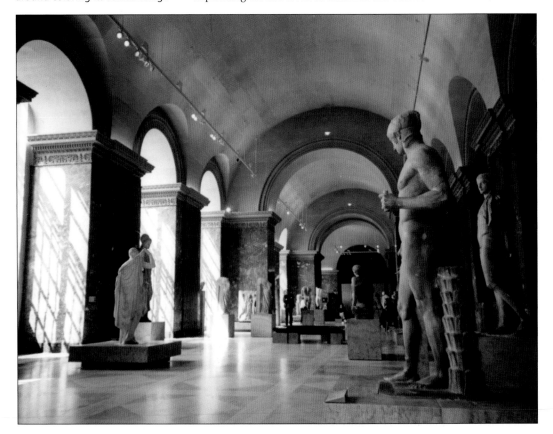

This is because this method works by calculating global illumination data for each polygon of your scene, so high-res detail will take a long time to compute. All visible surfaces in a scene are subdivided into patches based on the original polygon mesh, and each of these patches is treated as a light emitter.

The renderer first calculates the light being transferred from the lights to the surrounding patches, with these elements treated as light emitters in the second pass of rendering, and so on. These elements will be subdivided during the calculation where additional detail is required to complete the shading, typically at the borders between shadows and areas being directly illuminated.

Despite the steady increase of processor speeds, radiosity has yet to make much of a mark in animation, despite its beautiful results, and is generally limited to still images, especially in architectural visualization. The reason for this is that radiosity rendering actually calculates a view-independent radiosity solution. This means that once calculated, the scene can be quickly rendered from any point of view, any camera angle within the scene. This makes it perfect for architecture, where still images are used widely, so one calculation is all that is required for as many renderings as are needed.

However, in animation, the fact that objects move around the scene means that the radiosity needs to be constantly recalculated. Couple this with the fact that high-detail scenes typical of this kind of work take far longer to process, means that radiosity is simply too much to be considered for the vast majority of animation projects at the moment.

Of the major 3D solutions available, only LightWave has a built-in radiosity renderer. Maya and 3ds max rely on third-party applications, the most notable and successful of which is Lightscape from Autodesk, the parent company of discreet, the makers of 3ds max. As such, Lightscape works most closely with this application, though functions perfectly well as a standalone. Radiosity is by no means the be all and end all of realism, despite the beautiful color bleeding that makes for very realistic results; it does not address specular refraction and reflection. These two elements are best dealt with by raytracing, and for truly accurate

Figure 7.02
Radiosity rendering can produce some beautifully soft lighting

and convincing results, a two-pass solution that involves raytracing on top of radiosity is needed, which hybrid GI (global illumination) renderers such as cebas' finalRender are best suited to.

Furthermore, when working on a scene that will eventually utilize radiosity rendering, it's important to work to a sensible scale, as the rendering process works on a physical basis, and the physical scale of your scene is very important to the end result. If your radiosity solution interprets your scene to be as big as a matchbox, the results will be very different if the software interprets it to be the size of a warehouse.

Another side effect of an incorrect scale in a scene is that the division of the scene into a mesh for processing is more likely to go awry. This is also true of using triangular polygons, which are much more likely to produce discontinuities in the resultant rendering than four-sided polygons.

Radiosity is not always the best solution, and judging what will produce the best results for every occasion requires knowledge of the strengths and weaknesses of this method and more besides.

Photon mapping

Another perhaps lesser-used method for calculating global illumination is photon mapping, which is used in the mental ray renderer, the dedicated rendering engine for Softimage XSI, which can also be used alongside 3ds max and Maya as a third-party solution. This technique not only generates a scene's global illumination, but also caustics, the effects of light cast onto an object via reflection off or refraction through another object.

This method has the advantage of working independently from the scene's polygon count, though the photon map that is generated is view dependent - it must be calculated for every render. However, some renderers allow the reuse of the photon map in subsequent renders, which is useful if the lighting does not change drastically over the course of the rendering. Renderers working in this way trace photons emitted from a light through the scene being reflected or transmitted by objects, until it strikes a diffuse surface. When it strikes a surface, the photon is stored in the photon map.

The number of photons emitted from a light can be varied to increase the quality, or decrease the time it takes to render. Trace depth controls can also be used to limit the number of times a photon can be reflected, refracted, or both. This method can often compare with radiosity in terms of the render times, but unlike most radiosity renderers, some photon mapping renderers, like the aforementioned mental ray for instance, boast the advantage of support for caustics and raytracing, which can make them a very attractive all-round solution.

Caustics

The effect of caustics is caused by light cast onto an object via reflection off or refraction through another object, and governed by the law of refraction. Whereas radiosity only takes into account diffuse reflections, photon mapping also takes into account specular reflection, which results in caustics. In a lot of 3D packages, caustic effects need to be faked, as not all renderers support their creation. Generally radiosity renderers work with diffuse reflection and so will not feature caustics, but photon mapped renderers or hybrid GI renderers can.

Caustics are typified by the bright patches of light that form underneath glasses, vases and similar objects. These effects are caused when indirect light is focused into bright pools of light and are also found when looking at bodies of water, mirrors and similar transparent objects that are capable of reflecting and refracting light. Because caustics are the only element of indirect illumination that are formed from focused light, rather than from scattered light, they are comparatively speedy to calculate.

This fact means that caustics are a realistic proposition for animation, as the realism that they can add to a scene is not outweighed by equally long render times. Being a very visible byproduct of indirect illumination, they can add a real sense of realism if used subtly. Indeed, their use adds a highly convincing final touch to faked global illumination because of the added interaction between the scene's objects and its light. The fact that they don't carry a huge rendering cost makes their use alongside faked radiosity a good compromise to a full global illumination solution that would take a far greater time to render.

Figure 7.03
Caustics are caused by refracted and reflected light

Simulating global illumination

As with most lighting tasks, there are several ways of approaching global illumination, and that includes methods for faking radiosity and caustics. Cheating a solution might not always be the best answer, but a lot of the time it is, and appreciating as many approaches to different lighting tasks is key to being able to best balance the eternal output quality versus rendering time battle. For the time being at least, until computers ramp up (as they inevitably will) to be able to cope with the demands of rendering true global illumination, and this becomes commonplace in CG productions, lighting artists will be asked to come up with fast rendering representations.

Simulating radiosity

The fact that not many productions have the budget for the implementation of radiosity rendering means that methods of faking its look are widely understood. In most situations this means using extra fill lights placed around the scene and tinted to represent the colored light bouncing off the primary surfaces.

This is a relatively simple process, whose success depends upon the care and attention taken in setting up these bounce lights. The key light representing the primary light source is placed first of

Figure 7.04
Faking radiosity is common practice in production environments

all, which in the following tutorial is seen coming through a window. A primary fill light is then added to open up the interior illumination as required. Now, where the primary light hits and directly illuminates the floor, walls, windowsills and any adjacent exterior ground that might bounce light up into the room, extra fill lights are placed that are colored the same as the surfaces they are representing light bouncing from.

Shadows generally only need to be set for the key light, which has the benefit of keeping things fast, and attenuation should always be set to keep the bounced light local, controllable and as efficient as possible. Spotlights are best for the job of these bounce lights, as they are controllable in terms of their direction and quicker to render than omni lights.

All lights placed to represent bounced light, whether spotlights or not, should also be set to cast only diffuse illumination, not specular, as this results in highlights being cast on reflective objects that might give away the fact that there are several lights present, breaking your carefully constructed illusion.

Simulating caustics

Caustics are relatively straightforward to simulate, especially when they are small focused pools of light refracted or reflected through objects such as glasses and vases. In this case extra lights need to be added to produce the caustic effects, and the shadow color of these lights simply needs to be changed to white, or a radial gradient map can be allocated to the shadow map to produce more varied coloration.

Tutorial - simulating global illumination

In this tutorial you will learn how to simulate a global illumination solution. This will involve first faking a radiosity set-up, using various colored fill lights to represent the light bouncing around the room. You will then touch on raytracing and how to produce caustic effects using colored shadow maps.

Open the C7-01.max file from the tutorials folder of the CD. You will see a room with a marble bust on a white display stand. The room currently has no lights set up, and your first task will be to place the key light, representing the dominant light source, which in this case will be sunlight. Place a Target Direct light so that it shines through the window at the bust so that the patch of light that falls into the room looks similar to figure 7.05. This light should be set to cast shadows, and should have a slight blue tint, because indoor film makes outdoor light appear blue (as you should remember from chapter 2). Change the name of this light to *KeyDirectSun*.

To keep things as efficient as possible, the light's cone should be made to fit over the entire window it is illuminating, but as tightly as you can manage. The best way to do this is to change one of your viewports to correspond with the light's view. You do this by right-clicking its label and selecting Views > *KeyDirectSun*. Now you can use the controls in the bottom right of the interface to truck and dolly the light, and adjust its hotspot and falloff values, which should be brought as close together as you can. The default shadow map values for this light should be fine, as you want a hard-edged light to represent direct sunlight.

With this positioned satisfactorily, you next need to place a fill light that will illuminate the interior to a little below the level you want for the final lighting. This is a standard omni light with no shadows required, placed (in terms of the Top viewport) two-thirds of the way from left to right, to the right of the camera and up near the ceiling. Rename this light *FillOmniMain* and as this is representing indoor light, its tint should be a pure white.

Now using colored fills to represent the bounced light, we'll start with the patch of blue light in front of the display stand. Place a spotlight - renamed *FillBounceFloor01* - under the floor; pointing up through the patch of blue light at the angle that reflected light would bounce up at. Make sure the light is colored to match the floor, no shadows are set and that Specular illumination has been unchecked. Now set the Multiplier to 1.0. the light's decay to Inverse Squared, check the Show box and increase the Start spinner, until the decay begins roughly at the floor.

Rendering now should give you an overly blue patch on the front of the display stand, but being able to see this so clearly is useful for positioning. Use the Hotspot value as well as the standard

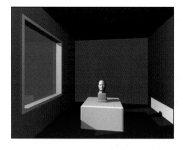

Figure 7.05 (above)
Move the blue fill into place until your results are similar to this

Figure 7.06 (right)
Reduce the multiplier value to give a more subtle amount of color

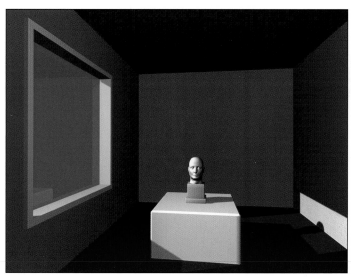

transform tools to move the light until it is producing a realistic looking bounce, as in figure 7.05. Next increase the Falloff value to cover the whole of the box for a gentle falloff. Now reduce the Multiplier value until the light provides a subtle amount of color bleeding, as in figure 7.06.

Similarly, spotlights should be used to represent the pool of direct light on the floor near to the wall, and as this is a rather complex pool of light, we'll need to use two. These should be placed, again, under the floor, pointing straight upwards, with a fairly wide cone (Hotspot of around 80 and Falloff of 120 degrees).

The advantage of placing the lights under the floor is that they don't illuminate the floor itself, as they would if they were above this plane. You would then have to use the Exclude function to make sure that the floor was not illuminated from these lights.

These two lights should be placed centrally in the two pools of light that fall either side of the bust's shadow, and again should have no shadows, no specular illumination and attenuation should be set to keep the effect local. Rendering now should give you something approximating figure 7.07.

Further fills should be placed to represent the light bouncing from the windowsill and the patch of light on the right-hand wall. Two lights need to be used for the display stand's bounced contribution, one for the top and one for the side facing the window.

Use the same techniques to finish off the radiosity solution and place three spotlights mimicking the bounced light from these elements, using figures 7.08 to 7.10, which show the result of these final four lights being placed, as a guide.

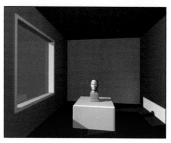

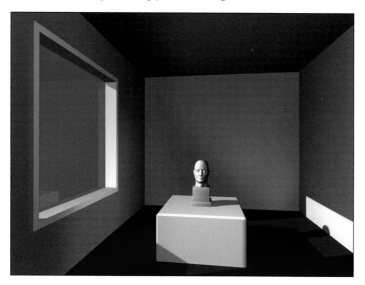

Figure 7.07 (top)
Spotlights placed under the floor

Figure 7.08 (middle)
The windowsill's bounced light

Figure 7.09 (bottom)
The patch of light completed

Figure 7.10 (left)
With the display stand's contribution done, the rendering is complete

Tutorial - caustics

Either continue with the tutorial you've just completed, or open C7-02.max. Open up the Material Editor, find the material called *Glass*, and drag this onto the bust object in your camera viewport. This is a Raytrace material, which is already used in the scene for the windowpane. If you render the scene now, the first thing you'll notice is that the render time leaps up considerably, by about a factor of eight. The second is that despite the raytracing producing a very realistic glass, the shadow that it casts is unrealistically solid. Changing the *KeyDirectSun* light's shadows to raytraced produces a shadow that is crisp, as it should be, and transparent, but the render time is now up over ten times the original.

Instead, change the shadow type back to Shadow Mapped. Now clone this light to produce an identical copy that we'll use for casting a specific shadow from the bust. As such, this light should only include the bust object for shadow casting, nothing else. Rename this light *KeyDirectShadow*, change a viewport to its view, and bring the Hotspot and Falloff values down as tight to the bust as possible without altering the light's orientation. Alter the Multiplier value to 0.0, and change the shadow color to white and the Density to 2.0. Within the Shadow Parameters rollout, click and the map button and select Gradient Ramp. Now drag an instance of this from the map button within the Shadow Parameters to an unused sample slot in the Material Editor.

In the Material Editor, in the Gradient Type drop-down found under the Gradient Ramp Parameters rollout, choose Radial. In the map's Coordinates rollout, make sure Mapping is set to Explicit Map Channel. In the Gradient Ramp Parameters rollout, right-click

Figure 7.11
Bring the Hotspot and Falloff values down as tightly as possible

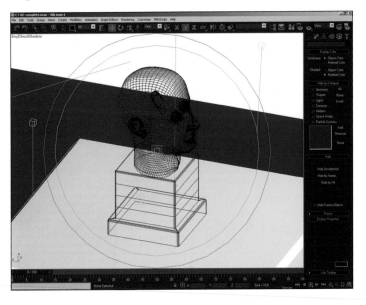

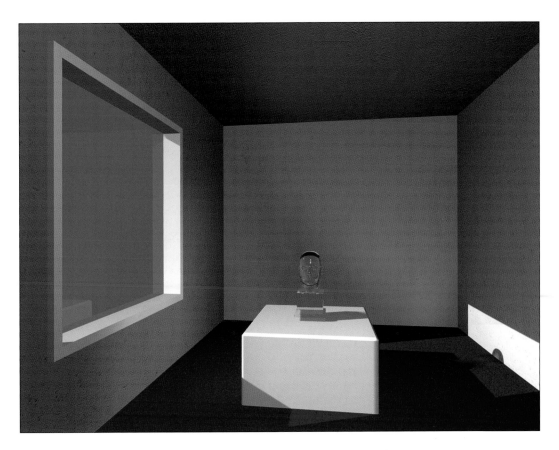

Figure 7.12
Caustics can add a subtle level of realism relatively easily

the red flag on the left side of the gradient display and choose Edit Properties, and then change its color to white. Change the color of the right and middle flags to black. Set one additional flag midway between the left and middle flags, whose color should be set automatically, if not change this to a medium gray. Now move the middle two flags along the gradient, positioning the gray flag at around 10, and your middle black flag near 70.

Now to position the effect and add some noise to make it less uniform. In the Coordinates rollout, change the U and V offset values to 0.1 and 0.15 respectively. Similarly, alter the Tiling values to 1.0 and 2.0 to stretch the effect along the width of the bust, as caustics appear in real life, and make sure the Tile checkbox for the V value is unchecked. Within the Gradient Ramp Parameters section, experiment with the Noise settings, until you get something that resembles caustics. This is a bit of a hit-and-miss process, so you'll just have to keep trying until you get there, though the following settings should produce what you're looking for: Amount:1.0, Size:4.0, Type:Regular, Phase:13.0. If you render now you'll see that you've got a result that is 20% quicker than using raytraced shadows, and with caustics adding to the global illumination illusion.

Outdoor light indoors

Armed with the knowledge from the last few chapters, you should be pretty comfortable with approaching the way in which outdoor lighting works indoors. The tutorial that follows this section will demonstrate concepts that you'll have already have covered, from the basic three-point set-up to replicating the look of global illumination using fills to represent indirect light. We'll cover outdoor light in more detail next chapter, but for the moment this can be thought of as a gentle introduction to this kind of light.

Having established the time of year, time of day and geographic location of your scene, you should begin to think about the color balance of your scene and the bearing this will have on the coloring of your lights. Just because a scene is set indoors, it does not automatically mean that as a film maker you should automatically choose tungsten-balanced film. If the dominant light source in a scene was entering the set from the outdoors, then daylight-balanced film could and generally should be used.

With this in mind, the changes in the color temperature of the sun's light throughout the day should be kept in mind and table 2.01 referred to. Remember: if the color temperature is lower than your chosen balance, the light will appear more yellow, if it is higher it will appear blue tinted. Also, the changes in the color of the sun's light should be examined, and cloud cover and weather conditions would also affect this color.

These kinds of shifts in the sun are closely controlled in cinematography through the use of colored filters called gels, which are placed over artificial lighting, or over openings like

Figure 7.13
Many different colored filters and gels are available to control color (www.rosco-ca.com)

windows to ensure that the direct sunlight is of a consistent color. In CG we may not have to battle with these changes in light, but we do have to simulate these subtle changes of time.

Cookies and gobos

In the world of cinematography, just as gels can be mounted directly onto the front of a light, so too can gobos and cookies. These are simple rectangular panels of metal or wood with patterns cut out of them to break up a light or shape its form.

In CG we can either place a physical object in front of a light to break up its shadow, or use a projector map, which acts exactly like a cookie. Whilst placing an object in front of a light will invariably produce more accurate shadows, as a result this can take a lot longer to render, especially if raytraced lights are used. However, if you've set up a visible object to move, like a tree swaying gently in the wind, using the object to create shadows would probably be the easiest option.

Often, generally because of render times, the use of projector maps is preferable over the use of shadow casting objects, especially if the camera cannot see the window through which the light is shining. When working on indoor scenes, a projector map is most likely to be of a tree's foliage or of blinds, and as these bitmaps are rectangular, it does make sense that your projection light be rectangular too.

Breaking up a scene's key light in this way can be a very effective way of giving a scene much more visual detail than it actually has. It's worth remembering that light passing through objects

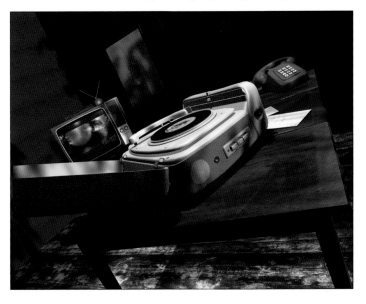

Figure 7.14
Breaking up a key light with a projector map can be effective

such as trees, whose leaves are semi-transparent, will pick up a light green tint as a result, which will again add a further level of subtle detail to the lighting scheme.

Likewise, blinds can add a great deal to a scene visually. Part of the reason why the horizontal striping of venetian blinds is so popular in CG is that the shadows that this throws into a room actually help to identify things as being three-dimensional, as the straight lines of the shadows curve round organic objects, emphasizing their forms.

Not only do the shadows cast into a room by things like foliage provide interior detail, they actually give the viewer valuable clues about what lies outside of your immediate scene, and this can help to build atmosphere and link locations. Similarly, there are many other objects that can be placed outside windows to give us clues to a location, set a mood and add to a scene's lighting.

Flickering neon signs have been used time and time again in films, particularly those involving private detectives it seems, to give the scene grittiness and a recognizable sleazy location. If your animation requires this kind of mood, then taking a cue from this kind of movie can provide this atmosphere whilst giving you the opportunity to introduce some interesting lighting. We'll take a closer look at designing neon lights in chapter 9.

Similarly, car headlights passing by a window can help build suspense by momentarily lighting up a dark scene, or can provide a shock or a clue by revealing something previously hidden in the shadows. Visual clues are provided as to what is offscreen, and the roadside location could again impart a certain grittiness.

Figure 7.15
Venetian blinds can emphasize the 3D nature of a subject

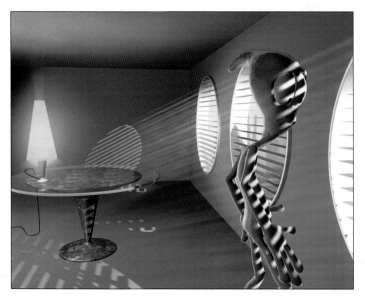

Again, this kind of animated lighting can provide an interesting yet simple visual effect that helps to emphasize the three-dimensional nature of your production, as the lights and shadows crawl over the scene's objects.

Finally, stained glass can easily be created in CG, which perhaps explains why we see so much of it. This is another simple effect that furnishes a scene's lighting with depth and detail. A semi-transparent surface will impart its colors to raytraced light shining through it, which is how stained glass is most easily achieved.

Volumetric lighting

Stained glass brings us on nicely to our next subject, volumetric lighting, as the two effects are often used together to impart a suitably old and dusty atmosphere to castles, churches and so on. This effect occurs in real life when light interacts with particles in the air, like fog, smoke or dust. Once a light has been specified as being a volume light, the light will act like one, and the skill in creating realistic looking volume light is in being able to craft these particles convincingly.

This principally involves understanding how to use noise to be able to recreate these different types of particles, which is an important skill in almost all atmospheric effects, vital for fog, smoke, clouds and so on, but equally central to underwater scenes, where the water's particulate matter gives it substance.

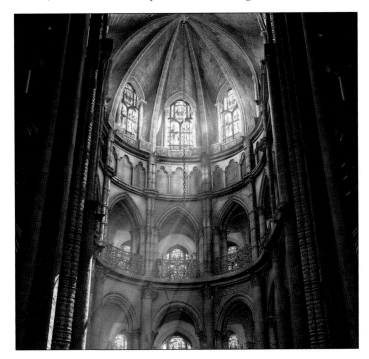

Figure 7.16
Volumetric lighting can be used to impart an old, dusty atmosphere

Image courtesy of:
Musa Sayyed
www.musa3d.com

Tutorial - outdoor light indoors

In this tutorial you will look at the effect of outdoor light casting shadows indoors. This will involve first setting up a light to represent the sun and a couple of lights to represent the bounced light within the room. Then you'll look at various methods of casting shadows from the sunlight: using physical objects to cast the shadows and projectors, before experimenting with volumetric lighting.

Open the C7-03.max file from the tutorials folder of the CD. You will see a room with round windows fitted with venetian blinds. First you need to set up a light representing the sun, so using 3ds max's Sunlight system, found in the Create panel under Systems, click and drag once in the Top viewport to create the compass portion of the system, then let go and click again to create the direct light representing the sun.

You should now have the system's controls displayed within the Create panel. Press the Get Location button, select the Europe map and choose London. Within the Time rollout, make it 1600 hours on March 1 2002. Ensure that the Time Zone is set to 0 and the Daylight Savings Time is checked.

Note: After you've created a sunlight system its settings are altered in the Motion panel, whilst the orientation of the system is changed by rotating the compass helper.

Now select the light source you have just created, *Sun01*, and change the Multiplier value to 1.0. This is not bright enough for our purposes, so double this value. You will need to change the shadow type to Ray Traced Shadows in order to have the light penetrate the windowpane object and cast shadows of the blinds. Once you have done so, this light should be shining through the three windows, casting a light on the floor and far wall as shown in figure 7.17.

Using the techniques you learnt earlier in the global illumination tutorial, you should place a light representing the light bouncing off the illuminated portion of the far wall, which should, of course, be colored to match the wall so that it throws a pool of yellow light onto the floor. Make sure that this light has its shadows turned off. To produce a subtle pool of light, the Multiplier value will probably be around the 1.0 mark.

For the fill, place a target spotlight in the top left corner of the room (in relation to the Top viewport) and make its hotspot and falloff 80 and 90 degrees respectively. Make sure its shadows are turned off and move its target object so that the light cone runs down the center of the room, as in figure 7.18. Give this a less saturated version of the previous yellow - around R:210, G:200, B:120 - and a

Multiplier of 0.5. For the light bouncing off the floor, place a spotlight underneath the floor, pointing upwards towards the ceiling, and adjust its cone and vertical position so that the ceiling is fully illuminated. The Multiplier value should be around 0.5.

If you render now, you should see an image with shadows falling across the floor that are nice and crisp, making the light that's coming through the window appear like a very distant light source on a clear day. This crispness is due to the fact that these shadows are raytraced, which means that the shadow generation algorithm follows the edges of the blinds and windows very

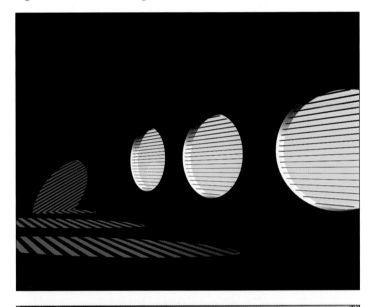

Figure 7.17
Raytraced shadows allow the light to penetrate the windowpane

Figure 7.18
The fill should be placed in the top left corner of the room

Figure 7.19
Compare your raytraced key with...

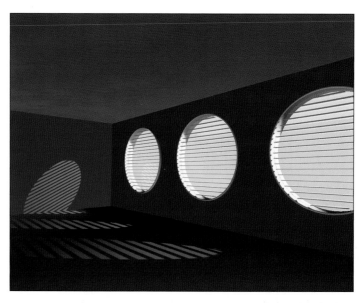

accurately when calculating the shadows. The downside to raytraced shadows is that comparatively speaking their calculation takes a long time, on my machine 45 seconds.

To compare this with shadow maps, unhide the three lights called *DirectVolume01, 02* and *03*. Turn off the *Sun01* light. These three lights are centered on each of the windows, in order to keep the shadow maps as small and efficient as possible. If you render now you'll discover that rendering takes about half the time, but you should also see that something's wrong: the light does not penetrate the interior. If you use the Exclude function to remove the *WindowPane* object from the light's illumination and shadow casting, you will find that the results are as you might expect.

Instead of using physical objects to cast shadows, however, you could use a projector map, which would also cut down on rendering times, though might not produce as satisfactory a result, depending on what look you were after. First turn off the three *DirectVolume* lights. Create a Target Direct light anywhere in the top viewport and move the light itself to X:-2.75, Y:-2.5, Z:1.6. Now move its target to X:-2.75, Y:0.0, Z:0.0. In the Directional Parameters rollout, change the light's Hotspot to 50 and the Falloff value to 55 and click the Projector Map swatch, before assigning window_projector.jpg and renaming the light *DirectProjector01*.

Each window is 2 meters in diameter, but max doesn't like Hotspot and Falloff values to come too close together, and if a Falloff value of 2 is entered directly, the Hotspot will automatically size itself to 0.5. The solution to this is to use larger values, as we have and use the Scale tool to get the correct value.

Right-click the Select and Uniform Scale button and in the Offset:Screen field enter a value of 2. This will scale the Hotspot and Falloff values down to fit the windows without forcing the Hotspot to be much smaller than you would ideally want it to be.

Now, with the light selected again, using the Array function, make two further copies of this light along the wall centered on the windows. To do this you should enter 2.75 in the Incremental X field (the very top left) and in the Array Dimensions area of the dialog, you should enter 3 in the 1D field, which should also have its radio button selected. Finally, select Instance as the Type of Object and hit OK. Now move each of the target objects over (along the X axis in the top viewport) until they are vertically in line with their associated lights.

You should now get pretty convincing shadows if you render, though with no great reduction in render time over the previous shadow mapped results. These kind of lights are most effective when the actual window they are representing is not visible, for example if the light was coming from the opposite side of the room, where the windows are not visible from the camera.

You will also notice problems with this method: the unrealistic shadows around the windows. To overcome this you'll have to Exclude the three *WindowFrame* objects. Now, by selecting these three lights' target objects at once and moving them around along the plane of the floor, you can have pretty convincing and controllable results. Move them to attempt to match the previous set of raytraced lights, so the pool of bounced yellow light on the floor looks correct. (To help you do this, you might want to switch the *Sun01* light back on.) Don't let the cones of each light

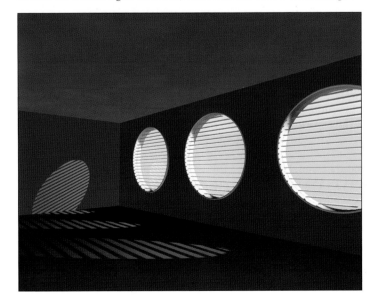

Figure 7.20
...shadow maps, which are quicker, but often require more attention

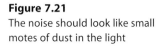

Figure 7.21
The noise should look like small
motes of dust in the light

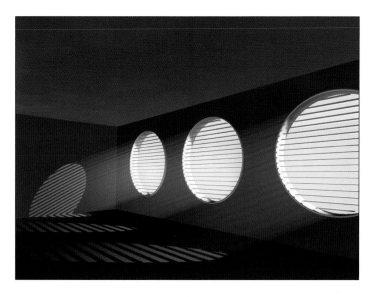

overlap though, as this will produce extremely undesirable results. Upon rendering again, you should notice that the shadows of the blinds are not oriented in the correct manner, and to correct this you'll have to use the light's Roll control, changing all three lights to have a Dolly value of around 25.

You can see that extra care must be taken when working with projector maps. The sharp eyed amongst you will note that the surfaces of the window frames, for instance, are now unrealistically illuminated. An extra direct light needs to be placed outside the building coming from the same angle as the projector mapped lights that are set to include only these objects. Rendering now reveals that this method actually takes slightly longer than the previous shadow mapped example, which we'll revert back to in order to explore volumetric lighting.

First turn off the *Sun01* and the three *DirectProjector* lights, and turn back on the three *DirectVolume* lights. It's very simple to make any light a volume light. From the Rendering menu, select Environment, and in the new dialog, click Add in the Atmosphere rollout, before adding the Volume Light effect. In the Volume Light rollout that now appears, click on the Pick Light button and using the Select by Name button (which can also be invoked by pressing K on the keyboard), choose the three *DirectVolume* lights. If you render now, with everything left at its default setting, you'll see that the results are largely OK. The real skill of volumetric lighting comes in knowing how to use the Noise controls to accurately reproduce the right looking dusty atmosphere.

First of all, in the Volume rollout, change the Density to 3 and the Max Light % value to 75. This will prevent the whiting out of the image. Set the Filter Shadows value to High, which increases the

sampling rate and the quality of the volume light, though of course also the rendering time. In the Attenuation rollout, alter the settings to start at 100% and end at 85%, which in fact relates to the Attenuation values within the light's controls. Now in the Noise rollout, first of all turn on Noise using the checkbox. Set the amount to 0.5, the Type to Fractal and the Uniformity to 0.3. Leaving everything else set to its default value should give you a nice delicate effect that looks like motes of dust dancing in the shafts of light, as in figure 7.21.

To give this light a little more visual interest, we can add some animation to the light, and this we can do in a number of ways. The first is to use the last few controls in the Volume Light Parameters rollout to animate the fog volume itself, by first of all defining what direction the wind is coming from, then using the Phase field to control the speed of the wind. Additionally, by setting the Wind Strength to greater than 0, the fog volume moves in accordance with the wind direction. Whilst the Wind Strength value controls how fast the fog volume moves, this is relative to phase, and if this is not set, the fog won't move, regardless of the Wind Strength.

By animating the Phase value, you can define precisely how your wind gusts occur. This might seem a little complex, but, for example, if you have the Phase animated to change slowly with a large Wind Strength, the fog moves rather than churns. Alternatively, if the Phase is animated to change rapidly with a relatively small Wind Strength, the fog churns fast, but only drifts slightly in terms of its movement. So, if you wanted to have the fog to just churn in place, which would be the likely choice here, you'd animate the Phase, but keep the Wind Strength set to 0.

Figure 7.22
Animating the projector map's noise to simulate churning dust

Figure 7.23
Mottled light is possible using a
colored bitmap as a projector

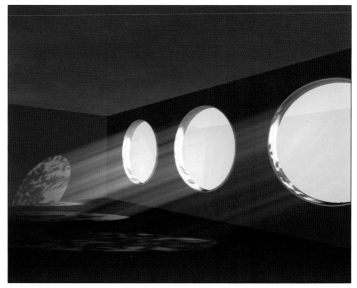

The second way we could give the light some animation is to
animate the light itself, which would give the light a mottled
effect, as if a tree outside were swaying gently and the sunlight
were coming through its leaves. First of all, open C7-04.max and
select any of the three DirectVolume lights and click the Projector
Map button. Now specify a bitmap and choose Leaves.jpg from
the tutorial materials folder, dragging this map from the light's
controls over into an unused slot in the Material Editor, being sure
to choose Instance as the copying method. Name the map
something appropriate like TreeShadow and set the material's
coordinate source to Explicit Map Channel. Set the U and V tiling
to 0.5 and turn on Animate, move to frame 25 and alter the
coordinates Offset values for U and V to 0.3 and 0.5.

Now turn on the Animate button, move the time slider to frame 20
and change the coordinates' Offset values for U and V to 0.3 and
0.7 respectively. At frame 50, set these same U and V values both
back to 0.0 and turn off Animate. Open Track View and expand the
tracks: MEdit Materials > TreeShadow > Coordinates and select
the U Offset track. First click the Parameter Curve Out-of-Range
Types button and hit the Loop graph. With this track selected, hit
the Assign Controller button and assign a Float List controller.
Now select the track marked available, under the Bezier Float
track, and assign a Noise Float controller. If you right-click this
and choose Properties, turning off Fractal Noise and changing the
Strength to 0.1, this should give your swaying some randomness.

Repeat this for the V Offset track, selecting a different Seed, so the
noise is slightly different. Now in the Bezier Float track, move the
key from frame 25 to 27 for the V Offset and from 25 to 23 for the
U Offset. If you have the Function Curves display on, you should

see the effect of this by highlighting the U and V Offset tracks. Now play the animation and the leaves should sway within the Material Editor. Rendering now will reveal leaf patterns that are slightly green tinted at the edges that sway as they cast their shadows.

Artificial lighting

Learning how to represent the different forms of artificial lighting, whether used indoors or outside, is a very important skill, and often a tricky one. This is principally because our perception of the varying bulb types is quite different from how they appear when filmed. As we've already touched upon, fluorescent lights can appear slightly green on film, but look white to the naked eye.

The same kind of variations apply to metal halide lights, though this kind of lamp is much more unpredictable from bulb to bulb and can appear from blue-green to blue to white. The only lights that appear the same on film as they do to the naked eye are sodium-based bulbs, which look yellow-orange.

As we're lighting for CG, the way in which things appear on film is arguably the most relevant, so this is what should be aimed for. You should always consider what your desired color balance is and use table 2.01 to decide how the source you're about to model will appear relative to the color balance you've chosen.

The actual placement of lights to work within physical fixtures might not seem that difficult, you just place your light where the bulb would be in the fitting, don't you? Well, the simplest solution is often to do just this, but as with most things in CG, what's easiest is not always what's best.

Figure 7.24
Three lights representing one bulb might seem excessive, but is quicker and more controllable

As we've already discovered, the generation of shadows is the most computationally intensive part of rendering a light, so this might not be the best option. Placing spotlights with their cones limited to fit to the geometry of your fitting can be the best option, and though you may need several lights to take the place of a single shadow casting source, the resultant render times can mean that this extra effort is well worthwhile.

Tutorial - artificial lighting

In this tutorial you will look at setting up a relatively simple artificial lighting fixture, examining how different methods can yield equally satisfactory results, but as usual with varying render times. You'll look at using physical geometry to cast shadows, then you'll build up a better solution that consists of several lights all serving different purposes.

Open the C7-05.max file from the tutorials folder of the CD. You will see the same scene as the last tutorial, with the addition of a table at the far end of the room, all viewed from a slightly different camera angle. To begin, go to the Display panel and Unhide the *LampTable* object, which will be the first fixture that you'll add light to. This, as you can see, is a very simple tabletop light fixture.

First of all then, place an omni light centrally to the lampshade relative to the Top viewport, and about a third of the way up the shade, roughly where a light bulb would be located in this fixture. This represents a standard household bulb, which are generally tungsten. According to table 2.01, this has a color temperature of 2,865 °K. However, as the dominant light source within this scene

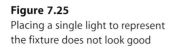

Figure 7.25
Placing a single light to represent the fixture does not look good

Figure 7.26
A simple light fixture is often best
built from many light sources

is certainly the outdoor light from the three circular windows, this
scene would likely be filmed on daylight-balanced film, which is
color balanced for 5,500 °K. The fact that the tungsten light source
has a far smaller color temperature means that it would appear as
an orange light on this type of film - refer to figure 2.05 if you
need to remind yourself of how this works.

Choose a suitable orange for the light's color, turn on shadows
and make sure the shadow type is set to Ray Traced. With a
Multiplier value of 0.5, render and you should see that though
light is cast through the top and bottom of the shade, these results
are somewhat short of convincing: the overall illumination around
the lamp is poor, the spots on the ceiling and floor are too well
defined and the lampshade itself should be brighter. There are
many problems with this solution.

A far more realistic solution comes from splitting this light's
illumination into several components. First, the general
illumination that would emanate from this light is best repre-
sented by an omni, and seeing as we already have one in place,
let's start here. Select the omni light you've just created, rename it
OmniLamp and turn off Cast Shadows. Set the Decay type to
Inverse Square and set the Start value somewhere around 1.0, so
you get a very subtle pool of light on the ceiling. In the Material
Editor, alter the Self Illumination checkbox of the *LampShade*
material to color and specify a light orange color, around R:200,
G:172, B:113, so the shade looks more realistically lit from inside.

Clone a copy of this light and turn off its Decay, instead turning
on its Far Attenuation and setting the Start and End values to 2.5
and 4.0 respectively. You don't want this light to illuminate the

ceiling as the last omni light did, but you do want it to illuminate the walls, because the last omni light did not. As the light stands, its Attenuation is completely spherical. Using the Non-uniform Scale tool, scale the light down to 50% along its local Z axis so the light does not reach the ceiling and scale again by 200% along the light's X axis, and 125% along the Y axis, so that the illumination reaches the far walls whilst leaving areas of lesser illumination in the corners.

Now create a spotlight, pointing directly upwards from just above the omni you've already created, and rename this *SpotLampTop*. This is representing light from the top of the light bulb, so move it up above the omni an appropriate distance. This should automatically be the same orange color you've used before and have no shadows set. Adjust the falloff cone so that it just fits the hole at the top of the lampshade and set the hotspot light to five degrees less. Set the Far Attenuation Start and End values to 1.0 and 2.0. Repeat this process, creating a second spotlight pointing out of the bottom of the shade, positioned roughly where the bottom of the bulb would be. All the light's parameters should already be set correctly apart from the hotspot and falloff which need widening right out. If you render now, you'll notice from this source's pool of light that it actually needs to cast shadows in order to look correct.

In order to further emphasize this light's illumination, a second volume light effect can be added to these two spotlights. Within Rendering > Environment, add a Volume Light effect and using the Pick Light button, specify both the spot lights associated with the table lamp. Alter the two Fog and Attenuation color swatches to values of R:255, G:237, B:208 and R:77, G:62, B:40 respectively.

Figure 7.27
Scaling a light cheats its illumination into areas it wouldn't normally reach

Alter the End Attenuation value to 65%, leaving everything else in the Volume section as it appears apart from the Density value, which you should set to 250. In the Noise section, use the same values as the Volume Light that appears adjacent to this one in the list of effects. This gives you the same Noise settings as the Volume Light for the windows you set earlier.

With this turned on; the lamp is complete bar a subtle glow that we'll add using max's Rendering Effects. To add a glow to a material, you need to alter its Material Effects Channel, which is unsurprisingly done in the Material Editor, in the row of icons underneath the sample slots. Change the *LampShade* material's value from 0 to 1 and in the Effects dialog invoked from the Rendering menu, add a Lens Effect. Now from the Lens Effect Parameters list, specify a Glow, click the arrow pointing right and check the Interactive checkbox. (At this point max might go away and render out a frame, but once this has been done, the effect will be displayed so that it can be altered interactively.) Now, down in the Glow Element rollout, within the Options tab, check the Effects ID box and in the Image Filters section, deselect All and check only Perim. Back in the Parameters tab, set the Size to 5.0, the Intensity to 75. Finally, alter the Radial Color swatches so that the Center Color is a saturated orange and the Edge Color is a much paler version. Your preview should reveal a subtle orange glow around the light.

Now with this glow already active, turn on all of your Volume Lights within the Environment dialog, and sit back whilst your machine chugs away on rendering your final image. Whilst it might have taken a comparatively long time to set up, you should agree that it was worth the trouble. There are some other

Figure 7.28
Select both of the fixture's spot lights for the volume effect

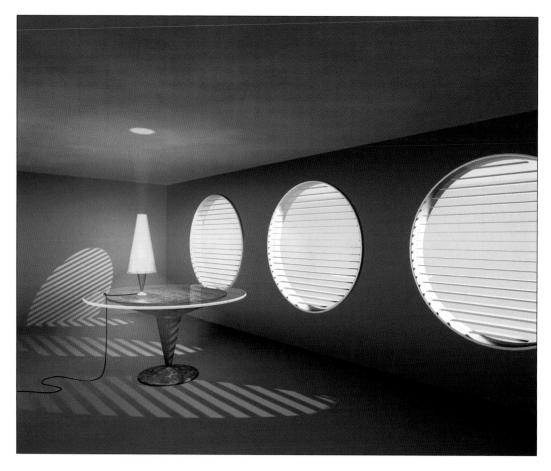

Figure 7.29
Volume lighting and a glow effect
finish off the simple fixture

light fittings that you can Unhide within this scene: an uplighter on the far wall, an overhead light and a neon light. Try applying what you've learnt in this tutorial to set up these lights to look as realistic as possible. You should use the same techniques of thinking about relative color temperature, using the Non-uniform Scale tool, applying Decay and Attenuation, as well as the Glow Lens Effect (which we'll go into in far more detail in chapter 12) to achieve this.

Candlelight

Though we'll cover fire more extensively in chapter 11, we'll take candlelight as a special case and consider it here. This can be thought of as a gentle introduction to fire, with more detailed tutorials to follow in a couple of chapters' time. We have an extremely primal attraction to fire and to be able to depict it accurately along with its warm and sensual feelings can make a CG scene very alluring, unlike a lot of the cold, plastic looking animation that we see so much of.

If you look back at table 2.02, you'll see that candlelight has one of the lowest color temperatures around - approximately 1,900 °K - which means that when we see it represented on either daylight-balanced or tungsten-balanced film, it is always going to appear somewhere between yellow and red.

However, the emotional associations that we have with fire and candlelight in particular mean that many cinematographers will play around with the way that candlelight appears in their films, and you may well see candles appearing to be yellow, but you may also see them looking distinctly white. We too as CG artists can do just the same.

Many people fall into the trap of simply making their CG candlelight some variation of yellow or orange and leaving it there. If you examine a candle closely, however, even though the source is very small, its light appears to slightly surround the objects it illuminates and its mid-tones appear quite desaturated. Convincing CG candlelight needs far more than just the correct color, the mid-tones must be made to appear quite colorless.

Tutorial - candlelight

In this tutorial you will look at simulating the candlelight of a single candle. This will involve setting up several lights to represent the different tones emitted by the flame, paying close attention to the decay and attenuation of these sources, whilst making sure the shadows are as realistically dark. You'll then use max's Fire Effect to finish the whole thing off with the actual candle flame.

Open the C7-06.max file from the tutorials folder of the CD. You will see a candlestick sitting on a table surface between two busts. There's a single omni light placed over the center of the candle, which you should first select and change the color to a warm orange - around R:255, G:175, B:0. Rename this light as *OmniCandleMiddle*, and in the Attenuation Parameters rollout, change the Decay Type to Inverse Square and specify a Start value of 75. Finally, check the Light Affects Shadow Color box within the Shadow Parameters rollout. If you render now, the candlelight looks fairly convincing, but it has not got the depth of color that a real flame gives out, and to solve this, we'll create a further two lights which along with this one will represent the flame's illumination.

So, clone a copy of this light, rename it *OmniCandleInner*, and change the color to a pale yellow: around R:255, G:250, B:175. The Decay Start value for this light should be set at 60. Rendering now shows more variation of tone than previously. Now clone a third copy, renaming it *OmniCandleOuter*, and give it a pale orange color: around R:250, G:225, B:150. The Decay should be

altered to Start at 100. If you render at this point, you'll see that we need to correct the lights' intensities, as the scene looks far too brightly lit. You should find that changing the three lights' Multiplier values to around 0.75 looks about right.

Now for the fill light, which should be a target spotlight placed directly above with a light blue color of around R:200, G:250, B:250 set not to cast shadows. The End Attenuation should be set to start just above the top of the busts' bases and just beyond the table's surface. With the light at X:0, Y:0, Z:400 and the Start and End Attenuation at 350 and 500, you should get slightly more

Figure 7.30
The first of the candle's omnis should have a warm orange color

Figure 7.31
The attenuation of your fill light should be carefully defined

definition in the shadows with a Multiplier of around 0.3. You're looking to see the shoulder of the nearest bust becoming slightly and subtly more defined, with the shadow region around the base of the candlestick becoming very slightly less dense.

Now create a spotlight in the Top view from the center of the left-hand bust, targeted halfway up the candle. Use the Align tool to center it on the bust object in X, Y and Z axes. Using the Include function set the light to illuminate only the *Candlestick* object. This light should have a pale orange-yellow color: around R:225, G:225, B:115. It should also be set not to cast shadows and its Specular checkbox should be unchecked - within the General Parameters rollout. Set the Multiplier value to 0.6 and clone a copy of this light, which should then be centered on the other bust. With a Multiplier of 1.2, this light should give a subtle illumination of the candlestick itself with a nice edge along its left-hand side.

Rather than backlight this scene, we're instead going to add a small amount of self-illumination around the outer edges of the busts using the Falloff map type. In the Material Editor, select the Bust material and go to the *Head* sub-material. Now, in the Maps rollout, click the Self-Illumination channel and select a Falloff map type. The Falloff Type should be set to Fresnel and every-thing else left the same. Go up a level in the editor and render to see this effect, which is way too strong. By bringing this down and rendering, you should eventually find that a value of about 25 gives a very slight edge to the image. Repeat this for the other sub-material and we're about done on the lighting.

To add the flame, you'll first need to zoom right in on the top of the candle in the Front viewport. Now halfway between the top of

Figure 7.32
Backlighting is faked using a falloff map in the material itself

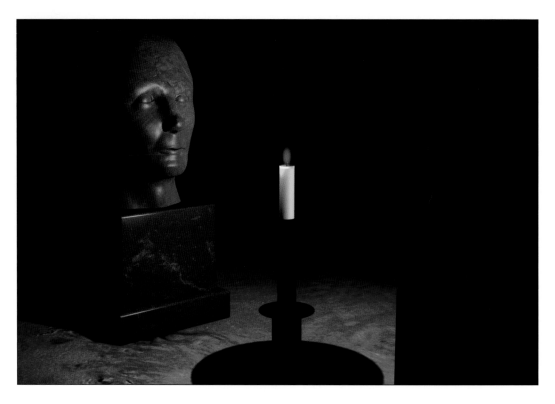

Figure 7.33
Fire effects are difficult to judge
without seeing them animated

the wick and the omni lights you placed earlier, create a
SphereGizmo object - found in the Create panel > Helpers >
Atmospheric Apparatus. Using the Select and Non-Uniform Scale
tool, you should scale this vertically along the Y axis, until it's
around twice as high as it is wide. Within the Modify panel, click
Add and specify a Fire Effect. By selecting this effect here and
hitting the Setup button, you find yourself in the Environment
dialog box. Check for Tendril, rather than Fireball, and drag the
color swatches from the *OmniCandleInner* and *Outer* lights to the
inner and outer color swatches in this dialog, tweaking the Outer
color to be more of a red-orange and more saturated. With the
Stretch set to 1.5 and the Flame Size and Density set to 25 and 75
respectively, you should have a decent enough looking flame. It
should be noted though, that these kinds of effects look far
superior when animated and no still rendering will really do the
effect justice, as it's the movement and flicker that are a large part
of producing convincing fire.

8

'But, soft! What light through yonder window breaks?
It is the east, and Juliet is the sun.'

William Shakespeare: *Romeo and Juliet*

The great outdoors

Natural light is much more difficult to portray realistically in an outdoor environment than indoors. Light coming through windows and other openings is relatively easy to control, but the fact that sunlight is an extremely bright source makes it a sizable challenge out of doors. Even photographers sometimes need to employ bounce cards, diffusing silk sheets and extra lighting to break down harsh light and soften its often hard shadows.

Whilst the light from the sun might seem like one distant, bright source, the way it behaves means that its illumination can be split into several components that layer on top of the single distant, bright source. The first lighting component can be referred to as skylight, which is the diffuse light caused by the scattering of the sun's light as it passes through the atmosphere. Also, because sunlight reflects off the many objects that make up an exterior environment, bounced illumination casting colored light back into the environment also has a sizable influence on outdoor lighting.

Images courtesy of:
Bastien Charrier
bast1@free.fr

Sunlight

One of the biggest clues to the time of day is the sun and how it changes the lighting around us. Furthermore, just as seasonal depressions can be treated with light, so the illumination that we specify in our animated productions can help create a mood, from light summery happiness, to dark claustrophobia. The weather has been used successfully in many feature films to set the emotional tone, and we must think similarly in CG.

The sun's angle

There are two main clues to time in CG, both of which concern the sun's light: the angle and the color temperature, which both change throughout the day. The angle of the sun starts at 0 degrees during sunrise and sunset, and rises to an angle at midday that changes depending on the time of year, and also the latitude. In London, for instance, the summer solstice on the 21st of June sees the sun rise to an angle of 58.5 degrees at noon, whereas on the same date in December, the highest angle the sun manages is around 12.5, the lowest midday angle of the year.

Most 3D solutions have some kind of sunlight system that allows you to enter the geographic location of your scene, the time of day and date, from which it can calculate the sun's position. Given the compass bearing of the scene, this kind of system can generally go one step further, placing an animated light over the given location. This kind of functionality is aimed at architects wishing to carry out shadow studies of proposed structures; however, it can be a useful feature for verifying that a scene's key light represents the sun at the desired time of day.

Figure 8.01
Clues to time can be given through the angle and color of sunlight

The sunlight falling through the window in the previous tutorial enters at an angle of around 26 degrees, which could represent midday in February, or either 6pm or 8am in June, as well as many other times - presuming our scene is in London.

Color temperature and time

As you should remember from chapter 2, the color temperature of sunlight changes throughout the day. This begins at around 2,000 oK at sunrise, increasing rapidly to 4,300 oK by early morning. At midday the color temperature reaches its maximum value of over 5,000 oK, though on the clearest of bright summer days, this can go in excess of 15,000 oK. Indeed, overcast skies generally have a higher color temperature than clear ones, around 6,000 oK. These values can vary greatly depending on the weather conditions, and the values presented here and in table 2.01 are just averages to be treated as a guide.

The sun's light changes color through the day, from a warm orangey-red at sunrise to a pale yellow around breakfast time, and desaturates to almost pure white by midday. As the day wears on, these colors occur again, in reverse, though cloudy conditions can tint the sun blue, and stormy weather gray.

However, how these colors will appear in your rendering depends on the chosen color balance you have selected - 3,200 oK and 5,500 oK for tungsten-balanced film and daylight-balanced film respectively - and how the color temperature of the sun relates to this color balance. If the color temperature is lower than your chosen balance, the light will appear more yellow, if it is higher it will appear blue tinted.

Figure 8.02
The sun's color changes through the day from yellow in the morning

Figure 8.03
Evening light simulated in CG

Image courtesy of:
Bastien Charrier
bast1@free.fr

To normalize these shifts of the sun in cinematography, colored filters called gels are placed over artificial lighting, or over openings like windows to ensure that the direct sunlight is of a consistent color. Of course, these can also be used to make indoor lights appear as if they were emitting daylight.

If your 3D application has a sunlight system, use this as a starting point to your lighting, that way you can be sure that at least the position of your source is accurate for the time of year, day and geographical location of your scene. One thing you must remember, however, is to change the color of the light to reflect the time of day, remembering to take into account which kind of film you're attempting to mimic, though for most daytime outdoor scenes your stock will certainly be daylight-balanced.

Without the use of a sunlight system, you need to do a little more calculation based on the factors that such systems use: what period of the year it is and what time of day, as well as the location. Armed with this knowledge you can make an educated guess at the angle and strength of the sun, if you want to be more precise you can use various websites - the one at www.susdesign.com/sunangle/ is the best. Entering this data will give you the relevant positional data for your light source. Of course, if you have no sunlight system, you should be using a direct light as the starting point for light representing the sun. Whether you use such a system or not, you'll still have to do further lighting work to represent the skylight's contribution and the bounced illumination.

Despite the fact that direct lights can yield quick and accurate results, if your rendering demands an extra level of quality, it's best to break the lighting down into a series of individual lights.

The problem with direct light is that it is too uniform, and in isolation results in an image that has too much contrast, and can result in a very flat image. The easiest solution is to add an array that represents the diffuse skylight coming from the sky's dome.

Skylight

The skylight's contribution to outdoor lighting is a very diffuse light, which is at its strongest in the part of the sky opposite to where the sun is located. When skylight is mentioned in CG circles, it is often assumed to include the contribution of the bounced lighting from the environment's objects. It is arguably simpler to think of the skylight as being a separate element that operates like an array of fill lights located around the sky, which can be thought of as a dome, all casting only diffuse blue light. Indeed the only difference between the individual lights that make up this dome of skylights will be the increasing intensity across the array, at its strongest directly opposite the sun.

Light bouncing off the major elements of a scene's environment is also best represented by a circular array of lights, placed down around ground level, again operating only as diffuse light. This array of lights can be thought of as having equal intensities, though their colors will vary depending on the color of the objects adjacent to them in the environment.

The simplest way then to set up both the skylight and the bounced light is to use a dome array, which you've already been introduced to in chapter 6. In this chapter's array lighting tutorial, you constructed a simple three-row dome array that was built

Figure 8.04
Dome arrays are good for creating the sky's lighting component

around a hemisphere, made up of 17 lights. This is perfect for representing both skylight and bounced light, with the top two rows (nine lights) operating as the skylight component and the bottom row acting as the scene's bounced light.

Your merged lighting array should operate in a subtle manner, with the ratio of the sunlight to skylight dependent on the amount of cloud cover in your scene. On a sunny day the skylight should just provide enough fill to soften out the lighting without detracting from your key light; on an overcast day, the skylight should make the shadows far less obvious.

The light at the very top of your dome should be the closest to white light, given just the slightest tint of blue. The next row down can consist of entirely blue or gray light, depending on the sky's cloud: the sunnier the sky, the paler the blue, and all of these lights should have their Specular Illumination switched off. The lights can't all be instances, however, because the intensity varies across the sky dome, but you can get away with splitting this second row into just two or three sets of instanced lights, and grouping them together with varying intensities.

If you want to be a little more accurate, split the row into four sets of lights, with three levels of intensity across the circle (the lowest and the highest having two lights with an average intensity value between them on both sides). You should place a dummy in the center of the quadrant with the highest intensity in order to easily place the dome with its brightest point directly opposite the sun.

The bottom row of lights that represent the bounced lighting, however, are best treated as individual lights. Despite the fact that these lights will have the same intensity and should all have their Specular Illumination switched off, they cannot be instanced, as their color will need to be changed individually to reflect the surrounding environment.

Sunlight and skylight together

Even with a direct light accurately representing the sun and a dome array providing the skylight, the end result can look a little unrealistic upon close inspection. For most purposes, this direct light and dome array combination will be suitable enough, but if you need that bit of extra quality, then it's the sunlight that needs to be looked at, because a direct light just does not behave quite the way real sunlight does.

The next time you find yourself in direct sunlight that is not directly overhead, look at your shadow in the sun, and you should see that the shadow's edge is both sharp and yet soft at

the same time. The penumbra, that is the very edge of the shadow that is partly illuminated, brighter than the main body of the shadow, is very subtly defined. Whilst this area is very soft, there also exists a sharp shadow that holds a lot of definition and detail, which if you look at the shadow of your hair in the sun, you should be able to understand.

Tutorial - sunlight and skylight together

In this tutorial you will learn how to set up a basic daylight scene. This will involve first placing a key light representing the sun using 3ds max's Sunlight System - choosing the time and geographical location for the scene - and examining the sky conditions to adjust this lighting. You'll then merge a lighting array to represent the skylight and bounced light from the surrounding environment. You'll then replace the direct light with a lighting array and compare the results.

Open the C8-01.max file from the tutorials folder of the CD. You will see the creature from chapter 6, this time standing simply against a wall. There is also a Sunlight System represented visually by a compass, which is aligned with North in our scene.

If you select Sun01 and go to the Motion panel, you can see that the sun's parameters are set to Barcelona, Spain, at 9:00am on 1 November 2002. If you render the camera view now, you should get shadows that fall nicely on the back wall, but look way too dark and extremely flat. Use the Clone Virtual Frame Buffer function to keep a copy of this first rendering open, so that we'll be able to compare the results at the end of the tutorial.

Figure 8.05
Setting the sun's parameters

To open up the edges of these shadows, first create a circle with eight sides in the Top viewport, giving it a radius of 6 and changing the Interpolation Steps to 1 so that you have an octagon. Create a shadow casting omni light of Multiplier 0.045 roughly over one of these vertices, and then clone instances of this light until you have one on each vertex. Select all of these lights and using the Select and Link tool link them to the circle. Now you should arrange these around the direct light by using the Align tool to move the circle's center to match the Sun01 light's X, Y and Z coordinates and align its axes too in all three directions. Now move the circle to X:300, Y:−250, Z:140.

Cloud shadows

The shadows cast by clouds are an important detail when it comes to portraying realistic outdoor scenes. This detail can add a very dramatic feel to a scene, and it's a detail that adds another layer of realism to a rendering. If your CG scene has a sunny sky and also a few clouds here and there, as in figure 8.06, then you'd expect the sun to cast shadows onto the landscape. Furthermore, without these shadows, something would not look quite right.

Tutorial - cloud shadows

In this tutorial you will learn how to simulate the shadows cast by clouds onto a hilly scene. You'll do this by adding a projector map to the direct light representing the sun.

Open the C8-02.max file from the tutorials folder of the CD. You will see a house in the foreground as the landscape rolls off behind it towards the horizon. There's a Target Direct light already set up to represent the sun and a dome array of lights that's hidden in the scene opening up the shadows and providing some bounced light. The scene is by no means the most realistic right now, but it's only really to demonstrate a technique. Still you'll be amazed how much difference you can make to the scene in just a couple of quick steps.

To create the cloud shadows, you'll create a new material that will be used as a projector map on the main light. Open the Material Editor, and in a new slot specify a Smoke map by clicking the Get Material button and double-clicking it from the resultant dialog. In the Smoke Parameters rollout, change the Size setting to 100 and hit the Swap button to swap the light and dark color swatches around. Now select the *DirectSun* light and find the Projector Map section within the Directional Parameters rollout. Drag the *Clouds* material from the Material Editor onto the Map button, specifying an Instance when prompted. If you render now, you should see the shadows of clouds cast across the rolling

If you now merge our skylight dome array into the scene from C8-array.max, rendering will show us that we need to do some work to correct the scene's levels of lighting. Making changes to large amounts of lights is best done with a handy utility that we haven't looked at yet: the Light Lister. This is found under the Tools menu, and bringing it up now lists every one of this scene's 26 lights. You can easily see and change the color of each, the Multiplier values, and so on. It's a very handy utility, but as you can also see, it's difficult to see which lights are actually which, unless your naming conventions can be compressed to six characters, which most people's aren't. You also have to press the

Figure 8.06
Cloud shadows provide a convincing detail to a rendering

landscape. If you were attempting to place moving cloud shadows within your scene, you could simply animate the Phase value over time. Try changing this value very slowly using the adjacent spinner and you can imagine the kind of effect you'd get.

Our cloud areas are a little dark, so to rectify this click on the black swatch labeled Color #2 and change the Value field to around 20, when these shadows should just open up slightly, making them look much more of a match for the clouds that we see in the background sky. Finally, in Rendering > Environment, click to highlight the word Fog from the list that appears in the Atmosphere rollout. Check the Active box to the right and render again. Notice how the saturation of the colors appears to fade into the image. The Fog Environment makes a big difference to the believability of the scene because even on a clear day the objects you see blur into the distance due to the particulate matter in the air. We'll take an in-depth look at environments, such as Fog, in chapter 11.

Refresh button at the top left of the dialog if you are changing the parameters of a light that is instanced. If you don't, you won't see the other instances reflect this change. Nevertheless, it's a very useful tool for adjusting your scene's lighting in one place, and furthermore, you don't have to open Groups like the ArrayDome object to access its lights.

So, using this tool, halve the Multiplier values of all the lights that are contained within the Array Object. These are easy to pick out despite their truncated names. If you have the ArrayDome object selected, then all the lights contained within it will be flashed with a yellow box on the left edge of the dialog. You might also spot that of the middle row of lights, those numbered 01-04 are lighter in tone than those numbered 05-08. You should rotate the dome array so that the lighter blue lights are opposite the Sun01 light, which should mean about a −45 degree rotation about the Z axis.

Render now and you will see the same hard-edged direct sunlight that your clone of the first rendering has, but the fill from both lighting arrays has opened up the shadow. Of these two arrays, the ring-shaped one around the key light representing the sun has

Figure 8.07
Sunlight often features two sets of shadows, hard and soft

xtra shadow around the hard one that is
you'd see around your own shadow in the
array has further opened up these shadowed
softness to the light, and the colored lights
of this array should have imparted a subtle
tually objects surrounding the statue.

ists are not all that familiar with the
vs during the day, they have been known
eir VDUs at night. There are actually
etween a daylight and a moonlit scene,
acting like a photographer's bounce
reflecting the sun's light to earth.

color, the light it reflects is actually
n's, which might seem a little
oon's light as blue comes from
eyes adapt to low light
the moon's light as this color,
would be strange to use anything but this color of
light when representing it.

Looking at its color shifts more closely, moonlight does actually
change from an orange-beige color to a pale blue color as it
approaches its highest point in the sky. Night time scenes can

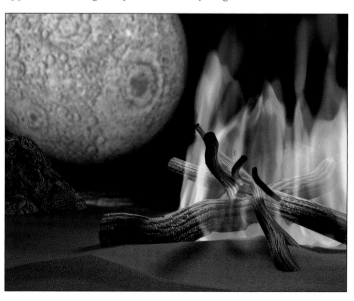

Figure 8.08
Our perception of the moon's light
as blue is due to the way our eyes
work in low light conditions

actually be much simpler to light than daytime ones, because there is less light bouncing off the objects in your environment. Its light can cast shadows in the same way that sunlight can, though these are generally far less defined and can be made less obvious by the presence of artificial street lighting, which can become the dominant light source in a scene. It is only when street lighting is introduced to a night time scene that it actually becomes as challenging as setting up a scene lit by daylight.

In cinematography, there are two main methods of simulating moonlight. The first and more common method is to use a white key light along with blue fills, the second and older method is to light the scene normally and fit a blue filter to the camera. As long as the highlights that fall on the shot's objects do not become too blue and remain a whitish color, this produces a very convincing night shot, despite this method - and indeed the first too - being far removed from actual night time lighting.

The best strategy for CG is to make the moonlight a realistic color - between the orange-beige and pale blue colors already mentioned - and adjust the specular color component of individual materials should the highlights start to look unrealistically blue. Blue fill lights are used to cheat in some illumination where darkness is needed, but actual darkness would result in too little visibility. The blue color provides some illumination, but does not break the illusion of darkness because of the way that our eyes adjust to low light situations.

Blue light actually strengthens the illusion in some cases, because of the way that it desaturates human skin tones. As our eyes adjust to the dark, the cones that pick up color information

Figure 8.09
Blue fill is used to simulate moonlight in CG

Image courtesy of:
Bastien Charrier
bast1@free.fr

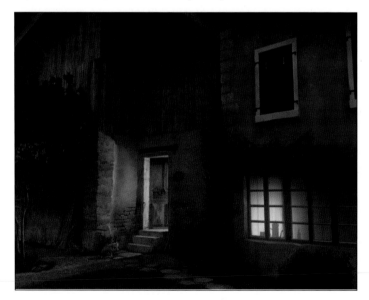

become far less sensitive than the rods that sense brightness. Our vision of a dimly lit situation is very murky: we can make out dark shapes, but not colors.

This explains why the blue light looks convincing against skin tones, suggesting a further approach to producing convincing night time scenes that aren't too underexposed to make out: using desaturation. Simply adjusting your colors in the scene's materials to be less saturated can make a big difference to the realism of a night scene, as everything can be made out in terms of its shape, but not really its color, which is an exact match for our perception of such situations.

Tutorial - moonlight

In this tutorial you will learn how to set up a moonlit scene. This will involve first placing a key light acting as the moon, before adding blue fill light selectively to bring out detail in the shadows.

Open the C8-03.max file from the tutorials folder of the CD. You will see a beach scene, with an overlarge full moon in the background, which is also extremely low in the sky. You already know that the moon's color is an orange-beige when it's low in the sky, so we'll begin by creating this, our key light, which will be a spotlight targeted towards the beach.

In the top view, place this light roughly in the center of the moon object, using the Align tool to center this light on the moon object in all three axes and its target on the beach object. Rename this light *SpotMoonKey* and adjust its Hotspot to fit over the whole

Figure 8.10
Place the first light roughly in the center of the moon object

beach, which should be a value of around 35. Turn on Cast Shadows, and give the light a color of around R:250, G:230, B:200 and a Multiplier value of 1.0. Clone a copy of this light to double the illumination and rename this light *SpotMoonWater*.

If you render now, you're getting some foreground illumination and highlights on the water, but no actual illumination of the moon itself, so before we go any further let's sort that out. This we can do by adding a spotlight that just lights up the moon object. Place your spotlight to the right-hand side of the beach object from the point of view of the camera, and target it roughly at the moon.

Again using the Align tool, center this new target object on the moon in all three axes. Back in the light itself, use the Include function and select only the moon object, before renaming this light *SpotMoonOnly*. Shadows for this light can be turned off, its color should be the same as the last light's, its Multiplier set to 1.0 and the Hotspot should be adjusted to just fit the moon: around 30 should do it. Now if you render, the moon looks nicely lit and its reflection on the water is also now visible.

However, there's a problem already in that the reflections look unrealistically bright, so Exclude the water object from the *SpotMoonKey* light. Leave the Multiplier of this light as 1.0, but change the *SpotMoonWater* light's Multiplier to 0.5, leaving its shadows turned on. Now the reflections have a more varied appearance with the addition of some brighter highlights.

The shadows from the moon would be nice and soft, so for the two shadow casting lights increase the Sample Rate within the Shadow Map Parameters. This determines how much area within

Figure 8.11
Scaling a fill light to fit the space

Figure 8.12
With the blue light added, our dark corners are subtly illuminated

the shadow is blurred and averaged, affecting how soft the edge of the shadow will be. A value of around 10 will give us a suitably gentle shadow, and because increasing this value blurs the shadow map, we can get away with using a smaller shadow map than usual. The default value of 512 will work just fine here, which is less than would usually be needed in this scene for sharper shadows.

Looking at the rendered image now, the sky, moon and water looks fine, but the foreground is somewhat lacking. The lack of illumination looks realistic, but without this any detail in this area is lost. The answer is to cheat some light in using blue fill light. We'll use an omni light again, using a useful trick to stretch its illumination unevenly to illuminate the rocky area to the right, immediately in front of the camera. First, in the top view, place an omni light roughly in the middle of the rocks and towards the camera, then move it up in the Left viewport, around 55 units.

Turn on the Far Attenuation and set the Start and End values to 75 and 150 respectively. As the light stands, its Attenuation is completely spherical. Using the Non-uniform Scale tool, scale the light down to 50% along its local Z axis so the Near Attenuation does not reach the floor and scale again by 160% along the light's X axis and 80% along the Y, so that the illumination stretches along the rocks. You can now move, rotate and continue to scale the light so that it illuminates the area around these rocks very subtly, just bringing in a small amount of detail. (This is aided by turning the light's Multiplier value up to 1.0 or more, so that its effect can be seen in the shaded Camera viewport.) With a pure blue color, the desired amount of illumination should lie somewhere around the 0.25 Multiplier level.

You might by now have noticed that the water's antialiasing looks a little poor, so in the Material Editor turn Sampling on in the SuperSampling rollout. This might up the render time by a significant amount, but for some materials anything less than this standard would just not be good enough for final output.

Streetlighting

Streetlights are not all that difficult to produce following the tutorials you've done so far. Most streetlights use sodium, which appears to have a yellow-orange tint to it to the naked eye, as driving down the freeway at night will confirm. Streetlights are illuminating a larger space remember, so their falloff will often be pretty visible. Their cones of light can also be quite visible too, especially on foggy or misty nights, so if this is the look you're after, introduce some volumetric fog to bring out these hazy cones of illumination.

We'll look at how fog is created more extensively in chapter 11. Just as with faking global illumination indoors, streetlights that cast light onto large brightly colored objects should be dealt with in the same way, by placing a second light acting as the reflected light, with the color of the light matched to the object, and the shadows and specular illumination component turned off within the new light's controls.

The bright sources that outdoor lighting features can make for a rendering that has way too much contrast. Without modification, a scene lit by streetlights will have very dark areas and extremely light areas, which won't look realistic. Blue fill lights employed to counter this problem complement the way that

Figure 8.13
Streetlighting can be quite visible

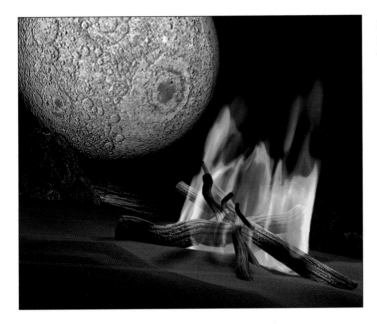

Figure 8.14
Framing and composition can be
very effective in night shots

our eyes work in low light situations, which is why this method
looks so convincing. Indeed, there are few situations that allow
for such atmospheric results as those set at night, as the artist has
both extremes of darkness and light to work between. For this
reason, night shots can be brooding and atmospheric, as in the
film noir look of the 1940s, which often employed low-key
lighting to emphasize the contrast between light and dark.

Alternatively they can be vivid and bright, depending on their
treatment. With darkness available to emphasize any lit
foreground elements, framing and composition can be very
effective in night shots. Increasing the amount of practical lighting
in a scene is one way to open up the darkness without breaking
the illusion that this is a night time shot, if this is what's desired.
Knowing how to design the many outdoor lighting sources, from
warm yellow colored streetlights to highly colorful neon signs, is a
very desirable skill in giving a night scene the atmosphere and
look that it requires, as well as lighting the all-important
foreground elements.

Tutorial - outdoor lighting fixtures

In this tutorial you will learn how to set up a scene involving a
small outdoor lighting fixture of the type used at floor level,
typically to illuminate paths in outdoor spaces. This unit has its
light behind opaque frosted glass, which we'll use to demonstrate
translucency, a technique that's applicable to many situations.
This will involve first setting up the unit's lights and exploring the
raytrace material's properties to get the right effect.

Open the C8-04.max file from the tutorials folder of the CD. You will see a cylindrical lighting fixture with glass panels. Your first job is to place the lights that will represent the actual bulb within this fixture. Place an omni light in the center of the fixture (which is at X:0, Y:0, Z:0.05) and give it a color of R:220, G:200, B:210. Set its Multiplier to 2.0, turn on shadow casting and change the shadow type to Ray Traced. Now turn on the light's Far Attenuation and set the Start and End values to 0.1m and 0.5m.

If you render now, you won't see anything, because the glass material for the lamp has not been set up yet. To do this, in a blank slot in the Material Editor, hit the Standard Material type swatch and select a Raytrace material. Change the Shading to Blinn, check the two-sided box and give the Diffuse color value a slight tint of yellow, say R:255, G:255, B:240. Give the Transparency color a light gray tone, around R:200, G:200, B:200 (it is this value that gives the glass its opacity, so play around with this value if you desire) and change the IOR (Index of Refraction) value to 1.5 to represent glass. Finally, alter the Specular Level to 20 and the Glossiness to 0 and apply this to the *FloorLightGlass* object.

Figure 8.15

Giving the glass a transparency color value makes it look very real

Now if you render, you should see that shadows are cast through this material, but the glass does not appear to glow as it should. In the Extended Parameters rollout, click the Translucency color swatch and enter a very light yellow-green value, of about R:240, G:240, B:210. Rendering now will reveal the glass looking much more realistic, with the light source inside actually looking very much like a real bulb would from the outside.

To reinforce this effect, create another omni light at the same point in space to represent the bulb itself. This should have the same parameters as the last omni, apart from the color, which should be a pure white and the Far Attenuation, which should be far smaller. Set the Start value to line up with the outside of the glass component and the End value to around 0.06m.

Rendering now will reveal that these two lights are a little too intense, so halve their Multiplier values and render again. The light should now look like it's being diffused correctly within the fixture. However, the lighting is far from right, the shadows around the base of the light are way too dark, so to open these up a little, create a Free Direct light at X:0, Y:0, Z:0.1, pointing straight down. Give this a light yellow-green tint (around R:240, G:240, B:220) and a Multiplier of 0.25. The Hotspot and Falloff values should be set to 0.05m and 0.25m respectively and its Specular component should be turned off. Finally, turn this light's shadows off.

At this point you might see a small problem with this set-up; there appears to a gap under the three vertical ribs of the light, where light can be seen sneaking through. The problem is not the geometry, but the two ray traced omni lights.

Figure 8.16
The bias control allows you to move shadows towards an object

The bias control in a light's Shadow Parameters rollout allows you to move the shadow toward or away from the shadow-casting object. If the Bias value is too low, shadows can 'leak' through places they shouldn't, produce moiré patterns or making out-of-place dark areas on meshes. If Bias is too high, shadows can appear detached from an object, as in this case. To see this happen in an exaggerated fashion, change the Bias control to 0.5 and render again. The shadows now look very disconnected. Change this to 0.15 and the shadows meet the base of the light correctly.

This technique of creating translucency is applicable in many situations, from glowing lampshades to paper lanterns and lampshades; even candles exhibit this kind of behavior. For example, to change the glass's current semi-opaque look to more of an obvious frosted effect; you only need to add some Bump. Add a Noise map in the Bump channel, changing its type to Fractal and its Size to 0.1. Now if you turn on SuperSampling in the Basic Parameters rollout of the topmost level and render, the glass looks very bumpy, similar to shower door material.

Figure 8.17
Add some bump to give the glass a frosted appearance

Tutorial - streetlighting

In this tutorial you will learn how to set up a complex streetlight scene. This will involve several different types of lighting, from regular streetlights to fluorescent tubes and light bulbs.

Open the C8-05.max file from the tutorials folder of the CD. You will see the front of a cinema, with various physical light fittings, from lampposts on either side to neon signs on the front of the building.

Your first job will be to use the two lamppost fixtures to give the whole scene some general illumination. Create an omni light and use the Align function to center this on the spherical part of the fixture to the left of the cinema lobby. Now copy an Instance of this light and center this one on the other lamppost fixture. Rename these lights *OmniStreetL* and *OmniStreetR* and with either of the lights selected give the light color a pale yellow-orange tint so it resembles a sodium-based streetlight at night – around R:255, G:250, B:210. Set the Multiplier to 1.0 and in the Decay rollout, set the Type to Inverse Square and give this a Start value of 5.0.

Turn the shadows on for these lights, render and you'll see that the shadows that do form are in the area underneath the lobby that is going to become illuminated quite strongly from the lights set into the ceiling. Turn off the shadows for the moment and you should find that your results look quite good in terms of the scale of the illumination that these lights are casting. This is an important factor when lighting outdoor scenes and it's here where using Inverse Square decay really makes a difference, even if you

Figure 8.18
Creating lampposts is the first job

have to cheat where the decay begins. The pools of light on the floor and walls look correct, but several things don't. First the spherical shade needs to be self-illuminated, so in the Material Editor, check the Color box in the Self-Illumination section of the *LightShade* material and drag the diffuse color to the Self-Illumination swatch.

Render again. You should see that the light shades now look correct and that the lights that are located in the ceiling of the lobby are also now visible, because they share the same material. What you see is just the self-illuminated geometry of the fixtures, and your next task is to furnish these 181 items with a light source. In the Top viewport, zoom in on the bottom left circular ceiling light and then click to create a Free Spot somewhere nearby in this viewport. Now using the Align function, center this spotlight on the actual circular fixture in the X, Y and Z axes. In the light's parameters, set the Multiplier value to 0.5, giving the light a similar yellow-orange tint to the previous ones. Again, set the Decay to Inverse Square, setting the Start value at 2.5.

Finally, set the Hotspot and Falloff values to 40 and 80 respectively and render again. You should hopefully see a pool of light on the floor that looks subtler than the streetlights. With this light still selected, hit the Array button and enter a value of 1.0m in the top-left (Incremental X Move) box and check the Instance box. Now enter 23 in the 1D Count field, check the 2D box and enter 11 in the adjacent Count field and 1.0m in the Y field. This should give you a total number of 253. If it does, hit the OK button.

Now you need to delete the unneeded lights from the top left and right corners of this grid of lights, as well as from over the ticket

Figure 8.19
With your lights looking right, your next job is the ceiling lights

booth. Delete the corner light, then the next five diagonal rows of lights (you should delete 21 from each corner leaving a total of 211). Now delete the 30 lights that fall over the top of the ticket booth to leave 181 lights.

Rendering now should show you that a Multiplier value of 0.5 is too high, as the pool of light is way too bright. Changing the Multiplier value of any one of these lights to 0.15 will produce a more realistic result. It will also up your render time by a comparatively large amount, so turn on Far Attenuation by checking the Use box and setting the Start and End values to 6.0 and

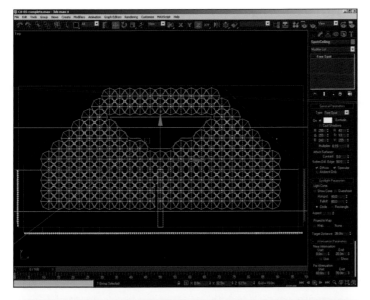

Figure 8.20
Your array should look like this

Figure 8.21
With the ceiling lights in place

7.0m, just beyond the sidewalk that these lights are illuminating. The Inverse Square decay method never actually reduces to zero, so it's a good idea to turn this on for any light using this decay method. Do just this for one of the Omnis you created before, using values of 25 and 30m. This should chop 20-25% off your rendering time. Now that you have the ceiling lights looking good, select all 181 of them and Group them together as *SpotsCeiling*.

Next we need some fill light, and so presuming that the moon would be providing this, create a Target Direct light, located around X:–20, Y:–25, Z:25, with its target at X:–5, Y:0, Z:10.

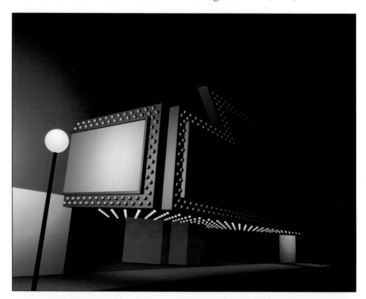

Figure 8.22
The color of the moon's light contrasts with the lights used so far

Figure 8.23
Add a subtle volumetric effect

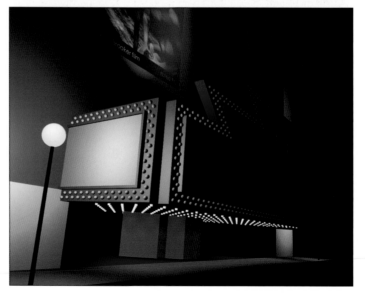

Rename it *TargetMoon*. Give it a pale blue color, which is typical of the moon when it's high in the sky. This color of light will also contrast with the yellow-orange we've been using so far. Set the Multiplier value to 0.2, set the Hotspot and Falloff to about 14 and 20m, changing the light to a Rectangle by checking the appropriate radio button. If you now right-click a viewport's label and change this view to that of this light, you will see that the light is positioned as well as it could be to illuminate the building. Lowering the light's Aspect Ratio spreads the illumination to cover more of the top and bottom of the building (you should find that about 0.8 is perfect). Finally, using the Truck Light tool, located at the very bottom right section of the screen, position the light to best illuminate the building as seen through the camera. Turn on Far Attenuation, setting the Start and End values to 40 and 50m respectively. Leave shadows turned off and make sure the Specular component is turned on. If you render again, you should see that the fill just brings out the front section of the building slightly.

You should now be able to see more clearly that there is a large billboard located above the lobby. There are in fact two, located either side of the central vertical sign. This would normally be lit using one or more spotlights, in this case located on the roof of the cantilevered section of the building. In the Top viewport, drag to create a Target Spot and position the light itself at X:–10, Y:–5, Z:6.5, aligning the target object centrally on the billboard in the X and Y axes with a Z value of 15.

Set the light's Multiplier to 1.0 and give it a pale yellow color, giving the Hotspot and Falloff fields values of 30 and 45 respectively. Turn on Far Attenuation and set its Start and End values to 10 and 25m before renaming it *SpotBillboardL*. Once satisfied, you should open the Rendering > Environment dialog ready to give this spot a subtle volumetric light.

In the Atmosphere rollout, click the Add... button to add a Volume Light. Change the rightmost Attenuation Color to a yellow and check the Use Attenuation Color box. Set the Density to 3.0, the Start and End values for the Attenuation to 50 and 100 respectively, and leave everything else as it is.

Now all that remains is to clone an Instance of this light, and with both the light and its target object selected, use the Align tool to center this selection on the right-hand billboard. This way, the light is automatically added to the Volume Light atmospheric effect that you just created. Render again and see that you now have two volumetric cones of light visible.

Back in the Material Editor, drag the diffuse color of the *NeonBlue* material to the Self-Illumination swatch and render again. You will now see that the vertical lettering is visible, and though again

Figure 8.24

Setting up the neon lighting

the results aren't bad, what you are seeing is nothing more than self-illuminated geometry. We'll take a more in-depth look at neon lighting next chapter, but for the moment, here's a quick taster of how to set up this type of lighting.

In the Material Editor, in the horizontal row of buttons, find the Material Effects Channel value and change this from 0 to 1. Close the Material Editor and choose Rendering > Effects, adding a Lens Effect by using the Add... button. Down in the Lens Effects Parameters rollout, select Glow and hit the > button. In the Glow Element rollout, select the Options tab and check the Effects ID box. This tells max to apply a glow to any material with an Effects ID of 1, which is what you just gave to the *NeonBlue* material.

Back at the top of the dialog, check the Interactive box and once the first render is complete you're free to play around with most of the values without causing a whole new render. In the Parameters tab, changing the leftmost Radial Color value to match the material's blue and giving the right-hand swatch a white color should be your first alteration. Then, with the Size set to 2.0 and the Intensity set to 80, you should have a pretty good neon glow. We'll look at this in more detail next chapter. For the moment, turn off Interactive for this effect before closing the dialog.

Repeat this process, creating a subtle glow for the *LightShade* material. You'll need to specify a different Material Effects Channel value in the Material Editor, then add another Glow Lens Effect and change the Effects ID box to match this value. This will apply itself to the ceiling lights as well as the lampposts, as both of these items share the same material.

Once you're finished, back in the Material Editor, drag the Diffuse color swatch of the *YellowBulbs* material to the Self-Illumination swatch, and repeat this also for the *WhiteSign* material. Another render will show the main backlit sign and the array of yellow bulbs around it now self-illuminated. Apply glows to these two materials in the same way, changing the parameters for each light within the Glow Element rollout, not the Lens Effects Global rollout, which you should leave untouched. These glows do a pretty good job of representing the illumination from these materials, but don't of course really illuminate the surfaces around them.

This level of detail might be sufficient for some purposes, but to make the scene more convincing, you'd need to set up some further lights to represent the illumination from the white backlit sign and the yellow bulbs, as well as some bounced indirect illumination. Start with this, which you should be pretty familiar with, as it's been covered in previous tutorials. Create a blue spotlight representing the reflected blue light from the back wall behind the ticket booth. Position this behind the wall, give it a blue tint, turn off the Specular component and use the Exclude feature to omit the wall it's located behind - *BuildingMassLow* - from the light's illumination

Also place a red spot representing the light bouncing up off the lobby carpet onto the walls around it. This is best done using several rectangular Target Spots placed underneath the *LobbyCarpet*, with just the *LobbyWallsInterior* and *TicketBooth* objects included in the illumination. Take this as far as you want to go, but the interior illumination should look pretty good with just these two extra lights.

Figure 8.25
A red spot placed under the lobby carpet acts as a bounce light

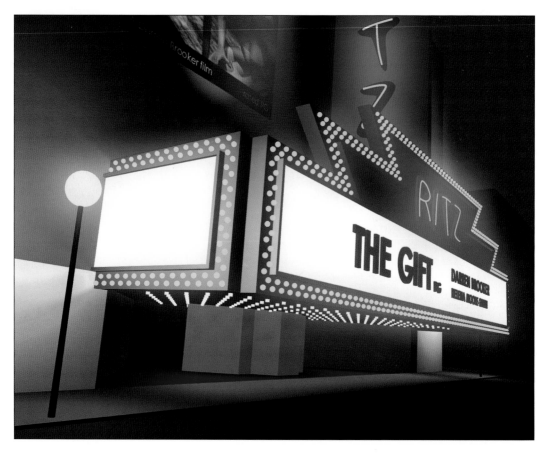

Figure 8.26

Color, volume light, glows and decay all contribute to the scale

For the exterior, place a yellow spotlight in the Front viewport pointing from the topmost set of yellow lights along to the left. Give this light a pure yellow color, a Multiplier of 1.0, set its Hotspot and Falloff to a suitable value – around 30 and 45 should do it – and set the Decay to Inverse Square, starting at 3.0m. Finally, the Far Attenuation should be set to Start and End at 3 and 5m. Position this so that the yellow illumination runs down the wall starting at the bulbs and once you've done this satisfactorily, Clone an Instance and place this vertically below, alongside the bottommost row of yellow lights. Now you need to do the same thing again, this time creating a white Target Spot placed to represent the light that would come from the white backlit sign where it's located against the wall.

That should about do it, because now we're just covering old ground, which is not really the point of this tutorial. What you should take note of from this section is how color, volume light effects, subtle glows and Inverse Square decay can be used to give streetlighting the scale and feel of actual outdoor light fixtures, as seen by the human eye.

9

'To them, I said, the truth would be literally nothing but the shadows of the images.'

Plato's *Republic*

Specific lighting problems

This chapter is dedicated to special lighting problems that are more difficult to solve, requiring slightly different techniques to those covered so far or their extended application. As such, it consists mainly of tutorials that will introduce procedures that once understood can be applied elsewhere and added to your general armory of lighting tricks and techniques.

However, this chapter does not aim to cover exhaustively every special case that you might encounter. Instead, it takes a select few examples and examines each one in close detail, so that you can learn from these lessons how specific tasks are approached and hopefully then have a better idea of how to begin on similar problems. For example, the lighting of an underwater scene is covered, which could also easily be applied to the task of setting up the lighting for an extremely foggy scene. Hopefully these few examples will illustrate how to approach similar related problems within your own particular production environment.

Image courtesy of:
© Brian Taylor 2001, 2002
www.rustboy.com

Tutorial - neon lighting

In this tutorial you will look at the process of producing realistic neon lighting. You'll start by designing neon materials in the Material Editor, where you'll also apply Material Effects IDs that will link these materials to max's Rendering Effects, where you'll apply glow, before animating the material to flicker on and off.

Open the C9-01.max file from the tutorials folder of the CD. You will see the basic geometry for a sign with three different neon strips. The first thing we'll do is to set up the materials that will represent the neon in its various states. First, the least exciting: an unlit neon tube. In an unused slot, change the Ambient color swatch to a mid-gray somewhere around R:150, G:150, B:150 and then drag this color to the Diffuse slot below, choosing Copy when prompted. The Specular slot should already be set at R:229, G:229, B:229. If it's vastly different change it.

Set the material to two-sided, and bring the Specular Level up around the 80 mark and the Glossiness spinner to around 70 to give some fairly tight highlights. Finally, set the Self-Illumination to 75 and the Opacity to 25 before renaming the material *NeonWhiteUnlit*. To the right of where you typed this, hit the Material Type button labeled Standard and choose a Blend material, opting to keep the old material as a sub-material. Change the name at this level to *NeonWhite*. Change the Mix Amount to 100 before clicking the Material 2 button to enter this material.

First of all, rename this *NeonWhiteLit*, and then change its Ambient and Diffuse swatches to pure white. With the Self-Illumination and Opacity both set to 100, go back up a level. If you now change the value of the Mix Amount spinner, you will see the material between its two sub-materials. This will be the value we'll animate to make the neon flicker, but for the moment set it back to 100. Finally, change the Material Effects Channel value (in the row of icons directly under the sample spheres) from 0 to 1.

You should now repeat these steps, making two other colors of neon. The easiest way to do this is to drag your *NeonWhite* material to another slot and change the Ambient and Diffuse color swatches within Material 2 to a bright color of your choice. (Don't forget to rename the material at its different levels to reflect the new color change.) At the very top level of the material, alter the Material Effects Channel value of these two new colored versions to 2 and 3. You will also want to check the Interactive radio button next to the lit material, rather than the unlit version.

Now apply these three materials as you want to the three neon objects in the scene *SignNeonArrows*, *SignNeonLettering* and *SignNeonOuter*. A quick render should now reveal that the tubes look pretty good but far from perfect: they are not bright enough

Figure 9.01
Your first render will reveal far
from perfect results

Figure 9.02
Merging a lighting array will give
the lighting some variation

and the reflections in the chrome portion of the sign look aliased,
but there's not even any lighting in the scene yet! Let's turn this
on. Unhide the four spotlight objects and turn any one of them
on, they are instanced copies so any one will do.

For our fill lighting, we're going to bring in a lighting array from
a separate file. From the File menu, choose Merge and select the
C9-array.max. This consists of lots of different colored lights all
targeted at one central helper object, so should give us some
interesting variations in the lighting and in particular the
highlights on the chrome sign.

Now for the glows, which are applied in Rendering > Effects. From the resultant dialog, add a Lens Effect. Now from the Lens Effect Parameters list, specify a Glow, click the arrow pointing right and check the Interactive checkbox. (At this point max will go away and render out a frame, but once this has been done, the effect will be displayed so that it can be altered interactively.)

Now, down in the Glow Element rollout, within the Options tab, check the Effects ID box and in the Image Filters section, deselect All and check only Edge. Back in the Parameters tab, set the Size to 2.0, the Intensity to 125. Finally, alter the Radial Color swatches so that the Center Color is a pure white and the Edge Color is a much vivid green.

You should now repeat this process for the different neon elements, remembering to change the Effects ID. You should find that for the *NeonLettering* element a larger glow Size is needed and for the *NeonArrow* object, a smaller glow Size along with a lesser Intensity value. As always, there's a finished version of this tutorial alongside the original one, if you want to see how your finished results compare.

We're not finished yet, however, there's still the small matter of animating the neon sign to flicker on and off. Open up the Track View and expand the branches down from Scene Materials to the MixAmount track for the material that you've assigned to the neon lettering. Display the track as a curve by clicking the Function Curves button and using the Add Keys button, add ten or so keys randomly along the line that runs straight through 100%. Right-click the first one and change this to Time 0, Value 100 and alter the In and Out Tangent Types to step. Cycle forward

Figure 9.03

Changing the glow in Track View to reflect the flickering neon material

to the next key and change this Time 4, Value 0, then the next one to Time 5, Value 100; then Time 8, Value 0; Time 9, Value 100; Time 14, Value 0; and finally Time 15, Value 0. For each of these keys you should also set the In and Out Tangent Types to Step. You should now press the Parameter Curves Out-of-Range Types and select Loop to continue this flickering across the full 100 frames of the animation.

The relevant Glow also needs to be changed in Track View to reflect this flickering. You should change the Intensity value of the corresponding Lens Effect to match these values you've just entered. Use the same time values, lowering the Glow's intensity to 50 rather than 0, with the same Stepped In and Out Tangent Types. Be sure to set the Parameter Curves Out-of-Range Types to Loop once more.

And there you have it, realistic flickering neon lighting. There's one thing that you might want to do before leaving your machine to render out this sequence, and that's turn on Super Sampling for the *ChromeLettering* material. Without it the reflections of the neon lettering will be somewhat aliased and jagged.

Animated materials

When designing complex animated materials like this caustic effect, it's often a good idea to use the Material Editor to render a preview of the material before committing to a full render. In 3ds max, to the right of the sample slots, the Make Preview button lets you preview the effect of an animated map on the object in a sample slot.

Figure 9.04
Your finished neon material

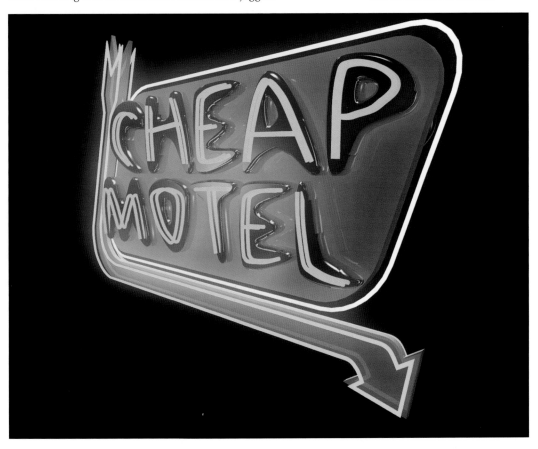

Tutorial - underwater lighting

In this tutorial you will look at the unique lighting challenge thrown up by the illumination of an underwater scene. This more than most other lighting tasks can be approached in several ways. We'll use volume lighting, depth-of-field and projector maps to create a realistic and atmospheric underwater environment.

Open the C9-02.max file from the tutorials folder of the CD. You will see above and below the camera the surface of the water and the seabed represented by two planes. First, we should give the water's surface some movement using a Noise modifier. Select the *WaterSurface* object and add a Noise modifier, setting its scale to 1,000 and the Strength to 10, 10 and 2 for X, Y and Z respectively. Check the Animate Noise checkbox and set the Frequency to 0.08.

For the water's material, set up the Ambient, Diffuse and Specular colors within a new slot to be R:7, G:16, B:27; R:50, G:120, B:200; and R:235, G:244, B:255 respectively. Rename this material *WaterSurface* and make this a two-sided material with a Specular Level of 150 and a Glossiness of 30. Set the Self-Illumination to Color and select a value of R:19, G:29, B:42. In the Bump channel, choose a Noise map, which should be Fractal, with a size of 75. Go to frame 100, hit Animate and change the Phase to 120. Turn off Animate and in Track View, expand Scene Materials > *WaterSurface* > Bump (Noise) > Phase and select this track, setting the Parameter Curve Out-of-Range Type to Relative Repeat.

For the sun, we'll use a pure white omni light positioned at X:0, Y:60, Z:15. Give this a Multiplier value of 0.7, leave shadows turned off and turn the Far Attenuation on using 60 and 90 as the

Figure 9.05
Simple fog adds a great deal of realism to the underwater scene

Figure 9.06
Caustics are created using a
cellular map as a cookie

Start and End values. Rename this *OmniSun*. If you render now,
you should have a nice gentle falloff of light for the seabed, but
no illumination of the water. To fix this, create another omni light
renamed *OmniWater*. This should have a tint of R:220, G:240,
B:255 and should not cast shadows. A Multiplier value of 1.0
should look about right. The positioning of this light is very
important to achieve the right highlights on the water's surface.
Somewhere around X:0, Y:180, Z:–120 should do the trick.

In Rendering > Environment, add a Fog effect. Set the color to
R:50, G:80, B:110 and check both the Fog Background and
Exponential options. Rendering with this effect on and off, you
should see the depth that this adds. Create one further omni light,
acting as a local fill. This should be placed at the same position as
the camera, X:0, Y:0, Z:1.25, and given a color of R:150, G:180,
B:200. Give it a Multiplier value of 1.0 and turn off its Specular
component by clearing the Specular checkbox. Finally, turn its Far
Attenuation on, setting 15 and 20 as the Near and Far values.

Next we'll create some fake caustic effects. Create a Free Direct
light pointing straight down in the Top viewport and make it a
rectangular light, whose Hotspot and Falloff fits just within the
water and seabed objects - 85 and 95 should do it. Give it a pure
white color, a Multiplier of 1.0 and turn off shadow casting. Click
the light's Projector Map button and pick Cellular. Now drag this
swatch onto a blank slot of the Material Editor, renaming it
WaterCaustic. Click the Cell Color and set it to a pure black.

Set the top and bottom Division Color values to R:130, G:190, B:255
and R:240, G:255, B:255 respectively. In the Cell
Characteristics section, select Chips and Fractal. Set the Size to 300,

the Spread to 0.3, and the Iterations to 5.0. In the Division Colors section, set the topmost swatch to a less saturated version of the *WaterSurface* material's Diffuse swatch and set the bottom to match the Specular swatch - R:120, G:170, B:220 and R:235, G:245, B:255 respectively. Finally, within the light itself, Exclude the *WaterSurface* object from the light's illumination and shadow casting. At frame 100, hit Animate and change the material's Z coordinate value to 250. Turn off Animate and in Track View, expand this track - *DirectCaustic* > Object > Projection Map > Coordinates > Offset - and change the In and Out Interpolations to Linear and set the Parameter Curve Out-of-Range Type to Relative Repeat.

Figure 9.07
Animating your caustic material

Figure 9.08
The caustic light should project moving patterns across the sea bed

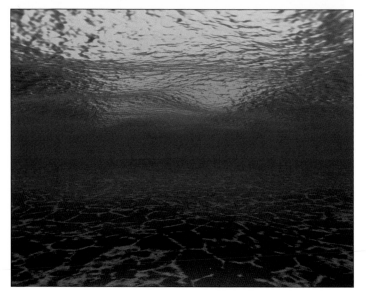

To create some shafts of light coming through the water towards the camera, create a Target Direct light, with a color value of R:210, G:230, B:240 and a Multiplier value of 1.0. Its Hotspot and Falloff should be set to 2.0 and 4.0, its shadows should be turned off and its Far Attenuation should be turned on and set to 14 and 25. The positioning of this light is important, it should be pointing directly into the camera from level with the water's surface. If the light is placed at X:0, Y:21.5, Z:6 and its target object at X: 0, Y:9, Z:0, the effect should be about right.

Back in Rendering > Environment, add a Volume Light and pick the direct light you've just created, which you should rename *DirectSunRays*. Set the Density to 1.0, with Maximum and Minimum Light values of 90% and 0% respectively. Turn on Exponential, set the Fog Color to R:200, G:220, B:235 and the Attenuation Color to R:0, G:0, B:160. Set the Attenuation Start and End values to 100% and 85%. Finally, turn on Noise, setting the Amount to 1.0, the Uniformity to 0.3 and the Type to Fractal. With the Levels set to 2.0 and the Size set to 4.0, you're all ready to render again. The speed of your render will now have gone up quite considerably, but the effect is worth the effort. One last thing that you might want to consider using is a softer antialiasing filter than the one max defaults to. The Soften filter applies a Gaussian blur to the finished frame, which can suit misty or hazy effects, such as in this case. A filter that simply blurs the image might not sound all that desirable at first, and though it might not look it upon examining a single still image, when applied to an animation can create a subtle softness that helps remove just a little bit more of the CG edge. For a further discussion of antialiasing and supersampling techniques, take a look at chapter 16.

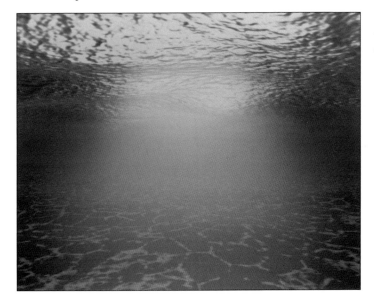

Figure 9.09
Your finished image should have a very soft and hazy feel

Tutorial - fluorescence

In this tutorial you will look at the way in which fluorescence can be simulated using max's raytrace material. This we see in our everyday lives as watch hands that glow in the dark, because they're painted with fluorescent paints, but can also be useful in sci-fi scenes, or in deep-sea scenes featuring phosphorescent fish.

Open the C9-03.max file from the tutorials folder of the CD. You will see a clock face, to which you will apply a raytrace material, which has a control that uses pure white light to illuminate the

Figure 9.10
Knowing the raytrace material's many properties can be rewarding

Figure 9.11
Fluorescence could also be used for deep-sea fish

material. This makes the material look as if it's glowing by itself, and is an effect that looks at its strongest when the lighting conditions in a scene are colored to contrast with the fluorescent material's color.

To build this material, click in an unused slot in the Material Editor and hit the Standard swatch to change the Material Type to Raytrace. Change the Diffuse color to a very vivid light green, say R:200, G:250, B:125. Drag this color to copy it to the Ambient color and then click this swatch, increasing its Value slider to around half way. Drag a copy of the Diffuse color to the Specular color swatch too and change both the Specular Level and Glossiness spinners to 10. To make the material appear to glow, drag a copy of this color to the Fluorescence swatch, located within the Extended Parameters rollout.

Now, underneath this swatch is a spinner marked Fluorescence Bias, which changes the influence of the scene's lights on the material. At 0.5, the fluorescence behaves just like diffuse coloring, but as this value increases, so does the fluorescence effect, making the material brighter than other objects in the scene. Increase this to 1.0 and render at frame 0, then at regular intervals between frame 0 and 100. As you can see, the key light's intensity has been animated to fade to zero, yet the shading of the glowing elements does not alter.

10

'My name is Raquel Welch. I am here for visual effects and I have two of them.'

Raquel Welch: presenting the Academy Award for Best Visual Effects

Background plates

In visual effects, working with live-action footage and matte paintings is commonplace, and these elements are referred to as 'background plates' in the context of CG. The first step to working with a live-action plate involves digitizing the footage via a process called telecine, which at its most basic involves each frame being scanned and saved. However, during this process intricate color correction often takes place. This footage then forms the background plate on top of which CG elements are placed.

Once stored digitally, these plates can be viewed on the objects they are mapped to within the 3D application. If the plate is mapped to a rectangular object using coordinates that match the camera, then the view through your camera will have the plate visible, aligned and acting as the background. If shadows are to be cast from the CG lights and interact with the footage, then matte objects need to be placed to roughly match the scene's geometry, with their texture mapping set to match the camera too.

Image courtesy of:
Big Face Productions
www.big-face.com

If you are working with live-action footage, then the best time to start thinking about match lighting is not when it first appears in digital form, but actually before the shoot itself begins. Proper preparation for the shoot can save a lot of effort afterwards, and preferably every shot should also include a reference of the lighting using reference balls.

Lighting reference data

The balls generally used to record lighting data as a reference come in two types: a matte light gray color ball and a highly reflective ball. Though professional versions of these are of course available to purchase, you can of course make your own matte version using a polystyrene ball (available from certain art and craft stores) painted a 20% shade of gray with a matte finish.

This can then be placed on set and recorded using the same camera, preferably just before or after the filming of the shot so the light has not altered greatly. This should be scanned at the same time as the rest of the shot, and if color correction is being applied, then it should receive the identical treatment.

Following this, the image should be brought into a paint package like Photoshop or your 3D application, where its RGB values can be interrogated. These values can then be assigned to the lights in the 3D scene. Indeed, if the reference image is brought into your 3D application, then an equivalent sphere can be built in with the same 20% gray matte finish, and the task of lighting the scene then becomes a straightforward matter of matching the 3D ball to the one in the reference image.

Figure 10.01
Balls used to record lighting data as demonstrated by FrameStore

The job of gauging where any light sources are coming from in an image are best judged using the reflective ball. Cheap versions of these can be bought from some gardening stores and should be filmed in just the same way, using the same camera from the same position as the shot was taken from. A similar process can then be applied using this as a background plate and a mirror material applied to the sphere, which will help you to match the lights in terms of their direction and how highlights should be falling from the key light and any other bright sources. Using these methods you should at least be able to place your lights so that the highlights of at least the dominant light source fall correctly and are of the correct appearance.

Often, of course, you won't have access to any of this kind of data, you might not have even been on set, and all you have to go on is the footage itself. The shadows within the plate are the best guide to the direction of the dominant light source and objects that are either white or some shade of gray within this image can be interrogated for RGB values. However, if you can ensure that these two types of balls are filmed as part of the shoot, then the job is going to be a lot easier, and there's a second very useful way that the reflective ball image can be used. This image can subsequently be used as a reflection map for the scene's objects. Mapping this image flat onto the inside of a hemisphere within your 3D scene gives a quick method of getting accurate reflections. If the sphere is set to render reflections only, you should ensure that your reflections match the background plates perfectly.

HDRI

There's a second approach to using reflective balls as a way of gaining lighting data from a scene that is a relatively old technology that's only now starting to have an impact on CG. High Dynamic Range (HDR) images have seen a rebirth that has seen their application make it into the core LightWave software, as well as into third-party renderers such as finalRender. Expect to see this kind of technology included in other core 3D solutions in the next release or so, as this is a concept that's been around for a while and should be fairly easy to implement.

A HDR image is another phrase for an image stored in a non-clamped color format, which stores the real values of the Red, Green, Blue and Alpha channels. Rather than being represented by a single integer from 0 to 255, non-clamped color contains the value of each color as the renderer sees it, which provides far more accuracy.

HDR references are gained by shooting the reflective ball on location (again without moving the camera) at a range of exposure settings, exposing first for the brightest light source,

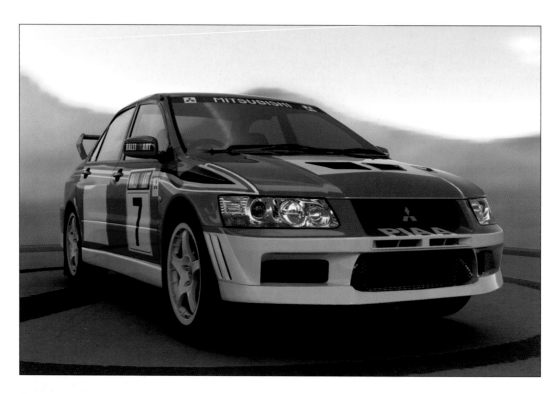

Figure 10.02
HDRI rendering (as produced in cebas' finalRender)

stepping down gradually to the least bright. From this series of images, the energy that each pixel carries is calculated, and it is this energy information that is used in the rendering. Another term you might hear for HDR is image-based lighting, which also describes the use of images as a replacement for light sources. Because of the range that can be seen in the different exposures in figure 10.03, the energy of a pixel can be cumulatively calculated.

A white pixel in a single RGB image could represent many things from a white wall to the sun itself, and these two items have very different energies. By looking at each of the images from the different exposure levels, an energy value can be built up which allows the renderer to know the difference between the different whites. A white pixel with a value of 300, for instance, would be a little beyond the range of the regular 0-255 RGB system, but if the software encountered a pixel with a value of 10,000, for example, it would assume that this did not belong to a surface in the scene, but to a sky or light source.

This series of images is then converted to spherical HDR images, which are also known as light probes or radiance maps, which are used as the sole light source for the 3D scene. Whilst this sounds superb, and the software vendors touting this feature will make it sound even more so, HDR imaging is not without its shortcomings. It's an incredibly processor intensive method of rendering and can often be quite tricky to use.

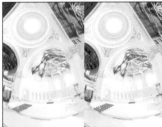
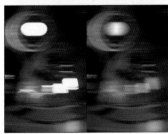

Figure 10.03
With pixels viewed as floating-point numbers, an HDR image can be darkened, lightened and even motion blurred more effectively than conventional 24-bit images. (HDR version right, 24-bit left)

Image courtesy of:
Paul Debevec
www.debevec.org

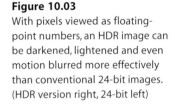

Light probe images

www.debevec.org is the best place to visit for more information about HDR imaging. As well as links to HDR software, there's also HDR images to download and Paul Debevec's excellent Fiat Lux animation. Additionally, you might want to check out CFC's Guinness Dream Club advert involving several computer-generated squirrels.

The extremes of energy values just discussed can happen between adjacent pixels and these neighboring pixels can sometimes have energy values of 10 and 10,000. This kind of contrast needs very intensive rendering, involving thousands of rays shot randomly into the scene, with the results from each of these rays bounced around and used to calculate the overall indirect illumination, which is why the process can be so slow. Generating the images themselves also requires some effort, particularly if you're working with film. Because these images need to capture all the information in the scene, the camera operator needs both to overexpose and underexpose in order to capture all the highlights and shadows at a mid-tone exposure level. This is easier said than done and bracketing widely is to be advised: shooting a few stops under the lowest exposure needed, which often means resorting to very slow film or expensive neutral density filters.

However, there's a wealth of information out there on the web - see the margin note - and this is a technology that can produce some stunning results, though its use within big Hollywood productions seems fairly limited: *X-Men the Movie* was the only big use of the technology from the many CG blockbusters of 2001 (the scene where Senator Kelly melts into a pool of water).

Match lighting in practice

When working on a production with a mixture of outdoor live-action footage and CG elements for professional broadcast, match lighting goes through many stages of development. The first time that the CG content is pulled together with the background plate little attention is generally paid to the lighting set-up. This is due to the fact that these initial renderings are not really looking at

lighting issues: they are generally concentrating on testing models and textures at this stage. Initial test renders of this type would typically feature a basic three-point lighting set-up, and even this might not be assembled with a huge amount of attention to detail.

These kinds of early studies are not even really intended to be an attempt at match lighting, so usually there wouldn't even be any shadows generated and the standard of the compositing work would be equally as basic. Once these early stages are out of the way, the lighting design begins in earnest, starting with the plate, which will first have been color corrected to achieve the desired aesthetic. If your plate was filmed from a fixed point, then the camera set-up in 3D is not going to be that difficult, but if your live-action sequence features a moving camera, this will need to be matched in your 3D application, as well as the creation of any 3D geometry that will be used as part of the set.

Given that all these tasks are complete, the lighting design would begin by examining the lighting references taken during the shoot. Normally this would begin with the key light, the dominant light source of the lighting scene. This is often all that would be used to light an outdoor shoot, possibly with the addition of some fill, provided either using lights or using simple bounce cards. However, as we already know, things are very different in the world of CG and it takes considerable effort to replicate the way the sun's illumination gets distributed around an environment.

The key light is placed by looking at the plate and attempting to determine where the dominant light is shining from. When doing this, it's not always that easy to place the key light accurately by looking at the plate alone, and this is where reference

Figure 10.04
The initial quick lit texture test

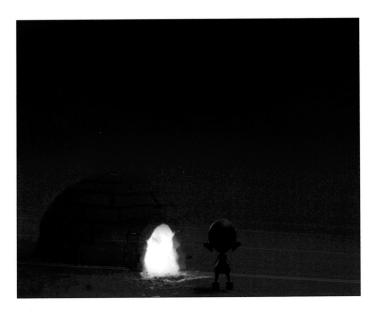

Figure 10.05
The complete lighting set-up without proper compositing

photography taken on location and any production notes are often invaluable. However, to be able to look at a single still of a person standing on set directly in front of the camera is often all you need to be able to place the key light precisely.

There are still occasions when production notes will need to be referred to, so when these are being compiled, ensure that they are clear and consistent. For instance, the dominant light's position should always be referred to from the point of view of the camera in terms of its position from left to right, but relative to the subject in terms of its position from front to back. For example, 'upper right, slightly forward' would be to the right and up from the camera, and slightly towards the camera from its subject.

Whilst reference photography and clear production notes can help to position a key light in 3D, there exists a fair margin of error to work within where the human eye will still perceive the results as being correct, so don't worry too much about positioning the key light or any that follow with exact precision.

It can be useful to reduce the shadow color from a pure black to a dark gray or increase the ambient lighting in order to get results that immediately begin to look more like global illumination, but care should be taken that the fill lights don't subsequently wash the contrast out from the shadows.

The next task would be to place the fill lights, starting with the most obvious bounced lighting, often referred to as the primary fill, which often will be the light reflected up off the floor, or from any walls or large elements within the environment. This will depend largely upon the angle of the key light and how it

hits the various surfaces on set. The secondary fill lights can be as few as you want to get away with or as many as you want, so long as the final rendering looks convincing. However many fill lights you decide to include, the only shadow casting light should really be the key light.

Whilst bounced light might produce subtle secondary shadows, the chances are that these shadows will be so extremely subtle as to be unnoticeable. Anything less than very subtle will look plainly wrong, and adding secondary shadows that have the right level of subtlety will in the vast majority of cases just add to render times unnecessarily. Often just a few extra fill lights will be enough to create a convincing match, with fills representing the light coming from the atmosphere, a left and right of camera fill light, and finally any lights representing bounced illumination, and you're about there.

A good practice to follow once the key and primary fill lights are set up can be to use a standard dome lighting array to represent the remaining secondary fill lighting. This would be the same as the one that you assembled in chapter 6, with two rows of eight lights and one further light at the dome's topmost point. The lights would then need to be tinted according to the color balance of the film stock that was used in the shoot. In this example we're presuming that this would be daylight-balanced film with a color temperature of 5,600 °K.

The bottommost row of eight lights would be set to match the color of the surrounding environment: representing the colors of the foliage, land, built elements and so on that border the scene. The other higher row of lights would be set according to the sky's

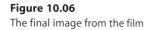

Figure 10.06
The final image from the film

color temperature: for example, these lights would be tinted with a hint of yellow if it were an overcast sky. However, if you were filming during early morning or late afternoon, they would be tinted slightly blue, due to the color temperature of this kind of sky being lower than that of the film stock. The topmost light would be given an almost pure white color representing the scattered light from the atmosphere.

None of these lights would be set to cast shadows and the bottom row would have an intensity of about half of the remainder of the lights. Finally, the intensities of each row should be made to increase in the portion of the sky directly opposite the sun, with a slight fall off occurring symmetrically across the dome towards the opposite side. Keeping a standard dome array set-up saved as a separate file and merged into each 3D scene before being tweaked to reflect the lighting in the plate is a good solution to finishing off a match lighting task.

The use of lighting arrays avoids a common pitfall of setting up fill lighting in a less organized manner: the gap in a lighting set-up that is often caused by the artist missing out the back lighting. To see whether a match lit rendering is evenly matched in terms of the contrast levels within the 3D elements and the plate, it's a good idea to look at the levels for the plate alone, and the CG elements alone. You should see an equivalent match at both the black and white ends of the distribution, plus a fairly even spread between these two points. If this looks about right, then your 3D is more than likely lit well enough to hand over to the compositing team.

Match lighting without reference

All this information on balls and probes is of no use whatsoever if the production you're working does not include these kind of references as part of the shoot, so what do you do if this does not happen? Well, if you can get to the set, do so, and arm yourself with camera, tripod, tape measure, and blueprints of the set if such things exist. Don't trust the blueprints though, take out your tape measure and jot down your own dimensions, making sure that you take diagonal measurements along the way to check your other measurements with.

Make notes as to where the lighting on set is located. An hour spent here can save many when it comes to building a 3D version. Take as many snaps as you think are necessary, then take some more: don't forget to take every surface flat-on if you plan on using its surface as a texture map, take a panoramic using a tripod from the middle of the set to record the environment, which can always be stitched together and used as a reflection map if required. Of course, you'll probably need to hang around on set for the whole of the day, because the minute you're done

taking your measurements and photographs and decide to leave, the production crew will no doubt decide to change the lighting set-up, or even move the set around.

There's always going to be times though where you can't even get near the set and all you have to work with is the background plate itself. When this is the case, the shadows will be your best clue as to where the dominant light is coming from. Use any elements that are as near to white or a shade of gray as you can find in the plate to interrogate for RGB values and use these values to help with your lighting set-up. If there's something that's easy to pick out and model within the plate, duplicate this element in 3D, using this as an aid not only in matching the illumination, but the highlights too. Match lighting is quite possible without any reference data, it's just that the process is a bit more time-consuming and laborious as it is more based on experimentation and making educated guesses.

Tutorial - match lighting without reference

In this tutorial you will learn how to match light a scene with no reference data. This will involve placing the plate onto an element that will act as the background and matching its mapping to the camera. Then the foreground needs to be modeled in 3D and given a shadow receiving material so that any objects placed in the scene will cast shadows. The task of lighting the scene can then begin.

Open the C10-01.max file from the tutorials folder of the CD. You will see a box and a camera, nothing more. Open the Material Editor, and in a new material slot, choose C10Plate.jpg as your

Figure 10.07
Roughly model the foreground terrain using Soft Selection

diffuse color map and make this material 100% self-illuminating. Rename this material *BackgroundPlate*. Change the Specular Level and Glossiness to 0 and apply this material to the box object, the one named *BackgroundPlate*. With this object selected, add a Camera Map modifier and in its controls, pick the scene's camera. If you render the camera view now, you should get the background image rendered as it will appear in the background.

To enable the objects that we're going to create in this environment to cast shadows on this background, we need to create some foreground geometry. Create a plane in the Top viewport that is roughly the same width as the *BackgroundPlate* object and stretches from its front edge all the way to the camera. Next, move it vertically until its far edge is roughly in line with the horizon. To give us some detail, which we'll need to deform it to match the riverbank, increase its Length and Width segments to about 40-50 in each direction. Now add an Edit Mesh modifier, followed by another Camera Map modifier, again picking the camera. Rename this object *Foreground*.

Copy your *BackgroundPlate* material by dragging it to another slot, and rename this new copy *Foreground*. Apply this new material to your *Foreground* plane. At this object's vertex sub-object level, move groups of vertices around to roughly match the foreground terrain, using Soft Selection to make this task a lot more organic. Don't fret about matching this too exactly, as the shadows will be moving fairly fast over its surface. If you'd rather skip this step, open C10-01-pt2.max where this modeling is complete.

To aid us in placing a light representing the sun, create a sphere floating somewhere over the grassy patch to the right. Now look

Figure 10.08
With your sphere placed, you can begin to try to match the key light

at which way the shadows on the plate are falling and create a Target Direct light representing the sun that reflects this direction, which is from almost overhead, slightly to the left and away from the camera. As this is an outdoor scene, you'd be using daylight balanced film. The sun, as we've already discovered, is almost overhead, so its color temperature, according to table 2.01, is 5,000 °K. Daylight-balanced film, you should remember, has a color temperature of 5,600 °K, so the light has an ever so slightly smaller value. Using figure 2.05 as a reference, this would mean that the light should be given the very slightest hint of yellow. Set its Multiplier value to 1.0 and turn on shadows, without worrying too much about their settings for the moment.

Change a viewport to the direct light's view and adjust the hotspot cone until they are large enough to just cover the entire plane. Now bring the *Foreground* material's self-illumination down to 0 and render the scene, adjusting the light's position until the shadows appear to match that of the scene.

Now add two omni lights to the left and right of the camera, at this end of the foreground, which will act as fills, lightening the unrealistically harsh shadow. You should find that Multipliers of around 0.1 and 0.2 respectively, opens up the shadows sufficiently. Give the light a pale green tint to reflect the color of the grass that would be responsible for the majority of bounced light. This should have its Specular checkbox unchecked to prevent it from creating highlights and it should also not cast shadows.

In order to give us water that will reflect anything above it, we need to create this as a separate element. Clone a copy of the foreground plane, delete the Edit Mesh modifier, and move it into

Figure 10.09
Adjust the direct light's cone to just fit over the foreground plane

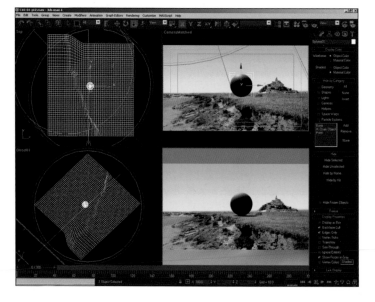

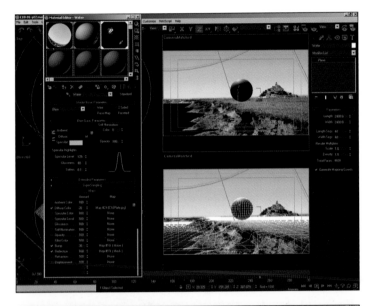

Figure 10.10
Water needs to be created to reflect the aircraft above it

Figure 10.11
Move the target towards the first Spitfire without making the camera map apparent

place just above the foreground plane over the water, reducing its size and segments appropriately so it just fits the water. Rename this *Water*. For the water's texture, in a blank Material Editor slot, change the Ambient and Diffuse color swatches to black and up the Specular Level and Glossiness to 125 and 40 respectively, turning on the Sampler in the SuperSampler rollout.

In the Diffuse map slot, select the C10Plate.jpg image, setting its Amount to 45, and in the Reflection slot choose a Mask map. Place the C10Plate.jpg image in its Map slot, and in the Mask slot specify a Raytrace map. Back at the top level, in the Bump slot, select a

Noise map, changing its Noise Type to Fractal and its size to 40. Turn Animate on and enter –1.5 for the Phase value at frame 0 and 2.8 at frame 300. Now turn Animate off and apply this material to the *Water* object. Rename this material *WaterRaytrace*. You now have the basic scene set up for bringing in 3D elements.

Go to File > Merge and select the C10-01-merge.max file. Select all objects and OK this. If you scrub through the timeline you should now see the animation attached to these merged objects. (You might need to hide the planes and just watch their dummy objects to see the animation happen in real time.)

Figure 10.12
At frame 260 move the camera target up and to the right

Figure 10.13
Your camera target's animation should look like this in Track View

Select the scene's camera and clone a copy, renaming this *CameraFree*. Change its FOV to 40 degrees and go to frame 40 before hitting Animate. Move the target in the Camera viewport left towards the first Spitfire, as far to the left as is possible without the Camera Map becoming apparent, then move it up until it's level with the Spitfire (don't worry about reaching the end of the Camera Map beyond the top of the backdrop). At frame 100 move the target right and down to follow the Spitfire, again within the horizontal bounds of the Camera Map.

Drag the key in the timeline from frame 0 to frame 20 and shift-drag a copy of the key at frame 100 to frame 150. At frame 100, change the camera's FOV to 30 degrees and at frame 140 change it to 40. Move the key from frame 0 to 80. Select the camera's target object once again, right-click and choose Track View Selected. Expand the Transform > Position track and right-click the keys, changing the in and out interpolations to Linear. Repeat this process for the *CameraFree* object's FOV. At frame 240, move the camera target to the left as far as it will go and down until it's level with the rightmost Spitfire, then at frame 260 as far right as it will go and up until the horizon disappears out of the bottom of the camera view. At frame 270, move the target to the right until the just half a Spitfire is left visible, and

Figure 10.14

With your matte placed, the camera can happily look up beyond the Camera Map

move the target up level with this plane. Drag this key to frame 280, adjust the in and out interpolations in Track View to Linear and turn off animate.

To mask off the sky, put C10PlateMatte.jpg into the *BackgroundPlate* material's Opacity slot and uncheck the Tile boxes in the Coordinates rollout of both this and the Diffuse map. In the Utilities panel, pick Colour Clipboard. Choose File > View Image File and select C10Plate.jpg. Right-click a colour at the very top of the sky and drag this from the swatch in the top menu bar to one of the clipboard slots. Now grab a mid sky colour and one from just above the horizon. In Rendering > Environment, choose a Gradient Ramp for the Environment Map. Drag this to an empty slot in the Material Editor, and in the Gradient Ramp Parameters rollout right-click the first flag to edit its properties. Now drag the colours (in order) from the clipboard to assign them to the ramp. In the coordinates rollout, enter –90 in the W Rotate field and change the Mapping to Spherical Environment.

Select the *CameraFree* object and right-click in a viewport, choosing Track View Selected. Now expand the Transform branch and highlight the Position label. Click Assign Controller from the top toolbar and choose Noise Position controller, changing the X, Y and Z Strength values to 5, 5 and 5 in the dialog that appears.

Select the *BackgroundPlate*, *Water* and *Foreground* objects, and by right-clicking, apply Object motion blur. Now add some Film Grain in the Rendering > Effects dialog, choosing a grain of 0.1 and leaving Ignore Background unchecked. Finally, before rendering, make sure the Object Motion Blur is turned on, with Duration of 0.5 and 10 Samples and Duration Subdivisions. Also ensure that the Disable all SuperSamplers checkbox is unchecked.

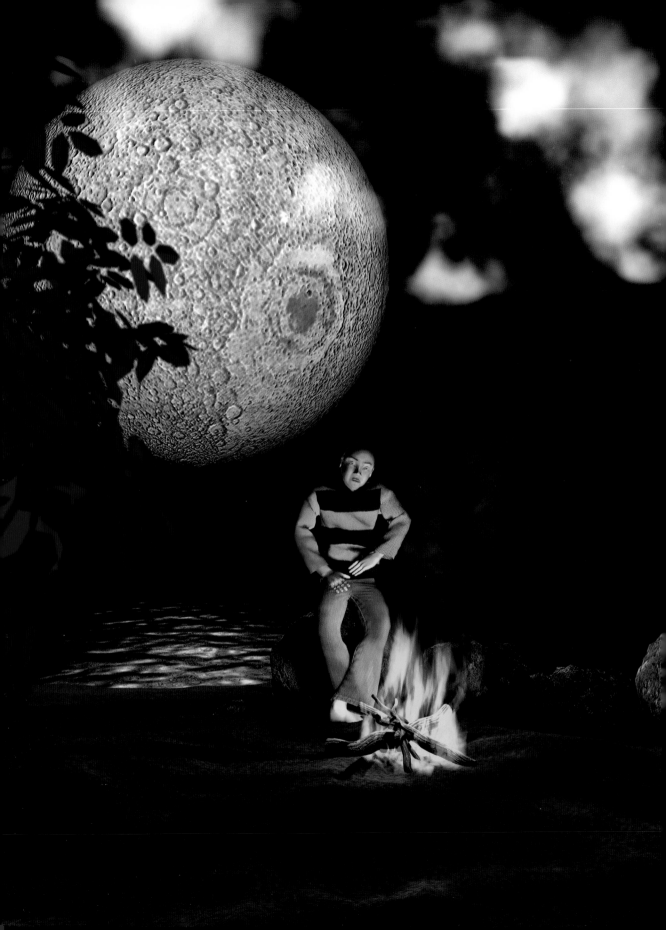

11

'The long light shakes across the lakes, and the wild cataract leaps in glory.'

Tennyson: *The Splendor Falls on Castle Walls*

The forces of nature

Since the dawn of time the forces of nature have provided the inspiration for poets, painters and photographers alike and still never fail to move us. The flicker of fire and the mystery of the ocean fascinate us, which is something that Hollywood has long realized. CG films based around the power of nature - *The Perfect Storm, Dante's Peak, Volcano* and *Twister* - carry on a long tradition that harks back to *The Towering Inferno* and *The Poseidon Adventure*. From the power of these forces at their most destructive to the beauty of a simple sunset, visual effects artists have long endeavored to impersonate Mother Nature.

These kinds of elements are not limited to the Hollywood blockbuster though, and their use in even small productions can help to enhance the realism of a scene, as well as giving it an added depth. Moreover, there's nothing quite like bright sunlight and wispy clouds or driving rain and howling wind when it comes to imparting a sense of atmosphere and place. Likewise,

Image courtesy of:
Big Face Productions
www.big-face.com

fire can bring about a whole spectrum of emotions; from the pure panic of a raging inferno to the warm and intimate feel an open fireplace can impart to a scene's lighting. Atmospheric effects like clouds, fog and smoke also help to reinforce this atmosphere, but are also incredibly good at emphasizing the depth of a scene. Rain is used widely in cinematography to impart a sense of melancholy to a scene, or an injection of tense drama when combined with thunder and lighting.

In this chapter we'll take a brief look at creating all of these phenomena and examine their role in terms of lighting, using the outdoor scene that you first looked at in chapter 6.

First we'll look at fire, the most important element in terms of lighting. We'll do this by bringing this scene's campfire to life, setting it alight and lighting the surrounding area to give it the warm and flickering feel you'd expect. We'll then add some smoke to the fire using a simple volume light, animating the smoke to rise and churn. Adding fog to the large expanse of water will make the scene seem much deeper, and drifting clouds will add to the atmospheric feel. We'll then introduce a particle system that will provide our rain and finish with some dramatic lightning flashes out at sea.

Fire

Note:
There are several commercial plug-ins available aimed at flame generation that will produce much more realistic looking results than may be possible with your vanilla 3D package. For listings of all the options available, see chapter 17.

Of all the elements mentioned so far, fire is the one that's most closely tied in with lighting, as its simulation involves not only the physical behavior of the fire itself, but also the placement of lighting to illuminate its surroundings accordingly. Fire is perhaps the most enthralling of the natural elements and we feel a deep-rooted and primitive attraction to its force. As a result, fire can be used as an extremely powerful lighting tool and though quite tricky to get looking right, it is far safer than in the world of live-action!

Though we touched on fire when looking at candlelight in chapter 7, we'll look at this most sensuous of lights in more detail here. Fire is a very powerful form of lighting in terms of the feelings it can evoke - its colors can bring a sensual warmth to a scene, its flicker can be used to impart a mysterious and eerie atmosphere, whilst its power can be used to ominous and terrifying effect. The small campfire that we're going to be looking at should bring an alluring light to the scene and an atmospheric flicker that will contrast with the cold, synthetic look of most animation.

Generally speaking, fire poses somewhat of a unique challenge in that its behavior is quite varied, depending on various factors that include the type of substance that's burning, the size of the fire and the space within which the fire is taking place. Our small

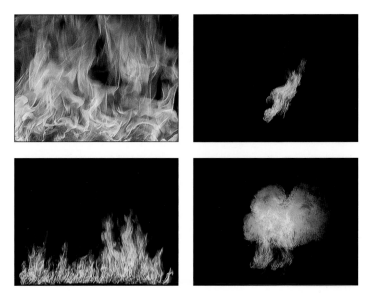

Figure 11.01
Fire's characteristics and behavior
can vary quite dramatically and
depend on many factors -
www.firecd.com

campfire could also be used just as easily in an indoor scene
based around a fireplace. However, to tackle a match being
struck, a blazing building, a flickering torch set against a wall or a
gas stove will undoubtedly involve a lot of differences.

Like most things that we're very familiar with, we're very quick
to recognize when fire does not look quite right. What's more,
the complex physics that are involved in the simulation of
realistic looking fire means that it's often a struggle to get this
element looking convincing in most 3D applications. As a result,
there's a fair number of dedicated plug-ins that can produce
extremely convincing results, which are outlined in chapter 17.
The option of compositing real fire footage into CG is also
another alternative, and again there are several companies
providing fire images with Alpha channels for this purpose,
which are also covered in this chapter. However, we'll work
within the confines of the vanilla 3D application here, using the
tools provided in the core package only.

Tutorial - fire

In this tutorial you will look at how to create a roaring campfire,
both in terms of the physical appearance and behavior of the
flames themselves, but also the way that the fire casts light and
shadow onto its surroundings. We'll begin by setting up the
combustion fire effect and animating its settings, then set up
some warm lights to represent the fire's illumination.

Open the C11-01.max file from the tutorials folder of the CD. You
will see the same beach scene that you encountered a few

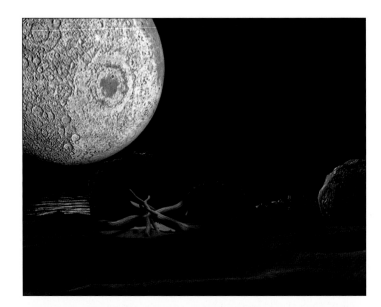

Figure 11.02
Your first lights create the light around the base of the fire

Figure 11.03
Use the same colors for the Fire Effect that you used in the light

chapters ago, with the addition of a campfire in the foreground. If you render at the moment, the campfire will be totally indistinct, as there's no lighting or fire effect set up at all, so let's begin with a simple spotlight pointing down at the fire so we can see what we're doing. Create a target spot in the Left viewport, centered on the fire and pointing straight downwards.

Now center this on the fire again in the Front viewport, moving the spotlight itself up to about Z:45 and its target to Z:0. Give this light a nice warm yellow color of about R:240, G:200, B:50 and turn on its shadows, setting its Multiplier value to 1.0. Set the

Hotspot and Falloff values to 70 and 100 respectively and turn Far
Attenuation on, setting its values to 40 and 80. Within the Shadow
Map Parameters rollout, decrease the Shadow Map Size to 256 and
increase the Sample Range value to 10 to give us much softer
edges to our shadows. Finally, in the Shadow Parameters rollout,
change the Shadow Color to a gray of about R:50, G:50, B:50.

Rename this object *SpotFire01* and Clone a Copy of this light,
changing its color swatch to R:210, G:50, B:30. Next, we'll assign
a glowing material to the coal at the bottom of the fire, so in a
blank slot of the Material Editor, change the Ambient color to the
same warm yellow you just used for the first spotlight and make
the Diffuse color the same red you assigned to the second. Set the
Self-Illumination value to 100 and change the Specular Level,
Glossiness and Soften fields to 0. Hit the blank button next to the
Diffuse color swatch and assign a Noise map, changing the Noise
type to Turbulence and the Size to 2.0. Now, at this level, enter
the same red and yellow values again for the two color values in
the Noise Parameters, with the red in the Color#1 swatch and the
yellow in the Color#2 swatch.

Hit the Animate button, go to frame 100, change the Phase value
to 2.0 and turn off Animate. Go back to the top level of this
material and rename it *GlowingCoals*, applying it to the *Coals*
object. A quick render now will reveal that the base of the fire
looks pretty realistic, but we really need some fire now to get a
feel for how the light immediately around it will look. For this,
we'll first need a gizmo object, which can be found under
Helpers in the Create panel within Atmospheric Apparatus from
the subcategory list. Choose a SphereGizmo and drag one out in
the Top viewport centered over the fire. Move it upwards to
about Z:10 and set its Radius to 25 and check the Hemisphere
box. Finally, using the Non-uniform Scale, scale it upwards along
its Z axis to about 250%.

In Rendering > Environment, add a Fire Effect and change the
Inner and Outer Color values to the same yellow and red that you
used for the spotlights and coal material. Change the Flame Type
to Tendril and set the Stretch value to 1.5. In the Characteristics
section, alter the Flame Size to 20, the Density to 30, the Flame
Detail to 5.0 and up the Samples to 30. Finally, hit the Pick Gizmo
button at the top of the rollout and click on the Sphere Gizmo you
just created. If you render now, you should have a decent looking
fire, though everything you've created so far apart from the coal
material has not been animated. Before we resolve this, however,
we'll add a couple more lights to give the area around the fire a
warm glow that matches the flames.

First, create an omni light directly above the fire, giving it the
same yellow color as before, with a Multiplier value of 1.0 and
shadows turned on. Change the Far Attenuation values to 100 and

Figure 11.04
Adding a Noise controller to the
omni's Multiplier value gives flicker

175 and check the Use box. Now, change the Shadow Color to
R:50, G:50, B:50 and give the Shadow Map Size a value of 256,
increasing the Samples to 10. Finally, using the Non-uniform Scale
tool, scale the light down about its local Y axis to about 30%, so
the light is squashed vertically. Rename this *OmniFire01* and
Clone a Copy, giving this new light the same red color as before
and altering its Far Attenuation values to 100 and 250.

Select the two spotlights, the two omni lights and the
SphereGizmo object, and under the Group menu, pick Attach.
Now press H to bring up the Select Objects dialog and pick the
Fire object to attach these objects to this existing group.

Now to add some animation to everything we've created so far.
First we'll animate the target objects for the two spotlights, to
make the lights move around slightly, which will impart a
flickering to their illumination. Select one of these targets and in
the Motion panel, under the Assign Controller rollout, select the
current Position: Bezier Position controller, click the Assign
Controller button and double-click the Position List controller.
Now expand this branch in the Motion panel and select the
Available tag, located underneath the one marked Bezier
Position. Hit the Assign Controller button again and this time
pick the Noise Position controller, changing the X, Y and Z
Strength values to 15, 15 and 0 respectively.

If you now drag the time slider along the timeline, you'll see the
target object moving around the base of the fire. Repeat this
process for the remaining spotlight target, giving the Noise
Position controller a different Seed value, so the movement of the
two targets is not identical.

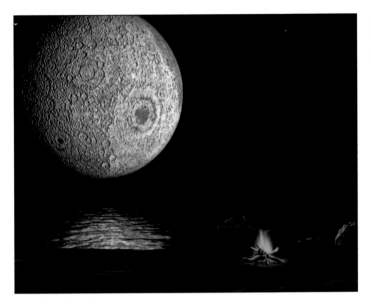

Figure 11.05
The finished fire illuminates the rocks around it nice and gently

For the omni lights, we'll add a Noise controller to the Multiplier values to give these lights some flicker too. To do this, select the first of these lights, right-click in any viewport and pick Track View Selected. Expand the *OmniFire01* > Object branch and pick the Multiplier track. Click the Assign Controller button in the top menu bar and assign a Float List controller. Expand this branch and select the Available track, assigning a Noise Float controller to this. Set the Strength to 2.0 and check the > 0 box. Now expand this branch and in the Noise Strength track use the Add Keys button to insert a key at frame 0. Right-click this and give it a value of 2.0. Now if you move through the animation frame by frame, you should see the light's Multiplier value change between about 0.25 and 1.75. Repeat this process for the second omni light, again giving it a different seed value to ensure the values don't correspond.

Finally, open the Rendering > Environment dialog and select the Fire Effect you added earlier. Now hit Animate, move to frame 100 and change the Phase and Drift values to 200. Turn off Animate and you're done. If you render the scene now, you should get a result that looks like C11Fire.mov, which can be found in the same folder as the tutorial file.

Smoke

This natural effect goes hand in hand with fire and though it won't always be needed for every type of fire, it does add a further level of convincing detail to our campfire. Here you'd expect to see the smoke churning and rising slowly upwards, and moving according to the Wind Space Warp that you just set up to

Figure 11.06
Particle systems can also make for very easy and realistic smoke

act on the fire. Besides being something that adds visual detail, a column of smoke or rising steam can (just like the trusty lens flare) be a useful thing behind which to hide something that's not looking quite right, avoiding another time-consuming rendering.

Depending on the nature of the smoke and the way it would behave, there are several ways of approaching it. The method that we will use here is perhaps the simplest and involves using a simple volumetric light, just like the one you set up in the indoor scene a few chapters ago. This provides a decent smoke effect, but is not nearly as versatile as using actual geometry and a map to represent smoke.

Most 3D solutions have a dedicated smoke map type, but those that don't certainly have the capabilities to produce this kind of procedural fractal-based material. This, combined with a solid object that can be deformed and animated like any other, provides arguably the most versatile smoke effects, particularly should you want your smoke to bend, twist and generally behave in a very predictable manner. As well as being quite controllable, this kind of smoke is the easiest to give a stylized cartoon character to, should this be what you're looking for.

Particle systems are another obvious candidate for making realistic looking smoke that behaves quite realistically, and when mapped with the same smoke-like opaque material, particles can provide a very solid solution. Further options include atmospheric effects, such as volumetric fog, and some 3D packages' fire effects also have smoke effects actually built into them. Finally, as we'll explore in a few pages' time, there's even a fog option within the raytrace material's options that can be used to create a fog effect.

This is a good choice for smoke trapped in a jar, as this is exactly what it resembles and can be used for neon tubes and even the glowing portion of wax at the tip of a candle.

Tutorial - smoke

In this tutorial you will look at creating a column of smoke that corresponds to the fire that you've just created. You'll do this using a simple volume light that you'll orientate according to the wind vector already in the scene. Then, you'll set up the light's noise to resemble smoke, which you'll animate to move with the wind and churn as it moves.

Either continue from where you are, or open the C11-02.max file from the tutorials folder of the CD. If you want to turn off the Fire Effect that you just created to speed up your rendering, you can do so in the Environment dialog, though these two effects together won't result in an unbearably long render. Creating a column of smoke using a volume light is a very straightforward task. First you need to create a Target Spotlight, located just to the left of the center of the fire as seen from the camera (around X:140, Y:105, Z:0), with the target placed according to the Wind Space Warp that you can see in the Top viewport alongside the camera. Placing this at about X:140, Y:40, Z:90 should give the light the right orientation. Rename this light *SpotSmoke* and link it to the *Fire* object.

You should now set this light to have a white color with the smallest hint of a warm orange (around R:255, G:240, B:220), a Multiplier value of 1.0 and it should be set not to cast shadows. Its

Figure 11.07
The volume light's noise settings are vital to realistic smoke

Figure 11.08
Your campfire's smoke will churn
slowly as it drifts upwards

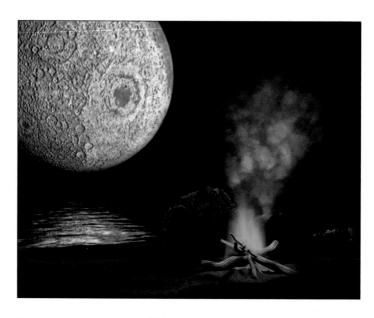

Specular component should be turned off, whilst its Hotspot and Falloff values should be set to 0.5 and 60 respectively and its Far Attenuation to 50 and 250. Now, down in the bottom rollout of this light (the one labeled Atmosphere & Effects) hit the Add button. Select Volume Light from the resultant dialog and OK this, then press the Setup button to jump directly to the Environment dialog.

Set the two color swatches to a light gray of about R:200, G:200, B:200 and a very dark blue (somewhere around R:0, G:0, B:30) and check the Use Attenuation Color checkbox. Uncheck the Exponential checkbox if it's checked, change the Density to 10.0 and the Attenuation Multiplier to 0.0. The Filter Shadows options can be set to Low, which provides the quickest rendering times and its quality will be enough for our needs. If you were rendering this for a PAL or NTSC application, the Medium setting would probably be preferable, and for high-res stills, the High setting might be required.

To create the smoke pattern within the volume light, turn Noise on and set its Amount to 0.55, changing its Type to Turbulence. Its Noise Threshold High and Low values should be set to 0.44 and 0.21 respectively, whilst its Uniformity should be set to 0.0. Set the Size to 20, the Wind Strength to 2.0 and the check the Front box for the Wind Direction option. Finally, hit the Animate button, go to frame 100 and in the Phase box, type in 2.0 then turn off Animate. This should give you a nice slow churning, which moves in accordance with the wind that you've specified.

If you have the Wind Strength set to a value greater than 0, the fog volume animates in accordance with the wind direction. With no Wind Strength, the fog churns in place, without the effect of

wind. By having the phase animate slowly with a large wind strength, the fog moves more than it churns. Alternatively, if the phase changes rapidly whilst the wind strength is relatively small, the fog will churn fast and drift slowly. If you render the scene now, you should get a result that looks like C11Smoke.mov, which can be found in the same folder as the tutorial file.

Fog

As well as being very handy for eliminating the need for high detail in the far reaches of a scene, fog is also useful in reinforcing the depth of a scene by giving substance to the space that surrounds all the objects you've created. Furthermore, the subtle use of fog adds a real element of believability to a scene, because even on a clear day the objects you see blur into the distance due to the particulate matter in the air. As you probably know, a clear blue sky is not actually clear or really blue: the color that you perceive is caused by water vapor in the air, which when looked through gives the sky its blue color. Similarly, the most spectacular sunrises and sunsets are seen over cities and built-up areas, because the airborne pollution catches the light.

Fog can be used subtly to enhance the realism of a scene, and used more visibly, it can help set the time of day and season. For example, you could give a rolling landscape shot a slight mist amongst its valleys to add to the early morning feel of a shot. Just like most other things in the 3D environment, fog can be animated to roll and churn, or to thicken or fade away, demonstrating the passing of time or the weather changing.

Figure 11.09
Particulate matter in the air causes fogging with distance

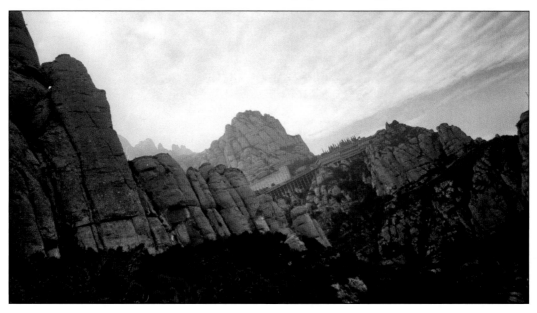

As well as fog and mist, this kind of atmospheric effect is valuable for underwater scenes, where the particulate matter in the water acts just like a fog. You should already know a little about fog from the last chapter, and the tutorial on setting up an underwater environment.

As we'll discover, care must be taken when lighting an environment that uses fog quite heavily. As we've already discovered, light attenuates at an inverse square rate, but it is common for attenuation to be even greater when the atmosphere disperses this light, especially when there is fog or mist present. When working in CG, fog is often built up in layers, with the nearest given the most attention to detail, which not only gives visually good results, but is also good practice for organizing effects.

Tutorial - fog

In this tutorial you will add some low-lying fog over the water at the back of the scene. This will emphasize the depth of the scene and give all this empty space some substance and atmosphere.

Either continue from where you are, or open the C11-03.max file from the tutorials folder of the CD. First of all, turn off the two environmental effects that you've so far added so that our renders don't start getting too long. Whilst in the Environment dialog, add a Fog effect, leaving its settings at their defaults and render. The result certainly looks foggy, but the Standard Fog option that max defaults to fills the entire scene and the result looks a little strong. Alter the Far (%) value to 50 and render again. As you can see, this defines how much fog is used at the far end of your scene.

Figure 11.10
With the default settings, the scene certainly looks foggy

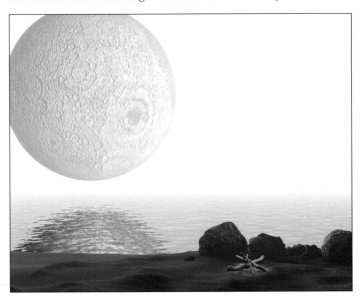

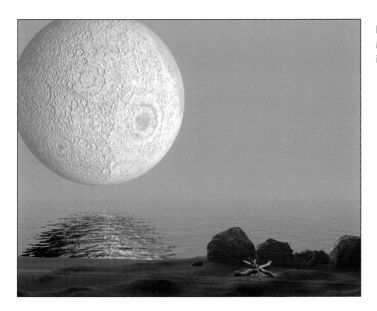

Figure 11.11
Making the fog exponential results in a more realistic falloff

The far end of your scene is defined within your camera's controls, under Environment Range. If you set the Near and Far values to 0 and 75 respectively, you get a pretty quick and dirty fog, but it's not massively realistic, as the horizon is quite clearly visible, which would not happen in real life. Check the Exponential button and try again and you should see that the results are more realistic in terms of the horizon, but the reflections of the moon look all wrong. The Exponential feature makes the fog increase at an exponential rate, rather than at a linear rate, which looks much more like real fog.

Standard Fog is quite useful for underwater shots, where you want a general fogging that affects the whole scene, but outside of this application it is not all that useful. Change the Fog Type to Layered Fog, leaving everything at the default settings and render again. You should get a big thick layer of fog that comes up just a little above the bottom of the moon. This actually helps to explain Layered Fog, which is more complicated than it sounds. Whilst Standard Fog operates relative to its depth from the camera, Layered Fog actually operates in world space, up the Z plane. Looking at its options, you will also see that its Top value is 100, which means that the fog ends at Z:100 and since the camera is located at Z:120, it is above this layer of fog. Change this Top value to 200, to extend the fog layer above the camera and render again.

The results are much more like you would expect, with the fog deepening toward the horizon, which is not visible and the reflections in the water lost in the fog too. Now change the Falloff value to Top and render, then Bottom and render again, observing the difference. The look that we're after is more like the second,

as our foreground detail does not get so lost with the falloff towards the bottom of the image, yet we still get the nice depth-based fogging out at sea. If the Density value is reduced to 40, then the result is a fog that is transparent enough to show some of the sky through at the top of the screen, with the horizon just distinguishable and the foreground not too obscured.

If you turn on Horizon Noise and render with everything left at the default value, you'll get a very strange result, a big gap running through the fog at the horizon level. However, change the Size to 30 and the Angle to 20 and set the Bottom of this effect to start at 150 and render once more. Now you should have a Fog effect that effectively forms a layer of misty cloud over the water, an effect that actually emphasizes the water, because it gets raytraced into its reflection. Of course, the Phase can be animated to make the fog churn over time and animating the Density could be used to make the fog disappear.

Now turn off this effect and add a Volume Fog effect instead. As you can see from its options, this effect works within a volume defined by a gizmo object. These are found under the Helpers section of the Create panel, under Atmospheric Apparatus from the drop-down. There are three different types, and whilst boxes are best for creating fog effects, spheres and cylinders can be used to produce some interesting cloud shapes, which we'll explore in the next section.

For the moment, create a BoxGizmo that's 2,000 units by 1,000 and 150 high. Align this with the *Beach* object and move it towards the camera in the Top view until its far end fits right across the entire width of the cone of the camera view. Now

Figure 11.12
Layered fog operates in world space and is generated up the Z axis

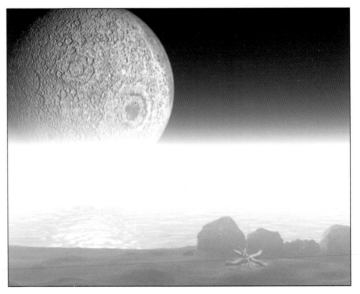

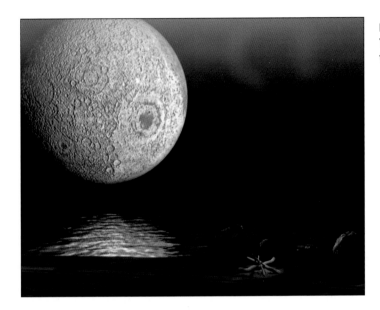

Figure 11.13
Your fnished fog is composed of two different atmospherics

move it until its bottom edge sits just above the water in the Camera viewport. Rendering now will give you a very thick, very defined layer of fog, which does not look very good, but a few changes will soon set this right.

First of all, set the Soften Gizmo Edges to 1.0, turn on Exponential and set the Density to 2.5. Change the Fog Color to give it a small amount of gray, say R:240, G:240, B:240 and ensure the Fog Background box is checked. In the Noise section, change the Type to Fractal and set the Size to 75. Give the Noise Threshold a Low value of 0.2 and render now.

You should have a nice thin layer of mist that just emphasizes the water nicely and gives the scene much more of a sense of depth. Turn back on your Fog effect and render with both of these effects on and you'll see that the Volume Fog effect just hides the horizon slightly, which becomes more noticeable with the high level Fog turned on and the water reflecting the light. This is the look we're after, a clear night with mist just beginning to gather on the water and the sky above.

Clouds

Whether small wisps of cloud drifting by on a summer's day or large rolling storm clouds gathering and darkening the scene below, clouds can have a big influence on our perception of the passing of time and the atmosphere of a shot. Clouds are very closely related to fog in terms of their generation, and use the same atmospheric effects though usually contained within individual objects whose sole purpose is to define their volume.

Animating these containing objects gives the clouds their primary movement, whilst animating the actual effect's parameters creates the characteristic movements of clouds. Though the parameters for controlling the volumetric fog effects that are used for creating clouds are given quite technical and cryptic names, some experimentation can give the churning, changes of density and color shifts that are required.

Tutorial - raytrace fog

An alternative way of modeling fog involves using the Raytrace material and creates an object that looks as if it contains a volume light. This is particularly effective should you want to create close-up renderings of neon tubes, as these kinds of bulbs exhibit these kinds of properties. Raytrace fog can also be used to simulate containers full of fog, should you want to simulate a chemical kept in a jar. It's also useful for candles, where the tip of the candle near the flame exhibits an opaque and subtly glowing effect. We'll take a quick look here at this material and discover more about what it is capable of.

Open the C11-04.max file from the tutorials folder of the CD. You will see a cylinder resting on a flat surface. Select the cylinder and in the Material Editor, in an unused slot, change the material type to Raytrace. Now alter the Diffuse color swatch to black and the Transparency to white. Within the Extended Parameters rollout, turn the Fog checkbox on and change its color to white. Finally, set the Fog End value to 100 and the Amount to 1.0. Rename this material *RaytraceFog100*.

If you render now, you should see that the cylinder appears to contain a very dense fog. Change the End value to 50 and render again. You should see that the fog within the new cylinder appears denser still. This is because the End value sets where the fog reaches its full Amount value relative to the object itself. Try this with the End value set to 200 before changing it back to 100.

Now clone an Instance of the cylinder and move it away from the first, along the top of the box's surface. Now drag a copy of the material you just made to an unused slot and change the name of this material to *RaytraceFog66* and apply this to the second cylinder. Within this new material, change the Amount value to 66 and render again. You'll see that the fog's density has decreased. By altering the Amount and the Start and End values, you can build up different fog types. Experiment with these values, using the two cylinders to compare your attempts. You might also want to try using a Noise map within the Transparency slot to further change its appearance.

Largely because of these technical parameters, getting the desired look of clouds is sometimes a matter of good luck rather than good judgment, as often the alteration of one of these parameters will have a direct affect on another. Furthermore, render times for these kinds of atmospheric effects can be comparatively high, so many decisions will be as much based on keeping render times down as getting the desired look.

Figure 11.14
Raytraced fog can be useful for neon tubes and jars of chemicals

Figure 11.15
Clouds are one of many clues
about the time of day

Tutorial - clouds

In this tutorial you will add some cloud drifting across the moon
in the background, adding a further level of detail to the
otherwise bare background and reinforcing the passage of time.
You'll use atmospheric helpers and effects to create the clouds,
before animating them to drift slowly across the moon.

Either continue from where you left off after adding fog to the
beach scene before the last tutorial, or open the C11-05.max file
from the tutorials folder of the CD. You will see the scene
(hopefully) just as you left it. First turn off your combustion
effect, volume light and fog to speed up the rendering times
whilst designing the clouds.

Creating clouds is very simple once you've got to grips with fog
and the first step in their creation is to make the helper objects
that will contain the cloud effect. So, under the Create panel, in
Helpers, choose Atmospheric Apparatus from the drop-down and
select CylGizmo. Drag to create one of these in the Left or Front
viewport and change its parameters so it has a Radius of 250 and
a Height of 2,000.

Now use the Align function to make it parallel with the *Beach*
object and position it just in front of the moon and vertically until
about a quarter of its height disappears beyond the top of the
camera view. Now move it again in the Camera viewport using its
Local coordinates so that its rightmost round end is just out of the
right edge of the frame.

Figure 11.16
The voume fog is added to the
gizmos that float across the moon

Figure 11.17
The finish clouds complement the
fog that you've already finished

Rename this object *GizmoCloud01* before using the Clone
command to make a copy of this gizmo and moving it slightly up
or down so it's not in exactly the same place as the last one, then
move it slightly towards the camera. Repeat this until you have
four gizmos placed all a little differently in front of the moon, all
at slightly different distances from the camera, though all with
their right-hand round edges just out of the camera's frame to the
right. Next turn on Animate, go to frame 100 and move these
gizmos one at a time along their local coordinates to the right
from the point of view of the camera, so they are just drifting
slowly across the moon's face.

Give them all slightly different values; the nearer to the camera a gizmo is, the more it should drift, though the difference should be quite slight. If you scrub through the animation now; you should see these helpers moving nice and gently, at subtly different speeds, from the left to the right across the moon in the Top viewport.

Now you need to set up the actual Volume Fog effect, which is added to the Rendering > Environment dialog. Once added, change the color swatch to a light gray of about R:240, G:240, B:240 and check the Fog Background box. Now set the Density to 15.0 and check the Exponential checkbox, which will avoid overly white areas of color within the cloud. In the Noise section, change the Noise Type to Fractal, with High and Low Noise Threshold values of 0.7 and 0.3 respectively. Change the Levels to 6.0, the Size to 300, turn on Animate and go to frame 100, changing the Phase value to 1.0 before turning Animate off again. Set the Wind Strength to 1.0 and set the Wind Direction as from the Left. Finally, at the very top of the rollout, click the Pick Gizmo button and select the first of the *GizmoCloud* objects, but not the others, and change the Soften Gizmo Edges value to 0.1.

Figure 11.18
RealFlow should be considered when serious amounts of water are involved - www.nextlimit.com

The reason you've only picked one gizmo is that there's one value that's very important to getting good-looking clouds, and this value is altered individually for each gizmo. Having them all visible at once, it would be difficult to see the effect of changing these values. Select the *GizmoCloud01* object and in the Modify panel hit the New Seed button and render a frame, repeating this process until you're satisfied that the result looks suitably cloud-like. You should be looking to get a series of fairly puffy little clouds that aren't too thin, yet not too dense either, as the scene is set on a fairly clear night.

This can be a very hit and miss process, but once you're happy with the first gizmo, remove it from the Volume Fog effect, add the next gizmo and repeat the process until you're happy with all four. Then add them all to the effect and render the result with all four gizmos containing the fog. You want to change the seed value of these gizmos again at this point, as you might after you've rendered the whole 100 frames out, though this is a fairly slow effect to render, so you might not! Your finished animation should look something like C11Clouds.mov, which can be found in the same folder as the tutorial file.

Rain

Unlike the rest of the elements covered so far, there's really only one way of creating rain in 3D that you'd seriously want to consider, and as you might have guessed, that's the particle system. This type of animation tool excels at creating a large collection of similar objects behaving in a similar fashion, and water is one of

the things that these tools do best. Equally, particle systems are also excellent at creating snow as you might expect, but can also be used more generally for water whether gushing from a hydrant, tumbling from a waterfall or shooting from a fountain. Smoke is also another application of particle systems that we've already mentioned, but other equally valid examples include explosions, ants, shoals of fish, and even crowds of people or flocks of birds.

The difficulties of producing rain on demand in live action situations has lead to a large number of tools for generating rain during the post production stage and though some studios will do this using a 3D application, there are many solutions for simply compositing rain over a background plate in 2D. These kinds of tools can produce some very believable results in very little time by building up several individual layers of rain over a plate. These kinds of tools are covered in chapter 17, along with other relevant plug-ins and related products. For those embarking on projects involving serious amounts of water, RealWave and RealFlow (www.nextlimit.com) are worth mentioning here and should certainly be checked out, as they are very capable tools.

There are tools for creating perfectly good rain within most 3D solutions, however, and using a particle system that is set to emit the rain particles from a flat plane is the usual approach and the one that we will examine in the next tutorial. These systems are certainly not that difficult to master. Using the right type of particle is the first important factor, as is setting the material correctly. Providing the lighting has been set up correctly a small amount of motion blur will seal the illusion completely, as you'll now discover.

Tutorial - rain

In this tutorial you will look at adding some rain to our beach scene using a Blizzard particle system and Tetra particles. You'll set the emitter to be a plane and place this directly in front and over the top of the camera before setting up the particle parameters to act like rain. After setting up the rain material, you'll add a little motion blur and render.

Either continue from where you are, or open the C11-06.max file from the tutorials folder of the CD. You should turn off any of the effects that you've worked on in this chapter to minimize the rendering speeds whilst you're building your particle rain. In your Top viewport, drag and create a Blizzard particle system (Create > Particles > Blizzard). Check that this is oriented downwards in your Front viewport, then resize the Width and Length in the Basic Parameters rollout to 500 and 250 respectively. Select the *Camera* object in the Top viewport to see the cone representing its Field of View, then Non-uniform Scale the particle system along its

local axis to squash the system until it just fits in the view so that as few particles as possible are falling outside of the Camera view. Now activate the Camera viewport and align the particle system to this view by selecting Tools > Align to View and checking the Y axis box. Now move the system in the Top viewport so it's central to the camera and so its far edge is about lined up with the start of the *Beach* object. Finally, move it upwards in the Front viewport until the emitter plane just disappears out of the Camera view.

In the Particle Generation rollout, change the Particle Quantity value to 50, along with Use Rate. Alter the Particle Motion Speed and Variation values to 20 and 25 respectively, then change the Particle Timing section so that the Emit Start is set to –10, change the Emit Stop to 100, and alter the Life value to 11. Now if you scrub through the timeline, the particles should die soon after falling beyond the *Beach* object. Depending on how far you moved the emitter up above the Camera view, you might need to increase this value slightly. You want the particles to reach the floor, but go as little distance beyond as possible.

In the Particle Size section of this rollout, the Size value should be set to 5.0. Now, in the next rollout, set the Particle Type to Standard and the Standard Particles to Facing. In the Rotation and Collision rollout, set all the Spin Speed Control values to 0 and make sure that Interparticle Collisions is turned off. The Object Motion Inheritance values can be left as they are, and so can the Particle Spawning Effects, which should be set to Die on Collision.

For the rain's material, select an unused slot in the Material Editor and rename it *Rain*. Assign this to the Blizzard particle system and in the Basic Parameters rollout of the material, check the Face

Figure 11.19
The rain material is mapped to the faces of the geometry

Figure 11.20
The particles should die soon after reaching the *beach* object

Map box. This applies the material to the faces of the geometry, negating the need for mapping coordinates. Set the Diffuse color to a light gray-blue of about R:175, G:185, B:195 and drag this color to the Ambient swatch, then click on this and decrease the Value field to around 25. Set the Specular Level and Glossiness values to 0 and assign a Gradient map to the Opacity channel, changing the Gradient Type to Radial, but leaving the remaining Gradient Parameters at their defaults. Alter the U tiling to value 10 and uncheck the Tile checkbox. If you render now, you should only see the rain particles against the moon, so to fix this, give the material a Self-Illumination value of 25, which should just bring out the particles against the night sky.

Now rotate the whole particle system about six degrees, so that the particles are falling slightly diagonally, from left to right. You've probably noticed that the facing particles aren't oriented perpendicularly, and if you hit the Show Map in Viewport button, it looks like your raindrops are falling from left to right, but in fact they are coming straight down. Increase the size of your particles temporarily to 25 (in the Particle Generation rollout) and at the Gradient level of the *Rain* material, change the W Angle value until the rain looks as if it's falling straight downwards. (You should find that a value somewhere around 30 does the trick.) Now if you subtract the six degrees from this value and scrub through the timeline, the material should be aligned with the direction in which the particles are falling. Change the particle size back to its original value of 5.0.

Right-click in any viewport and select Properties, checking the Object box of the Motion Blur options, making sure that this feature is enabled. Finally, in the main Render Scene dialog, check

Figure 11.21
See the QuickTime movie file on
the CD to see how the rain looks

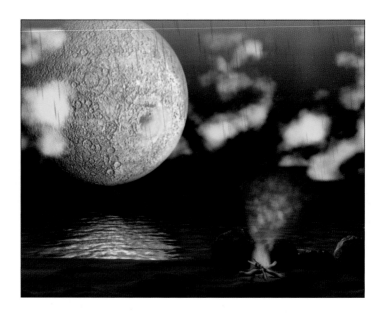

the Apply box in the Object Motion Blur section, changing the
Duration, Samples and Duration Subdivisions to 0.5, 5 and 5
respectively. If you render a single frame now, you should get a
fairly realistic result, but to get a real idea of your results you're
going to have to render out a movie. To get quick results, check
the Disable all Samplers feature in the main Render dialog and set
the Anti-Aliasing Filter to Soften, with a value of about 4.0. Your
results should look something like the C11Rain.mov file that's
located in the same folder as the tutorial file.

Lightning

There's nothing quite like lightning to inject a shot of drama, and
has been used for this purpose from the earliest black-and-white
horror film to its modern day CG equivalent. If you're trying to
depict a scary night scene, there's nothing that matches it,
especially when accompanied by the sound of crashing thunder.
Tools for creating lightning in a lot of CG packages are a little thin
on the ground, search the 3ds max help files for the word
'lightning', for instance, and you'll get no matches.

There are some good dedicated plug-ins for the creation of
lightning on the market, and you'll find these detailed in chapter
17 along with all these types of third-party products. Within our
regular 3D applications, lightning can be designed in a few
different ways involving the Material Editor. The easiest way to
create lightning is to find some footage and integrate this into
your footage, either as part of your environment map, onto your
background plate or onto another plane set up just for the
lightning. Alternatively, some wizardry with the procedural

marble textures will result in pretty realistic looking lightning that
has the benefit of being far more controllable, though it can take
considerable effort to get the desired effect. We'll take a look at
the first of these two methods.

Tutorial - lightning

In this tutorial you will look at adding some lightning out at sea,
giving our night time scene a final atmospheric touch.

Either continue from where you are, or open the C11-07.max file
from the tutorials folder of the CD. First of all turn off all the
Atmospheric Effects that you've created so far, except maybe the
two making up the sea fog. These don't take long to render at all
and will enable you to see the lightning through the fog, as it will
appear in the final render.

The lightning needs to be added to the existing Environment map,
and this involves creating a small lightning animation that will be
composited over the top of the existing map. In order to do this,
open the Material Editor and within the *StarryNightSky* material,
hit the Map Type button currently labeled Mix and select
Composite, opting to keep the old material as a sub-material of
the new one. First copy all the files beginning *Lightning* from the
Tutorial Materials folder of the CD to a local directory on your
machine, perhaps max's own maps folder. Now click the new slot
that's been added to this material and specify a Bitmap, selecting
the Lightning01.tga file from within the Tutorial Materials folder.
Make sure you check the Sequence box before clicking Open and
OK in the resultant dialog.

Figure 11.22
The material preview will seem
vivid when the bitmaps are loaded

You will see in the Material Editor's preview slot that the lightning appears to be very vividly colored. This is due to the fact that the lightning targa files were created with this color as the background. To fix this, at the very bottom of the Bitmap Parameters rollout, simply uncheck the Premultiplied Alpha box. You also need to alter the lightning's mapping coordinates so it appears correctly. Do this by checking the Environ button and changing the Mapping to Screen. Change this map's name to *Lightning* whilst you're at it.

When you select a group of sequentially numbered images like you just did, max automatically generates a simple .IFL (Image File List) file that lists the images to use in this simple sequence. The reason you copied the Lightning images to your hard drive at the start of this tutorial is that this IFL file is generated in the same folder as the images, which would not be possible were this folder on your CD. Using the Windows Notepad program, open the .IFL file that is located wherever you copied these files to earlier.

This file should have four lines, as shown in figure 11.23. If you scrub through the timeline, you should see in the Material Editor's preview slot that your lightning animation loops throughout the whole animation, which is not what we want. To give us just a couple of isolated lightning strikes, we need to edit this IFL file, which is a simple process. Click to place your cursor at the very start of the document, before the first L character and add the line LightningBlank.tga 25, as shown in figure 11.24. This adds the LightningBlank.tga file to the animation, with the 25 telling max to use this image for 25 frames. If you now edit the IFL file to

Figures 11.23, 11.24 and 11.25
Editing the .IFL file manually

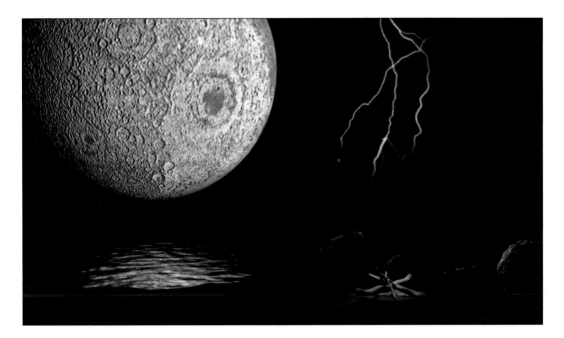

Figure 11.26
Your finished lightning strikes

look identical to the one in figure 11.25, you should have two good-looking lightning strikes. You'll need to save the IFL file when you're done editing it and hit the Reload button back in max so these changes take effect.

Now scrub through the timeline and watch the lightning appear within the Material Editor. If you render somewhere between frame 25 and 30 you should see that the lightning looks good, though it should stretch down to the horizon level. It's also a little too central. To fix these problems, stretch the lightning down to the horizon by first checking the Apply box in the Cropping/Placement section and entering a value of 0.75 in both the W and H fields, making sure that Crop is selected, rather than Place.

12

'The secret to creativity is knowing how to hide your sources.'

Albert Einstein

Visual hooks

The lighting artist has the power at his fingertips to influence the atmosphere of a production far more than the majority of his co-workers. His decisions, which are largely based on how light behaves in the real world, set the mood of the story and directly affect our perception of the script. However, often the creative vision of a script goes somewhere beyond our everyday reality. This is arguably more often the case than not when it comes to CG. As a result, to convince us that what we're seeing is as real as possible, it's often also the lighting artist's job to employ visual devices to reinforce the illusions of CG.

Whilst visual effects often take their audience way beyond the boundaries of credible science, the lighting artist has a big role to play in providing the visual hooks that make these effects look so believable. Adding film grain to a rendering in order to make the audience believe that a CG shot has actually been filmed is perhaps the most simple and commonplace technique. This trick,

Image courtesy of:
Big Face Productions
www.big-face.com

Character model:
Daniel Martinez Lara
www.pepeland.com

which is very effective at a subliminal level, relies on faithful replication of the artifacts of a familiar medium. It's somewhat ironic that now we have the ability to rid our screens of the scratches, lines and bits of debris that find its way onto film, we choose to put more back in there digitally.

Similarly, just as lens manufacturers have worked hard over the years developing special coatings to eliminate the artifacts that appear in their lenses, those involved in CG just can't seem to get enough of these lens effects. Though considered undesirable in traditional photography and cinematography, their popularity in CG lies in the fact that they are visual hooks that we associate with reality, or at least a photographed version of reality. They are also fairly useful when it comes to hiding something that's not rendering quite right too, but that's another story.

Inside the lens

To understand what causes the glows, streaks and flares that CG puts in and the lens manufacturer tries to take out, you simply have to look at things through a camera lens. This does not have to be an expensive one for you to notice that the sun looks quite different seen this way, rather than with the naked eye. It appears sharper, and you can see that lens flares are actually made up of several parts. Even those of you without a camera to hand will, I'm sure, already appreciate that the sun looks much different viewed with and without a camera.

The artifacts that we see depend very much on the construction of the camera lens itself. The circular artifacts that can be seen are

Figure 12.01
Real-life lens flares are generally much more subtle than CG portrays

called lens reflections and the number of these that appear can vary depending on how many components the lens is made up of. These are caused, as their name suggests, by light reflecting somewhere within the camera lens, which also produces the other artifacts: the stars, streaks, rings, rays, glows and so on.

Considering the amount of these effects that we see in CG, you'd think that the production of these kinds of artifacts was easy and you'd be not far wrong. Recognizing what kind of lens you're trying to simulate and knowing what kind of artifacts this lens is likely to produce is the most difficult part.

Glows

Unlike the other components of lens flares, glows have further production applications. For example, we often perceive glows around bright light sources such as the sun, or surrounding highlights on shiny metal objects. Though these glows themselves appear to be the same, they are in fact subtly different. A glow used as part of a larger lens flare effect would be designed to appear as if it were happening in the lens itself. Alternatively, a glow representing the glow surrounding a bright light source is generally perceived as happening at the source.

In this latter case, the appearance of the glow would depend largely on the source's intensity and the type of surface creating the reflection. Glows that appear around the sun also depend upon the weather conditions: on a misty or hazy day the sun will have a larger glow of a lesser brightness than the very small and well-defined glow that would appear on a fine and cloudless sunny day.

Figure 12.02
We perceive glows around lights to be happening at the source

Figure 12.03
Glows applied to unclamped colors reinforce the highlights

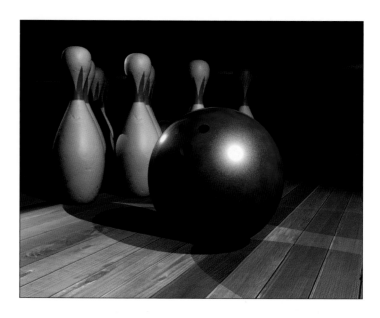

Glows on a scene's objects can be accomplished using several methods. You've already encountered glows in context of a neon sign back in chapter 9 and will recall that creating the actual glow was not that difficult. The crucial part of setting up a glow to look accurate is to set up the source for the glow using the right element. As well as applying glow effects to lights themselves, you can apply the glow to the whole object, generally using an individual ID number applied to the geometry. This ID is then also allocated to the effect, which glows the correspondingly tagged geometry. This method works well and in a very simple manner for applications like fluorescent light bulbs, neon signs and so on, where it's the entire geometry that you want to glow.

You can also apply glows to specific materials, again usually using an ID that is allocated to the individual material as well as the effect. In this way, if an object uses several materials, you can choose to apply a glow specifically to one or more of these materials, which then glows a selected part of an object. This has obvious advantages in that you can control very closely just where the glow appears on your object using multiple materials on one object. In some 3D applications, there are further advantages to this method that aren't so apparent. For instance, in 3ds max, glows applied to whole objects won't appear in raytraced reflections, but glows allocated to materials will. This is why, in chapter 9's 3ds max tutorial, we set up the neon sign glow by material.

Glows can also be allocated to the areas of your image that are brighter than pure white, which are sometimes called unclamped colors and are generally found around bright metallic highlights. Your 3D application might only be capable of displaying a final rendered frame in 24-bit color, but it does actually render them at

a higher color depth, generally 64 bits. These extra bits are used for storing information such as z-depth and alpha values, as well as details of the unclamped colors. This data can then be used as the basis for an effect, which is useful for adding a glow around only the brightest highlights in a scene, subtly reinforcing the intensity of these areas, as seen in figure 12.03.

These are only some of the more commonly used options available for adding glows and there are many more: glows can also be allocated by alpha value, z-depth and so on. These methods of applying effects are not as widely used, but knowing how to apply glows by object, material and unclamped colors will make these less common options more easily understood.

With an understanding of how best to use the different methods for applying the glow effect, all that remains for you to master is how to control the amount of glow applied to your object or material and how this is applied. There are several different methods of controlling this, and these range from applying the glow to the entire source to just its perimeter. Glowing the entire source generally applies the glow outwards from the source's center. Because of this, the glow's size depends on the object's size. Using the option for applying the glow to the perimeter of an object does not glow the object itself, just around its edges, making it appear to be lit from behind: perfect for backlit signs.

One word of warning at this point: lens effects are often measured in pixel sizes, so a change of rendering resolution can change the relative size of these glows. Before changing the output size and simply rendering, it's best to check on how the glows have been affected by this change. Additionally, maps can be used to control

Figure 12.04
Glows can be as intricate and psychedelic as you want them to be

glows, and this is where we encounter the most powerful and most tricky area of working with glows. By using gradient ramps, noise and so on, you can begin to set up some extremely intricate glows, with varying colors and falloffs as shown in figure 12.04.

Designing complex glows can be a painstaking process, as their generation is often fairly experimental, and the different elements of a lens effect can sometimes seem to work against each other. Start by considering the source of the glow and how this would behave, taking into account the atmospheric conditions and how this would affect the result. If it's possible to compare the effect you're looking for with a photograph, then do so, and if you can observe the glow in the outside world, go and do it. By giving yourself a reference in this way, you'll save yourself a lot of time in getting the glow looking roughly right. From here, getting the effect to look perfect can take a little experimentation and practice, like most things in 3D.

Tutorial - glows

In this tutorial you will look at glows, using the same neon sign that you encountered a few chapters ago, to experiment with the different settings. First you'll look at glowing unclamped colors using the chrome sign, then you'll take a look at applying glows to entire objects, followed by glows applied by material.

Open the C12-01.max file from the tutorials folder of the CD. You will see the same neon sign that you used in chapter 9, with a few of its elements currently hidden. First of all, we'll give the bright highlights on the chrome lettering a subtle glow, by assigning a glow to the scene's unclamped colors. Before we begin, in the Rendering > Render dialog, turn off the scene's antialiasing, as we're going to be doing quite a few renders and this will speed up the whole design process.

Next choose Rendering > Effects and click the Add button, specifying a Lens Effect. Now with this effect highlighted, change its name to *Lens Effect - Chrome Unclamped*. Down in the next rollout, select Glow and click the topmost arrow to add a Glow effect to the window on the right. Close the Lens Effects Globals rollout so that you don't alter anything here accidentally and in the Options tab of the next rollout, check the box labeled Unclamp. Leave everything else as it is and select the Parameters tab to bring this to the top.

Check the Interactive box under the topmost list of effects if it's not already checked and when the preview appears, change the Size value to 0.1. You should see the effect immediately update, giving you a glow that appears to be of the right size. However, its color is not quite right, so change the red Radial Color swatch

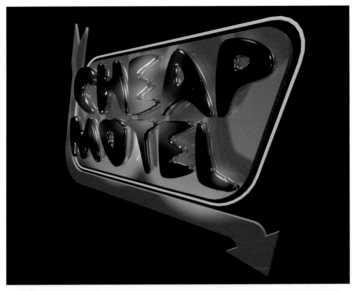

Figure 12.05
Glowing unclamped colors is an effective way of subtly reinforcing bright highlights

Figure 12.06
Using constrasting colors can help when designing subtle glows

to a pure yellow. To see the size of your glow more clearly, drag the yellow swatch to the left onto the adjacent white one and choose Swap. Adjust the Intensity until it looks about right, somewhere around 100 should do it, and then swap the yellow and white swatches around again. Rename this *Glow - Chrome Unclamped* and change its Size to 0.0 and then back to 0.1 to see the difference this effect makes.

Turn this effect off for the moment by clearing the checkbox marked Active. Add another Lens Effect, renaming it *Lens Effect - Neon Arrow*, then select another Glow, hit the arrow button

Figure 12.07
Object-based glows do not appear in raytraced reflections in 3ds max

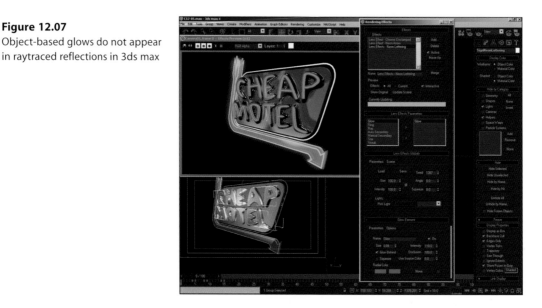

pointing to the right and in the Glow Element rollout rename this *Glow - Neon Arrow*. Unhide the *SignNeonArrows* object and with the object selected, right-click in any viewport, choose Properties, and change the G-Buffer Object Channel value to 2. OK this and hit the Update Scene button back in the Effects dialog to render again with this object included.

In the Options tab of the Glow Element rollout, check the Object ID box, changing its value to 2 to match that of the neon arrows. Now, in the Parameters tab, swap the two colored swatches around and change the red one to a pure yellow. Alter the Size and Intensity settings until you arrive at a value that looks both realistic and subtle. You should find that values of around 0.9 and 80 do the trick. You'll no doubt be able to predict the effect of changing the yellow color swatch to pure red. Do this, but then alter the Use Source Color to 50 and then 100 and observe what happens: the glow takes on a color that is a mixture of the Radial Color and the object's own color.

Leaving this value at 100, turn off this effect and Unhide the *SignNeonLettering* object. Right-click with this object selected and again alter the G-Buffer Object Channel value, this time to 4. Set up another Lens Effect as a Glow and in the Options tab of the Glow Element rollout, check the Object ID box, setting the value to 4. With Interactive turned on, change the settings of this glow to make a similar glow to the previous one, but cyan.

This might look just fine at first glance, but change the cyan color to a pure red and bring the size right down to 0.04 and you should see that this effect is not being rendered in its raytraced reflection. When this effect is required in raytraced reflections,

you need to apply glows by Material ID, so in the Options tab of the Glow Elements rollout clear the Object ID box and check the Effects ID box instead. When the scene renders again, you'll see that the glow has disappeared. This is because the Effects ID needs to be altered for this material too. So, in the Material Editor, at the top level of the *NeonBlue* material, change the Material Effects Channel value to 1.

If you hit the Update Scene button back in the Effects dialog, this glow should now render happily on the geometry as well as its reflection in the chrome sign. To change the glow back to the correct color, enter 100 in the Use Source Color field. Set the Size back to 0.9 before turning this effect off.

Now Hide everything in your scene and Unhide just the *SignPlasticLettering* object. Turn antialiasing back on in the main Render dialog. This object's material already has an Effects ID of 2, so set up another glow, using similar settings to the two glows already allocated to the neon objects, checking the Effects ID box and changing its value to 2 also. Give this glow a bright red color and turn it on, making it Interactive. You should know what to expect of your results by now.

In the Options tab of the Glow Element rollout, clear the All box in the Image Filters section and instead check the Perimeter box. This produces a glow around the perimeter of the object, it is true, but with terrible aliasing. Now switch instead to Perimeter Alpha and you should see that the results are vastly improved. However, this method is far from perfect and will often also result in strange aliasing. To see this for yourself, Unhide the *SignBack* object and hit the Update Scene button. You should see two problems: the

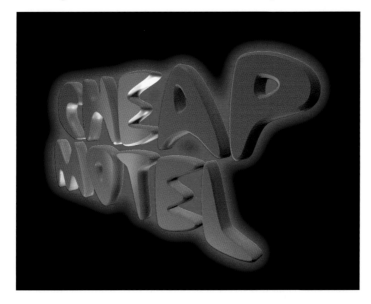

Figure 12.08
Glowing by alpha channel only works when there's nothing behind the object being glowed

first is that the glow is now horribly aliased and is most noticeable around the top left edge of the letter P. The reason for this is that the Perimeter Alpha uses the alpha channel in generating the glow. If there is an object behind the one glowing, then this also forms part of the alpha information, so the glow does not know how to position itself correctly. You should be able to see that the left-hand edge of the sign is still antialiased perfectly.

If you hit the Display Alpha Channel button in the menu bar above the Effects Preview, you will see why: the alpha channel still forms the edges of the leftmost letters where there's nothing behind. This has obvious implications. The second problem is that the glow does not work well with raytraced reflections: you'd expect the glow to go over the top of the raytraced reflections of the letters, but as you can see it does not. Switch from Perimeter Alpha to Perimeter and max works out where the perimeter is a little better, but not accurately, and the glow is still not raytraced properly.

Lens flares

Perhaps the most overused visual device in CG, the lens flare is used to bolster the impression of reality. As a visual hook, it instructs the audience that what they are seeing has been captured through a lens, when in fact it has been nowhere near one. If it had, the chances are that the artifacts one would see on the film would be much less pronounced than their faked CG equivalents. The manufacturers of such lenses strive to ensure that their components produce as few of these visual artifacts as possible, as those working in movie making and photography see them largely as unappealing.

Love them or loathe them though, the lens flare certainly does work as a visual hook in CG, and like everything else, when used subtly and sparingly, they can certainly add another layer of reality to the overall illusion. However, when used abundantly and freely there's nothing that quite gives a piece of work away so unmistakably as being computer generated.

Building lens flares can seem a little intimidating at first, but this is only because a lens flare can consist of many different parts - stars, streaks, rings, rays and so on - but these individual components are certainly no more complicated than the glows that you just looked at. The key to building successful lens flares is to approach them as a layered composition, tackle each component individually and the process won't be nearly as nerve-racking. Like everything else, practice makes perfect, and you should maybe start by dissecting the examples that come with your software. Trying to replicate these examples from scratch could perhaps then be the next step, or if you've got a copy of a recent sci-fi movie kicking around, take a good look at the many lens flares and how they appear.

Tutorial - lens flares

In this tutorial you will look at how to create a lens flare from the sun, shining directly into the camera over a body of water. You'll build up the various different components that make up a lens flare into a realistic looking flare and add some fog to make the scene more hazy and likely to produce lens flares.

Open the C12-02.max file from the tutorials folder of the CD. You will see a beach scene, which you might recognize from previous tutorials. However, this time, the scene is set up to be an evening sunset. If you render, you'll see that there's an image of a sunset placed as an Environment map and there are two lights that are providing the reflections on the water, as well as several others.

The first thing we need to do then is move this omni light down in the Camera viewport, hitting the Update Scene button, until the glow is centered on the sun in the plate. Now alter the Use Source Color until you're happy with the glow's color. About 50 should do the trick. Change the Size value to around 100, until the effect looks right, and bring down the Intensity slightly to 100. One important thing remains, and that's to clear the Glow Behind checkbox, which will make the effect look like it's happening in the lens, rather than at the source. Watch the effect of this change on the foreground of the scene.

Add a Ring entry to the list of Lens Effects and watch the preview update. The ring as it appears with its default setting is much too big, so change the Size value to about 2.5 and reduce the Thickness to about 2.5. It is also way too bright, so bring down the Intensity to somewhere around the 25 mark. Again, clear the

Figure 12.09

To give the secondary flares realistic falloff, edit their Circular Color Falloff Curve

Figure 12.10
With a little fog applied, the scene looks much more likely to produce this kind of lens flare

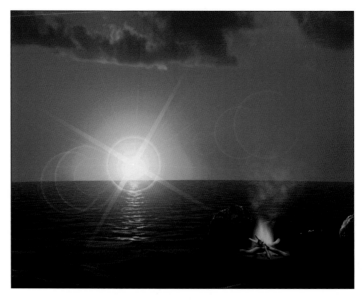

Glow Behind checkbox if it's checked and set the Use Source Color value to 50. Next, add a Ray entry. This component is not too far off what we want and just needs to have its Size value reduced to 200 and the Number value brought down to about 30.

If you're finding that the previews are now starting to take just that little bit too long, turn off one or two of the previous components. Add an Auto Secondary entry and first of all set the Minimum and Maximum values to 0.25 and 4.0 respectively. Increase the Intensity until these artifacts look right, which you should find happens around the 40 mark.

To make these secondary flares appear more realistic, open up the Circular Color Falloff Curve and adjust the points so that the secondary flares fall off from one side to the other. You should find that the values shown in figure 12.09 give a nice gentle falloff from the left to the right.

Finally, add a Star entry to the list of Lens Effects and watch the preview update. The result is rather large and unrealistic, so alter the Size and Width values until you're happy with the result, you should find that around 50 and 2.0 respectively look good. Now set the Quantity to 4 and the Angle to 30 and you should have a pretty decent result. Don't forget to clear the Glow Behind checkbox if it is checked.

Now turn off the Interactive option and turn all of the components of your lens flare on before hitting the Update Effect button. With all of the flare's parts displayed together, you can finally judge what your effect looks like as a whole and begin to make any little tweaks that you might think need making.

The flare looks pretty good, but the whole scene looks just a little bit too clear, and it's unlikely that such a sunset would appear in very clear conditions. First, change the antialiasing setting in the main Render dialog to Soften, altering the Filter Size to 4.0. This will soften our rendered output slightly, but the scene needs something by way of an atmospheric effect. Open up the Environment dialog and add a Fog effect. Give the Fog a color of around R:210, G:160, B:130, check the Fog Background box and set the far value to 30%. Now turn on your Fire and Volume light atmospheric effects and render once more.

Highlights

The kind of highlights that you might see when looking across a body of water on a sunny morning can also be a very effective visual device when used sparingly - like all lens effects they too can also have quite the opposite effect if they are used too heavy-handedly. These kinds of sparkling star-like streaks radiate from light sources of high intensity, as well as reflections of these sources off shiny surfaces such as water, chrome and glass.

Highlights might seem similar to some of the elements that make up a lens flare, but they differ in how they are generated. Whilst lens flares actually appear within the camera lens and glows are generated at the source, highlights actually occur within the human eye. Whilst the source does not produce the highlight itself, the eye perceives the highlight positioned over the source, which needs bearing in mind when designing these kinds of effects. Highlights appear for various different reasons, which can be as simple as moisture on the eyeball refracting the light.

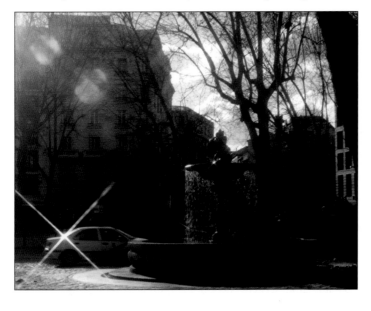

Figure 12.11
Lens filters can be used to exaggerate highlights

Different 3D applications generate highlights in different ways. In most they are simple 2D effects whose appearance depends largely on their distance from the camera. As such, they can generally be added at the final stage of a project, when rendering. However, as these effects are also dependent on the shininess of the materials in the scene, it's a good idea to bear in mind their inclusion from the moment that the design of materials and shaders begins. As well as using shiny surfaces, the lighting set-up can also affect the appearance of highlights, and it's the intensity of lights that is the primary factor in how highlights will appear. As such, highlights often look good when combined with a subtle glow, applied to the unclamped colors where the highlights will also appear.

Tutorial - highlights

In this tutorial you will take the beach scene that you just used when creating a lens flare and you'll look at how to create highlights sparkling on the surface of the water.

Open the C12-03.max file from the tutorials folder of the CD. You will see the same beach scene that you've just been working on. The first thing to do is turn off the effects in the Rendering > Environment dialog. Also turn off the current Lens Effect, before adding another, specifying just a Glow from the list below.

In the Options tab of the Glow Element rollout, check the Unclamp box and check the Interactive box. After the preview has generated, you'll see that the specular highlights on the water don't really receive the glow. Instead there's just a large glow that seems to be centered on the sun. This is OK; we just need to make some alterations in the Parameters tab. First of all, change the Size value to 2.0. This shows you that the water's specular highlights are not actually glowing, just the sun in the background plate and the fire.

The problem is that the Specular Level of the *Water* material is not high enough to produce the unclamped colors that the glow is applied to. If you change this setting in the Material Editor to 500, then hit the Update Scene button back in the Rendering Effects dialog, you should see that your water now generates the glow too. However, it is still less than perfect.

If you change the Use Source Color value to around 70, this makes a big difference, as now the glow looks to be the right color at least, and this lessens the effect around the fire. Back in the Options tab, change the Image Filters from All to Edge, which will lessen this effect further. In the Parameters tab, reduce the Intensity value slightly, to around 90, making sure that the Glow Behind box is checked.

Figure 12.12
The water's Specular Level is too low to produce the right glow

Figure 12.13
Changing the material and updating the preview fixes this

Now turn on your existing Lens Effect, turning off Interactive for this entry if it's turned on. The sunset is now glowing a little too strongly, so in this first Lens Effect entry, change the Glow's Intensity to 50 and click the Update Effect button. This now looks much better, and the water's highlights are glowing nicely. Now that you have these two effects working together harmoniously, turn off the first one, leaving just the water glow turned on.

Close the Rendering Effects dialog and open up the Rendering > Video Post dialog. Click the Add Scene Event button in the top menu bar and OK the dialog that appears, checking to make sure

that Camera is displayed from the drop-down list. Next, click the Add Image Filter Event button, choosing Lens Effect Highlight from the drop-down. Your two entries should appear on the left-hand side of this dialog directly underneath each other. If they appear offset slightly from each other from the left to the right, you should delete the Image Filter Event and add it again, making sure that the Camera Event is not selected when you do this.

Now double-click the Image Filter Event icon and click the Setup button. Press the Preview button, then the VP Queue button to bring the scene into the preview window. In the Properties tab,

Figure 12.14
With your two Events listed in the Video Post dialog, hit Execute Sequence to begin rendering

Figure 12.15
Your finished highlights should be subtle and not overwhelm

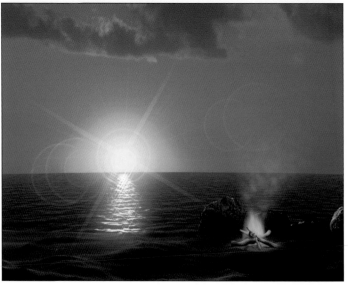

set the Source to Unclamped and click the up spinner button next to this value to increase it to 4.0. You should now have your highlights appearing only on the water's surface. In the Geometry tab, set the Angle value to 30 to match the value of the Star component of your existing lens flare. In the Preferences tab, set the Size to 10 and reduce the Intensity to around the 30 mark, which should give you a nice subtle effect.

Turn on the Lens Effect that you turned off earlier and click the grayed-out Queue entry in the left-hand side of the Video Post dialog to select both of the events you created. Finally, hit the Execute Sequence button in the top menu bar, typing in the same resolution settings as appear in the main Render dialog (768 x 439). Specify a Single image and hit Render. You should now see your scene with all the atmospheric effects, the Lens Effects and the Video Post highlights that you've just created.

part 3: tips and tricks

13

'The difference between pornography and erotica is lighting.'

Gloria Leonard, US Publisher

Working efficiently

With the main techniques section finished, it's time to turn our attention to how all these procedures can be made to work together most efficiently in a production environment. The tutorials and content of the last portion of the book should hopefully have provided a thorough grounding in the various methods used to approach the many different tasks that a lighting artist can face. Now we'll attempt to tie everything you've learnt together into some kind of cohesive whole, looking back over the general principles involved and attempting to impose some order on how you should organize your working methods.

It is very difficult to actually teach somebody how to be a good lighting artist, because there aren't really any hard and fast rules, just a set of guiding principles and a whole heap of different techniques, many of which achieve the same thing in different ways. Nevertheless, one of the main points you should thoroughly understand by now is that lighting should be

Image courtesy of:
Graham McKenna
graham.mckenna@ntlworld.com

motivational, its purpose being to set the desired mood and atmosphere, thus establishing the all-important emotional connection between the audience and the production.

When setting up the lighting for a scene, there are thus many things that an artist needs to bear in mind and balance together: as well as creating the atmosphere and tone that the script dictates, the lighting artist must unify the scene into a cohesive whole whilst gently highlighting its focal points, as well as emphasizing the three-dimensional nature of the production. All of these motivational aspects must be kept in mind whilst ensuring that the many technicalities are also considered. The demand to keep render times as slim as possible is generally paramount, and knowing the many different methods of lighting can make for significant time savings.

It's no surprise then that you are more likely to deliver results that consistently fulfill these many different demands with an organized and efficient pipeline. Different artists and studios might do things as efficiently as each other by different means, but what they all have in common is established methods for setting out their initial lighting, putting this to the test, examining how this could be improved and revising their set-ups until reaching a solution. While there's no one right method for everyone, what follows is a suggestion upon which your working processes should be based.

The first step

When first looking at a potential lighting task, your initial thoughts should be of understanding. Before you rush into creating any kind of light, think of the inherent purpose of the lighting, the requirements of the scene and the potential methods at your disposal for completing this task. By taking the time to consider your options, you will hopefully identify several possible approaches, from which the most suitable route can be selected. With alternative approaches already determined, the responsibility will not rest so heavily with the single solution. If you have the time, these different schemes can even be taken forward together in parallel, at least until you arrive at a critical juncture which forces you to go forward with only one. At the very least, this time spent attempting to appreciate the demands and requirements of the lighting should rule out which approaches would be inappropriate.

By examining the requirements of a scene in detail before you even set about creating your first light, you're ensuring that you don't get pulled down one particular route too quickly without considering your options. It's always difficult to abandon one particular solution and start working on another, especially if this alternative approach has not until this point been given adequate

thought, and by giving the task at hand a small amount of thought before deciding on the best approach, you're less likely to have to do this, and you'll be better equipped should you have to. This might sound a little tiresome, but you should ensure that whatever machine you are about to work on has had its monitor properly calibrated, so that the output that you are seeing on screen is actually representative of your final output. Make sure that the program that you use to display an image for monitor calibration has any automatic color correction features turned off. A basic routine for monitor calibration is included on the accompanying CD, and details of how to use it can be found in appendix A.

The key

Once you are happily sat in front of your calibrated monitor, ready to begin the approach that you have decided is the most appropriate, ensure that there's no existing light sources in the scene as you first find it. You should also ensure that there's no ambient light in the scene by checking that this function is turned off. If you were to render now, you should get a black image, which is what you're looking for, a blank canvas from which to begin.

The dominant light source in your scene will determine where your key light is placed, which is where most artists would choose to start. This will generally be the main shadow casting light in the scene, so take care with this first light to make sure that you give shadow maps the resolution they need. Use the light's sampling controls to blur the edges of the shadows appropriately - remember, the closer the light to the objects it is illuminating, the sharper the shadow will be.

Figure 13.01
Before you add a single light, stop to consider your potential options

You will probably start with a single spot or directional light functioning as the key light, but consider the source that this light is representing. Does an area light better represent this? Or a group of lights acting together as an array? You might not choose to replace the light that's acting as your key at the moment, particularly when you consider that the use of area lights can have a really costly impact on render times. Nevertheless, identifying issues like this as you create each light can save a lot of time when you're trying to rectify a problem with a set-up consisting of dozens of lights. Take notes of potential issues and ideas like these as they present themselves; don't rely on remembering every aspect of every one of your lights. Place your lights steadily and purposefully, because even though you'll sometimes hit upon something that looks just right through pure serendipity, you're more likely to achieve the results you were after by being organized and methodical.

Fills and backlights

It's best to keep things relatively straightforward to begin with, so just as you'd be well advised to avoid area lights and arrays for your key, don't jump in and create fills representing every single instance of bounced lighting in your scene. Instead, think of the position of your camera and how the light from your key light would react in the scene and create only the ones with the most obvious contribution to your final output. Create these just as purposefully as you did with the key, making sure that nothing is obviously awry at this early stage. The chances are that all the lights you are creating at this point will change. Some might only be altered slightly; some will even get deleted should you decide to introduce arrays or area lights at a later time. Don't use this as an excuse for rushing things.

The same principles apply when it comes to placing your backlights. You don't need to go overboard initially, creating large amounts of lights in order to create the subtle halos of light that you might want to appear in your final output. This will just overcomplicate things very quickly. Instead work by the same straightforward principles you used to create your key light by complementing this with only a minimal amount of fills and some very simple backlighting.

As you create all of these lights, be very attentive to simple things like remembering to turn off the specular component of fills and backlights. Furthermore, get into the habit of performing a run-through of all of a light's options when you think you've finished creating it. This way, you'll more likely remember things like limiting the far attenuation of a light and so on. A little effort paying attention to basic detail at this point can save a lot of time and effort further down the line.

Figure 13.02
Use flipbooks or RAM players to compare your rendered output

Rendering

It's never too early to start rendering. Start your first rendering as soon as you've created your first light and continue to render tests as often as you need them. If your scene is already too demanding in terms of render times, there are many things you can do to speed up your renderings at this stage. Disable all supersampling, and motion blur, turn off antialiasing and even substitute standard materials over those that are render-intensive. You need to be able to see the effect of your lighting, and you can't do this without rendering, so make sure that you can actually render in a reasonable time to begin with.

Now, because you gave the scene a respectable amount of forethought and placed your initial lights steadily and purposefully, you will have a very clear idea of the role of each individual light and what each is supposed to be doing for the scene. As well as rendering the scene with all the lights on to check that you are getting the desired effect as a whole, you should also get into the habit of rendering with individual light sources isolated to test their individual contributions.

To judge the contribution of a single light source to a general lighting set-up, it's useful first to render with this light turned off entirely, then render again with the light on, using your 3D solution or an image editing application to display the results side by side. If your 3D application has a method of displaying two or more images at once - some applications have simple flipbooks, whilst others allow images to be placed in different channels, effectively on top of each other, with a divider splitting the image between the two channels - then use it. It's also a good idea to give the light

source that you are examining a bright color that makes its contribution stand out from the scene. A color that contrasts with the rendered image will show up its illumination most effectively.

This method can also be applied to different lights in the same scene to look at them comparatively. Again, use colors that contrast with the scene and with each other, so that you can easily identify their contribution. Be careful when you allocate colors to these lights, however, that you don't increase or decrease the light's intensity by choosing a color with a different value. By giving lights different colors in this way, you can examine how the contribution of different lights blend together, without confusing their overlapping illumination.

You will always need to keep an eye on what the effect of changing individual lights is having on the scene as a whole, but by looking at lights in isolation you are reducing the chances of unpredictable results. Most people like to build up a lighting set-up starting with the light with the most influence, moving through the remaining lights in order of influence, finishing with the subtlest. There is nothing wrong with either method, but you can also learn a lot by going back over your set-up the opposite way round, starting with the subtlest and analyzing how the lights build up together.

Figure 13.03
Giving lights contrasting colors can help you judge their contribution

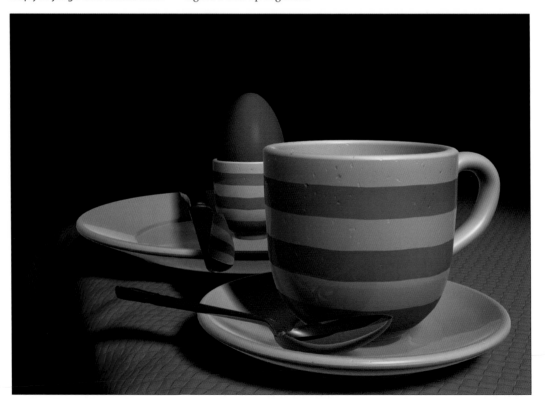

Revision

You'll spend the vast majority of your time making revisions to your set-ups, so it's important that you manage this particular part of the lighting process as efficiently as possible. From the moment you have a basic set-up in place that you are happy with, you will begin a gradual process of refinement that might well see these initial half dozen or so lights multiply into many times this amount, with the contributions of each light becoming more and more subtle.

The same rules that have been outlined so far still apply, but with the amount of lights increasing it's all the more important to stick to them. As you are replacing the lights that were initially created or adding new lights to complement your originals, it's vital that you understand the role of each light and how different lights are working together. Use all the tools that your 3D application has to offer on this front. Functions that list all of a scene's lights together in a single dialog can be very useful for quickly turning on and off numerous lights to render the contribution of different lighting elements. This kind of feature is also invaluable for looking over a scene's lighting as a whole, checking that all the relevant lights have their applicable features turned on.

These next few points might sound like obvious advice, but it's amazing how many people don't consider the most straightforward aspects of production. Set your applications to increment the files you are working on, so that you can always return to an earlier version to compare your results. This only works if you save your work at regular intervals too! Perhaps the most obvious advice is always to use a detailed and easily understandable naming convention, in order to keep track of your many lights and their purpose. This will be plainly apparent to most people, but is of paramount importance, especially if your work gets passed from person to person in a studio. Similarly, keep any production notes updated, so that the next person to come across your set-up won't be cursing you as she struggles to get to grips with comprehending it. Hang onto any notes that you keep on your desk as you work through the revision process towards a finished product, you never know when you are going to be asked to perform another revision.

Production pipelines

How your own working methodologies develop will depend largely on the pipeline that's in place at your studio. This will vary between different production houses and will depend on many factors: what business sectors the company works in, how many artists there are, how they are organized into teams and so

on. The job of a lighting artist often involves far more than just lighting. Indeed, more often than not a lighting artist's job will involve rendering, sometimes modeling and even animation.

If you work inside a small company with few artists, the chances are that the work is organized less by discipline. In this case, you could well be doing the whole CG gamut, from modeling to rendering via texturing and animation. This does have its advantages in that it's easier to track down individuals responsible for previous work and talk to them face to face about the scene, the work done so far and so on. This can also have its obvious disadvantages where you have people working in areas that are not their strong point. Frequently, in a smaller company you'll have one person who works solely on the rendering of a project. This person is usually responsible for all aspects of rendering; from material design and texturing to setting up the render parameters and producing the final render, and this job also frequently involves all aspects of lighting.

If you work at the opposite end of the spectrum, in a big production house, where a production gets passed through many stages from its initial developmental phase right through to compositing, the higher the chances are that you will be doing nothing other than lighting work, or at least lighting with a little rendering. Large production houses often employ technical directors - known as TDs - whose job involves looking after the teams of lighting and texture artists, as well as writing shaders and other custom software with the studio's research and development staff. The advantages of working in a structured set-up such as this is plain to see you have people working only in their areas of expertise and so the quality of work is likely to be higher. However, this type of system, with work passed from team to team, can feel a little too much like a production line in a factory.

Whatever size the studio, generally the lighting staff are involved personally with the texturing work, as these two tasks are very closely tied together. Revisions to materials and textures form an integral part of the lighting design process, which is why these two areas often overlap in terms of workload. However, it's not just ineffective texturing that needs to be altered when it comes to lighting, often a model's geometry prohibits it from responding well to a lighting scheme.

Modeling issues

You'll occasionally come across a model that just simply does not react well to lighting, no matter how much effort and how many lights you throw at it. The model is not necessarily badly constructed; it's just that it's not really been built with lighting in mind, which can make the job of lighting nigh on impossible.

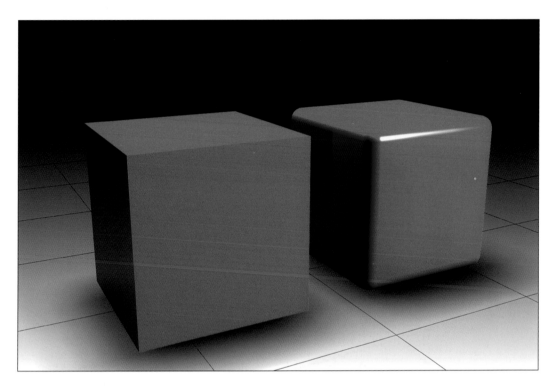

The problem lies mainly with models that are angular, which will not catch the light as well as more organic shapes, as you can clearly see in figure 13.04. The sharp edge of the box on the left does not create a specular highlight, whereas the small bevel applied to the box on the right gives us a subtle highlight that looks much more convincing. The only difference between these two models is the bevel, which is simply applied and makes a world of difference to the end result. Objects in real life that might well appear to have right-angled edges rarely do, and everything from cardboard boxes through to household furniture has a curve to its edges, no matter how slight.

It's important the modeling team bears this in mind and puts to use the more organic modeling tools, such as subdivision surfaces, that have pervaded 3D applications over the last few years, which make it much easier to create flowing organic curves that respond well to a scene's lighting. Modelers generally understand the needs of the animation team and build into their creations sufficient geometry where it's needed, around the joints of characters for instance. However, it's also important from the lighting team's point of view that sharp angles be rounded slightly wherever possible to give them a more realistic appearance that can be lit well. With communication between the different teams in a studio, issues like this can be avoided and the lighting team's job made easier, which also benefits the modeling team, who will see far less modeling revisions.

Figure 13.04
Modeling staff need to understand the needs of the lighting team

Texturing issues

Though you will sometimes be tasked with lighting an early version of a scene that's untextured, more often than not you'll be lighting a fully textured environment. It's beneficial to be involved in lighting a scene as early as possible, and if you are presented with an early untextured version of a scene, the lack of textures can be helpful in judging the influence of your lights and a decent lighting scheme at this stage can benefit subsequent texture design.

The more likely scenario, however, is that you'll be handed a textured scene that needs to be lit as quickly as possible in order to get the scene rendered. Lighting is something that seems to be regularly left until late in the day and needs doing quickly. The regrettable truth about lighting in most studios is that it is not really considered important enough to warrant the effort it actually deserves. Even when lighting is considered worthy of some time in the schedule, you'll often find that vital aspects of the scene are missing: the background plate you're working with is not the final color corrected version, for instance.

Though it is undoubtedly a welcome and refreshing change when the lighting design does begin at such an early stage that the textures have still not been produced, it's only when these are applied that you'll be able to really judge how your lighting scheme is taking shape. Textures make the world of difference to a scene's lighting and the purpose of setting up a fairly basic first lighting scheme is to see how these textures bear up.

Another reason why your first attempt at lighting the scene should not become too complex is that often a test render at this

Figure 13.05
Lighting of early untextured versions of scenes is not common

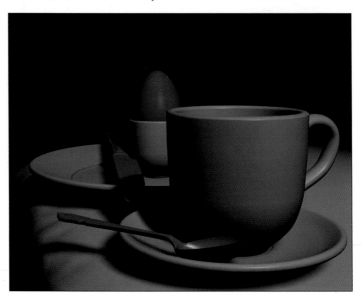

stage will reveal that the materials need revision and once this is complete, you don't want to have to readjust a complex lighting scheme again. Before altering a material based on the test renders at this stage, you should be sure that the lights themselves are not at the root of any problems - specular highlights in particular depend upon the lights around them.

Depending on the nature of the production in question, the problems that you will generally encounter at this stage will be with materials that look too perfect. It's easy to produce materials that are shiny and plastic-like; however, realistic materials are much less reflective than your raytraced material would have you believe, with much more by way of dirt, scratching and general wear and tear. If you generate details like scratches, water stains and so on, keeping them in a library for future use is a very good idea, as you will always need this kind of detail.

Keeping the saturation of colors down for natural materials can help make textures look more realistic, as can being subtle and cautious when using raytrace maps. These are just a couple of things that will help your textures look as good as possible and whilst texturing is not really the subject of this book, within the following chapter there are many tips and tricks, a good deal of which concern materials.

Figure 13.06
Only when textures are applied will you be able to really judge how your lighting scheme is shaping up

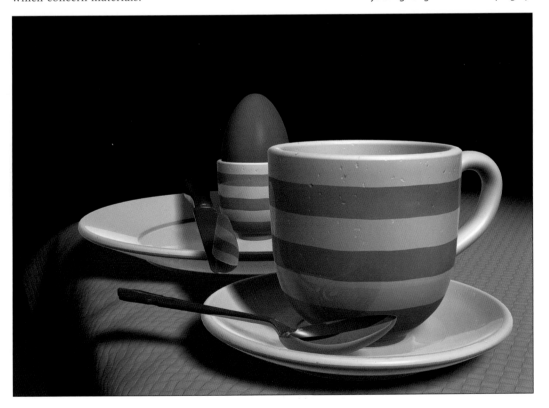

Lighting your scene to the best possible degree is only possible when the textures have been designed to an equivalent standard, and modeling too, though arguably to a lesser degree. No matter how big or small your studio, the different teams need to understand the needs of the others and there also needs to be a clearly defined approvals and revisions process for making changes when these are required.

More revision

There will always be more revisions, whether these are caused by new versions of materials, the arrival of a plate which was delayed at the telecine stage, or a straightforward request to change something from your client or boss. As such, you should never delete the old versions of the scenes you've been working on or the notes that you've been frantically scribbling since you started working on the scene. However, to avoid too many unnecessary changes being made, the approval and revision process should be organized in a simple manner.

The client has every right to question the decisions taken on his behalf, as it's his money that's paying for the work, but he or she needs to understand the scope and potential of the medium to prevent requests for the impossible happening. Furthermore, from the earliest meetings with a client, there should be put in place a structured schedule with clear definitions of what they can expect in terms of deliverables on which specific dates. This not only identifies what they can expect, it also sets down from the outset the demands that will be placed on your studio and enables you to schedule this work alongside any other projects that your staff might be working on.

Once the demands and goals of a project have been identified, it's important to establish good lines of communication within the teams that will be assigned to it. Depending on how big the project is, there could be any number of people and teams working on it. What is critical to establish early on is the approvals process and in particular who answers to who. The client will meet generally with key creative staff, who will be headed by one figure - generally the creative director or art director - though this will depend on your company and the project. The feedback from these meetings will be channeled through this one individual down through the leaders of each team working on the different elements of the production.

Similarly, the relationships between the individual artists at the end of the chain should be organized so that the hierarchical structure of approvals and revisions is as simple as possible. This should ideally include the team of artists at the bottom level of the chain - we'll assume we're talking about the lighting team - who answer to their TD, or whoever is in charge of their group.

This person should be the only figure who can authorize a lighting artist to revise a scene; otherwise you can start to get conflicting opinions. Similarly, this person should ultimately only receive requests for revisions through one person, and so on.

The client meetings should be organized so that they happen at key points in the schedule, based around the work, not the calendar. You want the client to approve things as they have just been completed, so that the project can move to the next stage of production to minimize the risk of rework at a later date. For example, you don't want to have to wait until your main characters are modeled, boned for IK and textured before your client tells you that he wants the modeling work changing. The meetings, workload and approvals all need to be efficiently managed in the schedule to keep rework to a minimum and efficiency to a maximum. Of course, this schedule needs to be flexible enough to be able to incorporate the changes that might be requested.

The client should be kept informed of the project at all times, and in the build-up to a meeting where work is to be presented, the client should be informed of what to expect. For instance, if it's modeling work that the client is being presented with, then he should know that the work will be untextured, that what he will see is a rendered figure rotating through 360 degrees under very basic lighting so that he can see all angles of the work. He should know that he's not going to be able to see the figure walking or in different poses, unless this has been specifically agreed beforehand. The expectations of clients have to be managed in this way, so that he understands the differences in delivery mediums, output formats and does not go away from one of these meetings feeling that the studio is not close enough to his ideas.

Figure 13.07
If only reviewing modeling work, make sure your client understands what this means

Similarly, it needs to be made plain what can and can't be changed after each level of approval. Don't expect the client to know the technical aspects that you take for granted. If the output is not to be rendered into separate elements and composited together, then explain the impact of this. You might feel like you're being patronizing, but it's best to talk to your client in straightforward terms rather than overwhelm him with technical jargon.

Preparation

Just as it's important to prepare your client for such a meeting, it's also vital that you are also organized and so are your staff. There's nothing like a high-powered laptop for these kind of meetings, but if you are using one, make sure that all the relevant files are on it and that you know exactly where they are. Using a laptop can be useful in that it can be used in isolation from the rest of the studio, but don't expect its hard drive's contents to look exactly like your own. Remember which 3D files generated which renderings and have everything stored in a logical system that perhaps mirrors how the production files are kept.

If you choose to hold the meeting in the production studio amongst the artists, you are more likely to know exactly where everything is stored, but you run the risk of the client seeing artists working on his project, which can be dangerous when your client suddenly wants to see the effect of a suggested alteration. The best bet is to have a comfortable area that's separate from the production studio, so that the client feels at ease and so do the artists. If you can connect your laptop to the network from here, then this is perfect.

Knowing where your files reside is only the start though; you also need to know about the work that these files contain and how this has altered from previous meetings. The client might well have forgotten how something looked during your last session and it's useful if you are able to quickly pinpoint any previous versions for side-by-side comparison. Take any notes that you have prepared about the work you are showing into the meeting with you, as well as any notes that you took during the last meetings, don't rely on your memory alone.

Finally, though you might have been working with a variety of styles as part of your own experimentations, it's not generally wise to offer the client choices between different images as to how something would look. The purpose of these meetings is to get things signed off and approved as efficiently as possible, not create extra work. In order to prevent this happening, you should also take extensive notes of what occurs in these meetings, and what the client expects by way of revisions for the subsequent meeting. Often the comments made by clients can be imprecise compared with the technicalities of the language of CG. If your client wants

something changed, make sure you both understand exactly what he wants changing. If an image is criticized as being too harsh, then is this a lighting issue or rendering? This may be something that involves simply using a different antialiasing filter, but it might also require a revision to both the textures and the lighting.

Furthermore, the client might be the one paying the money, but you should not be afraid of voicing your disagreement. However, don't take any criticisms too personally and be prepared to fight your corner and explain your decisions. If nobody mentions your contribution, then it means that it hasn't caught the eye and this is generally a good thing when it comes to CG, especially in these kind of critical environments. There will be times, however, when it would be politically correct to draw attention to your work to avoid the criticism getting bogged down in some detail that might lead to a troublesome revision, even if this work would fall on another team. If you're some way down the schedule, it's better to concern yourself and the client with tasks that fit in with this stage of the production's development than it is to have the client start up another discussion about the character modeling, for instance.

Guiding your client in this way through the production can be troublesome, but clear communication and a structured schedule with approvals points agreed with the client and based around the project rather than the calendar can make all the difference.

Pitching for business

If you're working in one of the smaller or newer companies involved in CG, the chances are that a lot of the company's time will be spent attempting to attract new clients and drum up new business. This can be a wearisome process, especially considering the tight budgets that most companies at this level are competing on. Nevertheless, a convincing pitch that's professionally put together can make the world of difference to discussions about budgets.

The average pitch is a two-stage process, which can be thought of as similar to making a job application. The first stage involves the initial approach, which is like sending out the CV that you've been working so hard on. The second is like the job interview, where you get to sit with the client and present your ideas. Both stages take effort, but once you have the basics of a polished pitch in place, you'll find the process much less frustrating.

The first step, after you've identified the companies that you want to approach, is to identify the correct individual to contact. Getting through to the relevant person straight away not only saves effort, but given a little effort to research some basics about both the company and the individual also makes you look much more

professional. This initial approach can be a tricky one, but by understanding a few basics about the company you're approaching this won't be so much of a cold call. Generally, your first contact will be made by telephone, in which your goal is to inform them that you wish to send them some basic information by way of an introduction, to which you'll hopefully get a reply that promises to take at least a cursory glance at this correspondence.

The information that you send should then arrive promptly, as promised, to the person you talked to, so make sure that you've got the correct email address. The email should be short, snappy and to the point. If you want to expand on any of the information, use a link from the email to the relevant part of your company website, which of course should always be simple enough to load in decent time, though it goes without saying that this should be visually appealing too; you are a creative company after all.

The follow-up call should certainly be made within the next week, too soon and you risk hassling the person before they feel they've had a chance to look at your document, too late and they might well have forgotten about the whole thing. It helps to keep some kind of log of calls with your clients, so you can remember whom you've spoken to, at what point and where you left things. The names of other people you've dealt with along the way, assistants and secretaries, should also be recorded, so you can identify everyone you've spoken to by name if asked. Certainly don't hound people at this stage if messages don't get returned, and if someone says that they are not interested, then say a polite farewell.

If, however, you get invited along to visit the company and make a presentation, then prepare yourself. This is where the stylish laptop comes in handy again. Make sure you have the relevant files to hand that you might need, but with your main sales pitch packaged together smartly inside something like Flash or PowerPoint. Never rely on the right codec being installed on someone else's machine, use your own and remember your power leads, passwords and so on. It's important to appear professional, but also approachable, and how you are perceived as a person will generally be established immediately, so be polite and reasonably informal at first. You should then briefly map out for them what the next fifteen minutes or so will involve, before leading them through your presentation. Allow them the opportunity to question you at any point, but try to keep the presentation flowing.

When you're done, leave them some information. Printed matter is always good at this point, because it does not rely again on codecs and software applications. This should sum up exactly what was covered in the pitch, so your prospective clients are not relying on their memory. If you are leaving a CD of sample work, make sure

it's simple to use and any movies use a simple codec that is likely to be on most machines. Pop the codec install on the CD too, with a note in a readme.txt file to explain how to set this up.

If this meeting went smoothly, all you have to do now is sit tight and wait for a response. The same rule applies about not leaving things more than a week, but again don't hound people, the last thing you want to do is to ruin all your good work by appearing aggressive at this stage. There's no guarantees that even the most polished pitch will work every time, so don't be disheartened to hear that your efforts were in vain, if you gave it your best shot just move on to the next name in your list of potential clients.

Experimentation

In between all of the regular work that's scheduled into your week, the meetings with your superiors and clients and any other involvements you might have, you'll also need to find to time for experimentation, both with your existing software and anything new that might be out there. Software in this industry changes at an alarming rate, your core 3D solution probably gets a major upgrade about every year and a half, and the stream of new plug-ins and complementary products is constant. Whereas radiosity

Figure 13.08
Don't be afraid to experiment, perhaps by taking existing scenes in a whole new direction

and global illumination for animation was unthinkable for the average studio to consider a couple of years ago, the increase in the power of our hardware gives the software developers the elbow room to be able to introduce such functionality.

The fact that hardware has increased as Moore's law predicted so far means that the applications we artists rely on get more powerful and as a result, more complex. Keeping up with just one major 3D solution can seem like a battle in itself, but for those involved with several systems plus plug-ins in a production environment, this can seem like a constant struggle. Upgrading for the sake of upgrading is never a good idea, but this is rarely the case in animation, and there's always some new functionality that will justify the move to the new release. It's important then that any new features and abilities of a new version are examined thoroughly and the existing techniques and processes in place tested against possible better new methods.

Many 3D artists find the time to work on personal projects in their spare time, which is always a good idea for keeping your skills sharp, especially if you work in a large production environment and your job description is comparatively narrow. Those in charge of the course at the college where I studied animation encouraged the students to do as many different short films as possible, with the onus on trying different things, rather than attempting just one marathon production. This was definitely a good piece of advice, and if you don't have the inclination to be working on a hefty side project during your leisure time, it's instead a good idea to stick to very short animations during any downtime that you might have at work.

Staying late at the office to work on something personal is understandably not everyone's idea of fun, but there will always be time to take a scene that's been produced for a client and rework it in a different direction than they requested, perhaps for the sake of experimentation. It seems that everyone in the business of computer graphics is incredibly busy, but nobody should be too busy to find some time to experiment and play a little with these great applications we all have at our disposal.

14

'Zeal without knowledge is fire without light.'

Dr Thomas Fuller

Tips and tricks

This chapter is rather different from the previous ones in that it gathers together all the tips, tricks and shortcuts that relate to lighting in one place, rather than have them sprinkled around the margins of the previous chapters.

This section is by no means an exhaustive one; it merely aims to put all the nifty little techniques that you'll have come across during the course of this book into one place, along with a few others that are of course relevant to lighting.

Whilst an attempt has been made to group these tips between headings, invariably the task of lighting is so closely tied in with other areas, such as rendering and materials, that these tips don't always fit comfortably into one single category. Nevertheless, these tips are all presented as short individual entries, so scouring through them should not take long, whether you're looking over them for something specific, or just hungry to find out more.

Image courtesy of:
Wang Jie
glintx@sohu.com

Lighting

1: Lights with negative brightness are sometimes used to add fake shadows into a scene. By adding such a light with its multiplier or intensity given a negative value, you can selectively darken a region. This technique is most commonly employed using lights with soft falloff to selectively and subtly darken a scene in areas like the corners of rooms, but it can also be a useful way of cheating quick rendering soft shadows.

2: Don't use the Multiplier value to increase the intensity of a light, as this will result in washed-out colors, instead use the HSV controls to increase its value. If a light is not bright enough with its Multiplier at 1.0, simply add another one.

3: To make a scene's lighting look more artificial, increase the green component of the colors of your lights, as you would with fluorescent lighting. Increasing this value by an exaggerated amount can produce some very stylized results.

4: Set your ambient lighting to black before you even begin adding lights to the scene, add some carefully thought out fill lights instead. If you do really have to add some ambient light, do it after you've placed all your lights and don't be too heavy-handed.

5: If you want to create shadows-only lights, but your 3D application does not support them, you merely need to create the light that casts the shadows you want, and then clone this first light. Then you should turn Shadow-Casting off the new clone and set the Brightness or Multiplier to the same amount as the first, but give it a negative value.

Figure 14.01
Tint your lights green to make a scene appear more artificially lit

Figure 14.02
Use an array of lights side by side
to avoid using large depth maps

6: Backlighting is something that has long been used with minia-
tures to heighten their realism. Similarly, in CG, lighting behind
and above the focus of your scene from the point of view of the
camera can result in quite an imposing and powerful feel. Provid-
ing you've got the computing power, applying subtle volumetric
effects to backlights positioned in this way can heighten this effect.

7: Because inverse square decay continues to calculate dimmer
and dimmer values as the distance from the light increases
without ever reaching zero, it's a good idea to attenuate the far
end of the light at a point where it appears to have reached zero.
This way you are eliminating any unnecessary calculations.

8: If you need to cast shadows across a wide area, rather than
just using one light, consider instead the use of an array of lights
to break up and cover the area between them, which will avoid
using large depth maps. Eight lights with a shadow map
resolution of 512 side by side would demand a mere 8Mb of
memory to render. This compares favorably with a single light of
resolution 4,096 (the same as eight lots of 512), which would
demand 64Mb, four times the amount.

Shadow map resolution² x 4 = memory requirement	
Shadow map resolution	memory requirement
512	1Mb
1,024	4Mb
2,048	16Mb
4,096	64Mb

9: Falloff maps are often used for special effects, where an iridescent x-ray look is required. Assigned to the opacity channel, this map type can be made to give an object a slight glow on faces whose normals point outward from the camera view, which applies the effect around its outer surface. Used very subtly, this can add to the backlighting of a subject quite effectively.

10: Omni lights can generate up to six quadtrees, so they generate raytraced shadows much more slowly than spotlights, using up more memory at render time too. Avoid using raytraced shadows with omni lights unless your scene absolutely requires this.

11: Every light can have its Diffuse and Specular illumination components turned on and off. This should be used to help enhance the realism of scenes: sometimes the specular highlight gives away the location of a light, when in reality the source light would be from too large an area to result in a specular highlight. Bounce lighting, for example, should always have its Specular component turned off when building up a faked radiosity solution.

12: This might seem obvious, but it's surprising how many professionals still don't stick to sensible naming conventions. My suggestion is that every light's name begins with its type, similar to max's default naming system - Direct, Omni, Spot etc. You then continue the naming with Fill, Bounce, Key and so on, before adding a short descriptive tag that will allow you to identify it easily. For example, SpotBounceYellow. If there is more than one of this type of lights, add a number to the end. max then groups all your spots, omnis and direct lights together, and all of your lighting will be easy to identify. There's no rigid rules here, this is just a suggested system, if you're happy with your own, then stick to it!

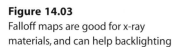

Figure 14.03
Falloff maps are good for x-ray materials, and can help backlighting

13: The attenuation of any light can be adjusted by using 3ds max's Non-uniform Scale tool to scale the light. Using this tool is the only way to create non-spherical attenuation around an omni light and can be a very useful method of controlling a light's illumination through different-shaped spaces.

14: Don't be tempted to place key lights (or indeed any lights) directly behind your camera, as this can lead to a very flat rendering that does not really emphasize the fact that it's 3D.

15: 3ds max does not like very small values used in a light's Hotspot and Falloff fields and automatically tries to keep two degrees between these values. If you are attempting to create a light where you want the outer Falloff value to be lower than this amount, this will cause problems, as 3ds max will automatically resize these values from time to time. The way to get round this is to set these fields to have much higher values and use the Select and Uniform Scale type-in to scale the light down to the appropriate size. The Hotspot can now come much tighter to the Falloff value and 3ds max will behave itself.

16: Using the shortcut CTRL + L switches from the scene's lighting to 3ds max's default lighting set-up, which can help to determine how a material has applied itself to an object when you've built up a complex lighting solution that has washed out the scene in your textured viewport.

17: When using colored lights, be careful about not making the colors too bright, as all bar the most muted colors will begin to blow out the lighter values of your rendering and it only takes a small amount of color to begin to tint a surface.

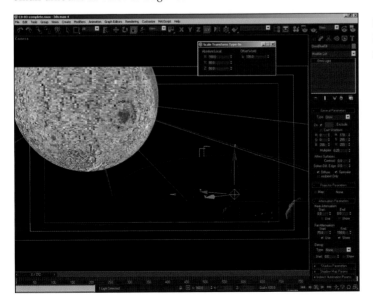

Figure 14.04
Use the Scale tool to stretch and squash a light's illumination

18: Most people find that starting with the dominant key light is the best approach when building up complex lighting scenarios. However, once established, it's often a good idea to turn this off and work through the lighting from the subtlest towards those with the most influence. This way the influence of even the smallest lights is not lost amongst the more powerful sources.

19: Rarely are lights ever pure white, whether natural or artificial. Just as different artificial light sources produce different colored results, so too does the sun's light, depending on the time of day. The color balance of the film stock that you're trying to mimic will also color the light sources differently. By coloring the lights within your scene, you'll be adding a depth that CG often lacks, and by exaggerating your coloring, you can establish a variety of moods.

20: For effective backlighting, your light should be created with increased diffuse illumination, and reduced specular illumination. This will lengthen the defining edge around the subject.

21: To create more pronounced highlights on an object without flooding the scene with too much unwanted illumination, add an extra light and only check the Specular component, preventing over-illumination of the diffuse colors.

22: To animate a light turning on and off in 3ds max, you can alter the Multiplier value using the Step tangent type to make the change instant, or you can assign an On/Off controller to its track.

23: If you've created an omni light in 3ds max and subsequently change its type, it will be targeted or oriented towards the grid of the viewport that it was first created in.

Figure 14.05
Turning lights on or off can be done using the Step tangent type

24: In 3ds max, once a Sunlight System has been placed, its settings are split between the Modify panel and the Motion panel. The first contains the controls for the direct light that the system itself has place, whereas the Motion panel allows the adjustment of the geographic location, as well as time of year and day.

25: Hidden with the Align tools flyout in 3ds max is the Place Highlight tool, which allows you to position a light controlling exactly where the highlight appears on the surface of an object.

26: To set a viewport to represent a light's view in Maya, use the MMB and drag the light from the outliner into the workspace. This can now be controlled in a similar way to how you would a camera.

Materials

27: Don't get carried away with raytracing reflective surfaces, as such surfaces around us rarely reflect more than a slight amount. Overly reflective marble and wood might provide interesting reflections, but it also looks obviously like computer graphics. No more than 5% should be employed for most materials.

28: When you're first designing materials that have raytraced components, turn off any anti-aliasing options globally, which will make the initial design decisions much more speedy.

29: Don't be afraid to take advantage of the Raytrace material's powerful parameters in 3ds max - Extra Lighting, Fluorescence and Translucency - in regular materials. With the Reflect option turned off, the extra time taken for a Raytrace material to render is negligible over regular materials.

Figure 14.06
A Sunlight System in 3ds max has its controls split between two panels

30: When designing materials, it's generally better to use a bitmap than a uniform diffuse color as surfaces of most objects contain subtle variations. Small color changes help to break up surfaces that otherwise might appear too obviously rendered, Photoshop's Clouds filter as well as the different Noise maps within your 3D application can be used to quickly add subtle variations.

31: Details like dents, scratches, water stains and so on are often applied as grayscale maps within a composite material. Keep all such textures that you generate in a library that will allow you to recycle and reuse them again and again, saving on time and effort.

32: Never underestimate the specular map when it comes to adding realistic detail. The way in which this component breaks up the specular reflection creates highly convincing results.

33: High Glossiness settings can cause a material's highlight to disappear and even for objects you think will be glossy, it's a good idea always to start with a low Glossiness setting.

34: To determine if your Ray Depth setting is high enough in 3ds max, within the Raytrace Global Options, set the color that max uses at its maximum depth to a bright saturated color that contrasts with the rest of your rendering.

35: For materials that represent natural surfaces, keep the saturation of colors below 170, because these surfaces are usually covered by a layer of grime or dust that keeps these values down. Higher values than this will begin to look like artificial surfaces. Using Blend materials for naturally occurring materials adds more randomness to a material that makes it appear more realistic still.

Figure 14.07
Keeping all your dirty textures in a library can cut down on effort

36: When modifying the Global Parameters for raytracing, bear in mind that these changes are applied to all materials, so using the Local Parameters on individual materials is often a better bet.

37: By using the Blur and Defocus options found in the Raytrace map and the Raytrace material's optional Ray Antialisers, you can avoid overly crisp and sharp reflections. These filters give a softer, rougher feel to the reflections and refractions.

38: By using the Attenuation controls found in the Raytrace map and the Raytrace material, you can force your reflections to reflect only those objects that are in the immediate vicinity of the raytraced surface. The most realistic Attenuation type is Exponential, which gives a realistic falloff to reflections. However, as with Inverse Square decay, the falloff can be too rapid.

39: When creating maps that are to represent naturally occurring materials, use procedural maps to add some noise and randomness to the materials, which will look much more convincing as a result.

40: Rendering materials that use the Cellular map can take a long time, so use 3ds max's Render Map feature to produce a bitmap and use this as a replacement for the Cellular map.

41: Bump maps are often used too strongly, which results in a loss of scale on larger objects. It's better to use your bump maps subtly and apply blur to them in your 3D application to prevent aliasing.

42: Procedural textures should be used with care as they can give work away as being CG. If you can, mix these textures with photographic elements to disguise procedural elements.

Figure 14.08
Bear in mind that altering Global Parameters applies to all materials

43: Use Photoshop's Offset filter to wrap your image back on itself before cloning out the seams in the middle of the image. Take care when repeating this texture, as tiling textures often look obvious. To hide the fact that bitmaps are tiling, use the same bitmap in both slots of a Blend material, though apply slightly different UV tiling to the second. The application of a noise material as the mask between the maps will help disguise the tiling.

44: Remove grazed lighting from your photographs by converting to LAB color, blurring the lightness channel and inverting it, then copying it using the Overlay mode to cancel out the lighting.

45: Using Blur Offset in 3ds max's material's options helps to prevent antialiasing and a small amount should always be used.

46: When using a Refraction map in 3ds max, be sure to keep the Opacity at 100%, otherwise the effect will not work correctly.

47: Use the smallest aperture that you can possibly get away with when photographing texture maps using film to avoid any potential problems with depth-of-field that happen at larger aperture sizes.

48: The power of the Global Ray Antialiaser within max's Raytrace material lies largely in its ability to blur or defocus pixels. When blurry reflections or refractions are not needed, just enabling SuperSampling can often be all that is needed.

49: max's global setting for its raytrace depth defaults to a maximum of 9, which is overkill for most scenes. Calculate how much depth is actually needed in your scene (2 or 3 will usually suffice). This will result in much faster raytracing.

Figure 14.09
Use Photoshop's Offset filter and clone to create tiling textures

Figure 14.10
Photographing your textures should be done in diffuse lighting

50: For a raytraced object within a scene that you want to reflect a background plate, but don't want the actual plate object to render, first duplicate the plate and assign it a Shadow/Matte material. Now using the raytrace material component's Global Exclude list, exclude the Shadow/Matte plane from the raytrace.

51: Shoot your textures in diffuse lighting conditions whenever you can as this will avoid blown-out details and less work to get rid of the obvious lighting from the photograph. Of course, you should also keep the camera flat on to the subject so as to avoid extra work correcting the converging lines that would result. If you're using film, then its best to go for 100ASA if possible to avoid grain.

52: Use Maya's Texture View tool to create an unwrapped version of your object, before exporting this to Photoshop. Now you can use this image as your reference for subsequent texture painting.

53: Most 3D applications deal with square textures more efficiently than they do with rectangular ones. Working with 128, 256, 512 sized textures can also help speed up the rendering process.

54: In Maya, turning on the texture caching function will make sure that the application does not have to load all the individual image files into your machine's RAM when it is rendering.

Rendering and cameras

55: The over-the-shoulder shot is a good choice in terms of cutting down on workload: because you only see the back of one character, there's one less facial animation task required. Similarly, point-of-view shots don't require the presence of the character at all!

56: Softimage XSI has no default PAL camera settings, so set your picture aspect ratio and camera format correctly, then open the History window, copy these lines into the script editor window. You can now drag this script to a custom toolbar to create a new button. Repeat this for 25fps and you have a simple PAL set-up.

57: Motion blur can be a critical tool when attempting to convey something with a lot of movement and this is especially true for scenes containing something rotating. This is because the positions of a rotating object (such as a helicopter propeller) form a repeated cycle, which at 25fps can often appear to strobe or flicker. Motion blur is an invaluable tool in this instance.

58: For quick previews in Maya, you can turn off shadows whilst rendering in the Render Globals Special Effects section.

59: To reduce the visible effect of multiple camera passes in 3ds max's depth-of-field effects, try setting the antialiasing filter to Blend, with a Width value in the range 4.0 to 5.0, and a Blend value in the neighborhood of 0.1. (You choose the antialiasing filter and adjust its settings in the Max Default Scanline A-Buffer rollout.) Also, try reducing the Dither Strength value, in the effect's Pass Blending group, to somewhere in the neighborhood of 0.2.

60: When animating cameras, examine how the action is portrayed in your scene. If you have a camera that's mounted on a vehicle like a plane or car, adding some noise to the camera's movements can help to take the smoothness out of the move.

61: Rendering from a command line rather than from within Maya means that your machine can devote more resources to rendering.

Figure 14.11
Adding noise to camera movements can yield more realistic results

62: A good environment map is worth a great deal in a quality production, so if you can stitch together a panoramic taken on location, use this to get seamless environmental reflections.

63: Be sure to take advantage of Maya's Render Diagnostics to spot any potential problems before you embark on a time-consuming render. Furthermore, the Playblast feature should also be used to render quick previews before any full-res render is started.

64: When working with XSI's spotlights, use the View > Show Cones feature to visualize these in the viewport. Using the Manipulate tool now enables these cones to be dragged around to adjust the light's cone, spread and falloff parameters.

65: If you are attempting to optimize renders in XSI, be sure to switch on progress reports under Logged Messages in the render options property page to record render statistics which can then be saved from the History window for quick comparisons.

66: Think about which antialiasing filter is best suited to your task whether you're rendering for video or not. Sharpening filters such as Catmull-Rom are best suited to still images, whilst video work benefits from softening filters. Some scenes, like those set under water, will benefit from extra softening.

67: If you want wireframe renders in XSI, try using the Toon Wire shader along with the Cartoon Lens shader. Connect the first of these shaders to the object's material surface and the second to the camera input. Now you need to edit the properties of the Toon Wire shader, using either Facet > Illumination to give hidden line rendering, or Facet > Ink Lines to produce full wireframe renders.

Figure 14.12
Consider which antialiasing filter is best suited for your scene

Figure 14.13
Try increasing the Filter Size option within the Antialiasing controls

68: Increasing the Filter Size option within the Antialiasing controls actually increases the size of the pixels that are averaged by the filter. This can be a useful option if your antialiasing looks a little awry.

69: XSI's Render Tree uses the standard zoom and pan controls, but pressing the ALT button and right-clicking in the workspace displays all the navigation and arrange tools.

70: When working with caustic effects or global illumination in XSI, the scene's ambient light is turned off to best see the effect.

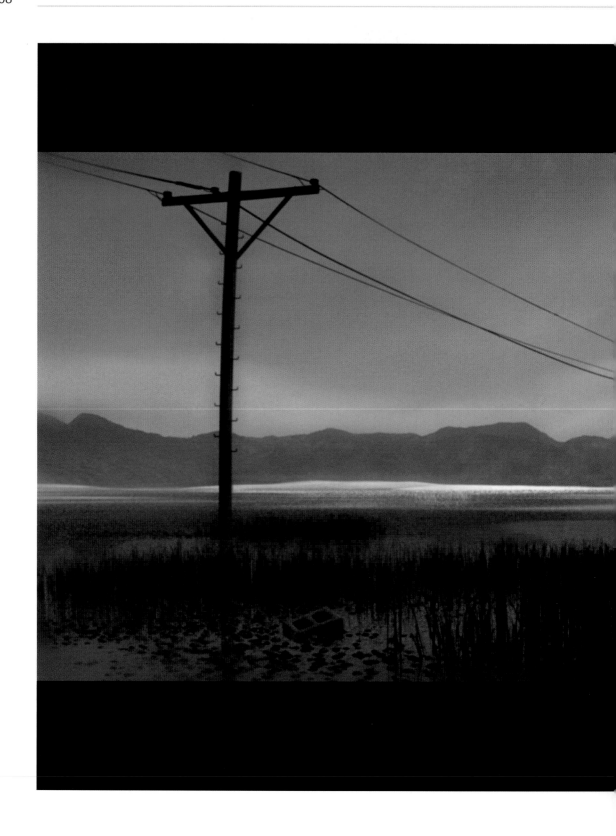

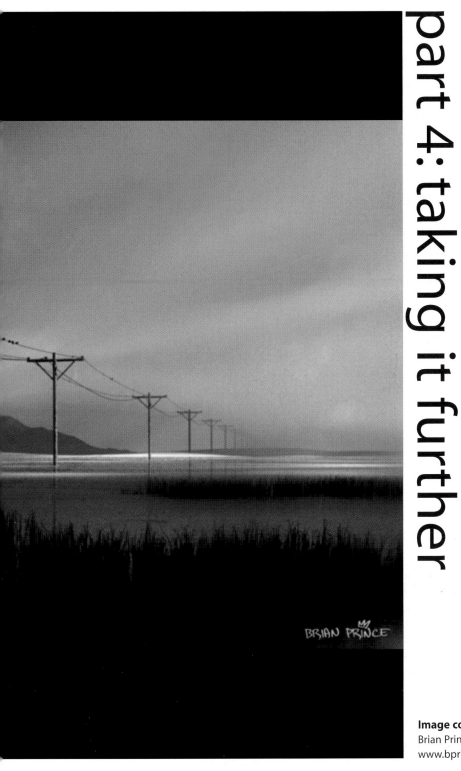

BRIAN PRINCE

part 4: taking it further

Image courtesty of:
Brian Prince
www.bprince.com

15

'Harmony of form consists in the proper balancing, and contrast of, the straight, the inclined, and the curved.'

Owen Jones: *Grammar of Ornament*

Visual storytelling

Though lighting has a massive role to play in cinematography in terms of visual storytelling, the lighting artist also needs a knowledge of concepts such as composition, camera positioning, staging, mood and depth, all of which are fundamental to the production of imagery in any medium, from film to photography, fine art to illustration. This chapter aims to discuss these concepts whilst keeping lighting in mind as central to all of these principles.

This area more than any other covered so far draws on principles from complementary disciplines, as well as from the psychology of visual perception, and because of this it is perhaps the area that those without a formal design or art background might want to research further for themselves.

What lies at the heart of good lighting, both in terms of the digital and real world, is the ability to put into visual form your ideas or your director's ideas about how a particular shot should

Image courtesy of:
Plaksin Valery
plaksin@ktk.ru

look. Discussions of such concepts as composition and staging deal with the ability to visualize each shot in context of its scene and consider the aesthetic possibilities afforded by the many different juxtapositions and arrangements of cameras, characters and, of course, lights.

Within any given shot the lighting should be focusing the audience's attention on the areas pertinent to the action, whilst reinforcing the depth and 3D nature of the production. It also has a vital role in conveying a sense of place in terms of the clues it can give with regard to time, both time of day and time of year. A good lighting artist also bears in mind the characters he is working with, and their personalities within each scene, thinking about how this can best be communicated, along with the overall mood and sense of drama that the script conveys.

With these fundamentals always kept in mind, let's move on and discuss the further concepts that can help to reinforce the visual structure of a production.

Composition

The concept of composition is perhaps best discussed starting with the context of cinematography and the different types of shots that are used by film makers. To ensure that your production sits comfortably within the established boundaries of recognizable cinematic conventions it's useful to know the different shots, and even if you're not going to stick strictly to these principles, it's always best to know how to work by the rules before you start to break them.

Figure 15.01
Accepted shot types in cinematography can be applied similarly to CG

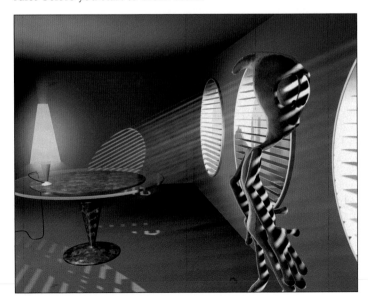

You'll often hear terms such as extreme close-up and wide shot in the context of filmmaking, and there are five commonly accepted shot types with the two just mentioned at both extremes. From the largest down, here's how they work in terms of a character:

Table 15.01 Common shot types

Wide shot
Often used to show a location alone, or one with one or more characters, this is the widest shot, which is also often used during action sequences and establishing shots.

Medium shot
Generally this type of shot shows a character from the waist upwards.

Medium close-up
Generally accepted as a head and shoulders shot.

Close-up
Focusing on one particular area, in this case the face of a character.

Extreme close-up
Frames a specific detail of a character's face, such as a character's eyes reacting to the action of a previous shot.

These types of shots can vary in context of the scale of the production that they feature in: in *Gladiator*, for example, some wide shots actually take in the whole arena environment. By contrast, in *A Bug's Life* this type of shot often takes in just the inside of the bugs' underground nest.

There also exist conventions that dictate how these types of shots are best used in relation to one another. For example, the first scene within a film will often start with a wide shot that establishes at once the environment in which the tale is about to be set. This is invariably followed by a closer shot that begins to give more detail, with the audience fully aware of the context within which the story is unfolding. When there's specific details or reactions that help to tell a tale, set a mood or reveal an aspect of a character's personality, the close-up and extreme close-up are useful tools, especially in communicating the emotional side of a story.

Bear in mind that it's all well and good going for the dramatic sweeping wide shots to create atmosphere that we've all seen in films as diverse as *Lawrence of Arabia*, *Ben-Hur* and *Apocalyse Now*, but without the tighter shots, the tale will lack a personal touch and the nuances of the characters will be lost. Similarly, if your production is made up largely of tight shots, then the whole context of the tale might well be unclear.

There are also specific types of shots that work together well when working with a particular type of scene. The most relevant of these to animation are the combinations that are relevant to character-based productions. When you have two characters engaged with each other, the most basic of the possible shots is called the two-shot and is shown in figure 15.02. This is a very simple way of framing the action, but can be a little short of dynamic in some cases.

However, just as wide shots are often used early on in a film to establish a context for a tale, a straightforward two-shot is similarly often used to initiate a scene involving the interaction of two characters, before switching to different shots.

One such shot is the over-the-shoulder shot (OSS), which appears just as you'd think, with the character whom the focus is on facing the camera, and the secondary character in the foreground, with the camera using their back to frame the action and place it in context. This is often accompanied by a depth-of-field effect to ensure that the audience knows immediately where the focus of the shot is.

This type of shot is extremely familiar from many, many films, and next time you sit down in a film theater look to see how this shot is used in combination with others. You'll often find that the OSS is used in combination with the equivalent shot, but from the other character's point of view. This convention, called the shot/counter-shot, is also often punctuated with close-ups to concentrate on a character's reaction, and works well in animation, not least because there's only one lot of lipsync or facial animation to be carried out at once.

Figure 15.02
A two-shot frames the action well but can suffer from being too static

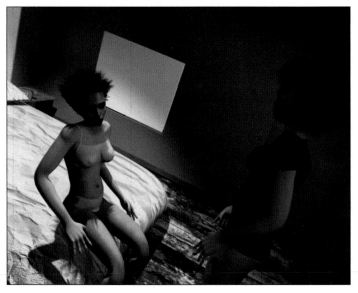

Figure 15.03
Over-the-shoulder shots can cut
down on animation work

A lot can be learned from these cinematic conventions, not just
in terms of composition using the physical objects and elements
within a shot: they can also teach us about using light with
composition in mind. Lighting's primary purpose is to
illuminate, but illuminate everything evenly in a scene and it's
often difficult for an audience to know where they are supposed
to be looking, which can lead to confusion and a loss of interest.
Lighting also has a purpose in terms of composition: to tell us
exactly where the focal point of a shot is, to enhance this whilst
not drawing attention to anything that's of lesser importance.
When a shot is on screen for only a matter of seconds, it's
important the audience is led as quickly as possible to the key
elements of the narrative.

This is essentially what composition in any visual form is all
about, directing the audience towards what is meant to be the
focal point of an image. As anyone with a formal art or design
background will tell you, there are many principles that relate to
visual composition. These principles are useful in that they can be
related to the planning of the layout of shots, but they can also
provide a valuable framework within which to analyze existing
imagery. Even early pre-visualization work can be relatively
complex in visual terms, and knowledge of the various principles
of composition makes for easier examination of the visual merits
and shortcomings of a particular shot.

As a lighting artist, you should always keep in mind that it's your
work that has the biggest effect on a shot's composition,
especially where relatively static shots are concerned. These
principles of composition are something that should be referred to
mentally when setting up the lighting of any shot.

Unity

When an artist steps back from a painting to look at the canvas from a distance, she is looking at the composition in terms of its unity. Though this is largely an instinctive process, there is a theory first developed in 1910 by three German psychologists that breaks down our intuitive tendencies into a framework of separate elements. Gestalt theory is actually a collection of principles that determines how we make sense of visual environments.

Though the word does not have a direct translation it can be thought of as the manner in which a form has been put together. Its essence is that a composition as a whole cannot be surmised from analysis of its individual parts. The theory, which has been applied to painting, architecture, photography and design over the years, is concerned with how we use patterns to view a complex composition holistically.

The lighting artist should bear in mind these principles in attempting to provide their compositions with unity, as they can be applied to the use of light, color and shadow. Applying Gestalt theory in this way can help in establishing a unified composition: if an image does not follow these principles it can appear too visually unappealing, because the brain can't make much sense of it as a whole. On the other hand, if these principles are adhered to too strongly, the brain can read it too easily and will again lose concentration. Gestalt theory presents a framework of principles for analysing composition, which can be broken down into several separate categories.

Figure 15.04
The principle of grouping deals with shape recognition

Grouping

Elements that are seen as being in close proximity to each other will be seen as belonging together, as can be seen clearly from figure 15.04, which we recognize as a number 2, rather than as a series of different colored dots. We are constantly comparing what we see with the many forms that we have already encountered in our lives in an attempt to make sense of the environment around us. Once familiar with a form or object, our brain records its various attributes for future comparison.

Taking the example in figure 15.04 a step further, we can clearly see within figure 15.05 the same number, despite the other dots surrounding it. The brain sees the elements that are in close proximity to each other and percieves these as a single entity. However, it is not just using proximity that our brains tend to assemble individual elements into a whole.

The way in which our brains group separate elements together is most clearly evident when these objects share the same attributes of form. This can be seen in figure 15.06, where the separate elements are grouped together by color, which is the attribute we use when we test for color blindness.

One tendency that we have which falls into the category of grouping is that of closure, or continuity, which is also demonstrated by figures 15.04 and 15.05. Despite the gaps in the shape of the number 2, the brain recognizes the underlying shape and perceives this as being whole, choosing to mentally fill in

Figure 15.06 (above)
Grouping is used within tests for color blindness

Figure 15.05 (left)
Grouping explains how we see shapes in random arrangements

these broken segments in order to form an unbroken contiguous form. Within figure 15.04, the lack of figure 15.05's additional dots reinforces this recognition, and if all the dots making up the number were of the same color this would be clearer still.

Emphasis

Try staring at a blank wall for more than a couple of minutes. Compare this with the ease with which you can stare at a wall with a painting, photograph or any other focal point (especially a television). A CG image can be thought of in a similar way: if the eye has nothing to focus on, then it will appear empty and listless. This is perhaps where the lighting artist can have the biggest effect: the careful and considered placement of lights can help to reinforce the location of the focal point of an image.

An image can have more than one focal point, but of these one should stand out, and it is part of a lighting artist's job to keep the audience's attention on the main focal point, whilst also emphasizing the secondary focal points to a lesser extent. Whilst this is being carried out, obviously the whole image has to remain harmonious. By looking at the script and the personalities of the characters involved, you can begin to identify what are the primary and secondary focal points of an image. From here a lighting artist can begin to formulate a scheme that highlights the desired areas and plays down any distracting elements. There are several means by which an element can be emphasized, which follow on from the aforementioned Gestalt grouping principles.

Figure 15.07
Emphasis through contrast is perhaps most relevant to lighting

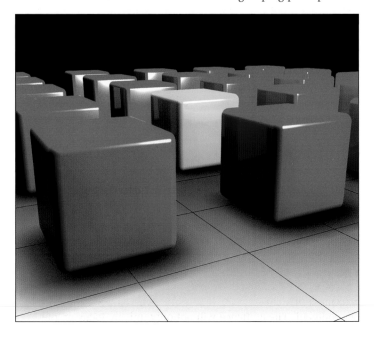

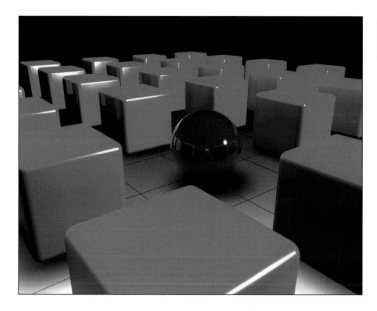

Figure 15.08
Our brain tends to sort objects into curvilinear and rectilinear

Using contrast to emphasize an area of an image is arguably the most effective and the most relevant to lighting design. There are several ways of making an element contrast with its surroundings: in painting and photography color, size, shape, texture and so on can be used to provide the contrast, but in animation you also have the added possibility of using motion. Whatever the difference, the brain automatically registers that something is breaking the overall pattern. The greater the contrast, the more obvious the focal point of the image. For example, in figure 15.07 the red cubes obviously have a great similarity to each other, but the yellow cube stands out quite clearly because it is of a different color.

This method of using contrast relates strongly to the grouping principle that we've already discussed. In deliberately choosing to allocate a contrasting color to the cube in figure 15.07, the element becomes clear because it is resisting the grouping of its surrounding objects. The fact that this element is not displaying the same behavior as the other cubes makes it a clear focal point. Isolating an element in this way can be a strong visual technique for drawing an audience into the desired part of a composition.

When our brains are evaluating the forms that we constantly encounter, there are many attributes that it is recording and comparing. Though there are many differing shapes of objects, our brains tend to group them into two categories: one consisting of curved forms and another made up of angular forms. We are instinctively more attracted to the more organic lines and this is something that we can take advantage of when setting up a shot. An extreme example of the use of this tendency would be the placement of a curvy character within a very stylized and angular environment. The audience will not only quickly focus on the

Figure 15.09
Shadows cast from vertical objects
can help to emphasize the
different planes of a scene

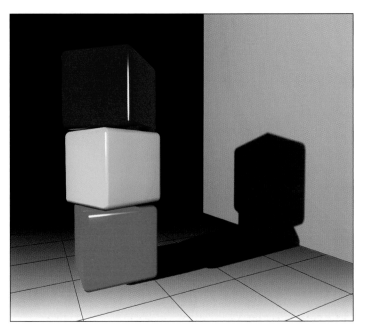

subject, but will also feel drawn towards it. However, taking
advantage of this categorization would usually require more
subtle means: the simple staging of a character within or beside a
largely angular form like a doorway or window would bring
attention to the curved form, making it more of a focal point.

One particular characteristic that we are very sensitive to is the
shape formed by the outline of a single form or several
intersecting forms. We will construct edges as part of the shape
recognition process as our eye scans along outlines of objects.
Just as our brain attempts to mentally connect small gaps, it will
also follow existing edges and construct new edges to elements
that almost touch leading the eye along the new outline. This can
be used as a potent device to lead your audience into an image
towards the desired focal point.

Furthermore, a shadow cast from a vertical object that falls along
the floor and up a wall behind the object emphasizes the fact that
the floor and far wall are planes of different orientations and
depths in the image. The visual power of vanishing points has
long been recognized and used as a visual device in painting.

This can be a potent device to lead a viewer's eye into a desired
area, especially when the composition's objects are also
purposefully oriented to point towards this region. However, in 3D
the fact that our vanishing points are set up for us can result in
our not giving them as much thought as we sometimes need to, as
our compositions can pull attention away from the desired focal
point of an image if they draw us into the image too strongly.

Conversely though, lines can be constructed that lead the audience's eye towards a desired focal point. There are several ways in which this can be achieved. The use of a series of physical objects, like a queue of people all facing in the same direction, can lead the viewer's eye into a specific portion of an image. However, these lines do not have to be constructed using physical elements, and the axes of objects, particularly those that are long and thin, will give a sense of linearity that can lead the eye, as will, of course, the sightlines of your characters.

If the line of people in this example were shuffling along, then the emphasis that this device would create would be further strengthened by its movement, especially if it were the only dynamic element of a scene. The use of motion in this way is something that we as animators can apply in many different ways.

Furthermore, just as motion can be used to provide emphasis in this way and direct your audience's eye through a shot, it should also be considered in the context of the different shots that make up a scene. How your elements are juxtaposed from shot to shot has a great effect on how your audience's attention will be guided across the screen.

One of the primary reasons why we can cut between different locations, characters and even times in the edit and not lose our audience is because of the way our brains remember and compare forms. This process of recognition is what binds together a series of complex cuts between shots.

One of the things that we are particularly good at recognizing is the human form, in particular the face. In our dealings with other people, we absorb a lot of visual detail from people's faces in order to remember them and are immediately drawn to this region of the human form. This is something that can be demonstrated quite clearly in cinematography's over-the-shoulder shot. Given the back of a head and a face to choose

Figure 15.10
Larger objects attract us more, but if only the smaller object is fully within the frame, this is reversed

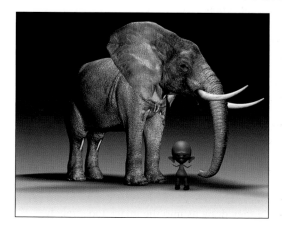
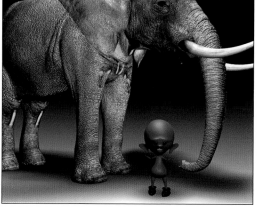

Figure 15.11
Emphasis through tangency
creates an uneasy tension

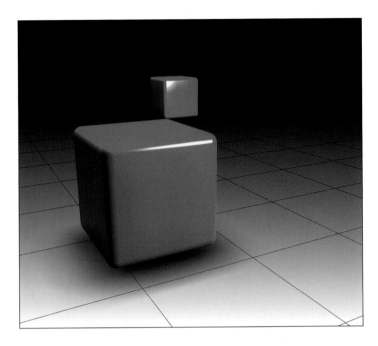

between, we unsurprisingly choose to immediately focus on the face. Furthermore, if the back of the foreground character breaks the frame of the image, then we are even more drawn to the character facing the camera.

This fact relates to using size as a device for emphasis, which is one of the more straightforward methods of calling attention to something, as our brains are automatically drawn towards larger elements. An overly large character interacting with an exaggeratedly small one can be compelling. The contrast in size will draw us to the larger character, but if the camera moves and only the smaller character is contained within the frame, then the emphasis shifts to the other, smaller character.

The methods of creating emphasis mentioned so far are usually employed purposefully to stress the desired focal points of an image. However, tangency is a little bit different, in that it generally provides a negative emphasis, which is usually off-putting, creating something that the eye is not fully at ease with. Moving objects around to avoid such undesirable tangencies is not always the job of the lighting artist, but his or her work is also likely to result in similar uncomfortable tangencies. For example, if shadows form tangencies with other shadows or objects these in turn can become distracting.

Nevertheless, though tangencies will more often than not create an undesirable distraction, this visual tension can also be used constructively. By juxtaposing two elements that almost touch, our desire to see them connect attracts our attention.

Depth

Though we are lucky in many ways that our hardware and software automatically calculate depth into our rendered images, of course the sequence of images that are output is still flat and two dimensional and this depth is really an illusion. Though you might never guess, *South Park* is actually put together using Maya, and purposefully staged to look flat and 2D, primarily by having all the surfaces flat on to the camera. If the primary surfaces within a shot are facing the camera in this way, then a scene will not display the depth that it could. Similarly, bad lighting can rob a scene of its depth and the way that lighting is used to emphasize the orientation and juxtaposition of a scene's surfaces imparts a great deal of depth to a scene.

In determining the relationships of objects and their comparative depth in a moving image, we use many methods. We look at the comparative size of objects as a clue to which are nearer the camera. Similarly we look at which elements are overlapping others to judge which ones are in front of others. These are simple examples: just because an object is small, it does not necessarily mean it is in the distance, so our brain employs more complicated procedures to help identify comparative depth and size.

We must be careful not to do things to confuse these processes, like using narrow-angle lenses too thoughtlessly, as these reduce the sense of size and depth in a shot. Conversely, there are devices that we can use that provide vital clues: such as depth-of-field and focus. The way in which light casts shadows across a scene can be of great benefit in establishing the size and relative position of its objects, as can use of several other techniques.

Figure 15.12
Using narrow lenses can make a shot look flatter than you want

One of the primary devices for adding depth to a scene in CG is the use of atmospheric effects such as fog and mist or dust and pollen. Furthermore, these techniques also go a long way in enhancing a scene's mood. Just as smoke and fog machines are commonly found on live-action shoots, atmospheric effects should be understood by the CG artist as being part of their everyday toolkit for enhancing the depth and mood of a shot.

Equally, atmospheric effects can impart a sense of depth to indoor scenes, like in figure 15.13, where a row of windows runs down one side of the camera and shafts of light are penetrating across the view of the camera.

The biggest clues we use in judging depth are size and overlap. These factors are the most plainly understandable ways of stressing the depths of objects in a scene. When looking at the comparative depth of several forms, we naturally expect the larger elements to be nearer than the small ones. However, without a context to place these objects in, it can be impossible to make comparisons and judge which object sits at what depth. In these kinds of situation, making sure that these objects overlap can be a simple method of making this clearly apparent.

If we are familiar with the visible forms, then we will begin to make these judgments and for this reason we must be careful and thoughtful in our compositions, as figure 15.14 demonstrates. Though both pictures show a large and a small circle, in the lower of the two, the smaller circle looks as if it is located further into the image, whilst the topmost image looks more as if it is a

Figure 15.13
Atmospheric effects can impart depth to indoor shots too

Figure 15.14
The smaller circle looks as if it is located further into the image in the lower image

large and a small object. This is because, on the left, the two circles sit at the same position vertically, which is something that we should look out for when something does not look quite right in terms of its depth.

One thing that often betrays the depth of a CG production is scale, something that can also give away a miniature as being just that. If the scale of an object's textures looks wrong, whether this object is a physical one or a computer-generated one, it will stand out. Furthermore, it's these surface details that give us a great deal of information as to how close an object is. Though not strictly a lighting task, often a TD's responsibility will involve both texturing and lighting, and this is something that should be looked out for when something appears wrong with a shot. Generally it's the fact that a surface texture is of too large a scale for something that makes a scene look not quite right and this should be examined closely.

At the other end of the scale from these potentially problematic small objects, lie the forms of considerable volume, like a scene's buildings and the ground plane, which certainly have a large role to play in emphasizing depth in an image. An object whose volume recedes into the scene should be lit to underline this

depth. A building receding from the camera is a perfect example of something that can be lit to show off the depth of the scene, but lighting in this way is something that should really be employed at all times, no matter what the subject matter. Without lighting from different angles, any object will appear flat and uninteresting.

A very useful and powerful tool that can be used both to emphasize depth and stress focal points is color. Indeed, the value and saturation of these colors are also important factors in reinforcing depth. Lighter values often seem to be closer to the camera than darker ones, which fade into the background, and this is reinforced further in a shadowy theater environment. With bold colors in the foreground over more neutral tones, the viewer is left in no doubt as to what is the focus of the image. Using more saturated colors in the foreground of an image can add to

Figure 15.15 (right)
Lighter values at the end of a long room can draw the audience in

Figure 15.16 (below)
Saturated colors in the foreground and a muted, blurred background establish a very clear focal point

Images courtesy of:
Johannes Schlörb (right) -
www.schloerb.com
Arild Wiro (below) -
www.secondreality.ch

the perception of depth. This can be used, for example, to lengthen the appearance of a space, which will appear more elongated if the lighting is brightest in front of the camera, with a marked falloff towards its far end. Conversely, if this is reversed, as in figure 15.15, and the end of the room has a window with bright light emanating from it but falling off towards the camera, this can produce a very powerful image that draws us into this area. Similarly, if the background is out of focus because of a depth-of-field effect as is the case in figure 15.16, or if there's some fog in the environment, the more saturated colors of the background become diluted. This example also works because contrast helps us to judge depth and relative position. Areas of greater contrast we associate with the foreground and those of lesser contrast we perceive as being part of the background.

A rather strange phenomenon is the fact that warmer colors appear to be closer than colder colors, which is another property that figure 15.16 also demonstrates. This most likely occurs because the human eye needs to focus slightly further away to see a blue element than it would to see a red element in exactly the same location - this behavior is known as chromatic aberration and occurs in all lenses. As you can see, this can be used effectively to give a scene a tangible sense of depth, but as you can imagine, is not applicable to all situations. However, with the common practice of using blue light subtly as a night time fill to bring out the details in overly dark shadows, there's no reason why a practical light in the foreground should not be of a warm color to take advantage of this.

Mood and drama

Virtually everything that appears in a scene can affect the atmosphere of a production, from the set and the score to the characters and the camerawork. Getting the mood of a script over to your audience is something that can be achieved with lighting, but with most other components of a scene too. When considering the dramatic qualities of a scene it's worth bearing in mind the less obvious factors that will contribute to the mood of a shot, and how they can combine with your lighting scheme.

It's always worth remembering that as a lighting artist you work in a 3D environment, the end result of what you and your fellow artists have labored over is invariably a series of flat two-dimensional images. Keeping a camera view open in your 3D application should be something that is ingrained by now, but sometimes not even this is enough.

Though this view might demonstrate quite clearly how something is moving, the wireframe or flat shaded preview is a far cry from the final rendered image. The whole of your world might have

been laboriously constructed in three dimensions, but at render time all this depth is flattened to a bunch of pixels. When this occurs, every element becomes a flat form within this image and in these forms there lies a lot of emotive power. Within this context, our brain organizes things between shapes and spaces, both positive and negative, between planes, lines, edges and axes.

Vertical lines speak of movement and the built environment, whereas horizontal lines reflect the stable lines of the landscape and the horizon. These lines of course also lie comfortably parallel to the periphery of the theater or TV screen and therefore look at ease in this position. A common technique to inject tension and volatility into a shot is to roll the camera slightly; so all the horizontal and vertical lines are set at a slightly more dynamic angle, as is demonstrated in figure 15.18.

Just as using a slight camera roll in live action and CG work moves the stable horizontal and vertical lines to a more dynamic angle, giving the shot an uneasy look, placing objects to look

Figure 15.17
The use of contrasting areas of tone is a great stylistic device

Image courtesy of:
Plaksin Valery
plaksin@ktk.ru

Figure 15.18
Simply rolling the camera slightly injects a sense of tension

somewhat unbalanced can have a similar effect. Our feelings towards something that looks unbalanced are primarily feelings of unease but also of fascination. This is demonstrated by the eternal appeal of the Leaning Tower of Pisa. Looking at the instability of the structure, your mind wants to stabilize it, but of course it can't, which is why this is such a visually powerful building.

As we touched on in the previous section on emphasis, the eye will search for and follow paths within an image based on repeated elements, sightlines and edges, amongst other things. Two repeated elements make for a linear path that the eye will follow, with the eye drawn to objects placed along its length.

Repeating elements in an image is a very powerful way of channeling your audience's focus through an image. Our eyes will be drawn between these similar elements as the brain makes comparative judgments between them. In this way, repetition of

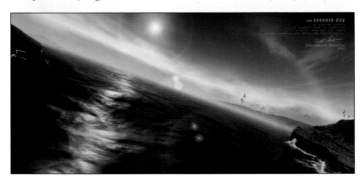

Figure 15.19
The two repeated land masses provide a linear path between them

Image courtesy of:
Alessandro Nardini
www.alexnardini.com

shape and color can not only bring about a sense of harmony to an image, but can also set up routes through the image which the eye will naturally follow. If only two repeated elements are used, then the path is a linear one, with our attention drawn to objects located along it.

As the number of repetitions grows, our brains begin to group these similar objects together as the grouping principle of the Gestalt theory describes. Taken further, we begin to separate the objects into different groups. Repeating elements in this manner over time can begin to introduce a sense of rhythm into a sequence, especially if the editing of these shots is done with this in mind, and whilst this is not often the role of a lighting artist, even when working as a TD, this should be taken into account, if the production is aiming for this sense of rhythm.

This concept of paths also applies to the overall balance of an image, where imaginary vertical and horizontal axes act as the pivots to the elements on either side of them. If the objects on either side of the vertical axis are perfectly mirrored, then this symmetry imparts a very stable, steady and secure feel to a shot. This device is frequently used in architecture, where this kind of formality is often desirable. Indeed, in attempting to portray formal settings, symmetry is a powerful tool. There was once an architectural lecturer under whom I was studying, who had a phrase that sticks in my mind to this day: 'Symmetry equals the box equals the coffin equals death.' The extremity of this statement is probably the reason why this stays with me, but he does have a point - there is a formality about symmetry that is not always desirable.

In CG, however, the use of balance about an axis can help to organize a busy scene into two halves, which gives an immediate central focal point. Balancing an image about an axis can at times create a more aesthetically pleasing image, as you can see in figure 15.21, but it can also have an effect on our interpretation of the script and the characters, especially where vertical balance about the horizontal axis is concerned.

Figure 15.20
Symmetry imparts a stable feel that is used heavily in architecture

As we'll cover in detail in the following section on camerawork, the vertical positioning of characters relative to the camera can carry a clear message about their personalities. This is because we

see height as one of the most noticeable characteristics of a person. Having a character visibly low in the shot can make him or her appear submissive, whereas placed towards the top of the shot, the same character can look much more dominant. We'll go into this in more depth in the following chapter.

We take cues as to our own position from the vertical position of objects, as well as obviously the location of the horizon, which we are used to seeing divide our vision just below the halfway mark. The vertical position of the camera gives us visual clues as to where you, as the viewer, are located, which is why for most regular work the camera is located at eye level. Even slight deviations above regular eye level can lend a feeling of power to the viewer, and this also works in reverse. If the camera is looking at a scene from the point of view of a character, targeting the camera slightly up or down can be very effective to help convey the type of personality that the character has.

In addition to these two symmetrical forms of balance, there also exists an asymmetrical balance that is a much more subtle and powerful device. Although it is also something that is far more difficult to accomplish, when carried out successfully it gives more understated results. The subtlety of this kind of balance takes out the staged aspect that can be all too evident with

Figure 15.21
The vertical position of the camera and horizon gives a visual clue as to where the viewer is located

symmetrical arrangements, but achieving this subtlety of balance can take a fair effort, especially when you are dealing with moving images. This is attained more by intuition than anything else, with the different shapes that make up the final image positioned within the frame to balance around its central point, given a distance from this imaginary point according to their visual impact due to size, color and so on.

There's a simple equation in math that states that Force = Mass x Distance from the pivot, which forms the basis of the calculation of the loads on beams in structural engineering, amongst other things. This can be applied similarly to balancing a composition, with mass representing the visual impact, which as we've already mentioned is principally determined by an object's size, but also by its color and shape.

If a large form is located a certain distance from the central point of the image, which can be thought of as the pivot, then a balance can be achieved by positioning an equivalent force in the opposite half of the image. If you are not balancing the composition using a similar object, then the distance needs to be altered proportionally with the relative visual impact of the two elements in order to result in the same force.

With a smaller shape, for instance, the distance from the pivot would need to be increased to result in the same force, so the smaller form would have to be located further away from the center of the image, towards the image's periphery. Balancing a composition in this way can make the shot appear stable and secure, as we are visually comfortable with it. Setting up this kind of harmony to break it down suddenly can be a powerful tool.

Figure 15.22
Asymmetrical balance is subtler but more difficult to achieve

Image courtesy of:
© Blizzard Entertainment
www.blizzard.com

Figure 15.23
The balance of positive and negative space should be considered

Positive and negative space

Our brains organize these 2D shapes that our final rendered images are made up of in several different ways. We obviously categorize things as being part of either the foreground or the background, but we also group things into positive or negative space. The positive space is formed from the main elements that are acting as foreground focal points, whilst the negative space consists of the adjacent background area.

Negative spaces aren't necessarily areas devoid of detail, as in figure 15.23, which demonstrates positive and negative space quite clearly, but they are the areas that don't catch the audience's attention. Despite this, care should be taken over how the negative spaces in an image are shaped and positioned around the positive spaces, and the balance between these should be kept in mind.

There is a balancing act that a lighting artist must constantly be aware of: the need to incorporate the separate elements of a scene into an integrated whole, whilst drawing out certain elements in order for the image to be immediately identifiable. Too much emphasis on one extreme can lead to too clearly defined an image, which is imminently understandable but dull. At the other extreme, there's the danger that the image will be too intricate, which can be beautiful, but also too much for an audience to take in quickly. Of course, this depends on the length of the shot and the action that's taking place: if it's a long establishing shot, the level of intricacy can of course go up a whole level of magnitude.

The rule of thirds

When putting together a shot, the rule of thirds can help in terms of arranging these shapes. By thinking of your image as divided into three sections vertically and horizontally, you can use these guides to help position your main elements. Positioning objects in the dead center of a frame can work in certain circumstances, perhaps when a deliberate symmetry is desired, but most of the time this looks too unexciting. By placing your elements along these imaginary lines, or on any of the four intersections, you'll straight away have a far more appealing arrangement. In landscape painting, you'll hardly ever see a horizon line placed exactly halfway up the canvas, as this can appear to divide the painting up too evenly, and this applies to CG shots as well.

Within any given shot the lighting should be focusing the audience's attention whilst reinforcing the depth and 3D nature of the production. It also has a vital role in conveying a sense of place in terms of the clues it can give with regard to both time of day and time of year. A good lighting artist also bears in mind the characters he is working with, and their personalities within each scene, thinking about how this can best be communicated, along with the overall mood and sense of drama that the script conveys.

Whilst the principles and theories discussed in this section should certainly be kept in mind when setting up individual shots in a production, sometimes there is simply not the time or budget to

Figure 15.24
The rule of thirds can help you to set up well-composed shots

set each shot up perfectly so that each one holds up individually. Indeed, often this is not even desirable. If a shot is only going to be on screen for a second or so, its composition will have to be fairly straightforward and plainly understandable, as this kind of shot needs to be comprehended almost immediately. The desire to change lighting from shot to shot in order to give each one individual treatment needs to be balanced with the need for continuity, though it's surprising how much you can actually do in terms of varying your lighting without drawing attention to this fact. Conversely though, being too afraid to change the lighting of a particular scene from one shot to the next can restrict the visual opportunities.

With these fundamentals always kept in mind, let's move on and discuss the further concepts that can help to reinforce the visual structure of a production.

16

'Film cameras are generally bulky, heavy affairs. When they move it is generally with a plodding massiveness that belies their inertia. Video camcorders on the other hand are light, flimsy affairs that we can fling around with mindless abandon.'

Scott Billups: *Digital Moviemaking*

The camera in 3D

Just as the new generation of moviemakers using digital camera equipment would be well advised to strap several kilos worth of weights to their lightweight DV units in order to make their shots look more filmic, in CG we have to be careful to stick to similar cinematic conventions.

We have it much easier than moviemakers in many ways, and one of them is the ease with which our cameras can be manipulated around 3D space. However, if you are looking to slot your production between conventional cinematic reference points, you would be well advised to follow some rules to make your camera and lights behave as if they would on set.

There's nothing that quite gives a 3D animation away as being CG than an overuse of camera movement, especially when the camera seems to move with a fluid ease that a real camera just simply cannot manage. The fact that you can move your camera

Image courtesy of:
Tom Marlin
www.marlinstudios.com

around in this fashion has led to this technique being one of the most overused practices in 3D animation. If you want the audience to look at your production as a film in its own right it's best not to remind them that they're watching CG with all kinds of unrealistic camera moves.

The camera's controls

In any 3D application the camera's controls mimic the movements that real cameras (and here we mean big bulky things, not lightweight DV affairs) make. However, there are several key differences. For instance, the pan function generally moves the camera itself, which should really be avoided as this does not happen in real life. Instead, rotate the camera as if it were on a tripod, using ease in and out curves to give the movement some weight. Similarly, a camera can be rotated to look further up or down, but generally would not be rotated around its remaining axis to roll, so you should avoid this control.

One control that is provided in 3D that mimics almost exactly its equivalent in the world of cinematography is depth-of-field, which provides the effect of focal distance in a real-world camera. Moving this focal distance gives what's known as a rack focus, and this can often be seen when action is changing from the foreground to further back in the shot, or vice versa. Animating your depth-of-field controls can easily imitate this kind of shot, though depth-of-field effects can be very expensive to render.

Zooms can be used, but if you watch most feature film work you'll struggle to spot a single zoom: the camera is actually moving closer to the subject, which is called dollying. Zooms are pretty much restricted to camcorders. Unless you are trying to

Figure 16.01
Amateurish camerawork seals the illusion in the stunning *Pepe*

Image courtesy of:
Daniel Martinez Lara
www.pepeland.com

make your 3D production look like it's been filmed using a hand-held camera, instead of animating the zoom feature, it's best to actually move your camera, but always try to give the move some weight.

However, these are not rules, just guidelines that presume that you want your animation to look like a film with high production values. There are times that you don't, and there is one particular animation that demonstrates beautifully how a well-crafted photorealistic environment can be made to look even more convincing by the use of shoddy camera work.

Daniel Martinez Lara's site - www.pepeland.com - is the home of a stunning animation called *Pepe*, which you can see in figure 16.01. Do try and download it, it's worth the effort. If you do, you can see when it begins that the illusion of reality is reinforced because of the unedited look to the footage of an artist's studio. The camera moves in, pans the studio and its focuses appear to be inaccurate and slapdash, typical of most home movies. These camera moves are in fact so deliberately constructed that it is this that completely clinches the illusion. *Pepe* is also as expertly lit as it is textured and without these skills, the illusion would never have been possible in the first place.

Line of action

With cinematic conventions we have the concept of the line of action, which dictates how different shots can be set up so that they'll look cohesive when edited together. This imaginary line of action runs directly between the two characters that are communicating, or in the case of a single character, runs in the direction that he/she is facing.

A moviemaker should never present a viewer with shots taken from both sides of this line, as it completely switches the action. This convention is quite useful in that it makes the task of the lighting artist easier, as the lighting set-up will remain if not the same then similar, requiring little by way of adjustment for different shots within a scene, with key and primary fill lights located on the camera's side of the line of action and backlights and possibly some secondary fill lights behind.

For regular work, most of these shots will be taken from around eye level. However, if you start to move the camera and its target up and down in this kind of circumstance, you can begin to add some drama to the shot, which suggests a surprising amount about the atmosphere and personality of the character. Low-angle shots make the character loom large over the audience, which has the effect of making him or her appear powerful and strong, which can be used well when trying to paint someone in a heroic light, or identify a character as being evil and powerful.

With high-angle shots the reverse applies, the character appears smaller, which can again be used to accentuate the fact that someone is small or childlike, but it can also emphasize that someone is vulnerable or pathetic. Furthermore, these kinds of angles have a similar effect on the actual environment within which the action takes place, making a character appear trapped in the corner of a room or having the space around someone look really open and expansive.

Perspective

This is just the beginning of the larger subject of perspective, which has a huge effect on how spaces are perceived. Take a simple scene and set up a camera. Now change the camera's field of view gradually from a very narrow 15 degrees up to a really wide angle of 85. See how the sense of space is drastically altered: not only do spaces look deeper, but also objects within them seem to be further apart the more the field of view is increased. And just as the distance between objects is exaggerated using wider angle lenses, so is movement towards and away from the camera.

Indeed, if your shot involves getting close to a character, and you want to keep more of a sense of the background in your render, you should opt for a wider angle lens. The fact that your camera is so close to a character also exaggerates their movement, which is useful for action shots. Likewise, if you are close up to a camera with a narrow lens, then the sense of depth can be lost, which might not sound awfully desirable, but can be quite useful for claustrophobic crowd scenes. However, get too close with a lens of too wide an angle and you start to get a fisheye effect, where the lens begins to distort the subject.

Narrow angle lenses distort things less, and this kind of lens positioned a distance away from the subject is the most becoming. For more natural looking shots the best advice is to work using your common sense. Keep the camera within the boundaries of the set that you have constructed and think about how a cameraperson would actually position himself or herself to get the equivalent shot. One thing that you should not really be doing, however, is swapping and changing lenses from shot to shot too much, as this will just draw attention to itself.

Point-of-view shots

Something that's considerably easier to set up in 3D than in real life and is particularly effective is the point-of-view (POV) shot. This is where a shot is taken from the point-of-view of a character, so what the camera records is what the character would see.

In cinematography a cameraperson would either have to be directed to mimic an actor's movements, or an actor would have to have a camera strapped to them, depending on the kind of shot that the director is attempting to capture. One great thing about 3D is the way that our cameras can be constrained to anything, so you really can capture what the character would see, no matter how small your character is.

The character from whose point-of-view the shot is taken might need to be hidden, it might not, depending on the scene. For instance, you might be happy with just the camera movement giving the shot its dynamic aspect, but you might also want the character's feet in the frame, or arms swinging by its side, depending on what you're trying to achieve. Indeed, a lot can be

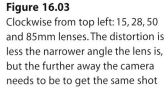

Figure 16.03
Clockwise from top left: 15, 28, 50 and 85mm lenses. The distortion is less the narrower angle the lens is, but the further away the camera needs to be to get the same shot

achieved using this kind of shot, from humor to suspense. For instance, if your character was a small dog that was chasing somebody down a street snarling and attempting to bite their ankles, then this would provide an unusual and amusing angle, given even more comic effect with the addition of growling noises. Alternatively, if you had a character about to jump out at another from a dark corner, rather than film this actually happening with both characters in frame, filming it from the point-of-view of the character about to get the fright will scare the audience in the same way, giving the shot much more impact.

POV shots are also useful in terms of workload, as you are effectively removing a whole character from a shot, which can make a big difference in terms of animation and rendering. In spite of this, there are also words of warning about the POV shot: its overuse can be quite off-putting, and as with most things, it's best used subtly, when it is given maximum effect. Sometimes though, it's difficult not to use the POV shot; for instance, a shot involving a person following another would be difficult to film without giving away the identity of the stalker.

Technical aspects

In the last chapter we discussed the art of composition. Now it's time to look at the important technical aspects that must be kept in mind when outputting your work for the different media that you'll want to work with. Whilst the comparative ease and cost of burning a CD makes this medium ideal for sending out a showreel, and the web is the best place to showcase your work to whoever wanders by, there's nothing to beat a full-res screening in a theater or even on a good-sized TV for leaving an impression. However, rendering for film and video has a few hazards due to the many different formats and aspect ratios that exist side by side.

PAL and NTSC

These two broadcast standards need to be understood if you ever want to have your work put onto videotape to be screened anywhere, whether this is in your own lounge or at an international film festival. PAL is the European system, whilst NTSC is the system employed in the US. PAL is considered technically superior to NTSC for several reasons: primarily its better resolution and the fact that the US system is notoriously bad at reproducing color. (Hence the acronym that you will hear jokingly applied to NTSC: Never Twice the Same Color.)

One primary difference is that both systems work at different frame rates: PAL at 25fps and NTSC at around 30fps. We say around 30fps because NTSC actually operates at 29.97fps, though 3D applications generally work at 30fps and use a standard

method of dropping 0.1% of the frames to output correctly. This is something that must be remembered, but is not generally something that will cause as nearly as many problems as you might at first think, especially when working from within 3D software, as this is dealt with automatically. These applications split your work up much more finely than the timeline suggests: 3ds max, for example, splits a second up into 4,800 segments, so when you pick any frame rate the software just takes the appropriate number of samples from this total.

Aspect ratios

The second major difference is the aspect ratio. This can be described in two ways: frame aspect ratio and pixel aspect ratio. The first ratio is the proportion of the width to the height of the frame dimensions of an image. PAL and NTSC both have the same frame aspect ratio of 4:3, that is 4 width to 3 height. These ratios are both the same because this is the aspect ratio of a standard TV screen, and this is at the end of the day what both systems get broadcast onto. 4:3 is also sometimes referred to as 1.33.

So far this has been easy to comprehend, but the complication comes when we look at the different ways there are of filling this identical rectangular space. Both PAL and NTSC can be achieved using varying resolutions. For NTSC, the first of these is 640 x 480, which will ring a bell with PC users as being the same resolution as VGA mode. However, 648 x 486 can also be used, which as you can see crams slightly more pixels into an image. Both of these resolutions will fit into the 4:3 ratio without having to be stretched vertically or horizontally, as 640:480 and 648:486 are both proportionally the same as 4:3. This means that every pixel will appear on screen as it began, square in shape. This

Figure 16.04
A 720 x 540 NTSC frame (inset) contains 14% fewer pixels than a superior 768 x 576 PAL frame

introduces us to the concept of pixel aspect ratio, which is the ratio of the width to height of each pixel as it appears in the broadcast image. Both of the resolutions mentioned so far have pixel aspect ratios of 1:1.

The complications arise because there are more flavors of NTSC that don't have this 1:1 ratio, and this is due to the fact that historically, different disk recorders have used different horizontal and vertical resolutions. D1 NTSC operates at 720 x 486, which might not appear to be a 4:3 format, but is because its pixels are not 1:1 or square, but are actually rectangular, with a pixel aspect ratio of 0.9:1, which means they are stretched upwards, giving them a tall appearance. Whilst this might seem odd, this is just a historical legacy that has to be dealt with and is not as difficult as it might first appear. If rectangular pixels are displayed on a square-pixel monitor without alteration, then images appear distorted; for example, circles distort into ovals. However, when displayed on a broadcast monitor, the images will be correct.

The various NTSC and PAL formats are listed in table 16.01 below, along with their frame aspect ratios, pixel aspect ratios and the aspect ratio regarding how they would appear on a computer monitor that can only display square pixels.

As you can see, this is a fairly confusing situation, and is less than perfect. If setting up a production from scratch and you have the choice, it's best to choose 720 x 540 for NTSC, as this is the biggest resolution that works on this broadcast standard that uses square pixels. The advantage here is that you'll be able to fit more detail in, and the pixels will be square, so your image won't appear distorted on your computer monitor. Similarly, if you're outputting for PAL, 768 x 576 gives the best option for the same reason. If you do a quick multiplication here, you can see that this PAL format gives you almost 14% more pixels in your image, which is one of the reasons why this format is considered technically superior over NTSC. Using a system with square pixels

Table 16.01 Broadcast formats and aspect ratios.

Format	Resolution	Frame aspect ratio	Aspect ratio on PC monitor	Pixel aspect ratio
NTSC	640 x 480	4:3	4:3	1:1
NTSC	648 x 486	4:3	4:3	1:1
NTSC DV	720 x 480	4:3	3:2	8:9
NTSC D1	720 x 486	4:3	40:27	9:10
NTSC D (Square pixels)	720 x 540	4:3	4:3	1:1
PAL D1/DV	720 x 576	4:3	5:4	16:15
PAL D1/DV (Square pixels)	768 x 576	4:3	4:3	1:1

Figure 16.05
NTSC DV footage as it would
appear on your PC monitor (left)
and when broadcast (below)

from the outset means that if you need to reuse footage for
streaming on the web or distribution via CD you don't need to
reformat the footage to display correctly on a computer monitor.

Widescreen and film

There's not a huge amount of difference in working to any
widescreen or film format over regular 4:3. The picture simply
needs to be composed for the following common formats:

4:3 (or 1.33) Standard television screen, whether PAL or NTSC.

16:9 (or 1.78) HDTV or widescreen television.

5:3 (or 1.66) A format popular in some parts of the world because
it's closer in shape to a television screen, so productions broadcast
in the theater will be fairly consistent when broadcast on TV.

1.85 (or Academy Aperture) Feature film format standardized by
the Academy of Motion Picture Arts and Sciences.

2.35 Another feature film format, sometimes referred to as
Cinemascope or Panavision, which are particular formats that
use this aspect ratio.

There are other formats that you may have to work with, but
these are certainly the most common. Your shots should simply
be composed to work when seen at these aspect ratios. Most 3D
applications show the view through the camera as a default 4:3
aspect ratio. If your output is to be 16:9, for instance, then you
should set your camera's aspect to match this, which is
commonly done through the rendering dialog, and the camera's
window should now crop the viewport image to how your scene
will appear when rendered.

What does need to be considered, however, is what you'll need to do if from another format you subsequently need to produce a 4:3 version as well for output on regular television. There are several options, the easiest perhaps is known as letterboxing. This involves sizing down proportionally the 16:9 image to fit across a 4:3 screen and placing it on a black background. The picture will then still be presented in a kind of widescreen; it's just that this version of widescreen should in truth be dubbed 'shortscreen'.

A second option involves simply cropping a portion of the 16:9 image from the left and right sides to fit the 4:3 screen. This is known as pan and scan, as the 4:3 portion that gets taken from the frame can be animated, so that this may be from the left of the 16:9 frame at the start of a shot, but by the end of the shot has moved to the right of the frame. This makes the process a little easier, but you still need to think ahead and make sure that the action that takes place in your 16:9 version occurs in a fairly central area, so that important elements won't get cropped off when it comes to the 4:3 version. Even with this taken into account, this method is often less than perfect in that it changes a shot's composition and framing, which can alter the whole emphasis and balance unnecessarily.

Figure 16.06
The Academy Aperture format has an aspect ratio of 1.85:1

Image courtesty of:
Norbert Raetz
home.t-online.de/home/nraetz

What was exposed on the negative does not always make it into the final image with film work. Some film formats expose a larger portion of the negative, which gets cropped down to fit the aspect ratio. However, for effects work, the full film frame is often digitized using the previously mentioned process called telecine. Capturing the whole frame in this way is known as scanning it at full gate. This means that the studio working on the visual effects

Figure 16.07
Here is the same image letterboxed to display on a 4:3 screen (left) and (above) resized using pan and scan

might have to render at an even larger size. This is especially true if the producers are thinking ahead to subsequent conversion to 4:3 and want the shot to be used with the full width of the frame in view. When you consider that rendering a full frame for 35mm 1.85 aspect work can involve image sizes of 4,096 x 2,214, a few calculations will reveal that a frame with this width and a 4:3 aspect is over 28 times the size of a single 768 x 576 PAL image. The upside of working like this though is the added flexibility that it provides in enabling a shift of framing, which can be incredibly useful in visual effects work.

Overscan

While we're on the subject of cropping, when broadcast on television, your PAL or NTSC frame will have the edges chopped off it slightly. Put your elements too close to the edge of the picture and you risk them being cut off or cropped when broadcast. This is because the cathode ray tube within a television set actually projects a picture that is slightly larger than its screen size. This process is known as overscanning and again is a historical legacy from the days when variations in picture size where caused by electrical current fluctuation. To cope with this occurrence, which varies from TV set to TV set, the animator must ensure that a border known as a safe area is kept around the action.

There are several guidelines for safe areas. Most 3D applications have the ability to turn lines on within the camera window to show where these safe areas are located. The smallest of these areas is the title safe area, or caption safe area, which occupies the middle three-quarters of a broadcast image. Around this is the action safe area, which takes up around 90% of the image.

Anything lying outside of this area should not be crucial to a shot, as there is the danger that this will be lost on certain television sets. Similarly, outside of this is the picture safe area, which will likely be cropped off on any TV. Don't ever be tempted to reduce your PAL or NTSC frame by 90% to save on rendering time, as some systems do show the whole image, including the overscan, such as broadcast monitors, projector systems used at film festivals and LCD screens.

Fields and motion blur

It was stated in a previous section that PAL and NTSC operate at 25 and 30fps respectively. This is true, but a screen refreshing at these rates would produce a noticeable flicker, so to eliminate this a single frame is split into two interlaced fields giving a screen refresh of 50 or 60Hz, which to the human eye does not flicker. This is something that you will need to be aware of, but is something that you'll not necessarily have to delve into, because most 3D applications have field rendering as an option and it's not something that you need to turn on unless asked to. The upside of field rendering is that it makes a shot appear smoother, but the downside is that it imparts a shot-on-video look, which is probably best avoided.

A better solution to field rendering is to use motion blur to give your work a smoothness that has a more filmic feel to it. There's more about achieving a filmic aesthetic in the following chapter. Motion blur can enhance the realism of a rendered animation by simulating the way a real-world camera works. A camera has a shutter speed, and if significant movement occurs during the time the shutter is open, the image on film is blurred. Motion blur is

Figure 16.08
Guides representing safe areas can be turned on in most 3D applications

Figure 16.09
Clockwise from top left: No motion blur, motion blur, fields and motion blur, fields and no motion blur

applied to fast moving objects in a scene to make them appear blurred in each frame, which will have the effect of making them appear to move smoothly in the finished animation.

If you are working with a live-action plate and need to match the amount of motion blur to your CG elements, there's a simple formula to calculate what you might at first think would be a fairly difficult problem. What you need to do is take your shutter angle and work this out as a ratio of this angle to the full 360 degree angle. For example, if you had a shutter angle of 90 degrees, then this is 90:360, or 0.25. Most 3D applications have motion blur settings from 0 to 1 or 0 to 100%, so in this case you'd apply 0.25 or 25% motion blur.

Figure 16.10
Fields allow the screen to refresh at twice the original frame rate

Antialiasing

One thing that television can be quite unforgiving with is aliasing, recognizable as 'jaggies' or staircasing, where a sharply defined line displays jagged edges, which can appear to crawl or at least flicker when displayed on screen. This is simply because a TV screen has a limited amount of pixels to display an image with, so objects that are very defined can appear jagged.

The answer to this problem is to apply antialiasing, which applies a smoothing filter that eliminates this undesirable effect. If you have a finished shot and need to cure this problem but don't have time to re-render, applying a very small (0.5 or 0.75 pixel) Gaussian blur can work wonders. As antialiasing adds to render times, it's best left turned off when rendering anything not resembling a final image. Likewise, if you are rendering out

different passes of a finished image for a compositor, any that are subsequently going to be blurred can be left without antialiasing, as the blurring will take care of this.

There are many types of aliasing filters available within every 3D solution, plus other related techniques such as SuperSampling, which you should verse yourself in thoroughly. Taking some time just to experiment with what each filter does is a good idea if you don't already know. Controls for antialiasing can generally be found within individual material and shader types, particularly raytraced materials, and within the renderer, where the final application of antialiasing across the entire image is carried out during the render.

Within 3ds max, for example, there's a drop-down list of eleven different basic antialiasing filters that form the last step in antialiasing during the final render. They work at the sub-pixel level and allow you to sharpen or soften your final output, depending on which filter you select. This, in turn, will depend on the media of your final output.

Sharpening filters

For still high resolution renders, especially for print output, the antialiasing filter should be one that sharpens the image, making it as detailed and clear as possible. Your own 3D solution will offer many different possibilities and it does not take long to learn what each one has to offer in terms of output quality. Taking 3ds max's filters as an example, there are several filters that in these circumstances could be considered:

Area:
The original 3ds max filter and the one that the software defaults to, computes antialiasing using a variable-size area filter (the user can specify between 1.0 and 20.0 pixels as the size).

Blackman:
This 25-pixel filter provides a sharpening effect, similar to the Sharpen filter found in Photoshop, but without the edge enhancement found in Catmull-Rom. There are no controllable parameters for this filter.

Catmull-Rom:
Named after Edward Catmull, one of the co-founders of Pixar, this 25-pixel reconstruction filter gives a sharpening effect like the Blackman filter, but it also has a slight edge-enhancement effect. There are no controllable parameters for this filter.

Sharp Quadratic:
This sharpening 9-pixel reconstruction filter from Nelson Max has no controllable parameters.

Experimentation with these filters is the best way of establishing which of these options is the best for a particular image, but for print resolution images in particular Catmull-Rom is the best bet, as it not only sharpens the object textures themselves, but also the edges of the objects.

Softening filters

Whilst filters that provide sharpening effects might bring out the detail in individual images, these filters can cause problems when applied to an animation. Filters that soften your results not only take the CG edge off a finished rendering, but also give a smoother look to animation output to video. Though the results might not look as good when you examine one imagine in isolation, when examining animation, these filters can make a world of difference.

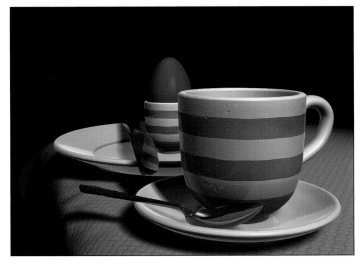

Figure 16.11
Softening filters (above) can give a more natural look to animation over sharpening filters (below) which are great for print output

Cubic:
This 25-pixel filter is based on a cubic spline and provides blurring, again with no user controllable parameters.

Quadratic:
This 9-pixel blurring filter is based on a quadratic spline, with no controllable parameters available to the user.

Soften:
This filter provides a simple adjustable Gaussian softening filter, which gives a blur that's variable between 1.0 and 20.0 pixels.

Video:
As the name suggests, this 25-pixel blurring filter is optimized for NTSC and PAL video applications. There are no user controllable parameters to this filter.

Between the extremes of softening and sharpening lie several other filters, which have different uses:

Blend:
This blends between sharp area and Gaussian soften filters, with a 1.0 to 20.0 size filter and a blend value of between 0 and 1. This is particularly recommended for shots that use depth-of-field, where its use can reduce the visible effect of multiple camera passes.

Cook Variable:
This general-purpose filter either sharpens or blurs the image depending on the value that is specified. Values of 1.0 to 2.5 are sharp, whilst higher values (up to 20.0) blur the image.

Mitchell-Netravali:
This two-parameter filter provides a tradeoff between blurring, ringing, and anisotropy. The user is given control of two values – Blur and Ringing - which both can vary from 0.0 to 1.0 and which both default to 0.333. If the ringing value is set higher than 0.5 it can impact the alpha channel of the image, causing non-opaque ghosting effects.

Plate Match/MAX R2.5:
This uses a method that involves no map filtering which dates back to 3ds max 2.5 and is used to match camera and screen maps or matte/shadow elements to an unfiltered background image. This method produces inconsistencies when rendering objects that are supposed to match the environment background, because the antialiasing filters do not affect the background. In order to correctly match an object's map to an unfiltered background image, you need to use the Plate Match/MAX R2.5 filter so the texture is not affected by the antialiasing.

These cover 3ds max's antialiasing options and provide an example of what's available for this particular solution. If you use a different 3D application, you just need to acquaint yourself with each available filter in the same way. If you are not familiar with the options available in your package, you simply need to work through them one by one with a sample scene or two and familiarize yourself with their strengths and weaknesses.

SuperSampling

Though this kind of technology might go by different names in the different 3D solutions, there are additional features for ensuring perfect antialiasing within troublesome materials, generally ones that involve raytracing. Within 3ds max, for example, the main extra tool that you have at your disposal is called SuperSampling, and is one of several antialiasing techniques that the software performs. Textures, shadows, highlights, and raytraced reflections and refractions all have their own preliminary antialiasing strategies. SuperSampling is an optional additional step that provides a best guess color for each rendered pixel, performing an additional antialiasing pass on the material. The SuperSampler's output is then passed on to the renderer, which performs a final antialiasing pass.

SuperSampling should in theory only be turned on when you notice artifacts in your final renderings, though with experience you'll know where these are likely to occur before going near the Render button. SuperSampling is helpful when you need to render very smooth specular highlights, or subtle bump mapping is required. SuperSampling requires considerably more time to render, although it does not necessarily require any additional RAM. Though raytrace materials and raytrace maps both perform

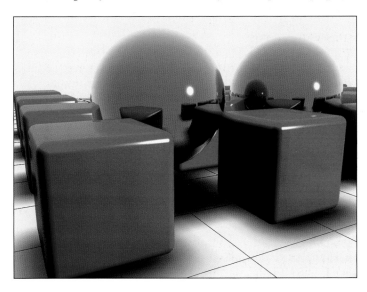

Figure 16.12
Technologies like SuperSampling provide extra tools for antialiasing

their own SuperSampling, they are often the areas that need this feature turned on the most. However, if you use a raytrace map to create reflections or refractions, turning on this option significantly increases rendering time, because the material is SuperSampled twice. In general, the SuperSampler should be avoided with raytraced reflections or refractions until the final render, particularly if the output is to a high resolution.

Continuing with 3ds max as an example, there are four SuperSampling methods available when this option is turned on:

Adaptive Halton:
This filter spaces samples along X and Y axes according to a scattered, 'quasi random' pattern. Depending on Quality, the number of samples can range from 4 to 40. The sample at the center of the pixel is averaged with four samples surrounding it, like the pattern of a five on dice.

Adaptive Uniform:
The samples in this adaptive filter are spaced regularly, from a minimum quality of 4 samples to a maximum of 36. The pattern is not square, but skewed slightly to improve accuracy in the vertical and horizontal axes.

Hammersley:
Whilst this filter samples regularly along the X axis, along the Y axis it spaces them according to a scattered, 'quasi random' pattern that depends on the user controlled Quality field, which allows the number of samples to vary from 4 to 40.

Max 2.5 Star:
As you might guess, this is the SuperSampling method that was available in 3ds max 2.5, with five samples arranged in a star pattern.

Of these four filters, regular sampling, as performed by the first and last methods, is more prone to aliasing than the irregular patterns performed by the Adaptive Halton and Hammersley methods. These two methods, as well as the Adaptive Halton filter have a Quality value, which can be set from 0.0 to 1.0. A setting of 0.0 gives minimal SuperSampling, with about four samples per pixel, whilst 1.0 is the highest possible setting, with between 36 and 40 samples per pixel that gives high-quality results, though can be very time consuming.

Again, you should familiarize yourself with these options in the same way that you should teach yourself what each antialiasing filter has to offer. The names of filters will change from solution to solution, but this does not really matter as long as you know which is best for the different looks that you want to achieve in your 3D application.

17

'Boy, when Marge first told me she was going to the Police Academy, I thought it would be fun and exciting, you know, like the movie Spaceballs. But instead, it's been painful and disturbing, like the movie Police Academy.'
Homer Jay Simpson

Looking beyond lighting

Though this book aims to deal primarily with lighting, this area cannot be comprehensively covered within one book without spilling over into several related areas: materials and rendering we've looked at as we've gone along, but there are several post production techniques that we've not yet touched upon.

This chapter aims to round off everything covered so far, looking at these connected areas, and examining those that you should be aware of. Whilst as a lighting artist you might not necessarily have to carry out the tasks outlined in this section, you should certainly be aware of how related technologies and processes operate.

Post production, as the name suggests, involves further work on the various elements - live-action footage, CG content, audio and so on - and is the final stage of the production pipeline. During this phase, there may be further color correction of the CG and live-action elements, the addition of effects like blurs, lens flares

Image courtesy of:
Hyungkun Choi
technoir@netsgo.com

and so on, and final touches like film grain might be added to rendered elements and so on. Final audio work and editing also fall under the umbrella of 'post production', but the main component of post that concerns us is compositing.

Compositing

In order to complete extremely complex shots with the necessary quality in the necessary time, the vast majority of work completed for broadcast does not come straight out of a 3D application ready to be put to tape. Instead, almost every professional production will be output in several parts ready for compositing. Rendering something with multiple passes involves the output of separate layers for the different components that make up a scene: diffuse, highlights, depth, shadows, lighting and so on.

The simplest example of this happening would involve some simple CG content rendered on top of a live-action plate, as in figure 17.01. In its simplest form there would be just two elements that make up this scene: the background and the foreground. A compositor's job here might involve two things: adding some film grain to the foreground component, and color correcting the foreground element, in order to make the CG content match the background as closely as possible.

The compositor's job is generally much more involved than this, however, and generally CG elements are rendered out into many different layers to enable as large a degree of flexibility as possible to be maintained. As such, the compositor's job is an extremely artistic and skillful one.

Figure 17.01

Compositing allows for much more complex effects to be constructed

Figure 17.02 (left)
Rendering in layers requires using layers, groups and hide tools

Figure 17.03 (above)
Rendering elements with alpha channels allows them to be layered

Rendering out the different CG elements in a form all set for compositing is not a difficult task. Starting with a single scene with everything together ensures that no obvious problems are present - nothing is located slightly below a floor plane and so on. The scene then needs to be structured into several sets of groups or layers, with only the relevant ones visible at render time. This can be done in different ways: either the objects that aren't to render can be hidden, or the various layers can be set up as individual files that are all externally referenced into a central scene file, with the referencing turned off for layers that aren't needed. The advantage of this system is that it can use fewer system resources as you're loading less into your 3D application, and rendering times can be reduced.

Whatever elements you have decided will make up your background form the first layer. If you are using a static background, for instance a photographed still or painted matte, you will only have to render out one frame of this layer, providing your camera is not moving. The remaining layers that comprise the CG elements of your scene are then rendered out with alpha channels in order to enable them to be placed over the background image, as shown in figure 17.02. Here, the black areas represent the area of the image that have 100% opacity, so the background image will be visible, whilst the white portions of the image represent 0% opacity, where the current layer will be added over the top of the background.

The complexity of the scene will dictate how many layers will be generated, which would involve the background, as well as the different characters, which might be assigned to individual layers or grouped together into one or more layers. Elements that make

up the environment might be grouped together, as might individual vehicles and so on, depending on how important these elements are to the shot and how much flexibility needs to be built into each of them.

This might seem like a lot of effort, but there are many reasons for working in this way: it can save time, duplication of effort and enable more complex results than would be possible from a single render. Arguably the primary reason involves saving on render times: if you output the whole scene every time you had to re-render because a revision had been made, you would be forever rendering. If the revision involved changing a character's animation, or the motion of a vehicle, then just rendering the relevant layer out again will save a lot of time.

Indeed, rendering everything together in a complex scene is often out of the question in terms of the amount of memory it would require to do this. Splitting a scene up into separate layers enables much more complex output. Also as mentioned previously, if elements like the background plate are static, then they only need to be rendered as a single frame, which can save on render times dramatically.

Similarly, you can render less important layers without the same fine degree of antialiasing or raytracing that you might need to if you know that these are going to be blurred in post, saving further render time. Blurring is an operation that really benefits from being carried out at this stage, if only because if this is done at render time, then reducing the blur is impossible without rendering again. Carrying out blurring operations within post means that the amount of blur can be fine-tuned quite straightforwardly. Similarly, effects like depth-of-field can then be simulated at this stage, rather than within the render, which also adds time to the render, as well as blurring the image irreversibly.

Elements rendered out in this way can also be recycled and reused from project to project, scene to scene, whatever. Libraries of elements can be reused without having to constantly render them: grass gently swaying in the foreground can be applied to different outdoor scenes to gently frame the shot, for example.

Finally, this way of working is often the only way to get around the production issues that generally arise around 3D software, especially when combined with third-party plug-ins. Often you'll come across a problematic situation which would be difficult to get around without working in this way: for instance, a rendered effect does not appear in a raytraced reflection.

One piece of software that offers a variation on this method is Softimage XSI, which with version 2.0 has a built-in compositor. Just as XSI's Render Tree allows the user to link together nodes in

a sequence to build up shaders, in the Fx Tree you can link together image sequences, effects and so on. With this system things like blurs can be applied as a post production effect, but the blur can be linked back to the 3D system, so could take its keyframe information from the XSI timeline. One advantage of working in this way is the fact that the software keeps track of the different elements and where they belong, which can be a sizable problem in conventional compositing. Knowing where these elements are stored and to which scenes and shots they are associated makes for easier asset management, which is especially important when you are working with many layers rendered out in multiple passes.

Multiple passes

Just as it's a good idea to separate the elements of a shot into different layers for rendering, it's also sensible to render out these layers in passes, for the same reasons. There are many different types of passes that can be rendered, and the most common of these are: diffuse, specular, reflection, shadow, effects, z-depth, self-illumination, refraction and lighting. Rendering in passes works by saving these individual passes into separate image files, each of which can then be individually tweaked by the compositor.

This process does not add an appreciable amount of time to the render, and working in this way affords the compositor a very fine level of control over the output, which is invaluable when working on very detailed shots, particularly those that involve live-action plates. Most 3D applications - certainly the ones that this book is mainly aimed at - enable you to render in passes without having to make modifications to the scene's materials.

Figure 17.04
The diffuse pass and Render Elements dialog inside 3ds max

Diffuse pass

Also referred to as the beauty pass or color pass, this component includes the color and diffuse illumination information, but does not contain reflections, self-illumination and so on, as these are contained in separate passes. The diffuse pass is generally rendered with an accompanying alpha channel and would be altered if color correction is carried out by the compositor, but it certainly does not receive the same level of attention as other passes.

Specular pass

Known also as the highlight pass, this component consists of just the specular information, which can be very useful to have as a separate component. When working with film, an effect known as blooming creates a subtle glow to the edges of bright objects, highlights in particular, as film enables light to leak through it, making really bright areas affect their surrounding areas slightly. To enable your CG elements to behave like your live-action plate in this way, it's common practice to add a blurred copy of the specular pass, and as a result this pass may not require the same level of antialiasing, thus actually rendering more quickly using passes. Furthermore, this pass does not need an alpha channel, as it's a grayscale image.

Reflection pass

This component consists of the reflections of what's surrounding your scene's objects. This pass can be slightly tricky, however, because if you've split your scene into layers then the objects that are being reflected may not actually be present in this version of

Figure 17.05
The diffuse pass does not contain (amongst other things) reflections, as you can see from the foreground

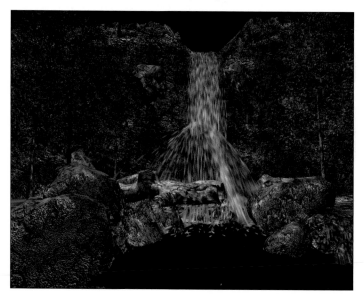

the scene. In this case you'll have a couple of options, depending on whether you're using reflection maps or raytraced reflections. If you're using the first method, you'll need to render out a reflection map of the complete environment to use when you start to hide layers. The latter method would require you to render using raytraced reflections with the surrounding objects in the scene visible only in reflections. As with the previous specular pass, this component is often blurred a little, so antialiasing quality can be reduced, again saving time. This pass needs to be composited using an alpha channel, but the one generated alongside the diffuse pass can often be used.

Figure 17.06
The specular pass (bottom left) can be blurred (bottom right) to mimic blooming in the final image (left), compared with the image without blooming (below).

Figure 17.07
Clockwise from bottom: shadow, atmospheric effects, reflection and Z-Depth passes

Shadow passes

A shadow pass can be extremely useful when it comes to producing a convincing shadow tone. A further benefit of separating this element out is that this can be blurred in post, softening the shadow if needed. Shadow passes sometimes appear to be completely black and empty, but in this case their information resides within the alpha channel, which can also appear to be the inverse of what you might expect, with the shadows appearing in the map as white and the non-shadow areas as black. Other applications render out the shadow pass as black on white, but any compositor will be able to use whatever variant your 3D application produces.

Effects passes

This component might consist of a single effects pass, or in an effects-heavy production might be split into many separate layers, depending on the complexity of a project. There are different types of effects and individual instances of each often need to be saved to separate files for easy alteration. We covered lens effects in chapter 12, but rendering effects passes can also cover particle effects and atmospheric effects too. Lens effects like lens flares which we mentioned earlier, which typically look like star-shaped streaks, rings and other artifacts emanating from light sources, occur naturally in camera lenses and are something that we often bring to CG as something recognizable from cinematography. Unfortunately these elements have been massively overused in the world of CG, but used with the right amount of restraint, they can add visual strength to a shot, and they can be useful for hiding elements that may have rendered incorrectly or just don't look quite right.

Figure 17.08
Treating lens effects as a separate pass is a very sensible option

Though a very quick element to render, when rendered as a separate pass, your compositor will be able to tone the effect down, strengthen it or turn it off entirely until it looks perfect. The last thing you want is to have to be rendering these items on top of other objects and having no option to change their appearance, so treating them as a separate pass is the sensible option. Plus, you don't want to have to keep having to render out a whole scene just because you're not happy with the way a lens effect is looking, that would just be ludicrous.

Particle effects can be used in many different ways, from smoke and explosions, to water and flying sparks. The look of these elements is difficult to get just right without some help at the compositing stage and rendering them as a separate pass is incredibly useful. However, due to the volumetric nature of many particle effects, they can appear in a scene in front of and behind different elements of the scene, which can cause problems in terms of the ease of compositing.

There are nevertheless several ways of dealing with this. Arguably the easiest method is to give the objects within the scene that are located within the particle system a matte material and include them in the render so that they will be picked up in the alpha channel. Alternatively, the particle effect can be rendered accompanied by the z-depth pass to enable the compositing system to place this relative to the depth of the scene. We'll get to z-depth passes next. However, whilst not the easiest method, perhaps the one that gives the compositor most control is the splitting up of a particle system into several layers, which can be composited in front of and behind a scene's other objects and thus be controlled individually and more closely.

Z-depth pass

Sometimes called the depth pass, this component is commonly a grayscale representation of the depth of the objects within the camera view. Depending on your 3D application, this pass can be saved as a file format specific to z-depth, or it can be a simple grayscale image, with the nearest objects appearing in white and the furthest objects rendered darkest. This system is a little inaccurate, as there are only 256 levels to choose from in an 8-bit grayscale image, and as you can imagine, this can be a little too imprecise. Z-depth-specific formats can also prove problematic, however, as they generally only store a single depth value for each of the rendered image's pixels, which can also be too imprecise. Getting around this involves rendering this pass at a higher resolution, giving suitable detail within the compositing solution.

Self-illumination pass

Not one of the more commonly used passes; this component is a grayscale representation of the self-illumination of the objects being rendered. In this pass, a pure white represents 100% illumination and a pure black represents 0% illumination. However, it is useful to have as a separate pass if you are going to be including blooming effects whilst compositing. Furthermore, objects such as light bulbs that are self-illuminated are likely to be the ones that glow within your final image. Just as with the specular pass, this layer can be blurred to extend the reach of the self-illumination, thus imparting a glow to these elements. This pass does not need an alpha channel; as it's a grayscale image it can be composited using an Add or Screen operation.

Refraction pass

Again, this component is one of the less common passes, representing the refraction within a scene. This would be useful if you were working with a scene where the refractions were very important, for instance a scene filmed with a glass in the foreground, through which elements of the scene were refracted. Generally, though, this is not a pass that would tend to be included in most applications of multiple pass rendering.

Lighting pass

The reason that we come to the lighting pass last of all is that it's the most relevant to us and by placing it last in the list of passes you should hopefully by now thoroughly understand how this system of rendering works. The lighting pass again is an element that won't always be included, but the flexibility that it lends in tweaking the lighting set-up at the compositing stage is substantial. The diffuse pass is actually a lighting pass, as it includes all the diffuse illumination information. By breaking

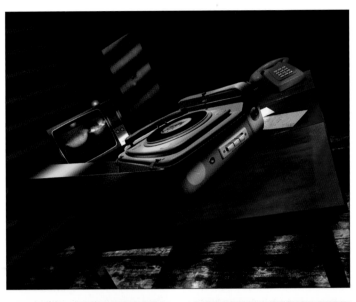

Figure 17.09
Splitting your diffuse pass into separate lighting elements can give considerable flexibility

down this component into different layers by lighting, you can separate the influence of your key light, fill lights and backlights by simply turning on and off the relevant lights. Depending on how much control is required here, different passes can be included for individual lights, or these lights can be grouped as desired. Like the diffuse pass, these passes need to be rendered with an alpha channel and composited over the background.

Realistically, this system is likely to be employed only in situations where it is identified as required, as a compositor would not generally request this level of breakdown. However, it is useful in several specific situations. When rendering system resource-hungry things that depend heavily on lighting, like global illumination and possibly caustics, having the lighting available as a separate pass gives a degree of control that means the lighting can be altered as required, reducing the possibility of having to run another long render. Lighting effects that are driven by actions occurring in the live-action plate can also benefit from being rendered as a separate pass, as these can then be tweaked in terms of their color, timing and intensity to match the plate accurately.

Whilst this list covers all of the common options for rendering using passes, there are other passes available, which include transparency, ID channels that have been allocated to materials or individual objects and non-clamped colors, as well as several sub-pixel options. There are also additional options available specific to different 3D applications. Softimage XSi, for example, features mental ray as its rendering engine. This renderer features physically correct global illumination, including caustics, and as such these two options can be allocated to separate passes. 3ds max also has a notable feature that concerns the way that it works alongside discreet's combustion compositing system. When rendering from 3ds max, the option exists to output a combustion workspace file. This saves a single file (as well as the various passes that have been specified) which can then be opened directly within combustion allowing simple transfer from the 3D environment to the compositor.

The appeal of film

The shiny CG aesthetic championed by the likes of Pixar and PDI undoubtedly has a certain appeal, and the toy-like feel that is imparted to productions aimed chiefly at children is reinforced by this plasticity. However, if you want to get away from this stereotypical CG look, there can often be no more appealing choice than that of film. We can all relate to its grainy yet polished feel, as we're so used to seeing footage shot on varying types of film stock. Even those not acquainted with CG or cinematography can spot when something's been filmed on DV, there's just a certain something that's missing from the colors and look of the footage.

There's a real allure to film, and this is something that's difficult to replicate with video. However, there are several ways that this appealing aesthetic can be lent to CG, which has the effect of making them appear more natural. There's something almost subliminal about footage with rich colors and graininess that we associate with film, and this can be used to make CG productions look less like CG and more like professional short films.

Motion blur

As we covered in the last chapter, motion blur can lend your animations a smoother feel that field rendering also achieves, but without giving it the shot-on-video feel that using fields can impart. Whereas fields are analogous to video, motion blur is something that occurs in film depending on the shutter speed: the slower the shutter speed, the more movement that is captured on each frame. Motion blur can be quite render intensive, so might only be something that you choose to use in final production quality renders, but is something that certainly lends moving objects, particularly those moving at speed, a smooth and natural feel.

If you are really intent on producing very realistic motion blur, then it might be worth remembering that slower shutter speeds are generally used in darker conditions, so you're more likely to get motion blur occurring on film in night shots than you are in bright conditions, when a faster shutter speed is used. Of course, field rendering has its place, and this is generally when video is involved as the end delivery medium: particularly if a CG element is being integrated with footage that is already inter-laced. Field rendering does produce smooth motion, and of course this technique can be combined with motion blur, which can produce very good results.

Blooming

The effect known as blooming occurs because film enables light to leak through it, making really bright areas affect their sur-rounding areas slightly, giving a subtle glow to the edges of bright objects, highlights in particular. This kind of effect can be written into a shader, but is most easily applied within post production. If your final output is rendered out in passes, as just described, then the highlight pass can be slightly blurred to produce this effect.

Grain

Many 3D applications have a film grain function that allows for CG elements being placed over existing grainy footage to exhibit a similar graininess and look more closely matched. The grain controls here are typically not as extensive as those offered within a compositing environment, where many filters exist for adding grain to mimic various individual film emulsions. These filters also have the ability to modify the luminance and color response

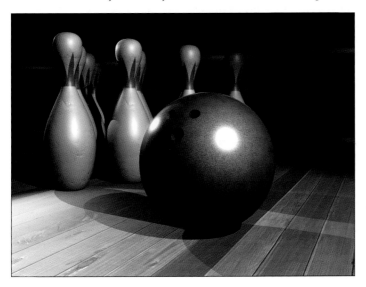

Figure 17.10 (below)
Motion blur can lend fast moving objects a smooth and natural feel

Figure 17.11 (left)
Blooming occurs because film enables light to leak through it

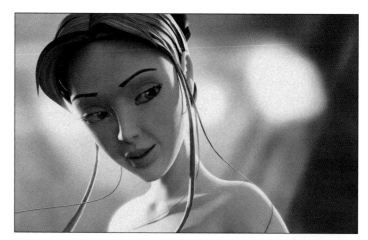

Figure 17.12
The addition of grain can give a much richer look to your CG work

Figure 17.13
Lens effects should be used subtly

curves and apply time integration to give the footage the slurry rotating shutter effects that are present in filmed presentations. There are also similar filters that add scratches, hairs, flicker and so many of the things that are have actually damaged the film, but are so closely associated with the aesthetic of film, that they can actually be desirable. See the plug-in section (pages 335-337) for further details of these kinds of products.

Lens effects

Lens flares are an effect that is caused by light being refracted through a camera lens and are something that lens manufacturers have strived to eliminate from their products. It's strange then that in CG quite the opposite is true: with no lens in sight, these effects are manufactured by the software and unfortunately overused to the point where they are more associated with CG than live-action. Their subtle use can be effective, but try not to overuse them or by attempting to make your CG look more like film, you'll just end up making your CG look more like CG.

Software

This book is written primarily for users of 3ds max, LightWave, Maya and Softimage XSI and no extra software is needed. However, there is a great deal of extra software in the form of third-party renderers and plug-ins that do various tasks associated with lighting: from providing an improved quality of rendering to providing extra bells and whistles to the existing tools available. There follows a list, which should certainly not be considered exhaustive, of these types of products.

Renderers

AIR - www.sitexgraphics.com
RenderMan-compliant hybrid scanline/raytrace renderer.

Arnold - www.projectmessiah.com
See *messiah:render.*

Entropy - www.exluna.com
A renderer based partly on a revamped *Blue Moon Rendering Tools*: including a scanline front-end and new shading engine. With an open architecture and support for *RenderMan* shaders, its developers, Exluna (which includes several ex-Pixar developers) are pricing the renderer competitively against *RenderMan*.

Blue Moon Rendering Tools (BMRT) - www.bmrt.org
A shareware, *RenderMan*-compliant renderer that is capable of raytracing and radiosity. Distributed by Exluna, developers of *Entropy* (see above).

Brazil - www.splutterfish.com
A fully integrated advanced rendering suite for 3ds max.

ELF - www.lightflowtech.com/elf/
A external rendering plug-in developed for Maya by Lightflow Technologies, which provides sub-pixel displacement mapping, caustics, global illumination, shadow maps, raytraced shadows, raytraced reflections and refractions, blurred reflections, volumetric rendering and full support for Maya's Dependency Graph architecture.

finalRender - www.finalrender.com
A global illumination and raytrace renderer for 3ds max that uses a physically correct approach to calculate diffuse and non-diffuse lighting situations. Developed by cebas.

Illustrate - www.davidgould.com
Non-photorealistic renderer available for 3ds max, used widely for cel and toon style rendering and illustration work. Includes *Flash* export.

Lightscape - www.lightscape.com
Standalone radiosity renderer that is widely adopted by 3ds max users,

Figure 17.14
Top: Brazil image courtesy of Arild Wiro (www.secondreality.ch)

Bottom: Entropy image courtesy of Claude Schitter (www.claude.schitter.org)

particularly those working in architecture. This is partly due to the fact that it is owned by Autodesk, the parent company of discreet.

Mai-Tai - www.dotcsw.com
See *RenderDotC*.

MaxMan/MayaMan - www.animallogic.com
3ds max to *RenderMan* and Maya to pipeline products, which fully integrate into the 3D applications and allow rendering with RenderMan renderers such as *RenderMan, Entropy, BMRT, PRMan, AIR* and *RenderDotC*.

mental ray - www.mentalimages.com
mental ray was the first rendering software to combine the physically correct simulation of the behavior of light with full programmability for the creation of any imaginable visual phenomena. Integrated into Softimage XSI and available to work with 3ds max, Houdini and Maya.

messiah:render - www.projectmessiah.com
Originally developed by Marcos Farjardo as a 3ds max plug-in, *Arnold* was acquired by project:messiah group just before SIGGRAPH 2000 and renamed *messiah:render*. It now supports Softimage, Maya, 3ds max and LightWave.

POV-Ray - www.povray.com
POV-Ray is based on David Buck's original raytracer, *DKB-Trace* and is a totally free raytracer available for virtually every platform.

Piranesi - www.informatix.co.uk
Aimed largely at architects, *Piranesi* is an NPR system for exhibition images.

RayGun - www.righthemisphere.com
Raytrace renderer from New Zealand developer Right Hemisphere that claims to beat 3ds max's own renderer both in terms of speed and quality.

RayTools - www.uberschmuck.com
Plug-in that provides a *mental ray* connection to Maya.

Figure 17.15
Illustrate image
© MGM Animation, Inc.

RenderDotC - www.dotcsw.com
RenderMan-compliant Maya renderer and export plug-in (*Mai-Tai*).

RenderMan - www.pixar.com & www.renderman.org
Pixar's rendering product, a specific renderer that is compliant with the *RenderMan* standard and is widely used for feature-film animation and visual effects.

Swift3D - www.erain.com
Vector rendering plug-ins for 3ds max, Maya and Softimage XSI that provide Flash output.

V-Ray - www.chaoticdimension.com
Advanced raytracing system for 3ds max.

Plug-in away

Visual effects production is a competitive business and in order to stay ahead of their competitors, the large studios employ R&D staff to extend the creative possibilities of their services on a technical front. This can involve, at the simplest level, writing shaders, all the way up to the development of in-house production tools like camera tracking solutions that work alongside commercial applications like those outlined here.

At the end of the day, 3D applications cannot be all things to all men, and there's always going to be things that a studio, no matter how big or small, wants to produce that simply won't be possible with the software as it ships. For those of us without access to R&D teams, the answer lies in plug-ins, which bolt on to commercial applications, providing extended functionality.

There are many plug-ins out there, produced by dedicated third-party developers, that are available to purchase and cover all manner of subjects, from fire to lipsyncing and everything in between. There are also numerous freeware or shareware plug-ins available, but generally won't come with any form of technical support, so not too much emphasis should be placed upon them in a professional production environment.

Sometimes nothing but a plug-in will do what you want to do, so for the purposes of demonstrating what's available, both commercially and freely, there follows a selection of the best that apply to those working in and around lighting.

Plug-ins:

ArtBeats - www.artbeats.com
Great royalty-free digital stock footage that covers explosions, effects and so on, delivered on CD at different resolutions with alpha channels.

Blur - www.blur.com/blurbeta
Blur Studio's R&D department might only consist of two people, but their plug-in page consists of many excellent free bits and bobs for max. Some are less stable than others, but all are given a confidence rating.

Cinelook - www.digieffects.com
Digital film effects tools that include the excellent Cinelook plug-in for After Effects that gives footage the look of many different film stocks.

Cuney Tozdas - www.cuneytozdas.com/software/max/
Several useful free plug-ins for 3ds max.

Deep Paint 3D - www.deeppaint3d.com
Excellent standalone 3D painting system that interfaces directly with 3ds max, LightWave, Maya, Softimage XSI and Photoshop.

Figure 17.16
Top: Digimation's website features over 100 max plug-ins
Middle: Shag:Hair in action
Bottom: Deep Paint 3D

Digital Nature Tools - www.sisyphus.com
Plug-in that provides photorealistic water surfaces and three-dimensional atmospheric and cloud effects for 3ds max.

Dirty Up - www.doschdesign.de
Enables more realistic textures by adding dirt and grime in LightWave.

Enlight - www.digimation.com
Pseudo-radiosity rendering plug-in. Places virtual lights on mesh faces creating the illusion of turning an object into a light-emitting source.

Fiber Factory - www.metrografx.com
Photorealistic fur, hair and fiber generation for LightWave users.

Gaffer - www.worley.com
Shading plug-in for LightWave users that creates soft shadows and finer control of surface shading and lighting. Also comes with Bloom.

HyperVoxels - www.newtek.com
LightWave plug-in that greatly simplifies the creation of highly advanced volumetric rendering effects.

InstantUV - www.digimation.com
Gives 3ds max two new UV mapping types for improved texturing.

Light Galleries - www.digimation.com
3ds max plug-in that allows lighting set-ups to be randomly generated.

Lightning - www.digimation.com
Geometry-based procedural electricity generator for 3ds max.

Lume Tools - www.lume.com
A series of shaders that provide a wide range of tools and natural effects for 3ds max, LightWave, Maya and Softimage users.

Phoenix - www.digimation.com
Incredibly realistic fire simulation plug-in for 3ds max.

PolyTrans - www.okino.com
A translation solution that allows work to be taken from different 3D formats and transferred between LightWave, 3ds max and Maya.

Pro Optics Suite - www.cebas.com
Complex glows, flares, highlights, and depth-of-field, with in-viewport editing. Radiosity, diffuse light and particle lights. Smoke, dust and clouds.

Quick Dirt - www.digimation.com
3ds max plug-in for creating dirt, rust, mud and other texturing effects.

RealFlow and RealWave - www.nextlimit.com
Incredible products those projects involving serious water simulation.

Reyes Infografica - www.reyes-infografica.net
The Reyes family of plug-ins for 3ds max have been around for some time and are available free for release 3 users.

Ripple Rain - www.kerlinsoftworks.com
Creates rain and water impact ripples using animated textures.

Shag:Hair - www.digimation.com
Hair plug-in that uses a custom renderer within the 3ds max environment.

Simbiont - www.darktree.com
Procedural texture application with plug-ins to max and LightWave.

Splash - www.digimation.com
Fluid dynamics within 3ds max for realistic waves and splashes.

Texture Lab: Tools - www.digimation.com
Advanced texturing and tiling tools for 3ds max.

Texture Layers - www.mankua.com
Advanced parametric mapping and texturing for 3ds max.

UView - www.cinegraphics.net
Advanced parametric texture mapping for LightWave.

VertiLectric - www.skstudios.com
VertiLectric allows LightWave users to create realistic lightning effects.

ZBrush - www.pixologic.com
Powerful modeling and texturing toolkit with export to .OBJ and .DXF.

Magazines

In such a fast moving industry, keeping up with new developments is perhaps best done using the internet, but there are some excellent publications out there that are also worth checking out, and their websites often offer email newsletters:

3D World - www.3dworldmag.com
Good monthly international magazine for 3D artists.

CGI - www.cgimag.co.uk
An excellent UK-based monthly publication looking at the world of CG.

Cinefex - www.cinefex.com
Unbeatable publication for those interested in the art of visual effects.

Cinefantastique - www.cfq.com

Cinescape - www.cinescape.com

Figure 17.17
Three of the best 3D websites around - www.raph.com/3dartists, www.gamasutra.com and www.highend3d.com

Starlog - www.starlog.com
Three publications that look behind the scenes at fantasy movies.

Videomaker - www.videomaker.com
Monthly video editing, computer video and audio/video production mag.

Websites

There are many useful resources for 3D artists on the internet, and again, this list is not attempting to be an exhaustive guide to what's out there. It does, however, provide a bunch of useful places to bookmark and from which to explore further.

www.3dartist.com
Website for US magazine *3D Artist.*

www.3dlinks.com
General 3D community website that's better than most.

www.aliaswavefront.com
The home of alias wavefront, developers of Maya.

www.cgchannel.com
Useful online resource for the CG community.

www.cgimag.com
Excellent UK-based computer graphics magazine website.

www.cgw.com
Website for *Computer Graphics World* magazine.

www.deathfall.com
The usual resources for 3D artists.

www.digimation.com
Preferred plug-in publisher for 3ds max with over 100 products.

www.discreet.com
The home of discreet, developers of 3ds max.

www.gamasutra.com
Great resource for those interested in the games industry.

www.highend3d.com
Excellent website for users of professional 3D solutions.
www.imdb.com
An incredibly useful website for research related to movies.

www.lightwave3d.com
NewTek, the, developers of LightWave's website.

www.max3d.com
Independent 3ds max user's site.

www.raph.com/3dartists
Excellent online gallery of work by independent 3D artists.

www.rendermania.com
Great resource for those involved with rendering and renderers.

www.softimage.com
The home of the developers of Softimage XSI.

www.turbosquid.com
Site for the trading of 3D content: models, textures, mocap data and so on.

www.vfxpro.com
Excellent, established site for visual effects work, particularly for jobs.

www.xsistation.com
Softimage XSI specific site with tutorials, scripts etc.

Studio websites

Digital Domain - www.digitaldomain.com
US giants responsible for such excellent work as *How the Grinch Stole Christmas*, *What Dreams May Come*, *X-Men* and *Fight Club*.

Industrial Light & Magic - www.ilm.com
From *Star Wars* to *A.I.*, the company's visual effects work is second to none, and its commercial work is pretty incredible too.

PDI/DreamWorks - www.pdi.com
With hits like *Antz* and *Shrek* under its belt, PDI's feature animation team is a force to be reckoned, as are its visual effects and commercial divisions.

Pixar - www.pixar.com
From features like *Toy Story*, *A Bug's Life* and *Monsters Inc.* to shorts like *For the Birds* and *Geri's Game*, Pixar are one of the biggest names in CG.

Rhythm & Hues - www.rhythm.com
Work on *Harry Potter* and *Cats & Dogs*, as well as *Lord of the Rings* has made Rhythm & Hues a force to be reckoned with in effects work.

Sony Pictures Imageworks - www.imageworks.com
Producing such excellent work as *Spider-Man*, *Stuart Little* and *Hollow Man*, Imageworks is one of the main players in visual effects.

Animal Logic - www.animallogic.com
One from outside the US for good measure: Animal Logic's incredible work includes *Lord of the Rings*, *Moulin Rouge* and *The Matrix*.

Figure 17.18
Two of the giants of CG's websites

A

The companion CD-ROM

This book's accompanying CD-ROM contains all the files required for the tutorials that appear in the techniques section of the book. Additionally, there are some demo versions of software products that work alongside the 3D animation solutions that this book deals with, links to the website of this book's publisher, as well as a simple monitor calibration routine.

The CD should run automatically after it has been put in the CD-ROM drive, but if you have Autorun disabled on your computer, it will not begin automatically. If this is the case you can run the software by double-clicking the StartHere.exe file located at the root of the CD. The instructions for using the CD are very self-explanatory and anyone who can find their way around a 3D package should find navigating the CD no problem whatsoever. Once launched, the welcome screen explains that you should select one of the options from the left-hand side of the screen, which appear once you have clicked to continue.

Figure A.01
The welcome screen should appear
when the CD is placed in the drive

Software requirements

In order to use the tutorial files directly, you will need to have 3ds max installed on your computer. However, the tutorials deal with concepts rather than application-specific techniques, so users with some existing knowledge should have no problems understanding the tutorials and transferring them to LightWave, Maya, Softimage or another 3D application. If your machine is capable of running a 3D application, it will be more than capable of running the very basic CD application, so there's no need to go into detailed machine specifications. However, it is worth mentioning a little about how the tutorials should be set up on your local machine:

3ds max

3ds max users will need to be using release 4.0 or higher. The tutorial files are stored in .max format and should be copied to the desired directory on the user's hard drive. The *Tutorial Materials* directory should also be copied into 3ds max's maps directory. This should ensure that everything works correctly. However, should you get error messages when rendering that there are image files missing, you need to point max to this folder of materials that you just copied. If you copied it into max's existing maps directory, then there should be no problems. If you placed this folder elsewhere, then you should select Customize > Configure Paths and in the Bitmaps tab, add the path to the folder that you copied.

There is a demo version of 3ds max 4 on the accompanying CD, so everything that is required to get started as a lighting artist is included. Those users of different 3D applications might want to familiarize themselves with lighting techniques in another application, or run max side by side with their own software in order to compare results.

Tutorials

The most important of the options presented to you from the main menu of the CD is the *Tutorials* link, which when clicked will open the relevant directory in Windows Explorer. This folder contains all the necessary files to complete each of the tutorials contained in the book.

Its content is organized by chapter, so within the tutorials folder you should open the folder of the relevant chapter, where you will find the files in the .max format for 3ds max 4.

Within the *tutorial* folder itself you will also find a directory called *tutorial materials* which contains all the textures required for all the tutorials. You could point your 3D application to this folder on

the CD, but you're better off copying it to your local machine. Within each of the individual chapter folders, you will also find a directory called *completed versions*, which contains, as the name suggests, these same tutorial files as they should look once completed. If you're getting unexpected results from following the tutorials, open up one of these files and compare your results.

Focalpress.com

This link will take you to Focal Press's website, this book's publishers, where you can browse their catalog of titles, make purchases online and subscribe to their monthly e-newsletters to ensure you keep up to date.

Figure A.02
From the next menu, you should choose an option from the left

Calibrate

Though by no means a professional monitor calibration routine, the link marked *Calibrate* will display a simple grayscale image for the purposes of calibrating your monitor to be able to display the complete range of grays from white to black.

Figure A.03
Clicking the Calibrate link displays an image for basic monitor calibration

You should adjust your monitor's brightness and contrast controls so that you can clearly see the full range of grays, from left to right and vice versa. If you are able to read the phrase *calibrate!* both at the top and at the bottom of the displayed image, then your monitor is displaying the full range of tones, which means that you should not be overlighting or underlighting a scene to compensate for your monitor.

If you want to display this image within your 3D application or within your image-editing application, make sure that any proprietary color correction features that this software might have are turned off. In Photoshop, for instance, this means turning off the Display Using Monitor Compensation option, found under File > Color Settings > RGB Setup.

The image itself - *calibrate.jpg* - can be found in the monitor calibration folder, which is located at the root of the CD. This is by no means a professional calibration routine, all it aims to do is ensure that your renderings will display the full range of tonal values possible. If you are working towards printed output, you should construct or find a suitable test image that displays the full range of colors and tones that you are aiming to eventually output.

You should have this printed on the device on which your work will eventually be output and attempt to match your monitor to this print by simply putting the print alongside your monitor and adjusting its controls. By looking at the distribution of an image's colors using the Photoshop Image > Adjust > Levels feature, you should be able to see whether the distribution roughly matches what is being displayed on your PC and alter your final output.

Software

This link will take you to another menu where the installation of several software packages can be instigated. To install one of the four demonstration versions included on the CD, simply pick from the four options on the left-hand menu, and the installation routine should begin automatically. Choose from:

Figure A.04
From the software menu you can choose to install the four different solutions from the left-hand menu

CineLook NT Broadcast

Two plug-ins for After Effects that combine many image-processing techniques to make images look like film. Select any of the 50 film stock presets or customize the presets to build your own. *CineLook* will add film grain, adjust the color correction and perform time integration. The second plug-in, *FilmDamage*, can then be used to add film artifacts like dust, hair, dirt, scratches and so on. A PDF help file is also included on the CD in the *software/cinelook* folder.

Deep Paint 3D

A great product that provides an intuitive, easy-to-use tool to paint and texture 3D models interactively in 3D. This creative environment supports an integrated workflow with 3d studio max, Lightwave 3D, Maya, and SoftImage. Deep Paint 3D includes a bi-directional interface to Photoshop and support for pressure sensitive tablets.

DarkTree 2.0

Procedural textures are built up from a selected group of algorithmic components linked together hierarchically. From intricately detailed and realistic textures to complex and perfectly geometric designs, DarkTree's capabilities are quite remarkable, as its library of pre-constructed shaders testifies.

3ds max 4

Fifteen-day trial version of 3ds max 4, the world's best-selling professional 3D modeling, animation and rendering platform for creating visual effects, character animation, next-generation game development and web-based media. Includes character studio 3.

Other menu items

As well as the tutorial content, the links to the website for the book's publisher and the monitor calibration routine, there are several other basic features of the CD. These are outlined below.

Browse CD

To jump straight to the CD's contents, simply click the link marked *Browse CD* and the CD application will exit, with Windows Explorer appearing at the root level of the CD.

Exit

To exit the CD application, simply click the link marked *Exit*.

Glossary of CG, lighting and cinematography terms

Achromatic
White, black or gray colors that contain no hue.

Action safe area
An area that occupies the central 90% of a broadcast image, which all of a shot's action should be located within in order to avoid it being cropped when viewed on a television due to overscanning.

Additive color
The color mixing system that works by blending three primary colors.

Aliasing
Aliasing is the unwanted staircase effect at the edge of a line or area of color when it's displayed by an array of discrete pixels. This is cured using a process called antialiasing.

Alpha channel
An 8-bit channel in a 32-bit color image which stores transparency data.

Analogous colors
Neighboring colors on the color wheel.

Anisotropic
Material whose surface exhibits eliptical highlights like brushed metal.

Antialiasing
An algorithm to prevent the jagged appearance of edges in an image, which works during rendering by averaging adjacent pixels with sharp variations in color or brightness.

Ambient light
Light that is present in the environment. It has no focus or direction.

Aperture
Its opening controls the amount of light entering a lens.

Area lights
A type of light that lights a region of space with its soft and diffuse illumination. These are often really an array of point source lights arranged around the shape.

Array
A multiple instance of objects arranged in a pattern.

Aspect ratio
The ratio of the width to height of the dimensions of an image.

Atmospheric effect
Components of a 3D software solution that produce effects like fog, fire, volumetric lighting effects and so on.

Attenuation
Describes how a light's intensity falls off over distance.

Bitmap
Also known as a pixel or raster image. An image composed of pixels.

Blinn's law
The observation, first published by Jim Blinn, that an artist is willing to wait a fixed time for an image to render, and that faster hardware simply results in more complex images that take the same amount of time to render.

Blooming
The effect of glowing edges around bright highlights occurs because film enables light to leak through it, making really bright areas affect their surrounding areas.

Brightness
An attribute of visual perception in which a source appears to emit a given amount of light.

CGI
Computer Generated Imaging, especially computer graphics imagery that is produced for use in motion pictures (such as for special effects).

CMYK
A color space that is often used in printing and means Cyan, Magenta, Yellow and Black (Key).

Caption safe area
See *Title safe area*.

Caustics
A result of specular light transmission that causes bright light patterns like the shimmering patterns that can be seen in swimming pools.

Channel
A channel of data that makes up an image is typically composed of 8 bits, for instance a 32-bit image is generally made up of four channels: Red, Green, Blue and Alpha. Additional channels such as G-buffer, Z-depth can also feature in image data.

CODEC
Short for compressor/decompressor, a codec is an algorithm for compressing and decompressing digital video data and the software that implements that algorithm.

Color
Also called hue. It is the property of objects that is derived from wavelength reflection and absorption. It also denotes a substance or dye that has a particular shade or hue.

Color balance
Film stock has a particular color balance which determines which color of light appears as white light when photographed.

Color bleeding
Result of Global Illumination rendering, where adjacent colors bleed subtly into each other because of the bounced lighting.

Color cast
A perceptible dominance of one color in all the colors of a scene or photograph.

Color constancy
The ability to perceive and retain a particular object's color property under different lighting conditions.

Color depth
The number of bits required to define the color of each pixel of an image. 1-bit images are just black and white: 8 bits provide 256 shades between black and white (grayscale); 24 bits provide millions of colors (eight each for red, green and blue);32-bit color provides and additional 8 bits for an alpha channel.

Color temperature
Measures in kelvins (°K) the perceived temperature of a light source compared to an ideal blackbody emitter.

Complementary colors
Colors located directly across from each other on the color wheel.

Cone
Photoreceptor located in the retina that is responsible for color perception.

Contrast
Measures the difference between light and dark areas of an image.

Cookie
Also called a cucoloris, a cookie is an irregularly patterned object placed in front of a light source to cast discernible shadows to break up uniformity.

Cucoloris
See *cookie*.

Daylight-balanced film
Film stock that has been designed to be used in daylight conditions, where its 5,500 °K color balance makes daylight appear white.

Decay
Describes the way in which a light's illumination attenuates over distance.

Depth map
See *Shadow map*.

Depth-of-field
Defines an area between a near and far point from a camera within which an object will appear sharply rendered.

Diffuse
In CG, the diffuse color is the color that the object reflects when illuminated by even omnidirectional lighting. Also refers to scattered non-directional light.

Diffusion
The way in which light is scattered from a surface by reflection. Also refers to the way in which light is transmitted through a translucent material.

Diffuse reflection
The component of light reflecting from a surface caused by its dull or matte surface, which reflects the light at random angles giving the surface an equally bright appearance from many viewing positions.

Directional lights
Directional lights cast parallel light rays in a single direction, as the sun does - for all practical purposes - at the surface of the earth.

Displacement mapping
A grayscale map that alters surfaces causing a 3D displacement.

Dispersion
The separation of light into different wavelengths due to passing through different media that have different refraction indices from each other.

Dolly
A wheeled platform used for mounting a camera.

Electromagnetic spectrum
With short wavelength gamma and x-rays at one end and long wave radio waves at its other, the electromagnetic spectrum also includes a narrow band that we perceive as light, the visible spectrum.

Exclude/Include
Useful feature which allows objects to be excluded or included in a selected light's illumination.

f-stop
The ratio of the focal length to the aperture of a lens.

Falloff
See *Hotspot/falloff.*

Field
A method of conveying frame information on a video signal using two portions of each frame called fields. One frame contains the odd scan lines of a frame, and the other the even scan lines. The fields are alternately cycled through every other horizontal line on the screen in a way that they interlace together to form a single image.

Field rendering
Involves the software rendering an extra sub-frame image between every two frames and compositing each frame and the following sub-frame into a single image with two fields. The result is 60 fields per second animation that appears smoother when viewed on a television monitor than standard 30 frames per second animation.

Fill light
A light source placed primarily to open up the dark shadow areas of a scene. Fills can also be placed to mimic bounced light.

Full gate
The process of digitizing an entire film frame common in effects work.

Gamma correction
Gamma correction compensates for the differences in color display on different output devices so that images look the same when viewed on different monitors.

Gels
Heat resistant material placed in front of light sources, which is colored to tint the light and match colors of light.

Global ambience
In real life, the distributed indirect light from other objects in a scene. In CG, an unrealistic control that is supposed to mimic this light component.

Global illumination
Illumination that incorporates the light reflected from other objects.

Go-betweens (gobos)
Sheets of metal or wood placed in front of lights that shape their illumination into patterns or break up the illumination.

Gray card
A card that has a gray and white side, with both sides reflecting a predictable amount of light, generally around 20%/90%.

HDRI (High Dynamic Range Images)
Images that can capture a higher than normal range of brightness due to the fact that they're made up of several images taken at different exposures.

HLS
A color space that is represented by Hue, Lightness and Saturation.

HSV
A color space that is represented by Hue, Saturation and Value.

HVC
A color space that is represented by Hue, Value and Chroma.

Highlight
A bright focused reflection formed on an object in the scene.

Hotspot/falloff
The bright circle at the center of a pool of light is the hotspot, and is of even intensity. The outer extremity of the light, where it meets the darkness, is the falloff. The difference in circumference between the hotspot and the falloff determines the relative sharpness of the pool of light.

Hue
Hue is the color reflected from or transmitted through an object, measured as a location on the standard color wheel, expressed as a degree between 0 and 360. In common use, hue is identified by the name of the color.

IOR (Index of Refraction)
In the physical world, the IOR results from the relative speeds of light in a vacuum and the material medium.

Illuminance
The amount or strength of light falling on a given area of a surface.

Incident light
Direct light falling on a subject.

Indirect illumination
The illumination that results from light being transmitted between objects.

Intensity
A light's intensity is controlled by its Value field and its Multiplier field.

Inverse square law
The realistic falloff of light from a source as it covers more area.

Kelvin
The unit of measurement used in color temperature.

Key light
The main light source in a scene, the key light is defined by being the most dominant light in a given scene.

Key-to-fill ratio
The ratio of a key light's intensity to the fill light intensity, measured at the subject. Low values create open shadows and a happy atmosphere, whilst high values produce high contrast and moody results.

Letterboxing
The process of placing a widescreen image onto a regular 4:3 frame with black borders above and below the image filling the frame.

Light probe
Used to record lighting, a mirrored ball is shot at a range of exposures and these images are combined to create an HDR image used to light the scene.

Local illumination
Lighting using only the direct components of your light sources, where the transmission from other objects in the scene is not taken into account.

Low-key
A high key-to-fill ratio creates a high contrast scene.

Luminaire
A term used in the lighting world to describe light fittings of different designs, normally including the bulb, reflectors, housing and so on.

Luminosity
The emission of light energy per second.

Map
The images assigned to materials as patterns are called maps and can include standard bitmap types such as .bmp, .jpg, and .tif , procedural maps and image processing systems such as compositors and masking systems.

Matte painting
Traditionally matte paintings started life as paintings of environments on glass that are combined with the filmed actors.

Moore's law
The observation that computing power increases exponentially over time, and that historically it has doubled every 18 months over a long time span.

Motion blur
Motion blur is applied to fast moving objects in a scene to make them appear blurred in each frame, which will have the effect of making them appear to move smoothly in the finished animation.

Multiplier
The Multiplier value in every light in 3ds max lets you increase the intensity or brightness of the light beyond its standard range.

NTSC
NTSC, or National Television Standards Committee, is the name of the video standard used in North America, most of Central and South America, and Japan. The frame rate is 30fps or 60 fields per second, with each field accounting for half the interleaved scan lines on a television screen.

Negative brightness
A light created with negative brightness will remove light from its area of illumination, creating a region of darkness that can be useful for selectively darkening areas or creating false shadows.

Noise
Used to create random patterns in materials, animation and geometry.

Non-square pixels
The result of rendering at a different pixel aspect ratio than 1:1, necessary because of the historical legacy of many digital disk recorders.

Normal
A vector that defines which way a face or vertex is pointing. The direction of the normal indicates the front, or outer surface of the face or vertex.

Omni lights
Omni lights provide a point source of illumination that shoots out in all directions. Easy to set up, but the focus of their beam can't be restricted.

Opacity
Defines how opaque a material is: from totally transparent at 0% to totally opaque at 100%.

Overscan
Broadcasters intentionally overscan the video image to ensure that no unintentional black areas are visible on a television screen. The result is that portions of an image around the edges are not visible on a typical set.

PAL

PAL, or Phase Alternate Line, is the video standard used in most European countries. The frame rate is 25fps or 50 fields per second, with each field accounting for half the interleaved scan lines on a television screen.

Pan and scan

The process of reframing a widescreen image to fit into a standard 4:3 screen involves cropping a portion of the original image, though the area visible can be animated to scan across the widescreen version.

Penumbra

A partial shadow between regions of total shadow and total illumination.

Photon

The single unit of light illumination.

Photon mapping

An approach to rendering global illumination creates a resolution independent photon map that stores the lighting information.

Picture safe area

The central 90% or so of a broadcast frame that will be safe from cropping due to overscan.

Pixel

An acronym that stands for Picture Element, this is the smallest component that makes up the display on a computer monitor. Just as each dot on the screen is a pixel, images are likewise stored in a pixel form that is mapped to the screen pixels for viewing.

Plug-in

An additional product that is used within or alongside a software solution, plug-ins extend the functionality of an application in a specific way.

Point light

A local source of illumination that shines in all directions from a single infinitely small point.

Point-of-view shot

A shot taken with the camera representing the point-of-view of a character, for example the exaggerated staggering of a drunken character.

Primary colors

Fundamental colors that when combined create a secondary color. Light's primaries are Red, Green and Blue.

Projector map

By adding a map to a light, you turn it into a projector. You can assign a single image, or you can assign an animation to simulate shadows seen through leaves or window frames, in the same way that gobos are used in theater lighting.

Quadtrees

A quadtree is a data structure used to calculate raytraced shadows. The quadtree represents the scene from the point of view of the light. The root node of the quadtree lists all objects that are visible in that view. If too many objects are visible, the node generates four other nodes, each representing a quarter of the view, each with a list of objects in that portion. This process continues adaptively, until each node has only a small number of objects, or the quadtree's depth limit (which can be set for each light) is reached.

RGB

A method of representing colors as the combination of Red, Green and Blue light, which works through additive mixing.

Radiation

The transfer or release of energy through particle emission, which all objects emit in some form.

Radiosity

The method of calculating global illumination that accounts for both the direct and indirect illumination in a scene.

Raytracing

A rendering algorithm that simulates the physical and optical properties of light rays as they reflect off and refract through objects in a 3D model. This method generally traces rays of light backward from the imaging plane to the light sources.

Raytraced shadows

Shadows are generated by tracing the path of rays sampled from a light source. Raytraced shadows are more accurate than shadow-mapped shadows. They are more realistic for transparent and translucent objects.

Reflection

The abrupt change in direction of a wave front at an interface between two dissimilar media so that the wave front returns into the medium from which it originated.

Refraction

The change in direction of light as it passes from one transparent material to another. This causes an apparent shift in the image showing through the transparent material.

Rendering

This is a process that combines a geometric model with descriptions of its surface properties, lighting and so on to create a visual image.

Renderer

The software, often a component of a 3D software package, that calculates and displays the resultant image frames from a 3D scene.

Resolution

The number of pixels per unit. The higher the number of pixels, the higher the resolution, and the greater the capacity to display detail.

Roll

To rotate a camera or light about the horizontal plane.

SMPTE

SMPTE (Society of Motion Picture and Television Engineers) is the standard time display format for most professional animation work. From left to right, the SMPTE format displays minutes, seconds, and frames, delineated by colons.

Safe area

Comprised of three separate regions, the safe area defines how close to the edge of a broadcast image various elements should go.

Sample range

Sample range affects the softness of the edge of shadow-mapped shadows, determining how much area within the shadow is averaged.

Saturation

The extent to which a color is made purely of a particular hue; the vividness of the hue.

Scanline rendering
As the name implies, this process renders the scene as a series of horizontal lines.

Self-illumination
Self-Illumination creates the illusion of incandescence by replacing any shadows on the surface with the diffuse color.

Shade
The color resulting from the addition of black to a pure hue.

Shadow color
The color allocated to a light's shadows.

Shadow map
A shadow map is a bitmap that's projected from the direction of the spotlight. This method provides a softer edge and can require less calculation time than raytraced shadows, but it's less accurate.

Shadows-only lights
Lights whose sole purpose is to generate a shadow with no illumination. These are often faked using two lights of the same intensity, one with a negative value and one with a positive so the illumination cancels itself out. The positive light is the only one set to cast shadows.

Snell's law
A law that defines how light refracts.

Soft light
Light which has been scattered in some way that casts shadows with soft edges. The larger and closer a light source, the softer it will be.

Specular reflection
The component of the light reflecting from a surface caused by its shiny or glossy nature. Shiny surfaces reflect light striking them in clearly defined angles of incidence, resulting in hotspots corresponding to the direction of the light sources providing the illumination.

Spotlight
A local source of illumination that shines in only one direction.

Subtractive color
The process of color mixing that exists in pigments where the primaries of red, yellow and blue combine together to make black.

Supersampling
Supersampling is one of several antialiasing techniques. Textures, shadows, highlights, and raytraced reflections and refractions all have their own preliminary antialiasing strategies. Supersampling is an optional additional step before the renderer performs its final antialiasing pass.

Superwhite
See *Unclamped color.*

Technical Director
Commonly abbreviated to TD, the technical director's job is the one that commonly involves the task of lighting a production and can also include texturing, rendering and shader development.

Telecine
The process of digitizing film, where each frame is scanned and stored digitally. It is at this stage where color correction often takes place.

Texture mapping
The process of applying textures to a 3D model.

Throw

How a light is broken up by objects around it into patterns and shapes.

Throw pattern

Used to mimic go-betweens in real lighting, a throw pattern when allocated to a light breaks the light up according to the map.

Tint

The color resulting from the addition of white to a pure hue.

Title safe area

The central 80% of a broadcast image, outside of which it is not recommended to place titles.

Tone

The addition of gray to a pure hue.

Translucency

A translucent material transmits light, but unlike a transparent material, it also scatters the light so objects behind the material cannot be seen clearly.

Transmission

The conduction of light through a media.

Transparency

The characteristic of allowing an underlying image to show through, either partially or totally.

True color

Describes hardware and software that can support up to 16M color values. Also known as 24-bit or (with alpha channel data) 32-bit color.

Tungsten-balanced film

Film stock that has been designed to be used in artificially lit conditions, where its 3,200 °K color balance makes tungsten lighting appear white.

Unclamped color

An unclamped color is brighter than pure white and is most likely to appear in highlights on shiny metallic objects. Used in HDRI rendering.

Umbra

The totally occluded area of the shadow that has no illumination.

Value

The relative lightness or darkness of the color, usually measured as a percentage from 0% (black) to 100% (white).

View-independence/-dependence

A view-independent calculation is calculated for the environment and hence is not tied to any one particular view. This means that rendering from any point of view can be carried out using these initial calculations. View-dependent calculations must be calculated for each rendered frame.

Visible Spectrum

The narrow band of the electromagnetic spectrum that we can see.

Volumetric lighting

Provides light effects based on the interaction of lights with atmospheric matter such as fog, smoke, dust and so on.

Bibliography

Ablan, D. (2002). *Inside LightWave 7*, New Riders Publishing.

Ahearn, L. (2001). *3D Game Art: fx & Design*, Coriolis.

Alton, J. (1995). *Painting With Light*, University of California Press.

Anders, P. (1998). *Envisioning Cyberspace: Designing 3D Electronic Spaces*, McGraw-Hill Professional Publishing.

Apodaca, A. A. and Gritz, L. (2000). *Advanced RenderMan*, Morgan Kaufmann.

Ascher, S., Pincus, E., Keller, C., Brun, R. and Spagna, T. (1999). *The Filmmaker's Handbook: A Comprehensive Guide for the Digital Age*, Plume.

Barratt, K. (1980). *Logic & Design in Art, Science & Mathematics*, Design Books.

Beckman, J. (1998). *The Virtual Dimension: Architecture, Representation, and Crash Culture*, Princeton Architectural Press.

Bell, J. A. (1999). *3D Studio MAX R3: f/x & Design*, Coriolis.

Billups, S. (2000). *Digital Moviemaking: The Filmmaker's Guide to the 21st Century*, Focal Press.

Birn, J. (2000). *Digital Lighting & Rendering*, New Riders Publishing.

Birren, F. (1978). *Color & Human Response*, Van Nostrald Reinhold.

Bizony, P. (2002). *Digital Domain: The Leading Edge of Visual Effects*, Watson-Gupthill Publishers.

Boardman, T. (2001). *3ds max Fundamentals*, New Riders Publishing.

Boardman, T. and Hubbell, J. (1999). *Inside 3D Studio MAX 3, Modeling, Materials and Rendering*, New Riders Publishing.

Bobker, L. R. (1979). *Elements of Film*, Harcourt Brace Jovanovich.

Brinkmann, R. (1999). *The Art and Science of Digital Compositing,* Morgan Kaufmann.

Child, J. and Galer, M. (2002). *Photographic Lighting Essential Skills,* Second Edition, Focal Press.

Cohen, D. (1994). *Professional Photographic Illustration*, Silver Pixel Press.

Davies, A. and Fennessy, P. (2001). *Digital Imaging for Photographers*, Fourth Edition, Focal Press.

Demers, O. (2001). *Digital Texturing & Painting*, New Riders Publishing.

Dong, W. and Gibson, K. (1998). *Computer Visualization: An Integrated Approach for Interior Design and Architecture,* McGraw-Hill Professional Publishing.

Ebert, D.S., Musgrave, F. K., Peachey, D., Perlin, K. and Worley, S. (1998). *Texturing and Modeling: A Procedural Approach*, Academic Press.

Ferguson, M. (2000). *Max Ferguson's Digital Darkroom Masterclass,* Focal Press.

Fleming, B. (1999). *3D Modeling & Surfacing,* Academic Press.

Foley, J.D., van Dam, A., Feiner, S. K. and Hughes, J.F. (1990). *Computer Graphics, Principles and Practice*, Addison-Wesley.

Friedmann, A. (2001). *Writing for Visual Media*, Focal Press.

Galer, M. and Horrat, L. (2002). *Digital Imaging Essential Skills,* Second Edition, Focal Press.

Gallardo, A. (2001). *3D Lighting: History, Concepts & Techniques*, Charles River Media.

Glassner, A.S. (1989). *An Introduction to Ray Tracing*, Academic Press.

Glassner, A.S. (1995). *Principles of Digital Image Synthesis*, Morgan Kaufmann.

Goldstein, N. (1989). *Design and Composition*, Prentice Hall.

Gordon, G. (1995). *Interior Lighting for Designers,* John Wiley & Sons.

Goulekas, K. E. (2001). *Visual Effects in a Digital World: A Comprehensive Glossary of Over 7,000 Visual Effects Terms,* Morgan Kaufmann Publishers.

Graham, D. W. (1970). *Composing Pictures*, Van Nostrald Reinhold.

Hall, R. (1989). *Illumination and Color in Computer Generated Imagery*, Springer-Verlag.

Harris, M. (2001). *Professional Architectural Photography*, Third Edition, Focal Press.

Heckbert, P. S. (1992). *Introduction to Global Illumination*, ACM SIGGRAPH.

Huffman, K. (2001). *Psychology in Action*, Sixth Edition, John Wiley & Sons.

Imperiale, A. (2000). *New Flatness: Surface Tension in Digital Architecture,* Birkhauser.

Jacobson, R. E. et al. (2000). *The Manual of Photography, Photographic and Digital Imaging,* Ninth Edition, Focal Press.

Katz, S. D. (1991). *Film Directing Shot by Shot*, Michael Wiese Productions.

Katz, S. D. (1992). *Film Directing Cinematic Motion*, Michael Wiese Productions.

Kelly, D. (2000). *Digital Compositing In Depth,* Coriolis Group.

Kent, S. (2001). *The Making of Final Fantasy: The Spirits Within,* Brady Games.

Kerlow, I. V. (2000). *The Art of 3-D Computer Animation and Imaging,* Rockport Publishers.

Kerlowi. (1996). *Computer Graphics for Designers & Artists*, Second Edition, John Wiley & Sons.

Kuperberg, M. (2002). *Guide to Computer Animation for tv, games, multimedia and web*, Focal Press.

Lammers, J., Gooding, L. (2002). *Maya 4 Fundamentals,* New Riders Publishing.

Landau, C. and White, T. (2000). *What They Don't Teach You at Film School: 161 Strategies to Making Your Own Movie No Matter What,* Hyperion.

Laytin, P. (2000). *Creative Camera Control*, Third Edition, Focal Press.

Lee, K. (2002). *Inside 3ds max 4*, Holt, New Riders Publishing.

Lewis, I. (2000). *How to Make Great Short Feature Films: The Making of Ghosthunter*, Focal Press.

LoBruggo, V. (1992). *By Design*, Praeger.

Lowell, R. (1992). *Matters of Light and Depth*, Broad Street Books.

Lynch, D. K. and Livingston, W. (1995). *Color and Light in Nature*, Cambridge University Press.

Lyver, D. and Swainson, G. (1999). *Basics of Video Lighting,* Second Edition, Focal Press.

Malkiewicz, K. (1986). *Film Lighting: Talks With Hollywood's Cinematographers and Gaffers,* Prentice-Hall Press.

Malkiewicz, K. (1989). *Cinematography: A Guide for Film Makers and Teachers*, Simon & Schuster Inc.

Mascelli, J.V. (1998). *The Five C's of Cinematography: Motion Picture Filming Techniques,* Silman-James Press.

Masson, T. (1999). *CG 101: A Computer Graphics Industry Reference*, New Riders Publishing.

Matossian, M. (2001). *3ds max for Windows,* Peachpit Press.

McCarthy, R. (1992). *Secrets of Hollywood Special Effects,* Focal Press.

McFarland, J. and Polevoi, R. (2001). *3ds max In Depth,* Coriolis.

McGrath, D. (2001). *Editing & Post-Production*, Screencraft series, Focal Press

McKee, R. (1997). *Story,* ReganBooks.

Minnaert, M. G. J. (1993). *Light and Color in the Outdoors*, Springer-Verlag.

Novitski, B.J. and Mitchell, W. (1999). *Rendering Real & Imagined Buildings: The Art of Computer Modeling from the Palace of Kublai Khan to Le Corbusier's Villas,* Rockport Publishers.

Ojeda, O. R. and Guerra, L. H. (2000). *Hyper-Realistic: Computer Generated Architectural Renderings,* Rockport Publishers.

Perisic, Z. (2000). *Visual Effects Cinematography,* Focal Press.

Polevoi, R. (1999). *3D Studio MAX R3 In Depth,* Coriolis.

Rabiger, M. (2000). *Developing Story Ideas*, Focal Press.

Ray, S. F. (2002). *Applied Photographic Optics,* Third Edition, Focal Press.

Rickitt, R. (2000). *Special Effects: The History and Technique,* Watson-Guptill Publications.

Rogers, P. B. (1999). *The Art of Visual Effects: Interviews on the Tools of the Trade,* Focal Press.

Saleh Uddin, M. (1999). Digital Architecture, McGraw-Hill Professional Publishing.

Schaefer, D. and Salvato, L. (1986). *Masters of Light: Conversations With Contemporary Cinematographers,* University of California Press.

Schoenherr, M. (2001). *Exploring Maya 4, 30 Studies in 3D,* Peachpit Press.

Steffy, G. (2001). *Architectural Lighting Design,* John Wiley & Sons.

Tarrant, J. (2000). *Practical Guide to Photographic Lighting for film and digital photography,* Focal Press.

Thomas, F. (1995). *The Illusion of Life: Disney Animation,* Hyperion.

Valentino, J. (2001). *Photographic Possibilities,* Focal Press.

Vineyard, J. and Cruz, J. (2000). *Setting up Your Shots: Great Camera Moves Every Filmmaker Should Know,* Michael Weise Productions.

Watkins, A. (2002). *The Maya 4 Handbook,* Charles River Media.

Watt, A., and Watt, M. (1992). *Advanced Animation and Rendering Techniques: Theory and Practice*, Addison-Wesley.

Weishar, P. (1998). *Digital Space: Designing Virtual Environments,* McGraw-Hill Professional Publishing.

Weishar, P. (2002). *Blue Sky: The Art of Computer Animation,* Harry N. Abrams.

Wright, S. (2001). *Digital Compositing for Film and Video,* Focal Press.

Zakia, R. D. (2001). *Perception and Imaging*, Focal Press.

Zellner, P. (1999). *Hybrid Space: New Forms in Digital Architecture,* Rizzoli.

Focal Press Visual Effects and Animation series

The Animator's Guide to 2D Computer Animation
Hedley Griffin

Producing Animation
Catherine Winder and Zahra Dowlatabadi

A Guide to Computer Animation: for tv, games, multimedia and web
Marcia Kuperberg

Digital Compositing for Film and Video
Steve Wright

Essential CG Lighting Techniques
Darren Brooker

Producing Independent 2D Character Animation
Mark Simon

Animation in the Home Digital Studio
Steven Subotnick

Buy online at: **www.focalpress.com**